THE SOCIETY OF PUBLICATION DESIGNERS

# 30TH PUBLICATION DESIGN ANNUAL

# ■ ACKNOWLEDGEMENTS

## The Gala

The Society wishes to thank The New York Times
Company Foundation for its generosity to
the New York Public Library, which has enabled
the Society of Publication Designers to hold
its annual awards Gala in this very special place.

## The Sponsors

The Society thanks its corporate sponsors for their
continuing support:

American Express Publishing
Apple Computers, Inc.
Applied Graphics Technologies
Champion Paper Co.
Condé Nast Publications, Inc.
Dow Jones & Company, Inc.
Hachette Filipacchi Magazines, Inc.
Hearst Magazines
IBM
Meredith Corporation
Newsweek
The New York Times
Wenner Media
Time Inc.
U.S. News & World Report

## Special Thanks

Frederica Gamble
   of Condé Nast Publications
Chris Hamilton and Diane Romano
   of Applied Graphics Technologies
Steven Freeman
Color Edge Film Processing
Alvaro Cuellar
Cameron Blanchard

## Officers

**President**
Tom Bentkowski, LIFE

**Vice President**
Sue Llewellyn

**Vice President**
Robert Altemus, Altemus Creative Servicenter

**Secretary**
Rhonda Rubinstein, R Company

**Treasurer**
Karen Bloom, Westvaco Corporation

**Executive Director**
Bride M. Whelan

## Board of Directors

David Barnett, Barnett Design Group
Caroline Bowyer, American Lawyer
Traci Churchill, Money
Gigi Fava, Marie Claire
Malcolm Frouman, BusinessWeek
Michael Grossman, Meigher Communications
Diana LaGuardia, Condé Nast Traveler
Greg Leeds, The Wall Street Journal
Janet Waegel, Time
Fo Wilson, Studio W
Scott Yardley, Good Housekeeping
Lloyd Ziff, Lloyd Ziff Design

## Ex Officio

Walter Bernard , WBMG
Phyllis Richmond Cox, Bride's & Your New Home

## The Society of Publication Designers, Inc.

60 East 42nd Street, Suite 721
New York, NY 10165
Telephone: (212) 983-8585
Fax: (212) 983-6042

## The SPD 30th Design Annual

Jacket and book designed and produced by Mimi Park.

Copyright © 1995
The Society of Publication Designers, Inc.

All rights reserved. No part of this book may be
reproduced in any form without written permission
of the copyright owners. All images in this book have
been reproduced with the knowledge and prior
consent of the artists concerned and no responsibility
is accepted by producer, publisher, or printer
for any infringement of copyright or otherwise,
arising from the contents of this publication.
Every effort has been made to ensure that credits
accurately comply with information supplied.

First published in the United States of America by:

Rockport Publishers,Inc.
146 Granite Street
Rockport, Massachusetts 01966
Telephone: (508) 546-9590
Fax: (508) 546-7141
Telex: 5106019284 Rockport pub

Distributed to the book trade and art trade
in the U.S. and Canada by:

North Light, an imprint of F & W Publications
1507 Dana Avenue
Cincinnati, OH 45207
Telephone: (513) 531-2222
Other Distribution by:
Rockport Publishers, Inc.
Rockport, Massachusetts 01966

ISBN 1-56496-165-6

10 9 8 7 6 5 4 3 2 1

Printed in Hong Kong

# CONTENTS

| | |
|---|---|
| Foreword | 4 |
| The Competition & Judges | 6 |
| B.W. Honeycutt Award | 8 |
| Design | 9 |
| Illustration | 137 |
| Photography | 163 |
| Student Competition | 223 |
| Index | 233 |

# ■ FOREWORD

## The Future Isn't What It Used To Be

In 1965, Lyndon Johnson was energetically organizing the series of legislative initiatives that he would call the "Great Society". He was, at the same time, doubling the monthly draft call in order to bring to an end a war that was to drag on for ten more years. The first man walked in space, and Pope Paul VI became the first Pontiff to set foot in North America. A rock song called "Eve of Destruction" was banned from many radio stations, its lyrics considered too dark and apocalyptic for a mass sensibility. Elvis Presley turned thirty, brooding that he was hopelessly mired in a career of mushy, miserable movies. The median family income in the U.S. was $6,509, a first-class stamp cost 5¢. There were the fewest forest fires in recorded history. The Beatles played Shea Stadium. The U.S. had a total of 661 television stations, and many people still watched in black-and-white. Pablo Picasso was going strong at 84. Winston Churchill died, and Charles deGaulle was re-elected president of France. "The Sound of Music" won five Academy Awards, and a woman in Los Angeles claimed to have seen it three hundred times. One night in November, a small relay switch at a power station failed, and 25 million people were plunged into darkness.

In 1965 the design profession was dominated by Milton Glaser and Saul Bass and Paul Rand and Henry Wolf and Lou Dorfsman and Herb Lubalin and Alan Hurlburt. Several years of relative peace and prosperity created an atmosphere in which corporations and magazines favored an image that was bountiful and polished. The style of the time reflected this equilibrium. Design was sober and self-assured. Magazines were urbane, rational, and faithful to the grid as an organizational element. At a 1965 AIGA conference called "Magazine USA", Otto Storch, the influential Art Director of McCall's, summarized his, and the prevailing, design philosophy: "Some of the things I've done in the past, I think now are a little over-designed. I'm beginning to feel that a simpler, quieter approach is better… A magazine doesn't have to be a circus where you keep jumping through a hoop with each spread." But there were rumblings beneath this surface of graphic tranquility. Push Pin Studios was creating an energetically eclectic and profoundly influential graphic style, mixing Art Nouveau, Art Deco, Victorian and Surrealist influences. It was a look that rejected the formal structures of the Bauhaus that had prevailed for a generation of designers. "Much that is ideologically sound is also thoroughly uninteresting", Milton Glaser observed. By the end of the decade, marchers would fill the streets, and graphic design would undergo a revolution of its own. Much

of the energy and innovation would come from underground newspapers and psychedelic posters. Design moved from the calm reflection of corporate prosperity to a kind of hip, fashionable anarchy. Design became the language of the emerging youth culture, and was increasingly seen as an instrument of social change.

By 1965, when the Society of Publication Designers was founded, it was already popular to address a pressing question: Had the march of technology already begun to relegate magazines to a place of marginal importance in the life of the culture, if not yet to the brink of obsolescence? And would that obsolescence be simply one more stage in the ultimate downfall of the written word? Marshall McLuhan, in his book "Understanding Media", had argued most persuasively the the demise of print was inevitable in the age of telecommunications. Print, he theorized, had changed society from a collective that relied on an oral tradition and memory as the storehouse of information, to a cult of individualism, characterized by a lone individual committing information to paper in a solitary environment. The invention of printing created categorization and specialization, and had transformed tribal unity into splintered, individual worlds. Television images, he observed, were disorderly, and demanded that viewers actively participate in the storytelling process. People forced together by these shared images would become a world community that McLuhan christened the "Global Village". It appeared that the golden age of magazines, sparked by the development of the 35mm camera, advances in color printing technology, and an ever more resourceful, daring editorial approach, had lasted barely thirty years. The philosophy and economics of magazines were all wrong, critics said. The great institutions, *LIFE*, *Look*, *The Saturday Evening Post*, *Collier's*, were falling. Ink on paper stood little chance in a world in which people were increasingly and ever more avidly sitting in front of a glowing screen.

But magazines have refused to simply fade away. Just when their impending obsolescence became part of the conventional intellectual wisdom, they seemed to display an unprecedented knack for reinvention, restructuring, and resurrection. *Rolling Stone* was started, *New York* gave new form and life to the city magazine. *Time* and *Newsweek* took advantage of new technologies to become more pictorial and more vital. LIFE was resurrected, *Esquire* revitalized. Perhaps the reason lies in the fundamental appeal of the magazine, perhaps in its extraordinary resilience.

4

# CONTENTS

Foreword 4

The Competition & Judges 6

B.W. Honeycutt Award 8

Design 9

Illustration 137

Photography 163

Student Competition 223

Index 233

# ■ FOREWORD

## The Future Isn't What It Used To Be

In 1965, Lyndon Johnson was energetically organizing the series of legislative initiatives that he would call the "Great Society". He was, at the same time, doubling the monthly draft call in order to bring to an end a war that was to drag on for ten more years. The first man walked in space, and Pope Paul VI became the first Pontiff to set foot in North America. A rock song called "Eve of Destruction" was banned from many radio stations, its lyrics considered too dark and apocalyptic for a mass sensibility. Elvis Presley turned thirty, brooding that he was hopelessly mired in a career of mushy, miserable movies. The median family income in the U.S. was $6,509, a first-class stamp cost 5¢. There were the fewest forest fires in recorded history. The Beatles played Shea Stadium. The U.S. had a total of 661 television stations, and many people still watched in black-and-white. Pablo Picasso was going strong at 84. Winston Churchill died, and Charles deGaulle was re-elected president of France. "The Sound of Music" won five Academy Awards, and a woman in Los Angeles claimed to have seen it three hundred times. One night in November, a small relay switch at a power station failed, and 25 million people were plunged into darkness.

In 1965 the design profession was dominated by Milton Glaser and Saul Bass and Paul Rand and Henry Wolf and Lou Dorfsman and Herb Lubalin and Alan Hurlburt. Several years of relative peace and prosperity created an atmosphere in which corporations and magazines favored an image that was bountiful and polished. The style of the time reflected this equilibrium. Design was sober and self-assured. Magazines were urbane, rational, and faithful to the grid as an organizational element. At a 1965 AIGA conference called "Magazine USA", Otto Storch, the influential Art Director of McCall's, summarized his, and the prevailing, design philosophy: "Some of the things I've done in the past, I think now are a little over-designed. I'm beginning to feel that a simpler, quieter approach is better... A magazine doesn't have to be a circus where you keep jumping through a hoop with each spread." But there were rumblings beneath this surface of graphic tranquility. Push Pin Studios was creating an energetically eclectic and profoundly influential graphic style, mixing Art Nouveau, Art Deco, Victorian and Surrealist influences. It was a look that rejected the formal structures of the Bauhaus that had prevailed for a generation of designers. "Much that is ideologically sound is also thoroughly uninteresting", Milton Glaser observed. By the end of the decade, marchers would fill the streets, and graphic design would undergo a revolution of its own. Much

of the energy and innovation would come from underground newspapers and psychedelic posters. Design moved from the calm reflection of corporate prosperity to a kind of hip, fashionable anarchy. Design became the language of the emerging youth culture, and was increasingly seen as an instrument of social change.

By 1965, when the Society of Publication Designers was founded, it was already popular to address a pressing question: Had the march of technology already begun to relegate magazines to a place of marginal importance in the life of the culture, if not yet to the brink of obsolescence? And would that obsolescence be simply one more stage in the ultimate downfall of the written word? Marshall McLuhan, in his book "Understanding Media", had argued most persuasively the the demise of print was inevitable in the age of telecommunications. Print, he theorized, had changed society from a collective that relied on an oral tradition and memory as the storehouse of information, to a cult of individualism, characterized by a lone individual committing information to paper in a solitary environment. The invention of printing created categorization and specialization, and had transformed tribal unity into splintered, individual worlds. Television images, he observed, were disorderly, and demanded that viewers actively participate in the storytelling process. People forced together by these shared images would become a world community that McLuhan christened the "Global Village". It appeared that the golden age of magazines, sparked by the development of the 35mm camera, advances in color printing technology, and an ever more resourceful, daring editorial approach, had lasted barely thirty years. The philosophy and economics of magazines were all wrong, critics said. The great institutions, *LIFE*, *Look*, *The Saturday Evening Post*, *Collier's*, were falling. Ink on paper stood little chance in a world in which people were increasingly and ever more avidly sitting in front of a glowing screen.

But magazines have refused to simply fade away. Just when their impending obsolescence became part of the conventional intellectual wisdom, they seemed to display an unprecedented knack for reinvention, restructuring, and resurrection. *Rolling Stone* was started, *New York* gave new form and life to the city magazine. *Time* and *Newsweek* took advantage of new technologies to become more pictorial and more vital. LIFE was resurrected, *Esquire* revitalized. Perhaps the reason lies in the fundamental appeal of the magazine, perhaps in its extraordinary resilience.

4

# CONTENTS

| | |
|---|---|
| Foreword | 4 |
| The Competition & Judges | 6 |
| B.W. Honeycutt Award | 8 |
| Design | 9 |
| Illustration | 137 |
| Photography | 163 |
| Student Competition | 223 |
| Index | 233 |

# ■ FOREWORD

## The Future Isn't What It Used To Be

In 1965, Lyndon Johnson was energetically organizing the series of legislative initiatives that he would call the "Great Society". He was, at the same time, doubling the monthly draft call in order to bring to an end a war that was to drag on for ten more years. The first man walked in space, and Pope Paul VI became the first Pontiff to set foot in North America. A rock song called "Eve of Destruction" was banned from many radio stations, its lyrics considered too dark and apocalyptic for a mass sensibility. Elvis Presley turned thirty, brooding that he was hopelessly mired in a career of mushy, miserable movies. The median family income in the U.S. was $6,509, a first-class stamp cost 5¢. There were the fewest forest fires in recorded history. The Beatles played Shea Stadium. The U.S. had a total of 661 television stations, and many people still watched in black-and-white. Pablo Picasso was going strong at 84. Winston Churchill died, and Charles deGaulle was re-elected president of France. "The Sound of Music" won five Academy Awards, and a woman in Los Angeles claimed to have seen it three hundred times. One night in November, a small relay switch at a power station failed, and 25 million people were plunged into darkness.

In 1965 the design profession was dominated by Milton Glaser and Saul Bass and Paul Rand and Henry Wolf and Lou Dorfsman and Herb Lubalin and Alan Hurlburt. Several years of relative peace and prosperity created an atmosphere in which corporations and magazines favored an image that was bountiful and polished. The style of the time reflected this equilibrium. Design was sober and self-assured. Magazines were urbane, rational, and faithful to the grid as an organizational element. At a 1965 AIGA conference called "Magazine USA", Otto Storch, the influential Art Director of McCall's, summarized his, and the prevailing, design philosophy: "Some of the things I've done in the past, I think now are a little over-designed. I'm beginning to feel that a simpler, quieter approach is better... A magazine doesn't have to be a circus where you keep jumping through a hoop with each spread." But there were rumblings beneath this surface of graphic tranquility. Push Pin Studios was creating an energetically eclectic and profoundly influential graphic style, mixing Art Nouveau, Art Deco, Victorian and Surrealist influences. It was a look that rejected the formal structures of the Bauhaus that had prevailed for a generation of designers. "Much that is ideologically sound is also thoroughly uninteresting", Milton Glaser observed. By the end of the decade, marchers would fill the streets, and graphic design would undergo a revolution of its own. Much

of the energy and innovation would come from underground newspapers and psychedelic posters. Design moved from the calm reflection of corporate prosperity to a kind of hip, fashionable anarchy. Design became the language of the emerging youth culture, and was increasingly seen as an instrument of social change.

By 1965, when the Society of Publication Designers was founded, it was already popular to address a pressing question: Had the march of technology already begun to relegate magazines to a place of marginal importance in the life of the culture, if not yet to the brink of obsolescence? And would that obsolescence be simply one more stage in the ultimate downfall of the written word? Marshall McLuhan, in his book "Understanding Media", had argued most persuasively the the demise of print was inevitable in the age of telecommunications. Print, he theorized, had changed society from a collective that relied on an oral tradition and memory as the storehouse of information, to a cult of individualism, characterized by a lone individual committing information to paper in a solitary environment. The invention of printing created categorization and specialization, and had transformed tribal unity into splintered, individual worlds. Television images, he observed, were disorderly, and demanded that viewers actively participate in the storytelling process. People forced together by these shared images would become a world community that McLuhan christened the "Global Village". It appeared that the golden age of magazines, sparked by the development of the 35mm camera, advances in color printing technology, and an ever more resourceful, daring editorial approach, had lasted barely thirty years. The philosophy and economics of magazines were all wrong, critics said. The great institutions, *LIFE, Look, The Saturday Evening Post, Collier's*, were falling. Ink on paper stood little chance in a world in which people were increasingly and ever more avidly sitting in front of a glowing screen.

But magazines have refused to simply fade away. Just when their impending obsolescence became part of the conventional intellectual wisdom, they seemed to display an unprecedented knack for reinvention, restructuring, and resurrection. *Rolling Stone* was started, *New York* gave new form and life to the city magazine. *Time* and *Newsweek* took advantage of new technologies to become more pictorial and more vital. LIFE was resurrected, *Esquire* revitalized. Perhaps the reason lies in the fundamental appeal of the magazine, perhaps in its extraordinary resilience.

In its appearance and execution, a magazine constitutes a form of almost unequaled complexity, depth, and energy. No other form, no poster, no jacket, no brochure demands the same narrative complexity and intellectual flexibility. Indeed, in the larger sense, the printed magazine represents an extraordinarily rich composite of cultural innovations– both esthetic and technological. It can, in one dense, portable package, reflect the latest developments in drawing, painting, typography, graphics, or photography. It can incorporate the most current ideas in philosophy, ethics, sociology or science. An amalgam of individual inspirations and mass production, a magazine is a work of art and a technological marvel; the product of Gutenberg, and Henry Ford, and Albert Einstein.

In 1995, desktop technologies have so democratized the publishing process that a barrage of points-of-view are now on display. The clumsiness and arrogance of some are the essence of their content, and a worthwhile price to pay for the vitality of new ideas. Even in the consumer publications that most capture our attention, the unconventionality of the graphics is a product of, as well as a reflection of, electronic technology. Reading has yielded to viewing. Appreciation of narrative order has yielded to stimulation by fragmentation, pattern, texture, and dissonance. In the 18th century, an audience could understand and anticipate the form of a symphonic work, while appreciating the harmonic and melodic development within that structure. Today, a magazine audience has certain preconceptions about linear narrative construction and visual harmony. But, just as composers came to employ atonalities and disharmonies to address the intellectual needs of some segments of the traditional audience, designers today fragment letter forms and deconstruct words to two ends: to display their disregard for the traditional boundaries of the material, and to impart to the audience a sense of superiority in believing that they can rise to greater intellectual challenges. Designers today display a Wagnerian obsession to enlighten by being obscure. "Ray Gun" is our "Tristan and Isolde".

What lies ahead? E.M. Forster, writing about the Renaissance said: "The printing press... had been mistaken for an engine of immortality, and men had hastened to commit to it deeds and passions for the benefit of future ages." Now that we are entering the uncharted regions of cyberspace, it might seem that the computer screen might be mistaken for an engine of evanescence.

We hasten to commit to it information that by its very nature is presupposed to be subject to update, expansion, obsolescence, and finally, erasure. What does the Internet do to the concept of immutability? The information on the screen, unshackled by any limitations of time or distance, may be updated, edited, or countermanded before the reader can even finish reading it. What of the concept of rationality, which in our experience has meant uniform and continuous and sequential? Will the multiplicity of choices and the almost limitlessness of information enable people to apply their experiences in a different way to the process of learning and discovery? In only five centuries, since the development of printing, information, knowledge itself, has gone from being a privileged commodity for the elite to pragmatic perceptive training and practical instruction for functioning in the culture. And how will we respond to the world that thirty years ago McLuhan seemed to be predicting when he said, "Today, after more than a century of electronic technology, we have excited our central nervous system itself in a global embrace, abolishing both space and time as far as our planet is concerned. Rapidly we approach the final phase of the extensions of man—the technical simulation of consciousness, when the creative process of knowing will be collectively and corporately extended to the whole of our human society..."

The magazine is the logical extension of the printing press's relentless capacity to organize and disseminate the sum of human knowledge. Will the ephemeral images of the Internet abolish the notion of time in the way that fiber optics and satellite transmission have abolished the notion of space? What happens to expectation and discovery in a world of limitless information? Our response to new ideas generally follows three steps: alarm, resistance, exhaustion. Will magazines' response to this new interactive-electronic world include, once again, reinvention? As W.B. Yeats observed: "The visible world is no longer a reality, the unseen world is no longer a dream."

**Tom Bentkowski**
President

5

# THE COMPETITION

RICHARD MITCHELL

1 **Competition**
Audrey Razgaitis, Co-Chair
Diana LaGuardia, **Chair**
Condé Nast Traveler

2 **Gala**
Scott Yardley, **Chair**
Good Housekeeping
Maya Kaimal MacMillan, Co-Chair
Good Housekeeping

3 **Student Competition**
Malcom Frouman, **Chair**
BusinessWeek
Rhonda Rubinstein, **Chair**
R Company

**Judges**

9 Robert Altemus
Altemus Creative Servicenter

10 Mary K. Baumann
Hopkins/Baumann

11 Gina Davis
Working Woman

12 Bob Eisner
Newsday

13 Maryjane Fahey
Roger Black, Inc.

The Society of Publication Designers Annual Competition draws several thousand entries from the United States and abroad. A distinguished jury, representing various design and editorial disciplines, judges the works submitted in seventy-five categories.

Once the most outstanding has been selected for the exhibition and publication design annual, the jury awards Gold and Silver medals, the highest awards for editorial design, and Merit awards for distinction. The result, is a body of work representing the best in design, photography, and illustration.

This year, in addition, the Society inaugurated two special prizes: the *Best In Show Award*, honoring the single outstanding achievement in magazine design in 1994, and the *B.W. Honeycutt Award*, recognizing exceptional design by a student.

30 Gael Towey
Martha Stewart Living

31 Janet Waegel
Time

32 Fred Woodward
Rolling Stone

33 Ira Yoffe
Parade

34 Shawn Young
Allure

6

Photographs by **Steven Freeman**

**Group Leaders**

**4** Walter Bernard
WBMG, Inc.

**5** Caroline Bowyer
American Lawyer

**6** Phyllis Richmond Cox
Bride's & Your New Home

**7** Will Hopkins
Hopkins/Baumann

**8** Melissa Tardiff
CMP Publications

**14** Dennis Freedman
W Magazine

**15** Karen Lee Grant
Carlson & Partners

**16** John Grimwade
Condé Nast Traveler

**17** Jessica Helfand
Jessica Helfand Studio

**18** Clive Irving
Condé Nast Traveler

**19** Andy Kner
Print

**20** Kati Korpijaakko
Glamour

**21** Richard Mantel
Mantel Studios

**22** Johno DuPlessis
The Manipulator

**23** Greg Pond
Details

**24** Robert Priest
GQ

**25** Diddo Ramm
Vibe

**26** Bruce Ramsay
Spin

**27** Kathy Ryan
New York Times Magazine

**28** Ina Saltz
Worth

**29** Virginia Smith
City University of New York

# ■ B.W. HONEYCUTT

**W**hile Bruce W. Honeycutt was the Art Director of *Details* magazine, his redesign helped the men's magazine earn accolades such as "Magazine of the Year" from *Advertising Age* and "Top Hottest Magazine" from *Adweek*. B.W. was also the Art Director of *Spy* magazine, and previously he worked for *Vanity Fair* and *GQ*, both published, like *Details*, by Condé Nast Publications. B.W.'s work has been recognized by Gold and Silver medals from Society of Publication Designers the American Institute of Graphic Arts, the Art Directors' Club of New York, and by *Print* and *Photo Design* magaines, B.W. taught publication design at the School of Visual Arts in New York City and served on the Board of the SPD. He was a native of Franklinton, North Carolina and attended North Carolina University at Chapel Hill. The B.W. Honeycutt Award honors the life and work of B.W. who died on January 12, 1994 at the age of 40

The 1995 Student Competition and B.W. Honeycutt Award are made possible by a generous contribution from Condé Nast Publications.

8

# ■ DESIGN

The Future of Rock

Rolling Stone

Generation Next

COLLECTORS' ISSUE

ISSUE 695 · NOVEMBER 17, 1994 · $3.95 CAN $4.50 UK £3.00

AFGHAN WHIGS ~ ALICE IN CHAINS ~ AMERICAN MUSIC CLUB ~ TORI AMOS ~ BABES IN TOYLAND ~ BAD RELIGION ~ BEASTIE BOYS ~ BECK
MEAT PUPPETS ~ NATALIE MERCHANT ~ MOBY ~ MUDHONEY ~ NAUGHTY BY NATURE ~ ME'SHELL NDEGÉOCELLO ~ NINE INCH NAILS

**Publication** Rolling Stone
**Art Director** Fred Woodward
**Designers** Fred Woodward, Gail Anderson, Geraldine Hessler, Lee Bearson
**Photographers** Cheryl Koralik, Albert Watson, Mark Hanauer, Dan Borris, José Picayo, Steven White, Mark Seliger, Frank Ockenfels 3, Matt Mahurin
**Photo Editors** Jodi Peckman, Denise Sfraga, Fiona McDonagh
**Publisher** Wenner Media
**Date** November 17, 1994
**Category** Entire Issue

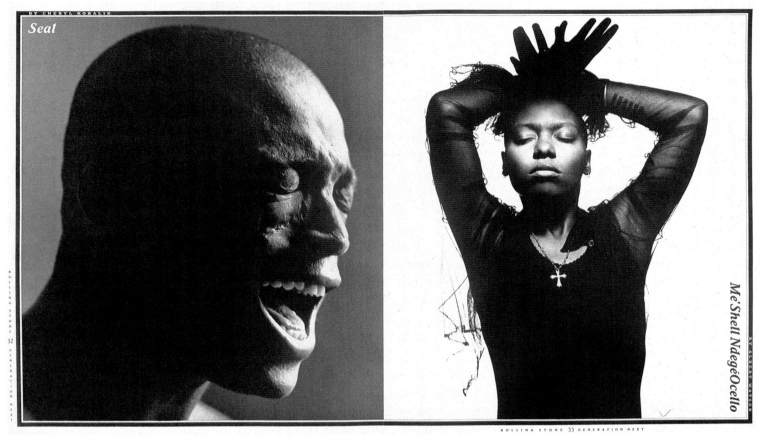

Seal

Me'Shell NdegéOcello

Frank Black

Babes in Toyland

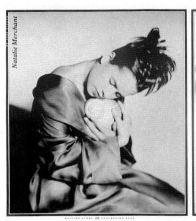

Natalie Merchant

Juliana Hatfield

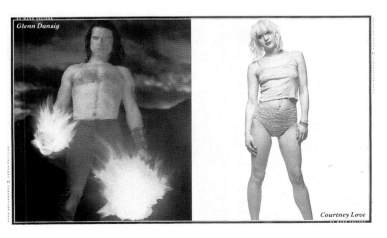

Glenn Danzig

Courtney Love

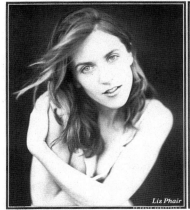

Liz Phair

Henry Rollins

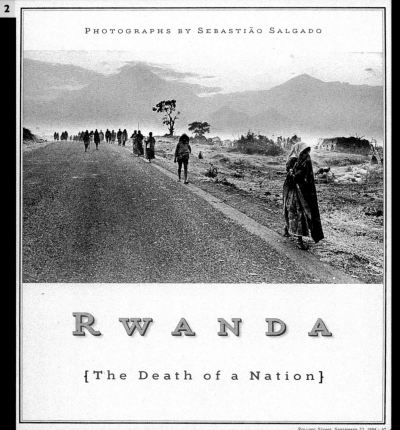

PHOTOGRAPHS BY SEBASTIÃO SALGADO

# R W A N D A

{ The Death of a Nation }

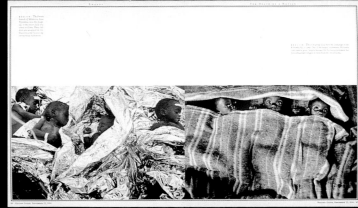

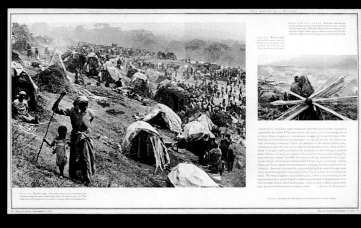

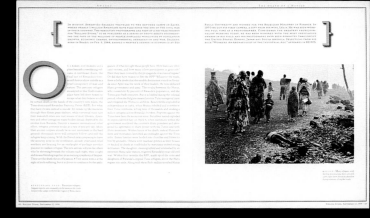

**2**

**Publication** Rolling Stone
**Art Director** Fred Woodward
**Designers** Fred Woodward, Gail Anderson
**Photographer** Sebastiao Salgado
**Photo Editor** Jodi Peckman
**Publisher** Wenner Media
**Date** September 22, 1994
**Category** Story

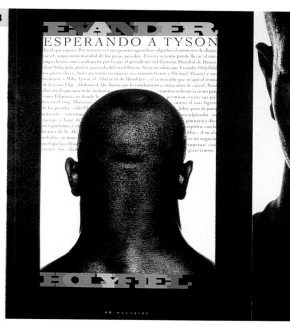

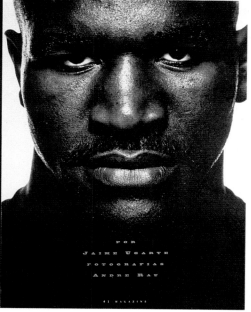

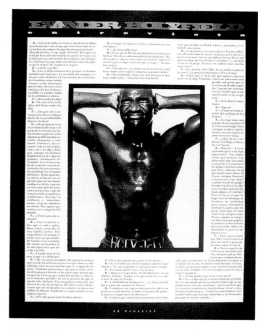

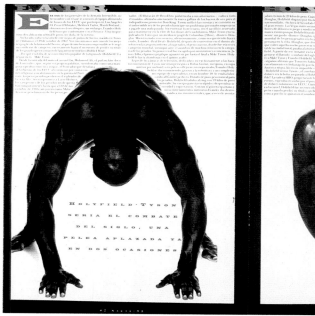

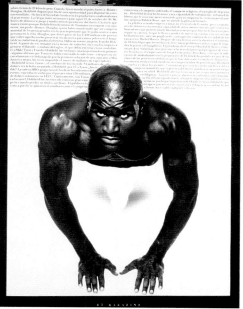

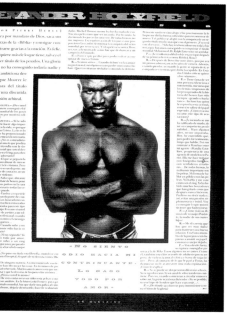

**3**

**Publication**  El Mundo
**Design Director**  Carmelo Caderot
**Art Director**  Rodrigo Sanchez
**Designers**  Rodrigo Sanchez, Miguel Buckenmeyer
**Photographer**  Andre Rau
**Publisher**  Unidad Editorial S.A.
**Date**  November 6, 1994
**Category**  Story

MARTHA STEWART **Living**

# WEDDINGS

A SPECIAL ISSUE FOR THE BRIDE

RINGS INVITATIONS **BOUQUETS** MENUS

**DRESSES** SHOWERS CAKES BRIDAL REGISTRY

$5.00 USA (CAN. $6.00)

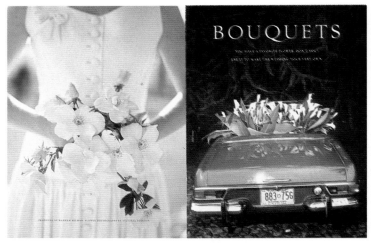

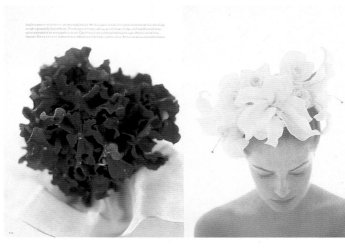

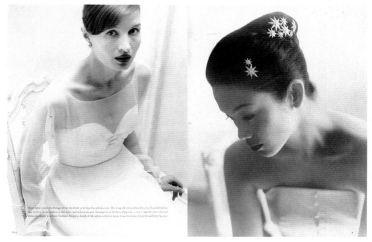

4

**Publication**  Martha Stewart Living
**Art Director**  Gael Towey
**Designers**  Gael Towey, Constance Old, Lisa Naftolin
**Photographers**  Victor Schrager, Victoria Pearson,
Carlton Davis, Thibault Jeanson, Stewart Ferebee,
Maria Robledo, O'Hana Enderle, John Dolan
**Photo Editor**  Heidi Posner
**Publisher**  Time Inc.
**Category**  Entire Issue

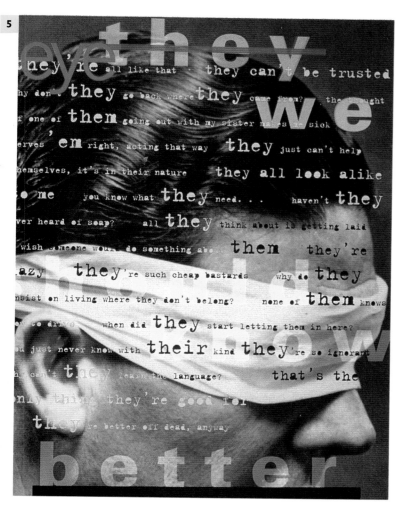

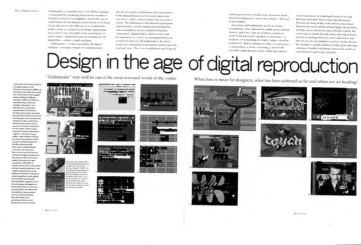

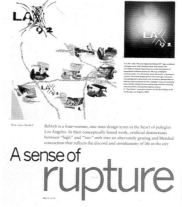

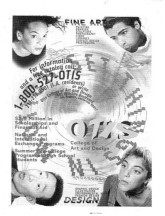

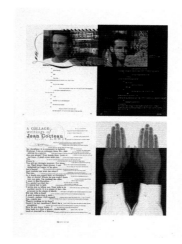

**Publication** EYE
**Art Director** Stephen Coates
**Designer** Stephen Coates
**Client** EMAP Business Communications
**Date** Autumn 94
**Category** Entire Issue

White Light

Goodbye, black. For summer, white's going to hit you in the eye. Choosing a bag, a shoe, a piece of jewelry? Think shiny, strappy, buckles. The right color? That's glaringly obvious. Left: Cuff bracelet, Roxanne Assoulin. Wrap bracelet with silver buckle, about $100, Liza Bruce. Right: Wrap bracelets with silver buckles, about $35 each, Genius-Dilettante at Showroom Seven. All in leather. Thongs, about $12, J. Crew. Polished perfection, L'Oréal Colour Riche Nail Enamel in French Tip White. Photographed by Raymond Meier.

**6**

**Publication** Harper's Bazaar
**Creative Director** Fabien Baron
**Art Director** Joel Berg
**Designer** Johan Svensson
**Photographer** Raymond Meier
**Publisher** The Hearst Corporation-Magazines Division
**Date** March 1994
**Category** Spread

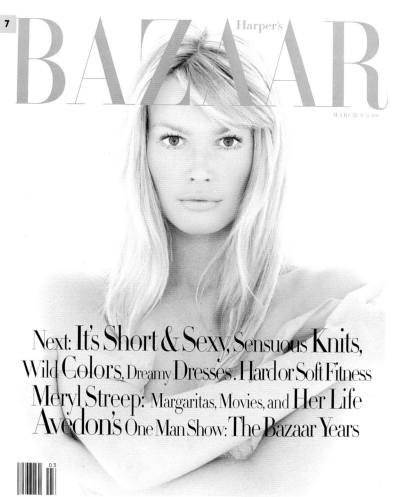

Harper's
# BAZAAR
MARCH $ 3.00

Next: It's Short & Sexy, Sensuous Knits, Wild Colors, Dreamy Dresses. Hard or Soft Fitness Meryl Streep: Margaritas, Movies, and Her Life Avedon's One Man Show: The Bazaar Years

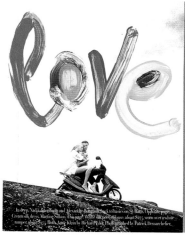

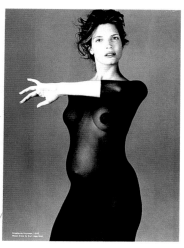

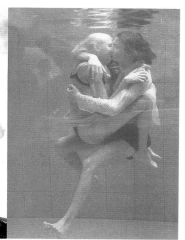

**7**

**Publication**  Harper's Bazaar
**Creative Director**  Fabien Baron
**Art Director**  Joel Berg
**Designer**  Johan Svensson
**Photographers**  Richard Avedon,
Patrick Demarchelier, Raymond Meier
**Publisher**  The Hearst Corporation-Magazines Division
**Date**  March 1994
**Category**  Entire Issue

17

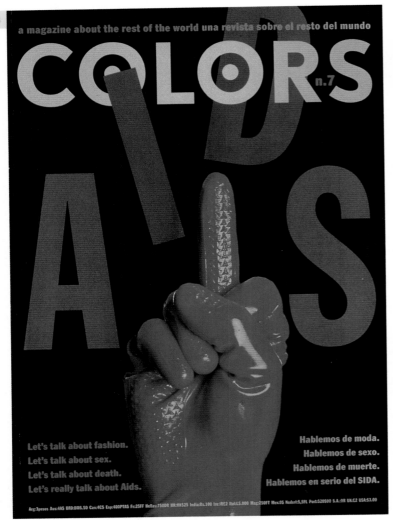

a magazine about the rest of the world una revista sobre el resto del mundo

# COLORS n.7

Let's talk about fashion.
Let's talk about sex.
Let's talk about death.
Let's really talk about Aids.

Hablemos de moda.
Hablemos de sexo.
Hablemos de muerte.
Hablemos en serio del SIDA.

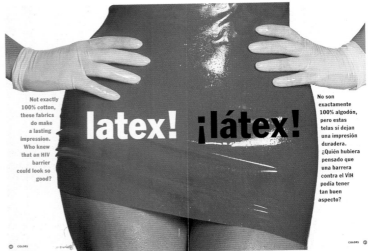

latex! ¡látex!

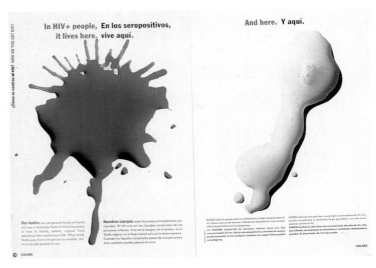

In HIV+ people, En los seropositivos, it lives here. vive aquí.

And here. Y aquí.

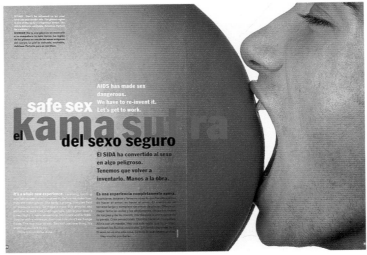

safe sex el kama sutra del sexo seguro

AIDS has made sex dangerous. We have to re-invent it. Let's get to work.

El SIDA ha convertido al sexo en algo peligroso. Tenemos que volver a inventarlo. Manos a la obra.

8

**Publication** Colors
**Editor in Chief/Design Director** Tibor Kalman
**Art Director** Scott Stowell
**Designer** Leslie Mello
**Photo Editors** Alfredo Albertone, Ilana Rein, Alice Albert
**Publisher** Colors Magazine, SRL
**Date** June 1994
**Category** Entire Issue

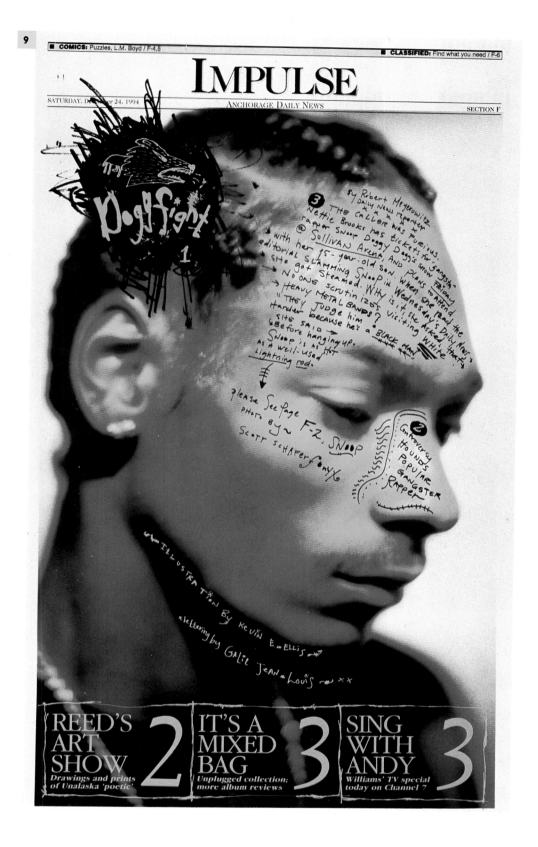

# IMPULSE

SATURDAY, December 24, 1994

ANCHORAGE DAILY NEWS

SECTION F

Dogfight 1

By Robert Meyerowitz
Daily News reporter

THE CALLER WAS FURIOUS. Nettie Brooks has tickets for "gangsta" rapper Snoop Doggy Dogg's show @ Sullivan Arena, AND plans to attend with her 15-year-old son. When she read the editorial SLAMMING SNOOP in Wednesday's Daily News she got steamed. Why is it she asked, that NO ONE scrutinizes visiting HEAVY METAL BANDS? "THEY Judge him harder because he's a BLACK man," she said before hanging up. SNOOP is hot as a well-used lightning rod.

Please see Page F-2, SNOOP

Photo by~ Scott Schafer/onyx

controversy
HOUNDS
POPULAR
GANGSTER
Rapper

illustration by Kevin E. Ellis
lettering by Galie Jean-Louis

REED'S ART SHOW **2**
Drawings and prints of Unalaska 'poetic'

IT'S A MIXED BAG **3**
Unplugged collection; more album reviews

SING WITH ANDY **3**
Williams' TV special today on Channel 7

**9**

**Publication** Anchorage Daily News/Impulse
**Design Director** Galie Jean-Louis
**Designer** Galie Jean-Louis
**Illustrator** Kevin E. Ellis
**Photographer** Scott Schafer
**Photo Editor** Galie Jean-Louis
**Publisher** Anchorage Daily News
**Date** December 24, 1994
**Category** Page 1

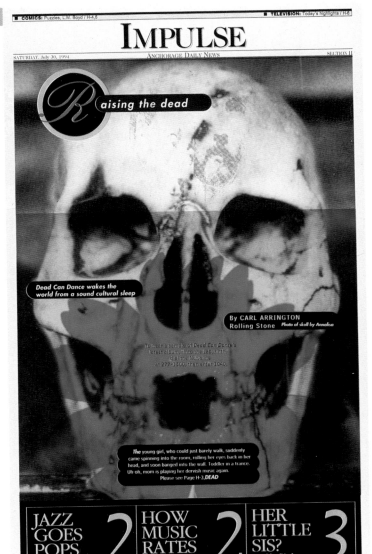

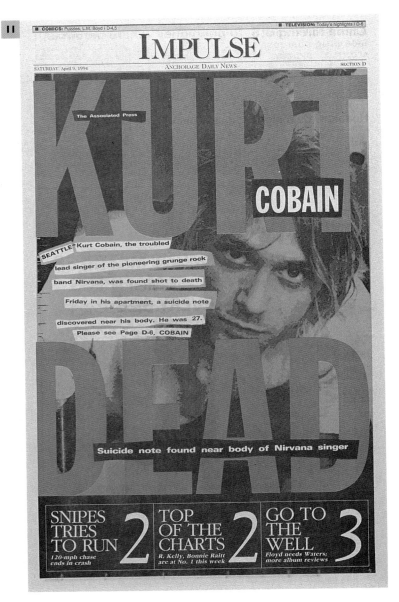

**Publication** Anchorage Daily News/Impulse
**Design Director** Galie Jean-Louis
**Designer** Galie Jean-Louis
**Photographer** Annalisa
**Photo Editor** Galie Jean-Louis
**Publisher** Anchorage Daily News
**Date** July 30, 1994
**Category** Page 1

**Publication** Anchorage Daily News/Impulse
**Design Director** Galie Jean-Louis
**Designer** Galie Jean-Louis
**Photo Editor** Galie Jean-Louis
**Publisher** Anchorage Daily News
**Date** April 9, 1994
**Category** Page 1

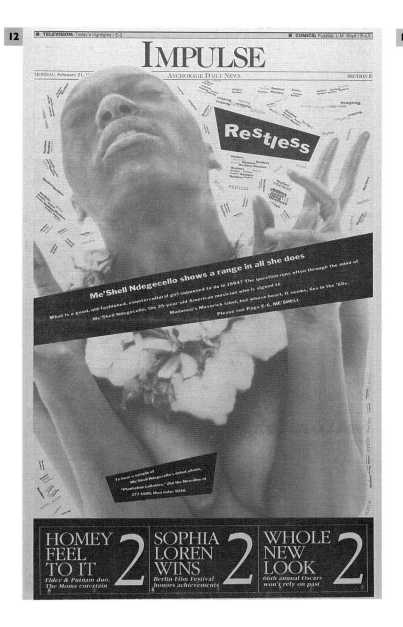

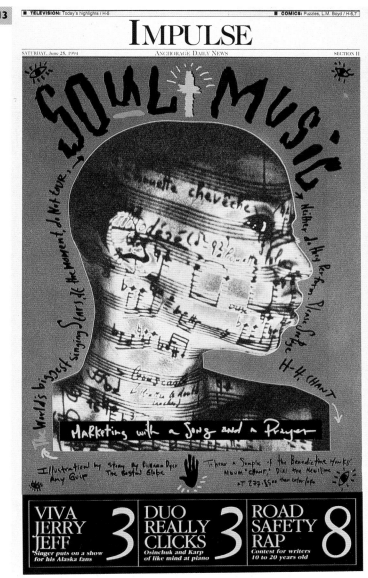

**12**

**Publication** Anchorage Daily News/Impulse
**Design Director** Galie Jean-Louis
**Designer** Galie Jean-Louis
**Photo Editor** Galie Jean-Louis
**Publisher** Anchorage Daily News
**Date** February 21, 1994
**Category** Page 1

**13**

**Publication** Anchorage Daily News/Impulse
**Design Director** Galie Jean-Louis
**Designer** Galie Jean-Louis
**Photographer** Amy Guip
**Photo Editor** Galie Jean-Louis
**Publisher** Anchorage Daily News
**Date** June 25, 1994
**Category** Page 1

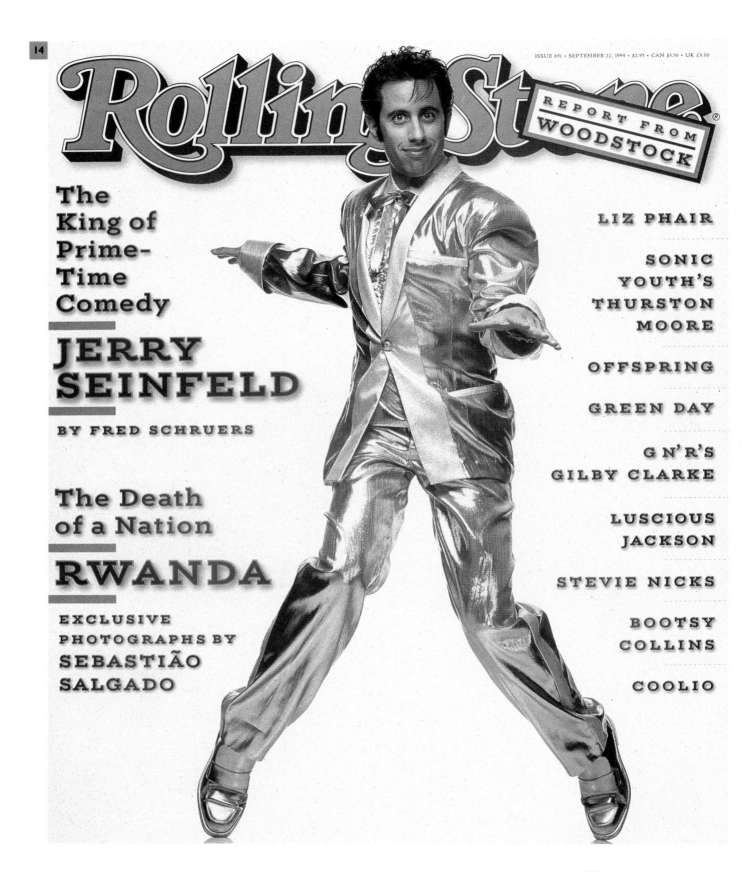

ISSUE 691 • SEPTEMBER 22, 1994 • $2.95 • CAN $3.50 • UK £3.00

*Rolling Stone*

REPORT FROM
WOODSTOCK

The
King of
Prime-
Time
Comedy
JERRY
SEINFELD

BY FRED SCHRUERS

The Death
of a Nation
RWANDA

EXCLUSIVE
PHOTOGRAPHS BY
SEBASTIÃO
SALGADO

LIZ PHAIR

SONIC
YOUTH'S
THURSTON
MOORE

OFFSPRING

GREEN DAY

GN'R'S
GILBY CLARKE

LUSCIOUS
JACKSON

STEVIE NICKS

BOOTSY
COLLINS

COOLIO

14

**Publication** Rolling Stone
**Art Director** Fred Woodward
**Designer** Fred Woodward
**Photographer** Mark Seliger
**Photo Editor** Jodi Peckman
**Publisher** Wenner Media
**Date** September 22, 1994
**Category** Cover

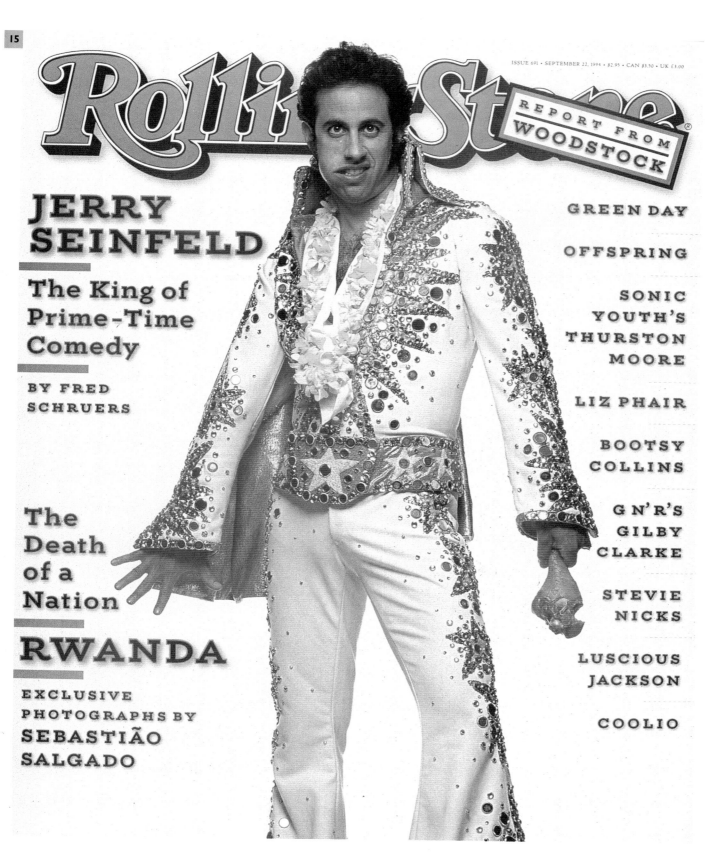

ISSUE 691 • SEPTEMBER 22, 1994 • $2.95 • CAN $3.50 • UK £3.00

JERRY SEINFELD

The King of Prime-Time Comedy

BY FRED SCHRUERS

The Death of a Nation

RWANDA

EXCLUSIVE PHOTOGRAPHS BY SEBASTIÃO SALGADO

REPORT FROM WOODSTOCK

GREEN DAY

OFFSPRING

SONIC YOUTH'S THURSTON MOORE

LIZ PHAIR

BOOTSY COLLINS

GN'R'S GILBY CLARKE

STEVIE NICKS

LUSCIOUS JACKSON

COOLIO

15

**Publication** Rolling Stone
**Art Director** Fred Woodward
**Designer** Fred Woodward
**Photographer** Mark Seliger
**Photo Editor** Jodi Peckman
**Publisher** Wenner Media
**Date** September 22, 1994
**Category** Cover

# R AYGUN,

ISSUE NUMBER 19 OF THE BIBLE OF MUSIC + STYLE AND THE END OF PRINT

# JESUS

## ANDMARYCHAIN

### PRETEND

BACK TO SCHOOL

ERS

WITH

PAVEMENT, BAD
RELIGION, SU-
PERCHUNK, ETC.

09>

SEPTEMBER 94
$3.50 USA $3.95 CANADA

0 70989 36606 0

16

**Publication** Ray Gun
**Art Director** David Carson
**Designer** David Carson
**Photographer** Colin Bell
**Studio** David Carson Design
**Date** September 1994
**Category** Cover

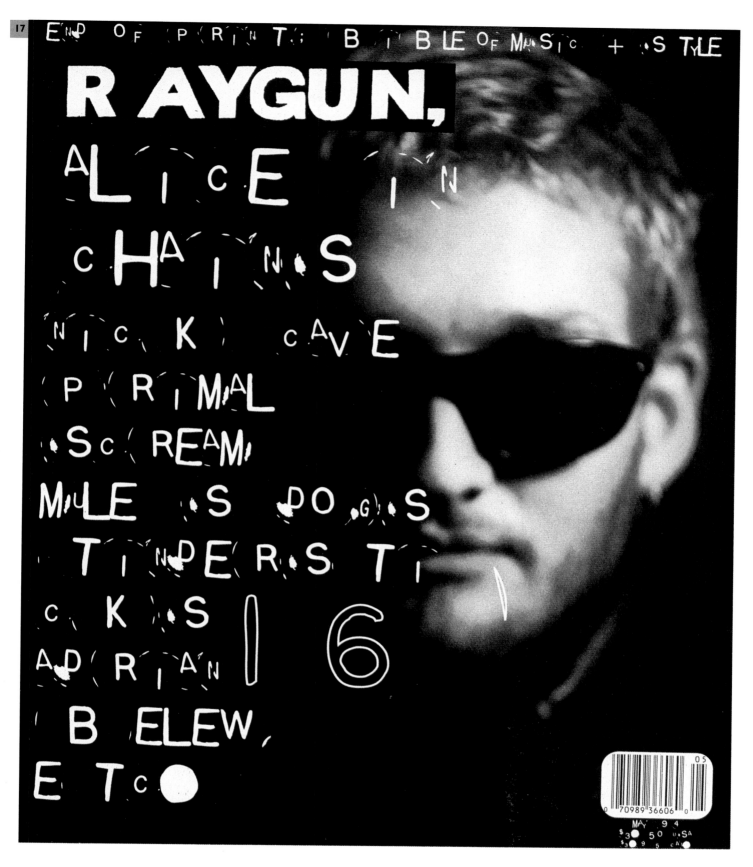

END OF PRINT: BIBLE OF MUSIC + STYLE

R AYGUN, ALICE IN CHAINS NICK CAVE PRIMAL SCREAM MILES DOGS TINDERSTICKS 16 ADRIAN BELEW, ETC

17

**Publication** Ray Gun
**Art Director** David Carson
**Designer** David Carson
**Photographer** Cynthia Levine
**Studio** David Carson Design
**Date** May 1994
**Category** Cover

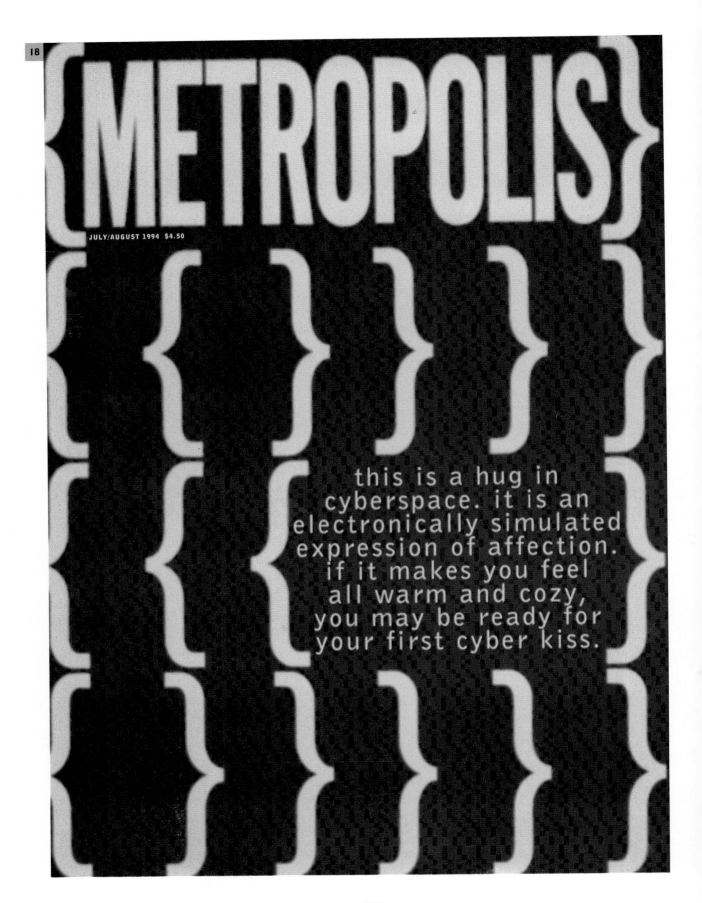

{METROPOLIS}

JULY/AUGUST 1994 $4.50

this is a hug in cyberspace. it is an electronically simulated expression of affection. if it makes you feel all warm and cozy, you may be ready for your first cyber kiss.

18

**Publication** Metropolis
**Design Directors** Carl Lehmann-Haupt, Nancy Kruger Cohen
**Designers** Carl Lehmann-Haupt, Nancy Kruger Cohen
**Publisher** Havemeyer-Bellerophon Publications, Inc.
**Date** July/August 1994
**Category** Cover

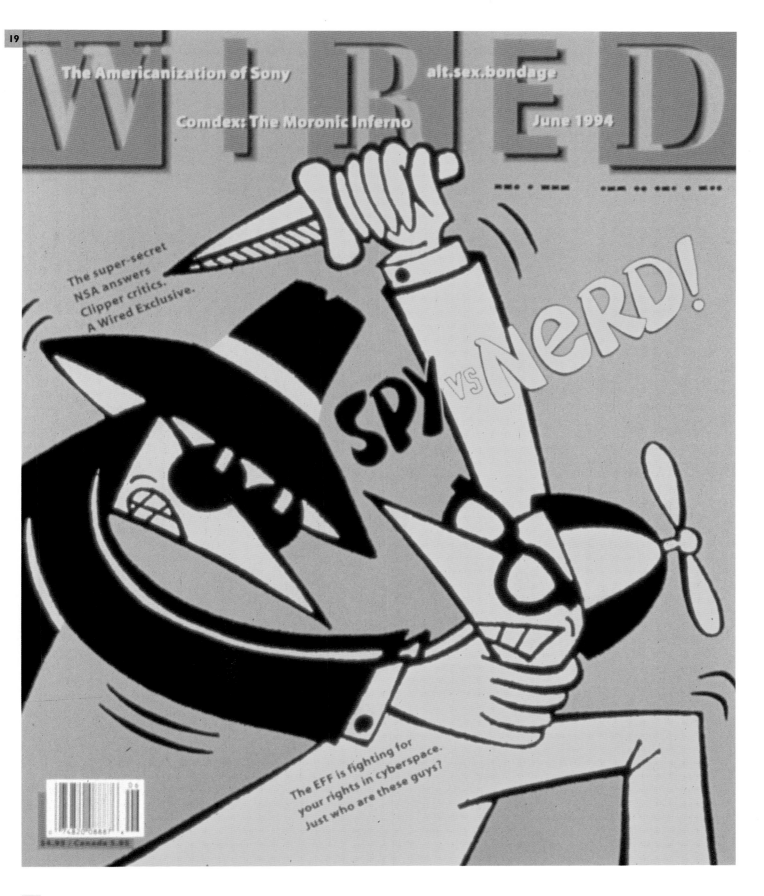

WIRED

The Americanization of Sony

Comdex: The Moronic Inferno

alt.sex.bondage

June 1994

The super-secret NSA answers Clipper critics. A Wired Exclusive.

SPY vs NeRD!

The EFF is fighting for your rights in cyberspace. Just who are these guys?

$4.95 / Canada 5.95

**19**

**Publication** Wired
**Art Director** John Plunkett
**Illustrator** John Plunkett
**Studio** Plunkett & Kuhr
**Date** June 1994
**Category** Cover

27

The world of the Old Colony Mennonites is a well-preserved slice of 16th century life. Rejecting progress as ungodly, living in a closed society, the faithful dress, work, speak and worship like Germans of the Reformation era. To preserve their way of life, they fled from Europe to Canada in the last century, then moved on to Mexico in the 1920s. There they farmed in biblical simplicity until drought and cheap U.S. produce killed their livelihood. Looking for jobs, hundreds of destitute families have now returned to Canada, where many toil in the fields for third-world wages. **Larry Towell** has documented on film this latest stage in their

# ENDLESS
# EXODUS

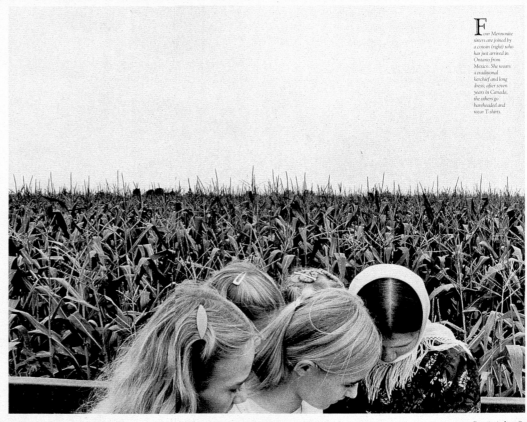

Four Mennonite sisters are joined by a cousin (right) who has just arrived in Ontario from Mexico. She wears a traditional kerchief and long dress; after seven years in Canada, the others go bareheaded and wear T-shirts.

Reporting by JOSH SIMON

**20**

**Publication** Life
**Design Director** Tom Bentkowski
**Designers** Tom Bentkowski, Mimi Park
**Photographer** Larry Towell
**Photo Editor** David Friend
**Publisher** Time Inc.
**Date** October 1994
**Category** Story

**21**

**Publication** Life
**Design Director** Tom Bentkowski
**Designers** Tom Bentkowski, Steve Walkowiak
**Photo Editor** Vivette Porges
**Publisher** Time Inc.
**Date** December 1994
**Category** Cover

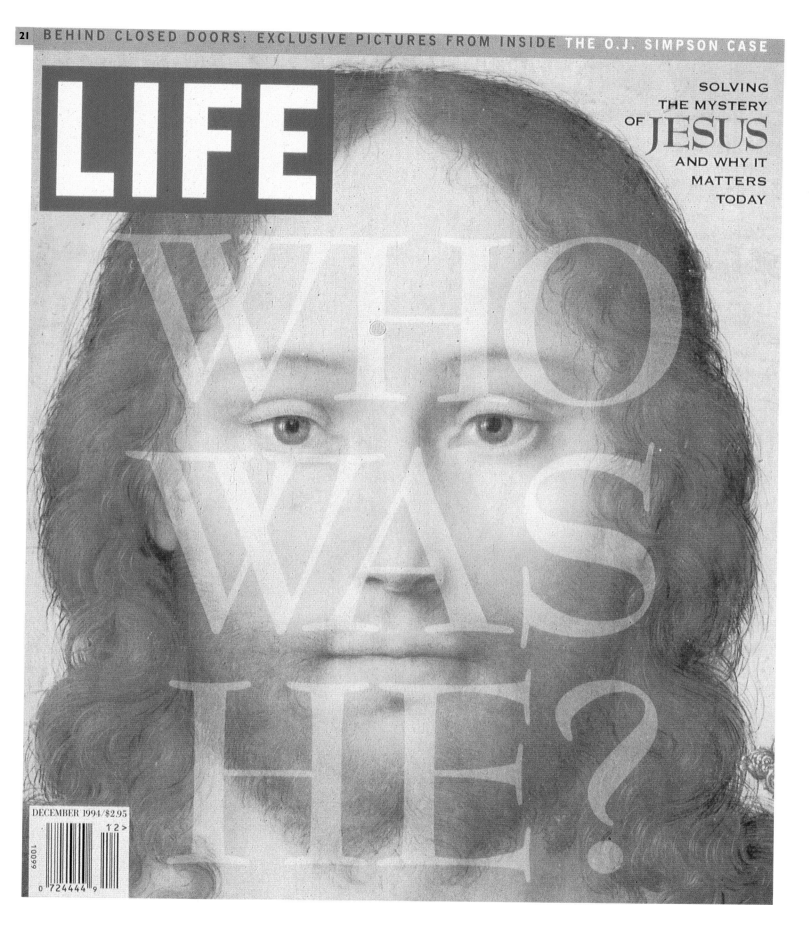

BEHIND CLOSED DOORS: EXCLUSIVE PICTURES FROM INSIDE THE O.J. SIMPSON CASE

# LIFE

SOLVING THE MYSTERY OF JESUS AND WHY IT MATTERS TODAY

WHO WAS HE?

DECEMBER 1994/$2.95

The BIG Picture

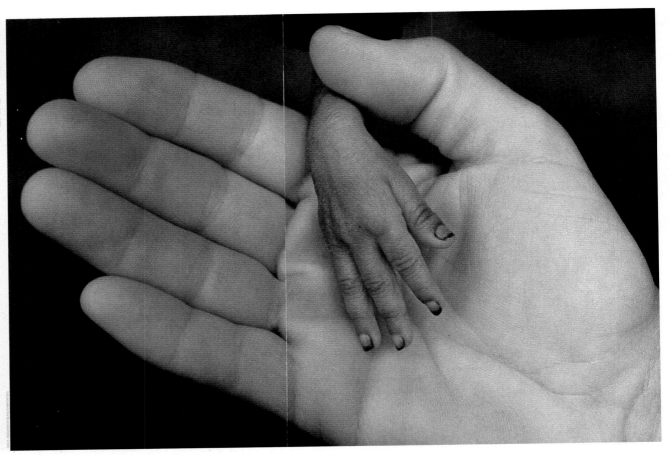

## The Color of Hunger

Purple is said to be the color of passion. How then do we account for the purple fingers of this child—one of 20 million people in Ethiopia and other parts of eastern Africa currently threatened by famine? Perhaps it's because at the age of six months she weighs less than four and a half pounds and can barely open her mouth to drink the milk offered by relief workers. Perhaps, experts say, it's because of an iron deficiency, which is the most common cause of this beautiful, horrible discoloration in malnourished children. Or perhaps it's because suffering is, in its way, a kind of grotesque passion.

16

22

**Publication** Life
**Design Director** Tom Bentkowski
**Designer** Marti Golon
**Photographer** Odd R. Andersen
**Photo Editors** Lee Dudley, Barbara Baker Burrows
**Publisher** Time Inc.
**Date** November 1994
**Category** Spread

# THE MUMMIES OF XINJIANG

IN THE DRY HILLS OF THIS CENTRAL ASIAN PROVINCE, ARCHEOLOGISTS HAVE UNEARTHED MORE THAN 100 CORPSES THAT ARE AS MUCH AS 4,000 YEARS OLD, ASTONISHINGLY WELL PRESERVED — AND CAUCASIAN.

One glimpse of the corpses was enough to shock Victor Mair profoundly. In 1987, Mair, a professor of Chinese at the University of Pennsylvania, was leading a tour group through a museum in the Chinese city of Ürümqi, in the central Asian province of Xinjiang, when he accidentally strayed into a gloomy, newly opened room. There, under glass, lay the recently discovered corpses of a family—a man, a woman, and a child of two or three—each clad in long, dark purple woolen garments and felt boots. "Even today I get chills thinking about that first encounter," says Mair. "The Chinese said they were 3,000 years old, yet the bodies looked as if they were buried yesterday."

But the real shock came when Mair looked closely at their faces. In contrast to most central Asian peoples, these corpses had obvious Caucasian, or European, features—blond hair, long noses, deep-set eyes, and long skulls. "I was thunderstruck," Mair recalls. "Even though I was supposed to be leading a tour group, I just couldn't leave that room. The questions kept nagging at me: Who were these people? How did they get out here at such an early date?"

The corpses Mair saw that day were just a few of more than 100 dug up by Chinese archeologists over the past 16 years.

### WUPU WOMAN
One of the first corpses to be unearthed near the village of Wupu was this young woman (opposite), who was about 20 years old when she died 3,200 years ago. Like those of most of the corpses, her knees were drawn up to allow her body to fit into its small burial chamber. And like the other mummies, she has the head shape, deep eyes, and thin lips characteristic of Caucasians.

All of them are astonishingly well preserved. They come from four major burial sites scattered between the arid foothills of the Tian Shan ("Celestial Mountains") in northwest China and the fringes of the Taklimakan Desert, some 150 miles due south. All together, these bodies, dating from about 2000 B.C. to 300 B.C., constitute a significant addition to the world's catalog of prehistoric mummies. Unlike the roughly contemporaneous mummies of ancient Egypt, the Xinjiang mummies were not rulers or nobles; they were not interred in pyramids or other such monuments, nor were they subjected to deliberate mummification procedures. They were preserved merely by being buried in the parched, stony desert, where daytime temperatures often soar over 100 degrees. In the heat the bodies were quickly dried, with facial hair, skin, and other tissues remaining largely intact.

Where exactly did these apparent Caucasians come from? And what were they doing at remote desert oases in central Asia?

Any answers to these questions will most likely fuel a wide-ranging debate about the role outsiders played in the rise of Chinese civilization. As far back as the second century B.C., Chinese texts refer to alien peoples called the Yuezhi and the Wusun,

BY EVAN HADINGHAM   PHOTOGRAPHS BY JEFFERY NEWBURY

APRIL 1994  **69**  DISCOVER

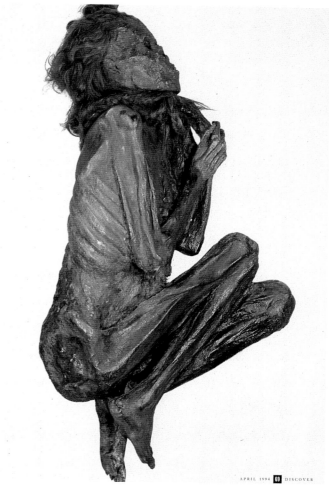

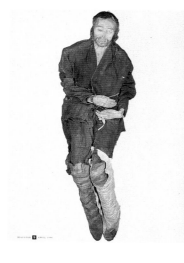

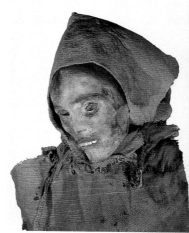

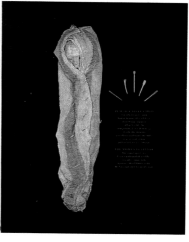

**Publication** Discover
**Art Director** David Armario
**Designers** James Lambertus, David Armario
**Photographer** Jeffery Newbury
**Photo Editors** John Barker, Dawn Morishigre
**Publisher** Walt Disney Publishing
**Date** April 1994
**Category** Story

31

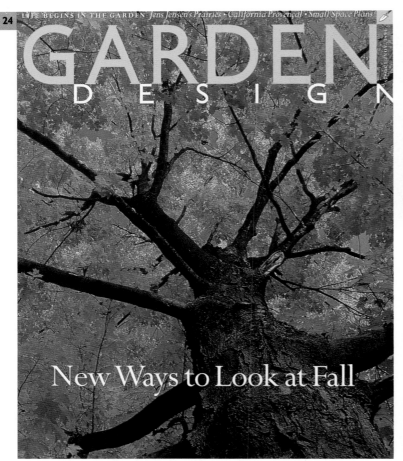

GARDEN DESIGN

New Ways to Look at Fall

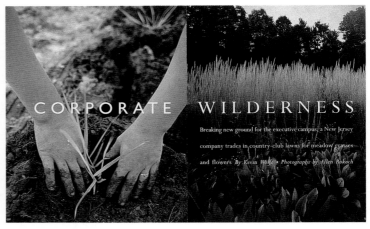

CORPORATE WILDERNESS

Breaking new ground for the executive campus, a New Jersey company trades in country-club lawns for meadow grasses and flowers  *By Kevin Wolfe* • *Photographs by Allen Rokach*

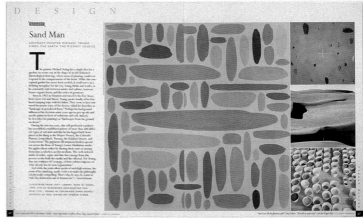

DESIGN

Sand Man

ABSTRACT PAINTER MICHAEL YOUNG FINDS THE EARTH THE RICHEST SOURCE

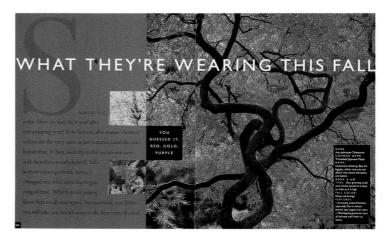

WHAT THEY'RE WEARING THIS FALL

YOU GUESSED IT: RED, GOLD, PURPLE

**24**

**Publication** Garden Design
**Creative Director** Michael Grossman
**Art Director** Paul Roelofs
**Photo Editor** Susan Goldberger
**Publisher** Meigher Communications
**Date** October/November 1994
**Category** Entire Issue

32

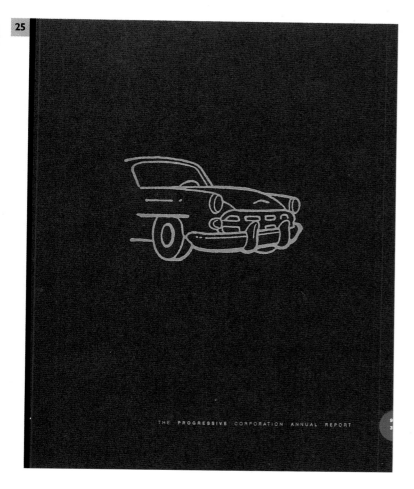

THE PROGRESSIVE CORPORATION ANNUAL REPORT

**25**

**Publication** The Progressive Corporation Annual Report
**Art Directors** Mark Schwartz, Joyce Nesnadny
**Designers** Joyce Nesnadny, Michelle Moehler, Mark Schwartz
**Illustrator** Merriam-Webster, Inc.
**Photographer** Zeke Berman
**Studio** Nesnadny & Schwartz
**Category** Entire Issue

# Blown Away

If this is the last thing you ever see, then you will, in your final moments, understand that the handgun exists for one very simple purpose

SEVENTY-ONE MILLION HANDGUNS IN the United States of America and every one of them designed, cast, tooled, calibrated, marketed, sold and loaded to end a human life.

Admire them if you wish: their perfection, their beauty, their efficiency. But do not deny the purity of their purpose. There is no logic to the handgun. During World War II, the Allied forces developed a .45 single-shot called the Liberator and planned to get the gun to the Resistance, to assassinate the German leadership. Thousands were manufactured, and then the plan was abandoned. It had dawned on the intelligence community that, after the war, there would be no way to recover the guns. And who could possibly justify arming an entire continent with easily concealable weapons of death?

The illogic of the handgun, which was so apparent to men of war only a half-century ago, has escaped us. Handguns are made readily—legally—available to all but the manifestly lunatic and the criminally convicted. We refine the technology of the guns and the bullets so that they are ever more lethal and then use this efficiency as a selling point. We blame the

rising death count on crack or the underclass or single mothers or anything but the gun.

We offer people an instrument that allows them to cause another person's death and then we ask them not to use it. Of course many of them do; thirty-six times a day, somewhere in the United States, somebody surrenders to his rage or his fear and kills with a handgun. Yet the voices persist: that the carnage is the price we pay for freedom, that the gun itself is a measure of our democracy, that a society without guns is a society of slaves. What is a gun? It is capability. It is blank potential. Theologians have explained the presence of evil in our world by saying that God wanted His creation to be free, and a man cannot be free unless he can choose between good and evil. It is the same with the gun; you hand it to a man, and he is no longer forced to obey the law. No, he has won the power to choose to obey the law; you have empowered him to kill and entrusted him not to, and as long as he holds the gun close to him, he is as powerful as any man can be, and as free. He is Adam, free to fall, and already falling.

### Stories by Tom Junod, Scott Raab and Peter Richmond
### Photographs by Dan Winters

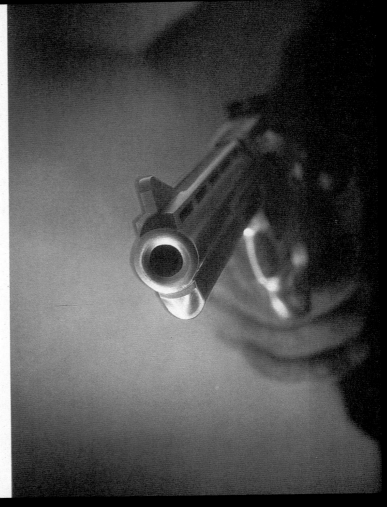

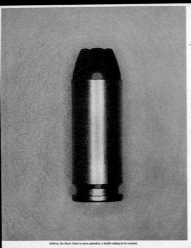

## The Black Talon

Winchester built the best bullet in history. It's not Winchester's fault that Jason White and Marilyn Leath were murdered with it
By Peter Richmond

A beacon in the night, over downtown Athens, Georgia.

**26**

**Publication** GQ
**Art Director** Robert Priest
**Designer** Laura Harrigan
**Photographer** Dan Winters
**Photo Editor** Karen Frank
**Publisher** Condé Nast Publications Inc.
**Date** July 1994
**Category** Story

**27**

**Publication** The Journal of Collegium Aesculapium
**Art Director** Dung Hoang
**Designer** Dung Hoang
**Illustrator** Gary Baseman
**Publisher** BYU Graphics
**Date** Spring 1994
**Category** Spread

**28**

**Publication** Ray Gun
**Art Director** David Carson
**Designer** David Carson
**Illustrators** Nicky , Eric Lynn, Beregausky
**Studio** David Carson Design
**Date** August 1994
**Category** Spread

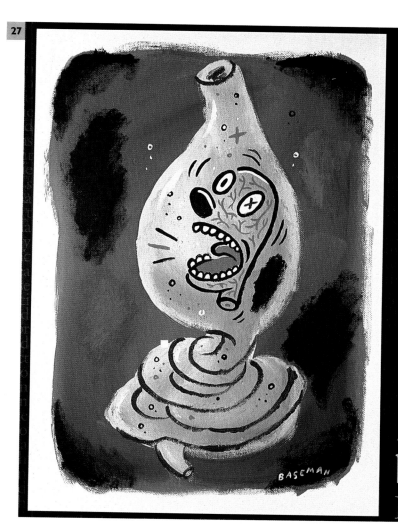

**27**

A Review of Recent Advances in the Treatment of Peptic Ulcer Disease and Helicobacter Pylori Infection

by Gary W. Wood, R.Ph.

Illustrations by Gary Baseman

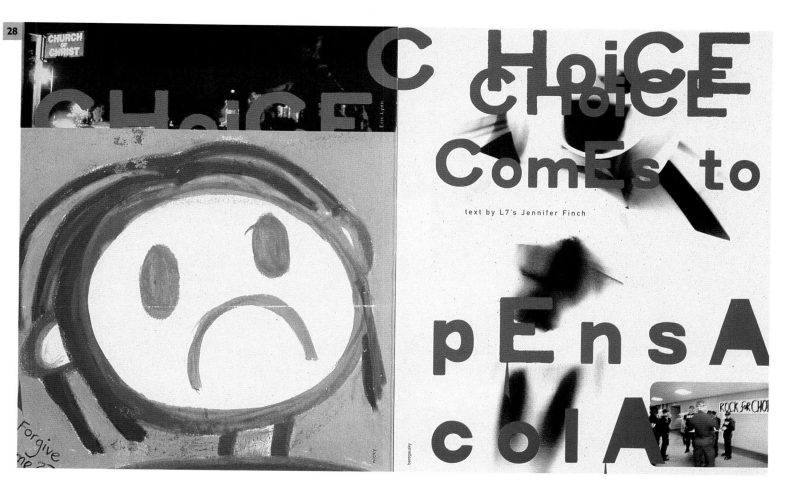

**28**

CHURCH OF CHRIST

CHoiCE

CHoiCE

CHoiCE

ComEs to

pEnsA

coIA

text by L7's Jennifer Finch

ROCK for CHOICE

Eric Lynn

bergausky

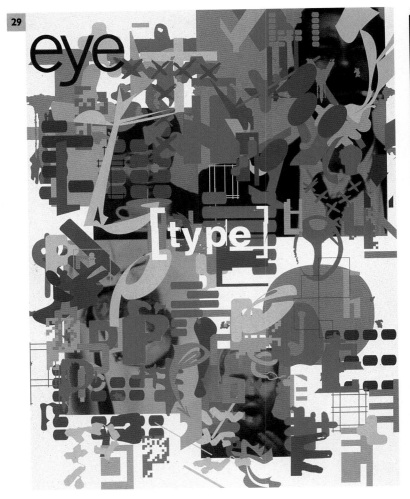

**29**

**Publication** EYE
**Art Director** Stephen Coates
**Designer** Stephen Coates
**Client** EMAP Business Communications
**Date** Winter 1994
**Category** Entire Issue

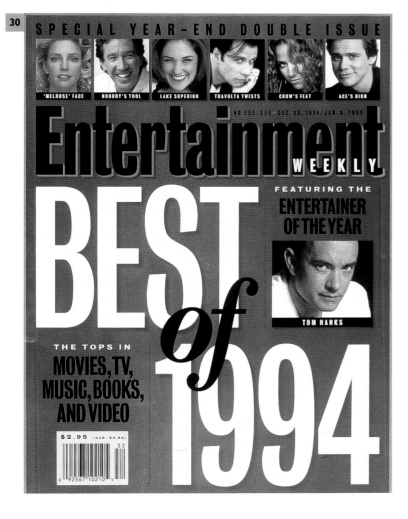

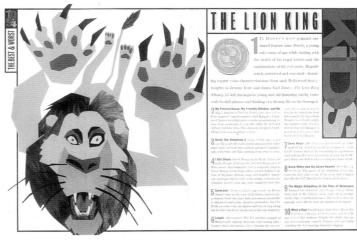

**Publication** Entertainment Weekly
**Design Director** Robert Newman
**Art Director** Jill Armus
**Designers** Elizabeth Betts, George Karabotsos, Joe Kimberling, Michael Picon, Florian Bachleda, Bobby B. Lawhorn Jr., Stacie Reistetter
**Illustrators** Stephen Kroninger, Calef Brown
**Photographer** Ellen Von Unwerth
**Photo Editors** Mark Jacobson, Heather White, Mary Dunn
**Publisher** Time Inc.
**Date** December 30, 1994/January 6, 1995
**Category** Entire Issue

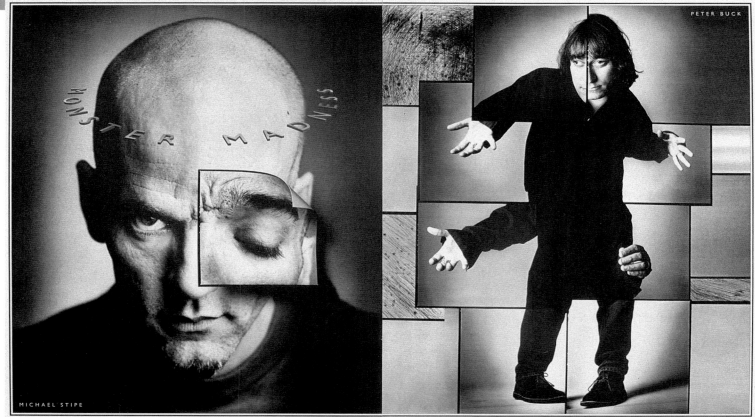

MONSTER MADNESS

MICHAEL STIPE

PETER BUCK

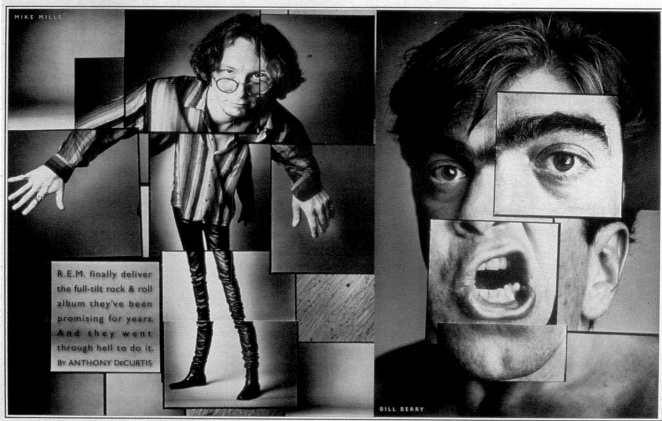

MIKE MILLS

R.E.M. finally deliver the full-tilt rock & roll album they've been promising for years. And they went through hell to do it.
BY ANTHONY DeCURTIS

BILL BERRY

EVERYTHING STOPPED. Cold," says Michael Stipe as he sits in a lounge at Ocean Way Recording, the Los Angeles studio where R.E.M. are attempting to put the finishing touches on their raucous, unsettling new album, Monster. It's after midnight – nearly everyone else has left for the day. Stipe speaks softly as he tries to convey the degree to which Kurt Cobain's death last April sucked the spirit out of R.E.M. as they worked on their album.

"We all loved and respected and admired him a great deal," he says. "It was not an incredible shock, because I had been in contact with Kurt. Everybody in the band kind of knew. We were speaking to each other daily, a couple of times a day. . . ." Stipe's voice trails off, and then he chuckles as the zany, flopping sound of someone flexing a cardboard poster wafts through the room. He looks toward the doorway. A visitor has arrived.

"Hey, how's it going," Stipe says, as Anthony Kiedis strides into the room. The Red Hot Chili Peppers have been working in a studio down the hall.

"It's going OK," says Kiedis. "How you doin'? You all right?"

"Yep."

"I'm just getting ready to go have a little midnight snack."

"Where you goin'?"

"Jones!" Stipe exclaims, acknowledging the restaurant's status as the town's hottest eatery. "Get the tomato leek soup. Do you guys know each other?" Stipe asks and then introduces me to Kiedis.

"Oh, I'm interrupting an interview here, my goodness," Kiedis says, genuinely chagrined.

"No, it'll be good," Stipe says,

PHOTOGRAPHS BY MARK SELIGER

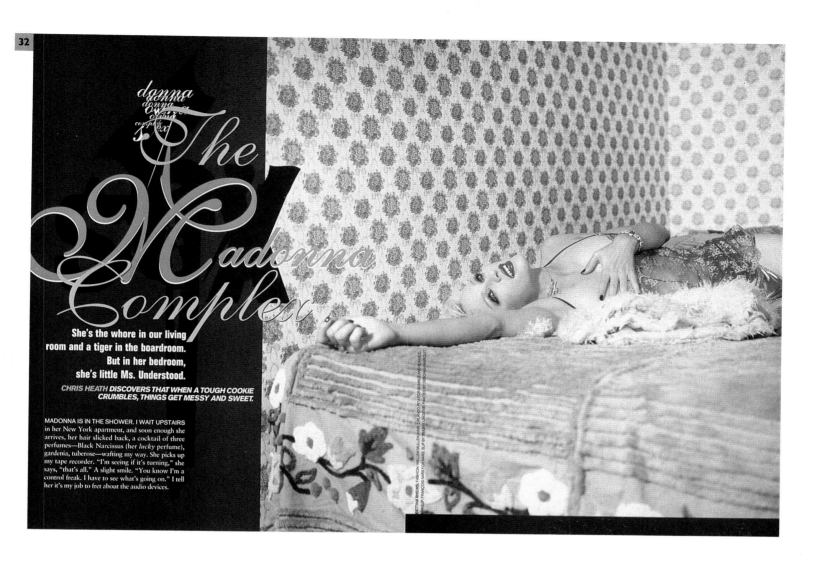

donna donna donna Complex

# The Madonna Complex

She's the whore in our living room and a tiger in the boardroom. But in her bedroom, she's little Ms. Understood.

*CHRIS HEATH DISCOVERS THAT WHEN A TOUGH COOKIE CRUMBLES, THINGS GET MESSY AND SWEET.*

MADONNA IS IN THE SHOWER. I WAIT UPSTAIRS in her New York apartment, and soon enough she arrives, her hair slicked back, a cocktail of three perfumes—Black Narcissus (her *lucky* perfume), gardenia, tuberose—wafting my way. She picks up my tape recorder. "I'm seeing if it's turning," she says, "that's all." A slight smile. "You know I'm a control freak. I have to see what's going on." I tell her it's my job to fret about the audio devices.

**31**

| | |
|---|---|
| **Publication** | Rolling Stone |
| **Art Director** | Fred Woodward |
| **Designer** | Fred Woodward |
| **Photographer** | Mark Seliger |
| **Photo Editor** | Jodi Peckman |
| **Publisher** | Wenner Media |
| **Date** | October 20, 1994 |
| **Category** | Story |

**32**

| | |
|---|---|
| **Publication** | Details |
| **Art Director** | Markus Kiersztan |
| **Designer** | Markus Kiersztan |
| **Photographer** | Bettina Rheims |
| **Photo Editor** | Greg Pond |
| **Publisher** | Condé Nast Publications Inc. |
| **Date** | December 1994 |
| **Category** | Spread |

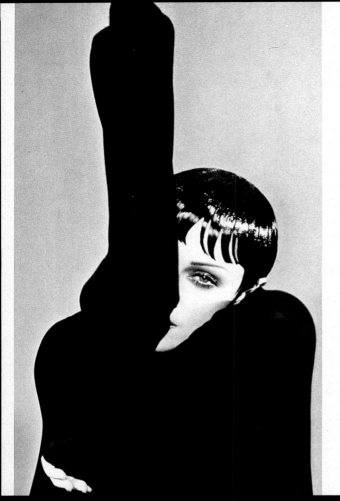

# Madonna makes dance!
Primally sexual, stripped down and muscular, Martha Graham's aesthetic is here made eternally new by Madonna, who recalls her first meeting with the legend. Photographed by Peter Lindbergh

It's NBA All-Star Weekend and I'm sitting in front of my television, excited, full of anticipation, completely sucked in. It's gotten to the point where I'm happy to watch NBA players simply walk down a hallway. They don't even have to be doing anything; their accomplishments, their talent, and their energy make their most pedestrian activities mesmerizing. You know that they've just done something great, or that they're about to.

You're probably wondering what all this has to do with anything. I just thought I'd share a subject that I happen to be completely inspired by before sharing another subject that I happen to be completely inspired by: Martha Graham. I'm not an authority on the NBA or Martha Graham, but I don't think you have to be an authority to instinctively know when you're in the presence of greatness.

I had the privilege of meeting Martha Graham and speaking with her on several occasions shortly before her death. She absolutely lived up to all of my expectations with her wit, intelligence, and nerve-racking imperiousness. I even felt a sort of camaraderie with her pioneering spirit and rebellious creative energy. What really stayed with me (and I suppose this is true for everyone) was my first impression.

The first time I saw her in the flesh, right in front of me, I had been studying at the Graham School for only a few months. I was 18 and had come to New York to be a professional dancer—to set the world on fire. What I really wanted was to dance in Alvin Ailey's company. Though I was cut in the first round of auditions, I won a partial scholarship to study at his school, but was told that if I wanted to master Ailey's technique, I should really study at the Graham School. Of course, I knew who Martha Graham was—in the dance world you had to be brain-dead not to. Needless to say, I arrived there within 24 hours of receiving this information.

I enrolled in beginning classes and became entranced with the Graham technique, which was taught by unbelievably beautiful—mostly Asian—women who all seemed to be clones of Martha Graham. It must have been a prerequisite of the school that instructors be small, inscrutable, and stern. I started dreaming about being flat-chested and Asian. I later learned that most of the teachers also sewed costumes when they weren't learning or performing in her dance company. There was something very comforting about this arrangement: the efficiency, the teamwork, appealed to me because of my own upbringing and the work ethic my father had banged into my head. All time is accounted for. Constant productivity. Everybody pitches in. Kind of like the circus, kind of like the army, kind of like my life now and then.

I dug this place. The studios were spartan, minimalist—like Graham's technique. Everyone whispered, so the only sounds you heard were the music and the instructors, and they spoke to you only when you were fucking up—which was pretty easy to do around there.

It's a difficult technique to learn. It's physically brutal and there is no room for slouches. I was up to all these challenges. I was learning something new every day. I was on my way. At one time in my life I had fantasized about being a nun, and this was the closest I was ever going to get to convent life. But I wanted to meet the mother superior, the woman responsible for all this. I had heard that she was in the building a lot and that she sat in on classes from time to time. I don't know if she was checking up on the teaching staff or scouting for talent, but she never came into any of my classes. I guess she hadn't been made aware of my potential. In any case, she stayed pretty hidden. I had heard she was vain about growing old. Maybe she was really busy, or really shy, or both. But her presence was always felt, which only added to her mystique and to my longing to meet her. I knew she was still very active in the company, creating new works and resurrecting

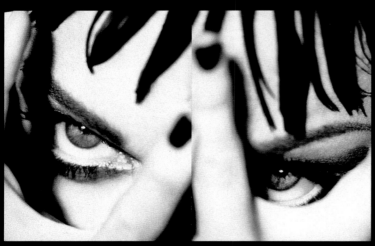

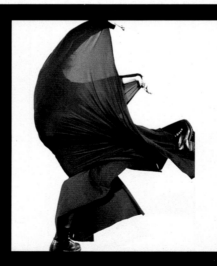

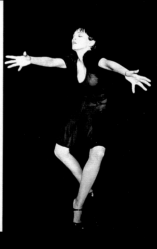

33

**Publication** Harper's Bazaar
**Creative Director** Fabien Baron
**Art Director** Joel Berg
**Designer** Johan Svensson
**Photographer** Peter Lindbergh
**Publisher** The Hearst Corporation-Magazines Division
**Date** May 1994
**Category** Story

34

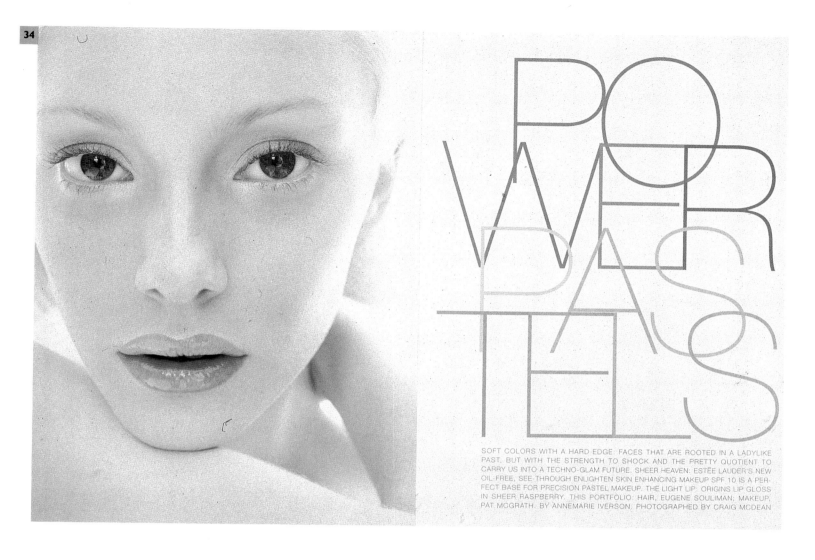

# POWER PASTELS

SOFT COLORS WITH A HARD EDGE: FACES THAT ARE ROOTED IN A LADYLIKE PAST, BUT WITH THE STRENGTH TO SHOCK AND THE PRETTY QUOTIENT TO CARRY US INTO A TECHNO-GLAM FUTURE. SHEER HEAVEN: ESTÉE LAUDER'S NEW OIL-FREE, SEE-THROUGH ENLIGHTEN SKIN ENHANCING MAKEUP SPF 10 IS A PERFECT BASE FOR PRECISION PASTEL MAKEUP. THE LIGHT LIP: ORIGINS LIP GLOSS IN SHEER RASPBERRY. THIS PORTFOLIO: HAIR, EUGENE SOULIMAN; MAKEUP, PAT MCGRATH. BY ANNEMARIE IVERSON. PHOTOGRAPHED BY CRAIG MCDEAN

34

**Publication** Harper's Bazaar
**Creative Director** Fabien Baron
**Art Director** Johan Svensson
**Photographer** Craig McDean
**Publisher** The Hearst Corporation-Magazines Division
**Date** December 1994
**Category** Spread

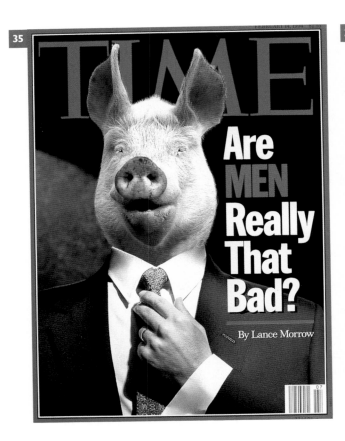

35

TIME

Are
MEN
Really
That
Bad?

By Lance Morrow

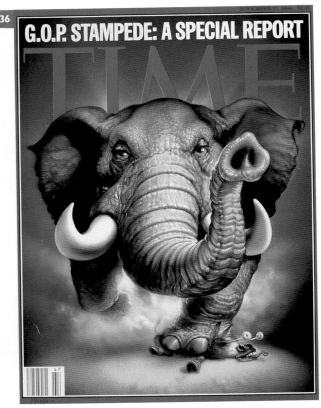

36

G.O.P. STAMPEDE: A SPECIAL REPORT

TIME

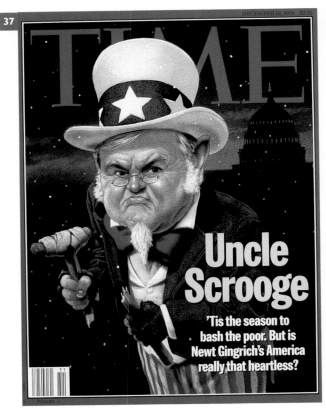

37

TIME

Uncle
Scrooge

'Tis the season to
bash the poor. But is
Newt Gingrich's America
really that heartless?

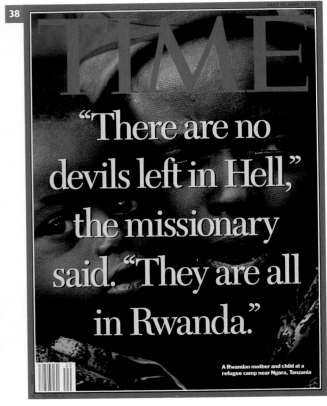

38

TIME

"There are no
devils left in Hell,"
the missionary
said. "They are all
in Rwanda."

A Rwandan mother and child at a
refugee camp near Ngara, Tanzania

35
**Publication** Time
**Art Director** Arthur Hochstein
**Photographers** Hans Reinhard,
Dennis Chalkin
**Publisher** Time Inc.
**Date** February 14, 1994
**Category** Cover

36
**Publication** Time
**Art Director** Arthur Hochstein
**Designer** Arthur Hochstein
**Illustrator** Mark Fredrickson
**Publisher** Time Inc.
**Date** November 21, 1994
**Category** Cover

37
**Publication** Time
**Art Director** Arthur Hochstein
**Designer** Arthur Hochstein
**Illustrator** C.F. Payne
**Publisher** Time Inc.
**Date** December 19, 1994
**Category** Cover

38
**Publication** Time
**Art Director** Arthur Hochstein
**Designer** Arthur Hochstein
**Photographer** Frank Fournier
**Publisher** Time Inc.
**Date** May 16, 1994
**Category** Cover

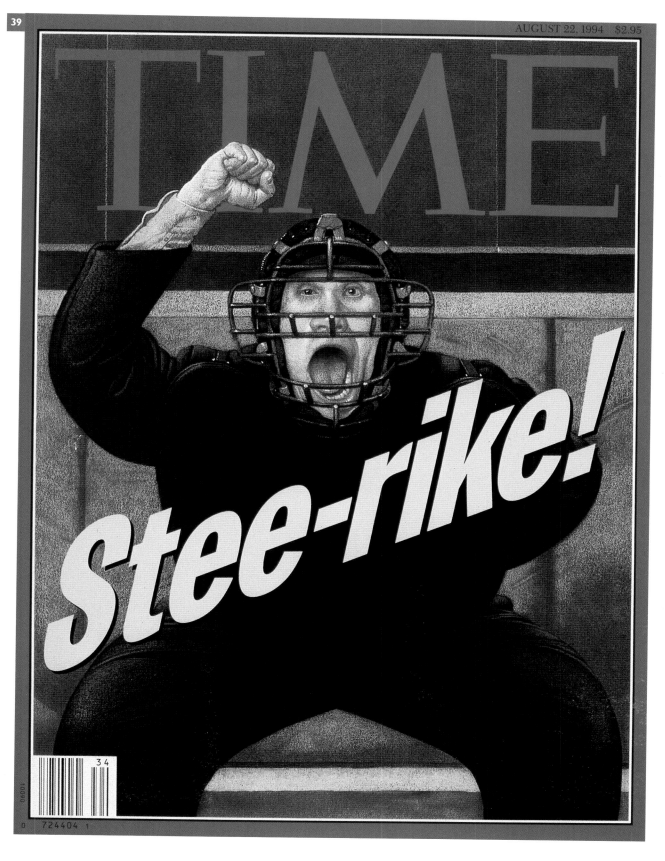

TIME

AUGUST 22, 1994    $2.95

Stee-rike!

**39**

**Publication**  Time
**Art Director**  Arthur Hochstein
**Designer**  Arthur Hochstein
**Illustrator**  C.F. Payne
**Publisher**  Time Inc.
**Date**  August 22, 1994
**Category**  Cover

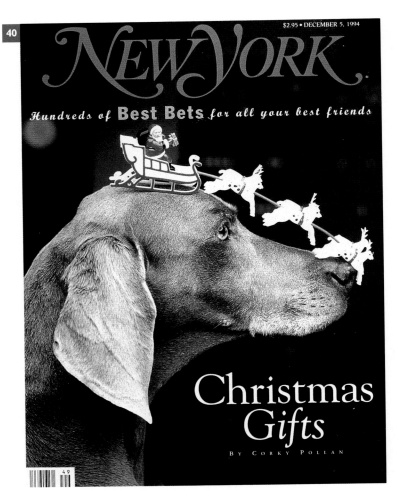

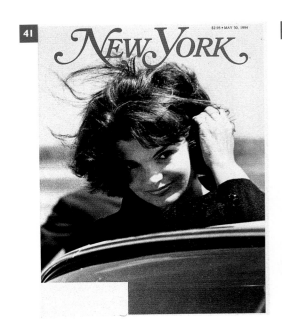

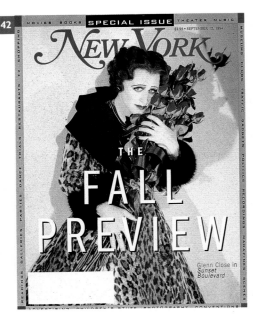

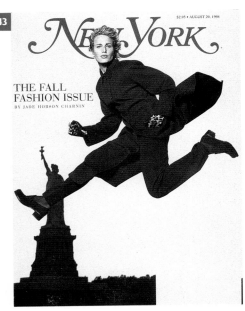

**40**

**Publication** New York
**Design Director** Robert Best
**Designer** Robert Best
**Photographer** William Wegman
**Publisher** K-III Magazines
**Date** December 5, 1994
**Category** Cover

**41**

**Publication** New York
**Design Director** Robert Best
**Photo Agency** Bettman Archive
**Photo Editor** Susan Vermazen
**Publisher** K-III Magazines
**Date** May 30, 1994
**Category** Cover

**42**

**Publication** New York
**Design Director** Robert Best
**Designer** Robert Best
**Photographer** Firooz Zahedi
**Photo Editor** Jordon Schaps
**Publisher** K-III Magazines
**Date** September 12, 1994
**Category** Cover

**43**

**Publication** New York
**Design Director** Robert Best
**Designer** Robert Best
**Photographer** Michael O'Neill
**Photo Editor** Jordan Schaps
**Publisher** K-III Magazines
**Date** August 29, 1994
**Category** Cover

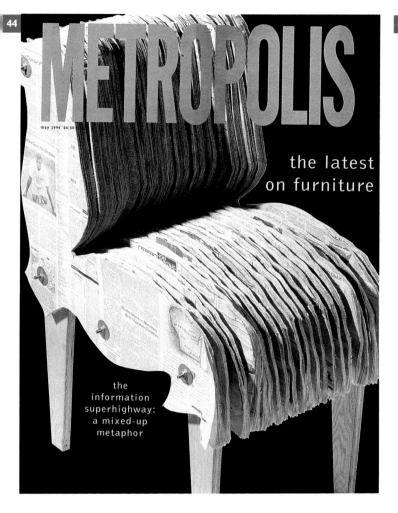

the latest on furniture

the information superhighway: a mixed-up metaphor

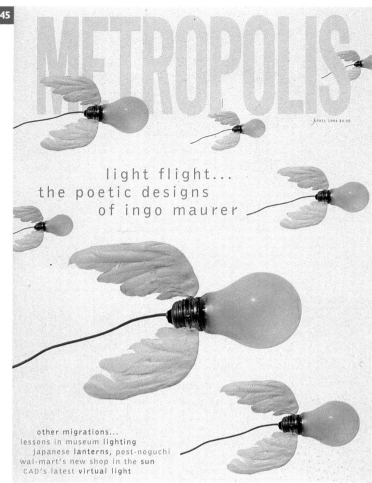

light flight...
the poetic designs
of ingo maurer

other migrations...
lessons in museum lighting
japanese lanterns, post-noguchi
wal-mart's new shop in the sun
CAD's latest virtual light

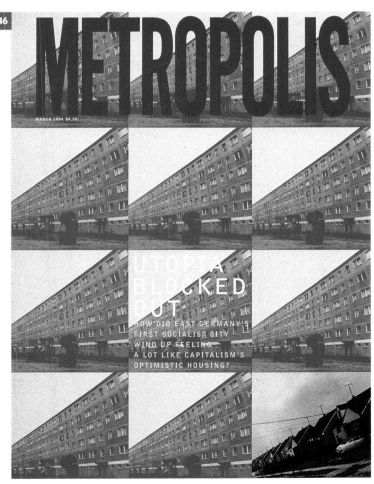

UTOPIA BLOCKED OUT

HOW DID EAST GERMANY'S
FIRST SOCIALIST CITY
WIND UP FEELING
A LOT LIKE CAPITALISM'S
OPTIMISTIC HOUSING?

**44**

**Publication** Metropolis
**Art Directors** Carl Lehmann-Haupt, Nancy Kruger Cohen
**Designers** Carl Lehmann-Haupt, Nancy Kruger Cohen
**Photographer** Andrew Williamson
**Publisher** Havemeyer-Bellerophon Publications, Inc.
**Date** May 1994
**Category** Cover

**45**

**Publication** Metropolis
**Art Directors** Carl Lehmann-Haupt, Nancy Kruger Cohen
**Designer** Nancy Kruger Cohen
**Publisher** Havemeyer-Bellerophon Publications, Inc.
**Date** April 1994
**Category** Cover

**46**

**Publication** Metropolis
**Art Directors** Carl Lehmann-Haupt, Nancy Kruger Cohen
**Designers** Carl Lehmann-Haupt, Nancy Kruger Cohen
**Publisher** Havemeyer-Bellerophon Publications, Inc.
**Photographer** Philip Meuser
**Date** March 1994
**Category** Cover

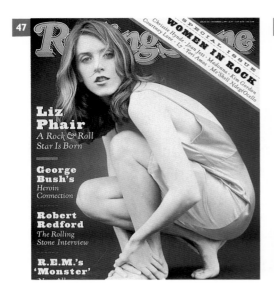

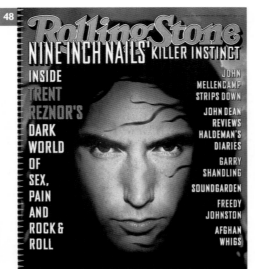

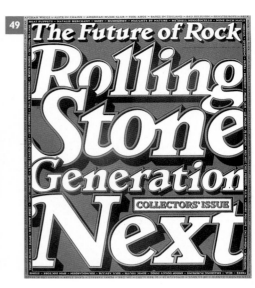

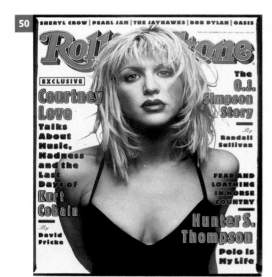

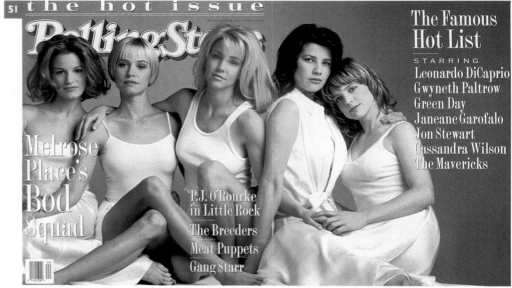

**47**

**Publication** Rolling Stone
**Art Director** Fred Woodward
**Designer** Fred Woodward
**Photographer** Frank Ockenfels 3
**Photo Editor** Jodi Peckman
**Publisher** Wenner Media
**Date** October 6, 1994
**Category** Cover

**48**

**Publication** Rolling Stone
**Art Director** Fred Woodward
**Designer** Fred Woodward
**Photographer** Matt Mahurin
**Photo Editor** Jodi Peckman
**Publisher** Wenner Media
**Date** September 8, 1994
**Category** Cover

**49**

**Publication** Rolling Stone
**Art Director** Fred Woodward
**Designer** Fred Woodward
**Photo Editor** Jodi Peckman
**Publisher** Wenner Media
**Date** November 17, 1994
**Category** Cover

**50**

**Publication** Rolling Stone
**Art Director** Fred Woodward
**Designer** Fred Woodward
**Photographer** Mark Seliger
**Photo Editor** Jodi Peckman
**Publisher** Wenner Media
**Date** December 15, 1994
**Category** Cover

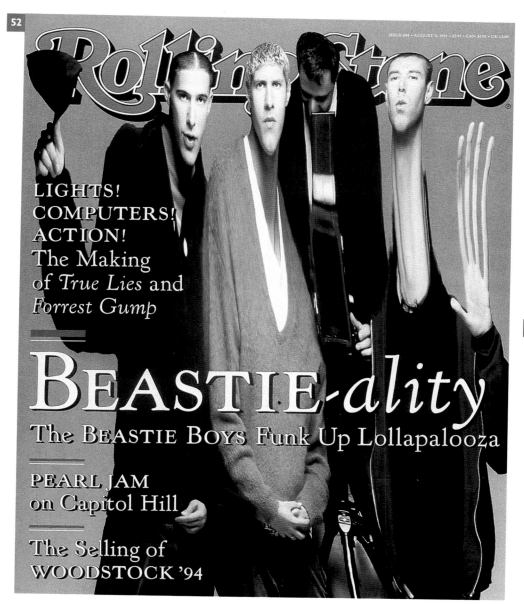

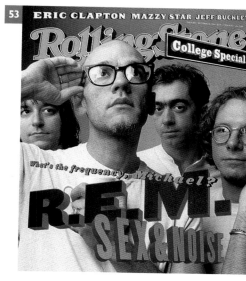

**51**

**Publication** Rolling Stone
**Art Director** Fred Woodward
**Designer** Fred Woodward
**Photographer** Mark Seliger
**Photo Editor** Jodi Peckman
**Publisher** Wenner Media
**Date** May 19, 1994
**Category** Cover

**52**

**Publication** Rolling Stone
**Art Director** Fred Woodward
**Designer** Fred Woodward
**Photographer** Matthew Rolston
**Photo Editor** Jodi Peckman
**Publisher** Wenner Media
**Date** August 11, 1994
**Category** Cover

**53**

**Publication** Rolling Stone
**Art Director** Fred Woodward
**Designer** Fred Woodward
**Photographer** Mark Seliger
**Photo Editor** Jodi Peckman
**Publisher** Wenner Media
**Date** October 20, 1994
**Category** Cover

**54**

**Publication** Rolling Stone
**Art Director** Fred Woodward
**Designer** Fred Woodward
**Photographer** Anton Corbijn
**Photo Editor** Jodi Peckman
**Publisher** Wenner Media
**Date** August 25, 1994
**Category** Cover

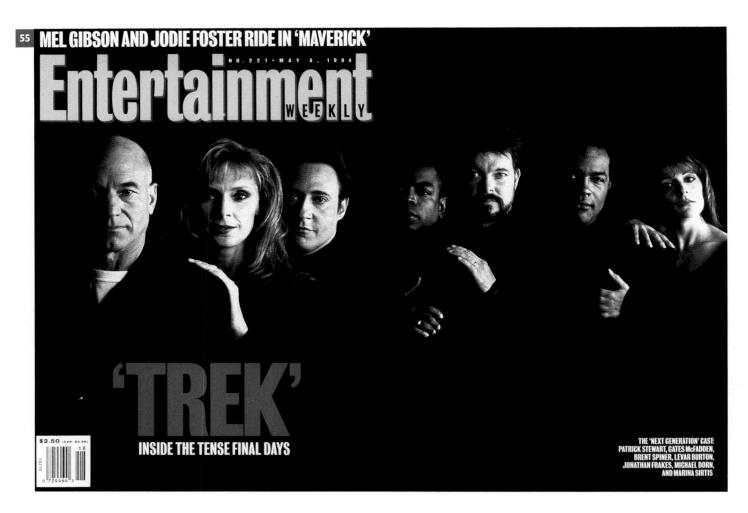

55 MEL GIBSON AND JODIE FOSTER RIDE IN 'MAVERICK'

NO. 221 · MAY 6, 1994

# Entertainment WEEKLY

'TREK'

INSIDE THE TENSE FINAL DAYS

$2.50 (CAN. $3.05)

THE 'NEXT GENERATION' CAST:
PATRICK STEWART, GATES McFADDEN,
BRENT SPINER, LEVAR BURTON,
JONATHAN FRAKES, MICHAEL DORN,
AND MARINA SIRTIS

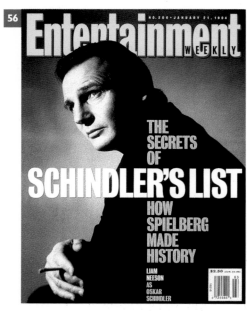

56 Entertainment WEEKLY

NO. 206 · JANUARY 21, 1994

THE SECRETS OF SCHINDLER'S LIST

HOW SPIELBERG MADE HISTORY

LIAM NEESON AS OSKAR SCHINDLER

$2.50 (CAN. $3.05)

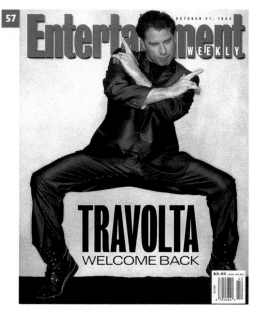

57 Entertainment WEEKLY

OCTOBER 21, 1994

TRAVOLTA
WELCOME BACK

$2.50 (CAN. $3.05)

## 55

**Publication** Entertainment Weekly
**Design Director** Robert Newman
**Photographer** Jeffery Newbury
**Photo Editors** Doris Brautigan, Alice Babcock
**Publisher** Time Inc.
**Date** May 6, 1994
**Category** Cover

## 56

**Publication** Entertainment Weekly
**Design Director** Michael Grossman
**Photographer** Frank Ockenfels 3
**Photo Editors** Doris Brautigan, Mary Dunn
**Publisher** Time Inc.
**Date** January 21, 1994
**Category** Cover

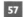

## 57

**Publication** Entertainment Weekly
**Design Director** Robert Newman
**Photographer** Albert Watson
**Photo Editors** Doris Brautigan, Mary Dunn
**Publisher** Time Inc.
**Date** October 21, 1994
**Category** Cover

48

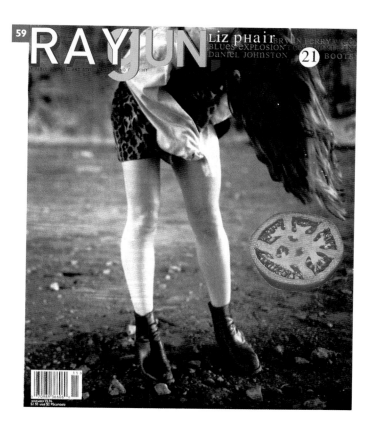

**58** PECIAL SUMMER DOUBLE ISSUE • 20 COOL LOOKS FOR YOUR HOT SWEATY SELF

# VIBe
## MURPHY'S LAW
### EDDIE'S BACK ON THE BEAT. DON'T CALL IT A COP-OUT.

**REGULATING WITH WARREN G**

**SEARCHING FOR SLY STONE**

**GROWING UP WITH SPIKE LEE**

**CRUISING WITH TEDDY RILEY**

$2.50 June/July 1994

**59** RAY GUN — liz phair

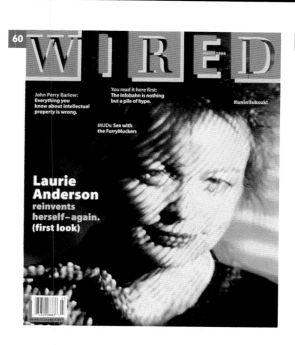

**60** WIRED — March 1994

John Perry Barlow: Everything you know about intellectual property is wrong.

You read it here first: The Infobahn is nothing but a pile of hype.

MUDs: Sex with the FurryMuckers

**Laurie Anderson** reinvents herself–again. (first look)

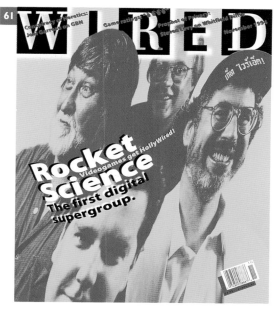

**61** WIRED — November 1994

**Rocket Science**
Videogames get HollyWired!
The first digital supergroup.

---

**58**

**Publication** Vibe
**Creative Director** Gary Koepke
**Art Director** Diddo Ramm
**Designer** Ellen Fanning
**Photographer** Uli Weber
**Photo Editor** George Pitts
**Publisher** Time Inc. Ventures
**Date** June/July 1994
**Category** Cover

**59**

**Publication** Ray Gun
**Art Director** David Carson
**Designer** David Carson
**Photographer** Kevin Kerslake
**Studio** David Carson Design
**Date** November 1994
**Category** Cover

**60**

**Publication** Wired
**Art Director** John Plunkett
**Designers** John Plunkett, Barbara Kuhr
**Photographer** Neil Selkirk
**Studio** Plunkett & Kuhr
**Date** March 1994
**Category** Cover

**61**

**Publication** Wired
**Art Director** John Plunkett
**Designers** John Plunkett, Thomas Schneider
**Photographer** William Mercer McLeod
**Studio** Plunkett & Kuhr
**Date** November 1994
**Category** Cover

49

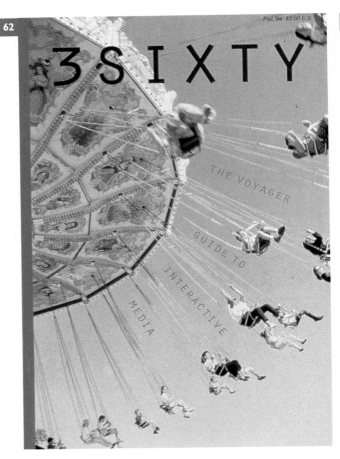

62

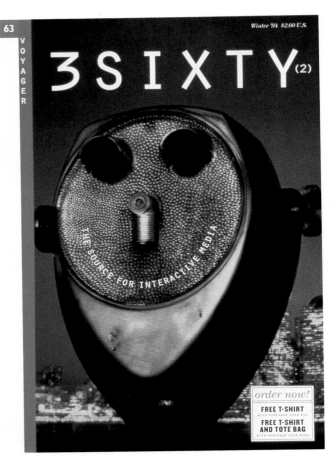

63

**Publication** 3 Sixty
**Design Director** Alexander Isley
**Designer** Paul Donald
**Studio** Alexander Isley Design
**Client** The Voyager Company
**Date** Fall 1994
**Category** Cover

63

**Publication** 3 Sixty
**Design Director** Alexander Isley
**Designer** Paul Donald
**Studio** Alexander Isley Design
**Client** The Voyager Company
**Date** Winter 1994
**Category** Cover

64

**Publication** Atlantic Monthly
**Art Director** Judy Garlan
**Illustrator** Seymour Chwast
**Studio** The Pushpin Group, Inc.
**Publisher** The Atlantic Monthly
**Date** August 1994
**Category** Cover

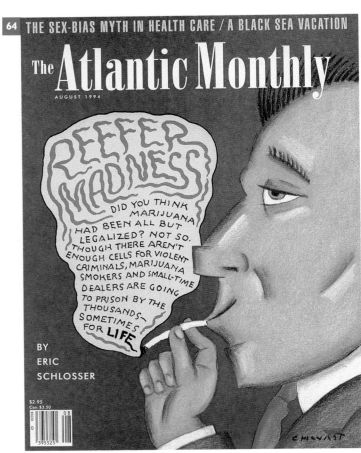

65

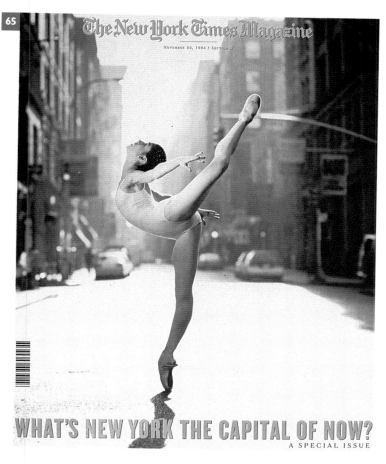

The New York Times Magazine

WHAT'S NEW YORK THE CAPITAL OF NOW?
A SPECIAL ISSUE

66

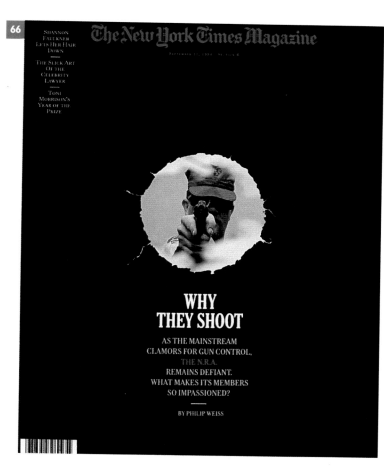

The New York Times Magazine

SHANNON
FAULKNER
LETS HER HAIR
DOWN

THE SLICK ART
OF THE
CELEBRITY
LAWYER

TONI
MORRISON'S
YEAR OF THE
PRIZE

WHY
THEY SHOOT

AS THE MAINSTREAM
CLAMORS FOR GUN CONTROL,
THE N.R.A.
REMAINS DEFIANT.
WHAT MAKES ITS MEMBERS
SO IMPASSIONED?

BY PHILIP WEISS

67

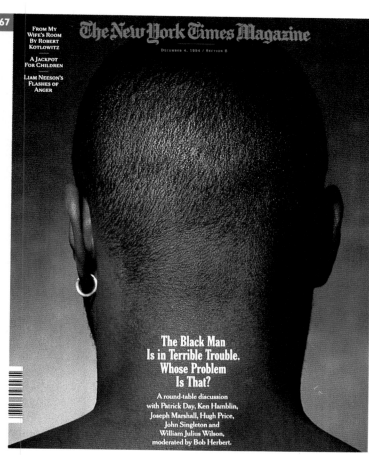

The New York Times Magazine

FROM MY
WIFE'S ROOM
BY ROBERT
KOTLOWITZ

A JACKPOT
FOR CHILDREN

LIAM NEESON'S
FLASHES OF
ANGER

The Black Man
Is in Terrible Trouble.
Whose Problem
Is That?

A round-table discussion
with Patrick Day, Ken Hamblin,
Joseph Marshall, Hugh Price,
John Singleton and
William Julius Wilson,
moderated by Bob Herbert.

65

**Publication** The New York Times Magazine
**Art Director** Janet Froelich
**Designer** Catherine Gilmore-Barnes
**Photographer** Michael O'Neill
**Photo Editors** Kathy Ryan
**Publisher** The New York Times
**Date** November 20, 1994
**Category** Cover

66

**Publication** The New York Times Magazine
**Art Director** Janet Froelich
**Designer** Lisa Naftolin
**Photographer** Mark Peterson
**Photo Editor** Kathy Ryan
**Publisher** The New York Times
**Date** September 11, 1994
**Category** Cover

67

**Publication** The New York Times Magazine
**Art Director** Janet Froelich
**Designers** Janet Froelich, Lisa Naftolin
**Photographer** Albert Watson
**Photo Editor** Kathy Ryan
**Publisher** The New York Times
**Date** December 4, 1994
**Category** Cover

51

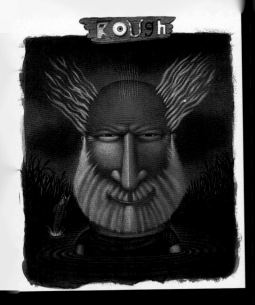

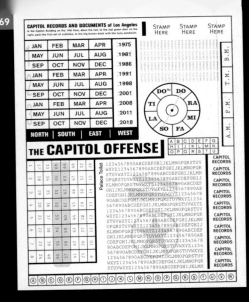

the Capitol Offense

in the good ol' summertime

**68**

**Publication** Rough
**Art Director** Scott Ray
**Designer** Scott Ray
**Illustrator** Keith Graves
**Studio** Peterson & Co.
**Date** November 1994
**Category** Cover

**69**

**Publication** The Capitol Offense
**Creative Director** Jeff Fey
**Art Director** Michael Strassburger
**Designer** Michael Strassburger
**Publisher** Modern Dog
**Date** Fall 1994
**Category** Cover

**70**

**Publication** The Capitol Offense
**Creative Director** Jeff Fey
**Art Director** Robynne Raye
**Designers** Robynne Raye, George Estrada
**Publisher** Modern Dog
**Date** Fall 1994
**Category** Cover

**71**

**Publication** The Capitol Offense
**Creative Director** Jeff Fey

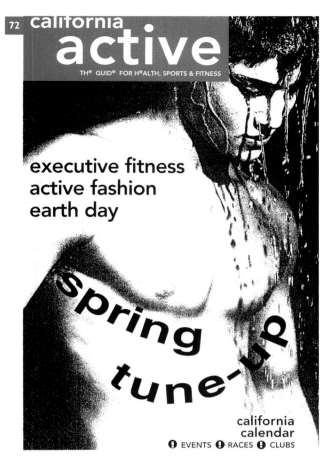

california
**active**
THe GUIDe FOR HeALTH, SPORTS & FITNESS

**executive fitness
active fashion
earth day**

spring
tune-up

california
calendar
❶ EVENTS ❶ RACES ❶ CLUBS

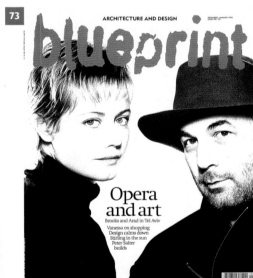

ARCHITECTURE AND DESIGN

blueprint

Opera
and art
Brooks and Arad in Tel Aviv
Vanessa on shopping
Design calms down
Stirling in the sun
Peter Salter
builds

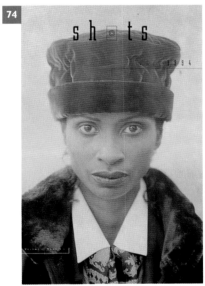

sh◎ts

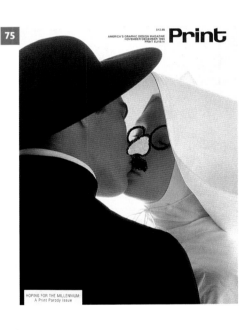

AMERICA'S GRAPHIC DESIGN MAGAZINE
NOVEMBER/DECEMBER 1994
PRINT XLVIII:VI

**Print**

HOPING FOR THE MILLENNIUM:
A Print Parody Issue

**72**

**Publication** California Active
**Art Director** Mike Salisbury
**Designer** Mike Salisbury
**Illustrator** Regina Grosueld
**Photographer** Bruce Weber
**Photo Editor** F. Stop Fitzgerald
**Studio** Mike Salisbury
Communications Inc.
**Category** Cover

**73**

**Publication** Blueprint
**Art Director** John Belknap
**Photographer** Mann & Man
**Publisher** Wordsearch Publishing
**Category** Cover

**74**

**Publication** Shots
**Art Director** Lynn Phelps
**Designers** Diane Hart, Lynn Phelps
**Photographer** Bill Phelps
**Publisher** Star Tribune
**Date** Fall 1994
**Category** Page 1

**75**

**Publication** Print
**Art Director** Andrew P. Kner
**Designer** Steven Brower
**Illustrator** Steven Brower
**Photographer** Oliviero Toscani
**Studio** Steven Brower Design
**Date** November/December 1994
**Category** Cover

53

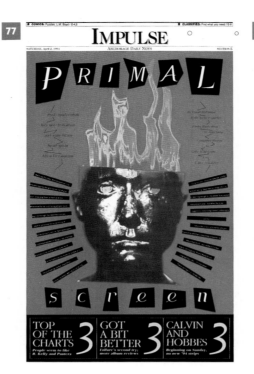

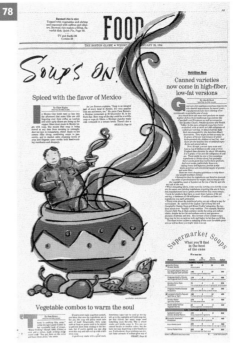

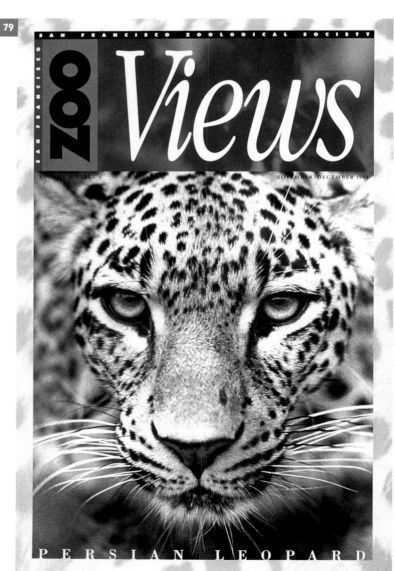

**76**

**Publication** Anchorage Daily News/Impulse
**Design Director** Galie Jean-Louis
**Designer** Galie Jean-Louis
**Photographer** Iraida Icaza
**Photo Editor** Galie Jean-Louis
**Publisher** Anchorage Daily News
**Date** November 26, 1994
**Category** Page 1

**77**

**Publication** Anchorage Daily News/Impulse
**Design Director** Galie Jean-Louis
**Designer** Galie Jean-Louis
**Photographer** Amy Guip
**Photo Editor** Galie Jean-Louis
**Publisher** Anchorage Daily News
**Date** April 2, 1994
**Category** Page 1

**78**

**Publication** The Boston Globe
**Art Director** Rena Sokolow
**Designer** Rena Sokolow
**Illustrator** Ward Schumacher
**Publisher** The Boston Globe Publishing Co.
**Date** February 2, 1994
**Category** Page 1

**79**

**Publication** Zoo Views
**Art Director** Melanie Doherty
**Designer** Joan Folkman
**Photographers** Steve Underwood,
Phillip Pauliger, Rick Mann Shardt
**Studio** Melanie Doherty DSG.
**Date** November/December 1994
**Category** Cover

## 80

**Publication** The Wall Street Journal Reports
**Design Director** Greg Leeds
**Art Director** Nikolai Klein
**Designer** Nikolai Klein
**Illustrator** David Suter
**Publisher** The Wall Street Journal
**Date** September 30, 1994
**Category** Page 1

## 81

**Publication** The Washington Times
**Design Director** Joseph W. Scopin
**Art Director** John Kascht
**Designer** John Kascht
**Publisher** The Washington Times
**Date** December 25, 1994
**Category** Page 1

## 82

**Publication** The Washington Times
**Design Director** Joseph W. Scopin
**Art Director** Paul Compton
**Designer** Paul Compton
**Illustrator** Sharon Roy Finch
**Publisher** The Washington Times
**Date** June 26, 1994
**Category** Page 1

## 83

**Publication** The Washington Times
**Design Director** Joseph W. Scopin
**Art Directors** John Kascht
**Designer** John Kascht
**Illustrator** Don Asmussen
**Publisher** The Washington Times
**Date** April 17, 1994
**Category** Page 1

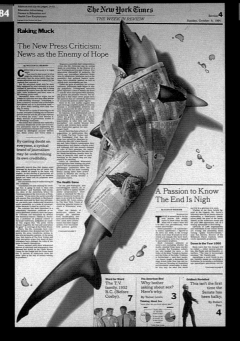

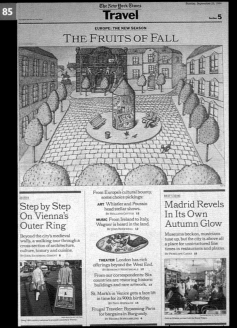

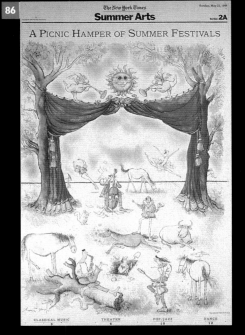

**84**

**Publication** The New York Times
**Art Director** Greg Ryan
**Designer** Greg Ryan
**Photographer** Terry Morrison
**Photo Editor** Rick Perry
**Publisher** The New York Times
**Date** October 9, 1994
**Category** Page 1

**85**

**Publication** The New York Times
**Art Director** Nicki Kalish
**Designer** Nicki Kalish
**Illustrator** Peter Sis
**Publisher** The New York Times
**Date** September 25, 1994
**Category** Page 1

**86**

**Publication** The New York Times
**Art Director** Linda Brewer
**Designer** Linda Brewer
**Illustrator** Ronald Searle
**Publisher** The New York Times
**Date** May 22, 1994
**Category** Page 1

**87**

**Publication** The New York Times
**Art Director** Linda Brewer
**Designer** Linda Brewer
**Illustrator** Josh Gosfield
**Publisher** The New York Times
**Date** December 25, 1994
**Category** Page 1

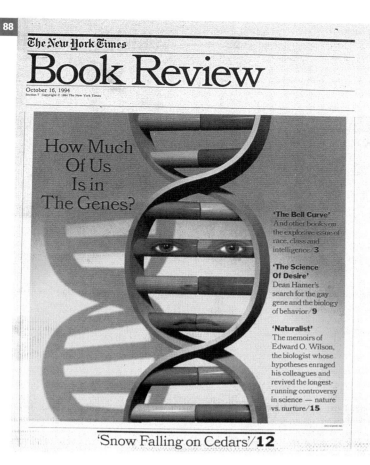

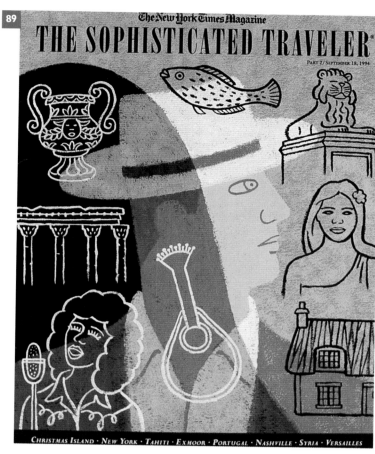

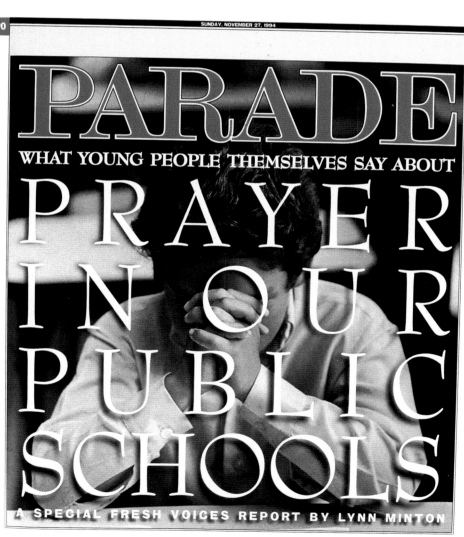

88

**Publication** The New York Times
**Art Director** Steven Heller
**Designer** Steven Heller
**Illustrator** Oko & Mano, Inc.
**Publisher** The New York Times
**Date** October 16, 1994
**Category** Page 1

89

**Publication** The New York Times Magazine
**Art Director** Nicki Kalish
**Designer** Nicki Kalish
**Illustrator** James Steinberg
**Publisher** The New York Times
**Date** September 18, 1994
**Category** Cover

90

**Publication** Parade
**Design Director** Ira Yoffe
**Designers** Ira Yoffe, Jeffrey Brown, Christopher Austopchuk
**Photographer** Bryce Flynn
**Photo Editor** Miriam Lorentzen
**Publisher** Parade Publications Inc.
**Date** November 27, 1994
**Category** Cover

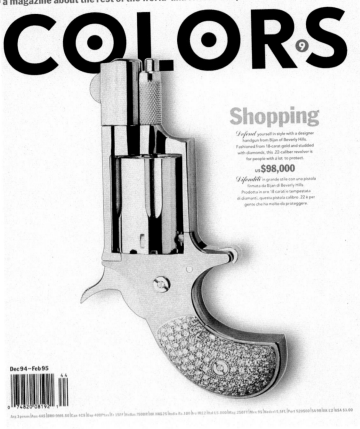

a magazine about the rest of the world una rivista che parla del resto del mondo

# COLORS 9

**Shopping**

*Defend* yourself in style with a designer handgun from Bijan of Beverly Hills. Fashioned from 18-carat gold and studded with diamonds, this .22-caliber revolver is for people with a lot to protect.

US$98,000

*Difenditi* in grande stile con una pistola firmata da Bijan di Beverly Hills. Prodotta in oro 18 carati e tempestata di diamanti, questa pistola calibro .22 è per gente che ha molto da proteggere.

Dec 94–Feb 95

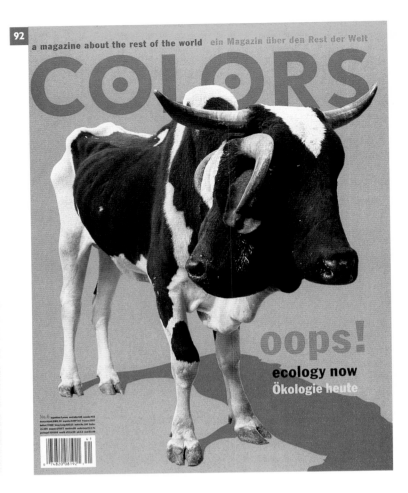

a magazine about the rest of the world ein Magazin über den Rest der Welt

# COLORS

**oops!**

**ecology now**
**Ökologie heute**

a magazine about the rest of the world una revista sobre el resto del mundo

# COLORS VIII

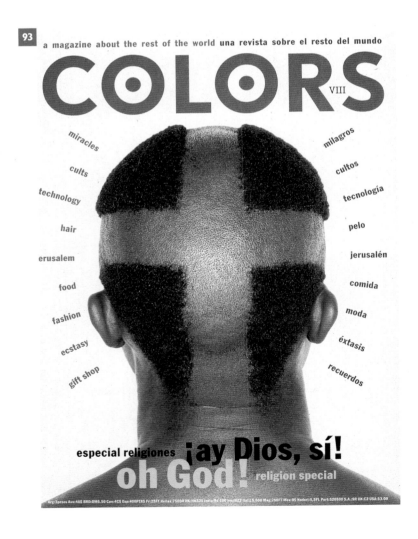

miracles
cults
technology
hair
erusalem
food
fashion
ecstasy
gift shop

milagros
cultos
tecnología
pelo
jerusalén
comida
moda
éxtasis
recuerdos

especial religiones ¡ay Dios, sí!
oh God! religion special

---

**91**

**Publication** Colors 9
**Editor in Chief/Design Director** Tibor Kalman
**Art Director** Mark Porter
**Photo Editors** Alfredo Albertone, Alice Albert
**Publisher** Colors Magazine SRL
**Date** December 1994
**Category** Cover

**92**

**Publication** Colors 6
**Editor in Chief/Design Director** Tibor Kalman
**Designer** Scott Stowell
**Photo Editors** Alfredo Albertone, Alice Albert
**Photographer** Marcos Muzi
**Publisher** Colors Magazine SRL
**Date** March 1994
**Category** Cover

**93**

**Publication** Colors 8
**Editor in Chief/Design Director** Tibor Kalman
**Art Director** Scott Stowell
**Photo Editors** Alfredo Albertone, Alice Albert
**Photographer** Oliviero Toscani
**Publisher** Colors Magazine SRL
**Date** September 1994
**Category** Cover

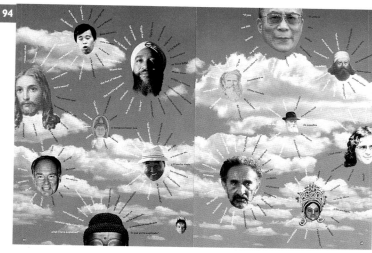

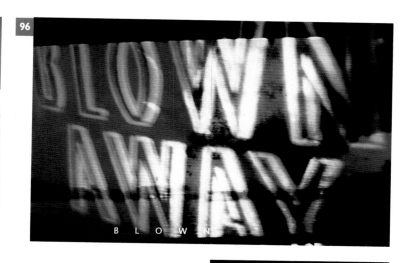

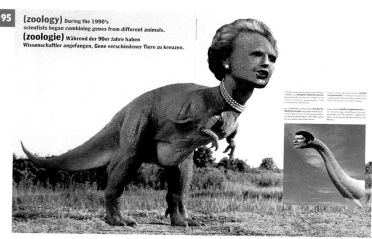

**(zoology)** During the 1990's scientists began combining genes from different animals. **(zoologie)** Während der 90er Jahre haben Wissenschaftler angefangen, Gene verschiedener Tiere zu kreuzen.

You're still seeing in black and white who's right, who's wrong...? Who cares? Kali and Vishnu are one. Out of chaos came order. Out of death, life.

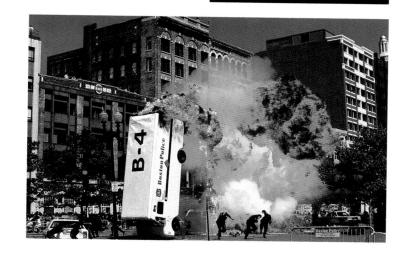

**94**

**Publication** Colors
**Editor in Chief/Design Director** Tibor Kalman
**Art Director** Scott Stowell
**Photo Editors** Alfredo Albertone, Alice Albert
**Publisher** Colors Magazine SRL
**Date** September 1994
**Category** Spread

**95**

**Publication** Colors
**Editor in Chief/Design Director** Tibor Kalman
**Designer** Scott Stowell
**Photo Editors** Alfredo Albertone, Alice Albert
**Photographer** Michael Waine
**Publisher** Colors Magazine SRL
**Date** March 1994
**Category** Spread

**96**

**Publication** Blown Away
**Art Directors** Mike Salisbury, Patrick O'Neal
**Designers** Mike Salisbury, Joel D. Warren, Bruce Birmeliw
**Photographer** Mark Salisbury
**Studio** Mike Salisbury Communications
**Category** Entire Issue

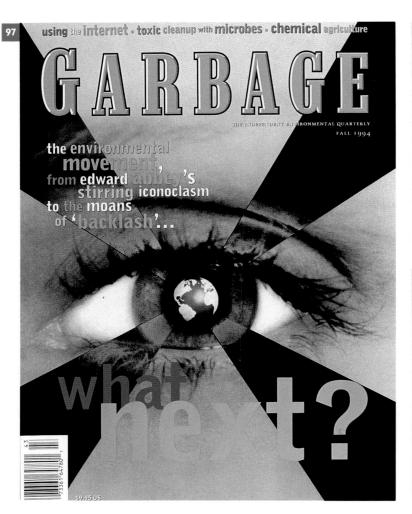

once and
future
farming

BY RONALD BAILEY

environmentalists who want to preserve wildlands from the
farmer's plow as we feed a burgeoning human population should
reconsider an old enemy: chemical-based agriculture.

Vilified by his enemies and even
environmentalists — his putative
friends — Interior Secretary
bruce babbitt is forging a new
kind of pragmatic environmen-
talism. Perhaps the heat he takes
from both sides is a sign that
he's on the right track.

by bill gifford

the view from the citadel

photograph by daniel arsenault

edward abbey confessions of a barbarian
(an exclusive preview of his soon-to-be-published journals)

ILLUSTRATIONS BY BARRY BLITT

**Publication** Garbage
**Design Director** Patrick Mitchell
**Designers** Patrick Mitchell, Inga Soderberg
**Illustrators** Brian Cronin, Barry Blitt
**Photographers** Fredrik Broden, Daniel Arsenault
**Publisher** Dovetale Publishers
**Date** Fall 1994
**Categories** Entire Issue
Redesign

**60**

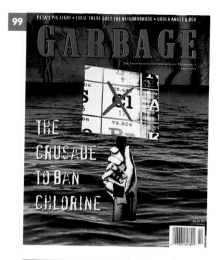

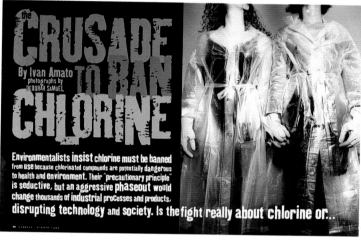

**98**

**Publication** Garbage
**Design Director** Patrick Mitchell
**Designers** Patrick Mitchell, Inga Soderberg
**Illustrators** Seth Jaben, Kevin Irby
**Photographers** The Douglas Brothers, Abrams Lacagnina
**Publisher** Dovetale Publishers
**Date** Spring 1994
**Category** Entire Issue

**99**

**Publication** Garbage
**Design Director** Patrick Mitchell
**Designers** Patrick Mitchell, Inga Soderberg
**Illustrators** Brad Holland, Amy Guip
**Photographers** Deborah Samuels, Pete McArthur
**Publisher** Dovetale Publishers
**Date** Summer 1994
**Category** Entire Issue

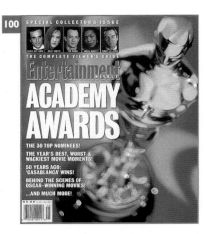

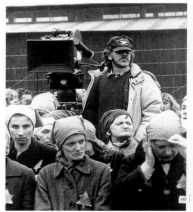

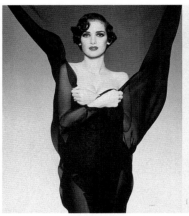

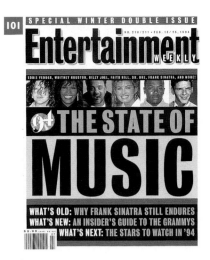

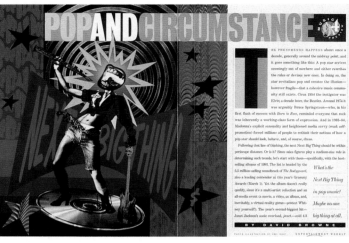

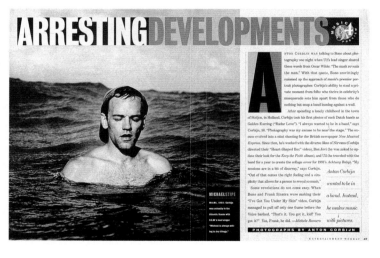

**100**

**Publication** Entertainment Weekly
**Design Director** Michael Grossman
**Art Director** Don Morris
**Designers** Don Morris, James Reyman
**Photo Editors** Heather White, Lynn Bernstein, Mary Dunn
**Publisher** Time Inc.
**Category** Entire Issue

**101**

**Publication** Entertainment Weekly
**Design Director** Michael Grossman
**Art Directors** Jill Armus, Arlene Lappen
**Designers** Jill Armus, Elizabeth Betts, Joe Kimberling,
Bobby B. Lawhorn Jr., Michael Picon, Stacie Reistetter
**Illustrators** Michael Bartalos, Henrik Drescher, Josh Gosfield, Amy Guip
**Photographers** Ruven Afanador, Josef Astor,
Anton Corbijn, Alastair Thain, Dan Winters
**Photo Editors** Michele Romero, Mark Jacobson, Marry Dunn
**Publisher** Time Inc.
**Date** February 18, 1994
**Category** Entire Issue

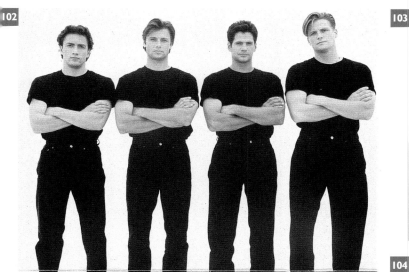

THE HARD-BODIED MEN OF
MELROSE PLACE
PONDER LIFE PLAYING SOFTHEADED
HIMBOS

BY ALAN CARTER
PHOTOGRAPHS BY JEFFREY THURNHER

Texas Ranger

After commanding the field in 'Cobb,' Tommy Lee
Jones still has never met a bad guy he didn't like

BY ALLEN BARRA AND MARION HART
PHOTOGRAPHS BY ALISTAIR MORRISON

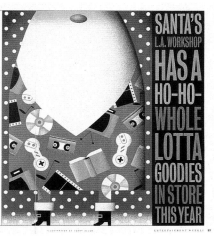

HOLIDAY PREVIEW

SANTA'S L.A. WORKSHOP HAS A HO-HO-WHOLE LOTTA GOODIES IN STORE THIS YEAR

**102**

**Publication** Entertainment Weekly
**Design Director** Robert Newman
**Art Director** Jill Armus
**Designer** Jill Armus
**Photographer** Jeffrey Thurnher
**Photo Editors** Alice Babcock, Doris Brautigan
**Publisher** Time Inc.
**Date** May 20, 1994
**Category** Spread

**103**

**Publication** Entertainment Weekly
**Design Director** Robert Newman
**Art Director** Jill Armus
**Designer** George Karabotsos
**Photographer** Alistair Morrison
**Photo Editors** Doris Brautigan, Mary Dunn
**Publisher** Time Inc.
**Date** December 23, 1994
**Category** Spread

**104**

**Publication** Entertainment Weekly
**Design Director** Robert Newman
**Art Director** Jill Armus
**Designer** Jill Armus
**Illustrator** Terry Allen
**Publisher** Time Inc.
**Date** November 18, 1994
**Category** Spread

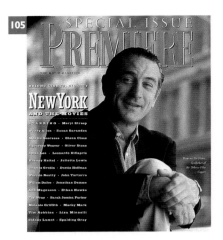

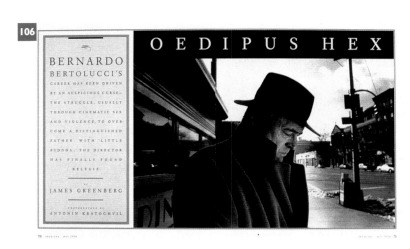

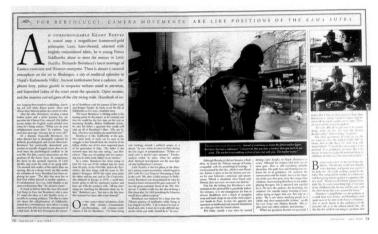

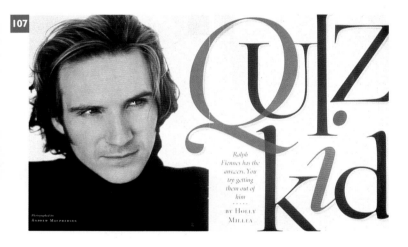

**105**

**Publication** Premiere
**Art Director** John Korpics
**Designers** John Korpics,
Dave Matt, Sharon Cowen
**Photo Editor** Chris Dougherty
**Publisher** K-III Magazines
**Category** Entire Issue

**106**

**Publication** Premiere
**Art Director** John Korpics
**Designer** John Korpics
**Photographer** Antonin Kratochvil
**Photo Editor** Charlie Holland
**Publisher** K-III Magazines
**Date** May 1994
**Category** Story

**107**

**Publication** Premiere
**Art Director** John Korpics
**Designer** John Korpics
**Photographer** Andrew Macpherson
**Photo Editor** Chris Dougherty
**Publisher** K-III Magazines
**Date** August 1994
**Category** Spread

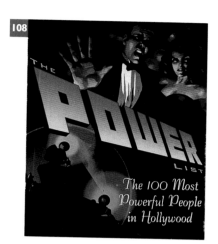

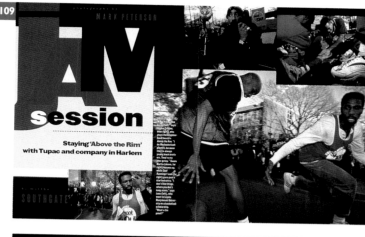

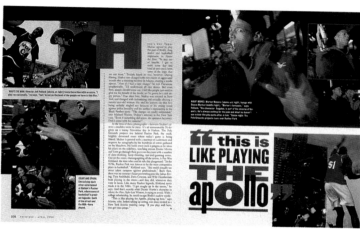

**108**

**Publication** Premiere
**Art Director** John Korpics
**Designer** Dave Matt
**Photo Editor** Chris Dougherty
**Publisher** K-III Magazines
**Date** May 1994
**Category** Story

**109**

**Publication** Premiere
**Art Director** John Korpics
**Designer** John Korpics
**Photographer** Mark Peterson
**Photo Editor** Charlie Holland
**Publisher** K-III Magazines
**Date** April 1994
**Category** Story

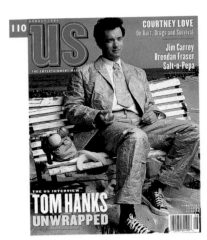

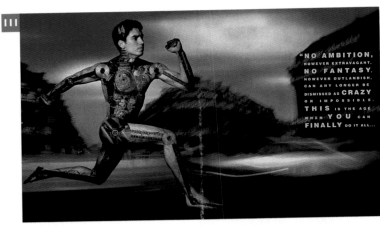

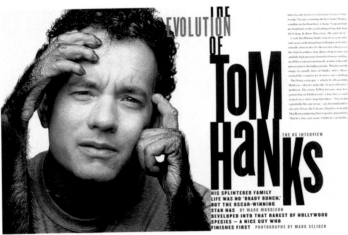

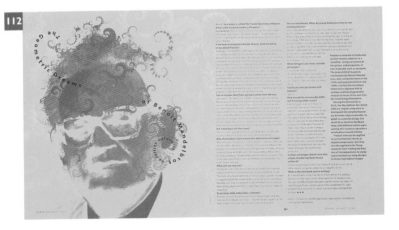

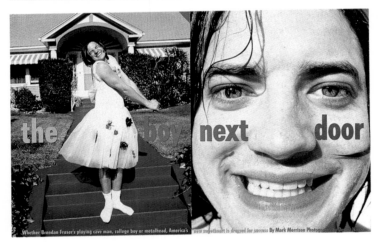

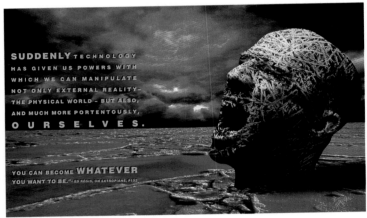

**110**

**Publication** US
**Art Director** Richard Baker
**Designer** Richard Baker
**Photographer** Mark Seliger
**Photo Editors** Jennifer Crandall, Rachel Knepfer
**Publisher** US Magazine Co., L.P.
**Date** August 1994
**Category** Entire Issue

**111**

**Publication** Wired
**Art Director** John Plunkett
**Designers** John Plunkett, Thomas Schneider
**Photographer** James Porto
**Studio** Plunkett & Kuhr
**Date** October 1994
**Category** Story

**112**

**Publication** Wired
**Art Director** John Plunkett
**Designer** Tricia McGillis
**Illustrator** Kai Krause
**Studio** Plunkett & Kuhr
**Date** August 1994
**Category** Spread

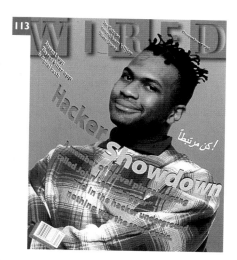

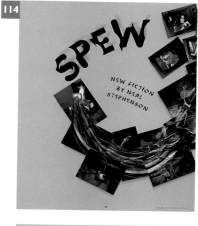

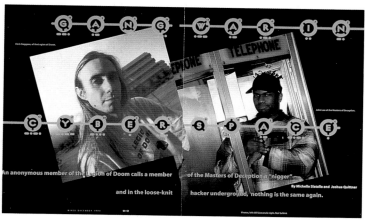

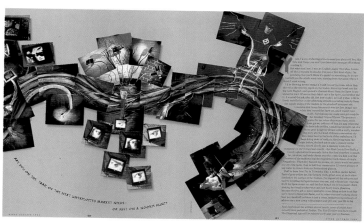

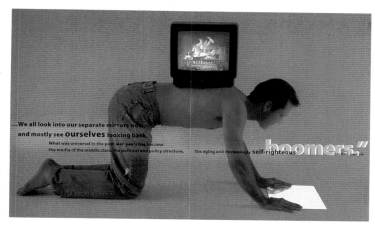

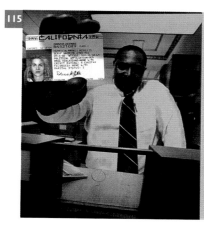

**113**

**Publication** Wired
**Art Director** John Plunkett
**Designers** John Plunkett, Thomas Schneider,
Eric Courtemanche, Andrea Jenkins
**Photographer** Bill Zemanek, Neil Selkirk
**Studio** Plunkett & Kuhr
**Date** December 1994
**Category** Entire Issue

**114**

**Publication** Wired
**Art Director** John Plunkett
**Designers** John Plunkett
**Photographer** David McGlynn
**Studio** Plunkett & Kuhr
**Date** October 1994
**Category** Story

**115**

**Publication** Wired
**Art Director** John Plunkett
**Designers** John Plunkett, Tricia McGillis
**Photographer** James Porto
**Studio** Plunkett & Kuhr
**Date** February 1994
**Category** Spread

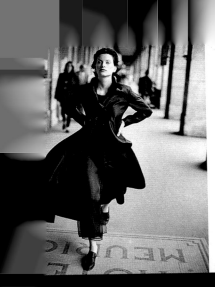

# The General Drift

*Photographed by Peter Lindbergh*

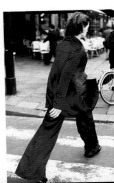

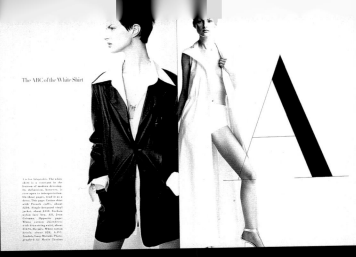

## The ABC of the White Shirt

A

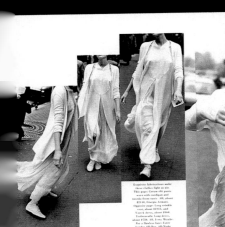

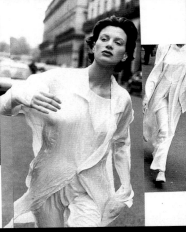

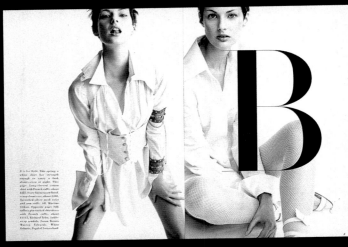

B

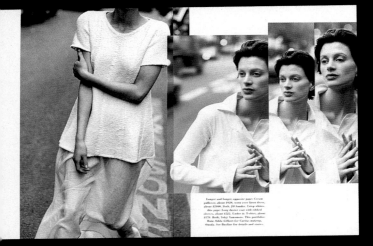

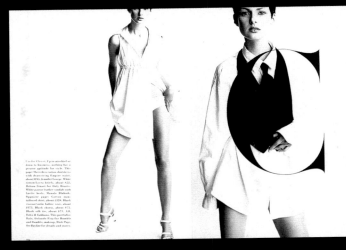

C

116

**Publication** Harper's Bazaar
**Creative Director** Fabien Baron
**Art Director** Joel Berg
**Designer** Johan Svensson
**Photographer** Peter Lindbergh
**Publisher** The Hearst Corporation-Magazines Division

117

**Publication** Harper's Bazaar
**Creative Director** Fabien Baron
**Art Director** Joel Berg
**Designer** Johan Svensson
**Photographer** Mario Testino
**Publisher** The Hearst Corporation-Magazines Division

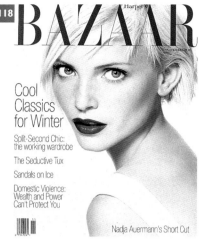

## 118 BAZAAR

Cool
Classics
for Winter

Split-Second Chic:
the working wardrobe

The Seductive Tux

Sandals on Ice

Domestic Violence:
Wealth and Power
Can't Protect You

Nadja Auermann's Short Cut

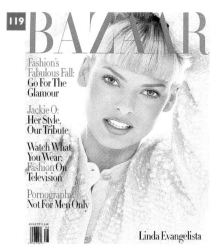

## 119 BAZAAR

Fashion's
Fabulous Fall:
Go For The
Glamour

Jackie O:
Her Style,
Our Tribute

Watch What
You Wear:
Fashion On
Television

Pornography:
Not For Men Only

AUGUST $3.00

Linda Evangelista

**A** Neo Nadja

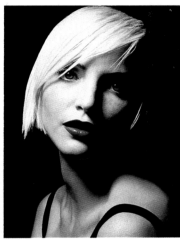

**A** SO, SUIT ME!

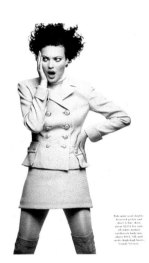

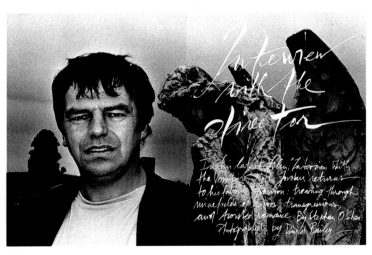

**B**

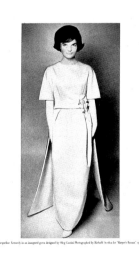

---

**118**

**Publication** Harper's Bazaar
**Creative Director** Fabien Baron
**Art Director** Johan Svensson
**Publisher** The Hearst Corporation-Magazines Division
**Date** November 1994
**Categories** Entire Issue
    A Spread

**119**

**Publication** Harper's Bazaar
**Creative Director** Fabien Baron
**Art Director** Johan Svensson
**Publisher** The Hearst Corporation-Magazines Division
**Date** August 1994
**Categories** Entire Issue
    A Spread
    B Spread

69

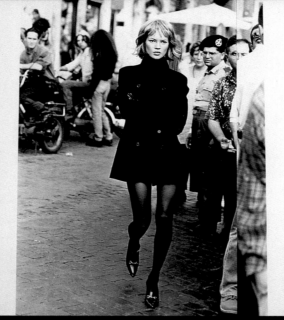

Who's That Girl? It's Kate Moss, actually. With cool elegance, she embodies the figure emerging from the avenues of change this fall. Her tastes are acutely defined: A sharp tailleur, a clean A-line, the pointed toe of a well-heeled shoe, the decorative edge of a smoking trimmed in marabou. Take a good look. She's someone you'll be seeing a lot more of. Opposite: Black wool twill pea coat, about $925. Black panne-velvet sweater, about $195. Both, and shoes, Gucci. Photographed by Peter Lindbergh.

Nicolas Cage

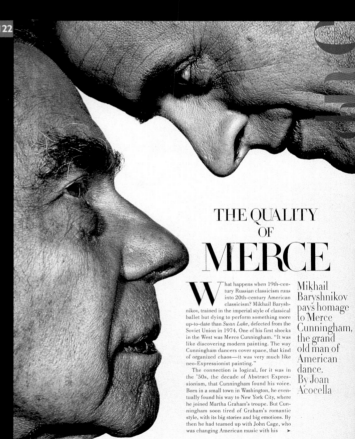

# THE QUALITY OF MERCE

What happens when 19th-century Russian classicism runs into 20th-century American classicism? Mikhail Baryshnikov, trained in the imperial style of classical ballet but dying to perform something more up-to-date than *Swan Lake*, defected from the Soviet Union in 1974. One of his first shocks in the West was Merce Cunningham. "It was like discovering modern painting. The way Cunningham dancers cover space, that kind of organized chaos—it was very much like neo-Expressionist painting."

The connection is logical, for it was in the '50s, the decade of Abstract Expressionism, that Cunningham found his voice. Born in a small town in Washington, he eventually found his way to New York City, where he joined Martha Graham's troupe. But Cunningham soon tired of Graham's romantic style, with its big stories and big emotions. By then he had teamed up with John Cage, who was changing American music with his ▶

Mikhail Baryshnikov pays homage to Merce Cunningham, the grand old man of American dance. By Joan Acocella

---

**Publication** Harper's Bazaar
**Creative Director** Fabien Baron
**Art Director** Johan Svensson
**Photographer** Peter Lindbergh
**Publisher** The Hearst Corporation-Magazines Division
**Date** September 1994
**Category** Spread

**Publication** Harper's Bazaar
**Creative Director** Fabien Baron
**Art Director** Johan Svensson
**Photographer** Wayne Maser
**Publisher** The Hearst Corporation-Magazines Division
**Date** July 1994
**Category** Spread

**Publication** Harper's Bazaar
**Creative Director** Fabien Baron
**Art Director** Paul Eustace
**Photographer** Richard Burbridge
**Publisher** The Hearst Corporation-Magazines Division
**Date** March 1994
**Category** Single Page

City Slick

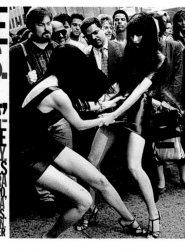

ESCAPE OF THE TECHNO VIXENS. WATCH OUT! VINYL, RUBBER, AND THEIR CLING-FIT SISTERS ARE BACK ON THE STREETS, BEHAVING OUTRAGEOUSLY BUT SAY WHAT YOU LIKE, THESE GIRLS KNOW HOW TO PULL A CROWD. LEFT: LYCRA SHEER MESH AND RUBBER DRESS, ABOUT $320, AND MATCHING BRIEFS, ABOUT $65, BOTH, LIZA BRUCE. SHOES, SUSAN BENNIS WARREN EDWARDS. RIGHT: RUBBER TURTLENECK DRESS, ABOUT $199. SIREN. SHOES, MARC JACOBS. PHOTOGRAPHED BY WAYNE MASER

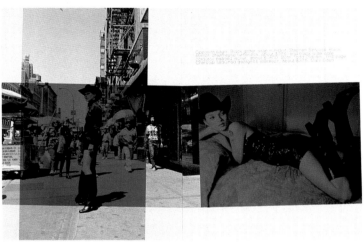

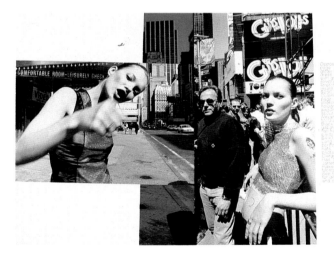

**123**

**Publication** Harper's Bazaar
**Creative Director** Fabien Baron
**Art Director** Johan Svensson
**Photographer** Glenn Luchford
**Publisher** The Hearst Corporation-
Magazines Division
**Date** September 1994
**Category** Story

**124**

**Publication** Harper's Bazaar
**Creative Director** Fabien Baron
**Art Director** Joel Berg
**Designer** Johan Svensson
**Photographer** Patrick Demarchelier
**Publisher** The Hearst Corporation-
Magazines Division
**Date** March 1994
**Category** Spread

**125**

**Publication** Harper's Bazaar
**Creative Director** Fabien Baron
**Art Director** Johan Svensson
**Photographer** Wayne Maser
**Publisher** The Hearst Corporation-
Magazines Division
**Date** August 1994
**Category** Spread

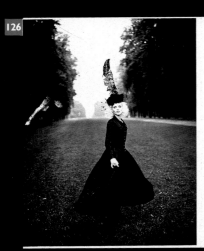

An
# ode
to the female form

The Paris couturiers have rediscovered the eloquence of disciplined structure. The lines are sinuous and measured, divinely drawn to define waist, breast, and hip. Black satin double-breasted corset jacket and black silk satin (Taroni) divided skirt. Both, Chanel Haute Couture by Karl Lagerfeld. Hat and shoes, Chanel; Christian Dior hosiery. Photographed by Patrick Demarchelier.

Can cosmetic companies find beauty in this improbable pair?

## Ode to the A-Cup

Never mind that the world seems to be busting out all over—small breasts have their own attraction. But where do we find a bra to do them justice?

By Sarah Mower

Think of the Paris Couture as a kind of lyrical interlude between seasons, a moment when designers practice their skills for love instead of commerce. Spring turned out not to be a session of free-form improvisation, but of set pieces perfectly performed. If the black lace, the chiffon, the draped satin, the goddess dresses, and even the reproportioned tailleurs with their long jackets and short skirts had something familiar about them, no matter the interpretation was sublime. Here: Beaded lace tunic with silk crepe (Taroni) bodice and sheer sleeves (Vermont); silk crepe (Schlaepfer) pants and satin (Abraham) cape. All Emanuel Ungaro Haute Couture. Photographed by Peter Lindbergh

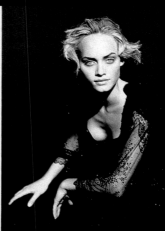

**126**
**Publication** Harper's Bazaar
**Creative Director** Fabien Baron
**Art Director** Johan Svensson
**Photographer** Patrick Demarchelier
**Publisher** The Hearst Corporation-Magazines Division
**Date** October 1994
**Category** Spread

**127**
**Publication** Harper's Bazaar
**Creative Director** Fabien Baron
**Art Director** Johan Svensson
**Photographer** Bill Silano
**Publisher** The Hearst Corporation-Magazines Division
**Date** August 1994
**Category** Spread

**128**
**Publication** Harper's Bazaar
**Creative Director** Fabien Baron
**Art Director** Joel Berg
**Designer** Johan Svensson
**Photographer** Raymond Meier
**Publisher** The Hearst Corporation-Magazines Division
**Date** March 1994
**Category** Spread

**129**
**Publication** Harper's Bazaar
**Creative Director** Fabien Baron
**Art Director** Joel Berg
**Designer** Johan Svensson
**Photographer** Peter Lindbergh
**Publisher** The Hearst Corporation-Magazines Division
**Date** April 1994
**Category** Spread

**130**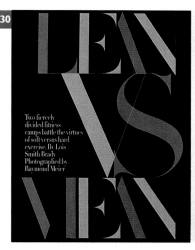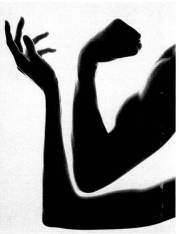

**132**

**131**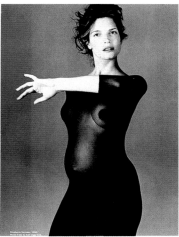

**133**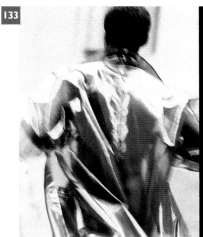

**130**

**Publication** Harper's Bazaar
**Creative Director** Fabien Baron
**Art Director** Joel Berg
**Designer** Johan Svensson
**Photographer** Raymond Meier
**Publisher** The Hearst Corporation-Magazines Division
**Date** March 1994
**Category** Spread

**131**

**Publication** Harper's Bazaar
**Creative Director** Fabien Baron
**Art Director** Joel Berg
**Designer** Johan Svensson
**Photographer** Richard Avedon
**Publisher** The Hearst Corporation-Magazines Division
**Date** March 1994
**Category** Spread

**132**

**Publication** Harper's Bazaar
**Creative Director** Fabien Baron
**Art Director** Joel Berg
**Designer** Johan Svensson
**Photographer** Frederik Lieberath
**Publisher** The Hearst Corporation-Magazines Division
**Date** April 1994
**Category** Spread

**133**

**Publication** Harper's Bazaar
**Creative Director** Fabien Baron
**Art Director** Joel Berg
**Designer** Johan Svensson
**Photographer** Peter Lindbergh
**Publisher** The Hearst Corporation-Magazines Division
**Date** February 1994
**Category** Spread

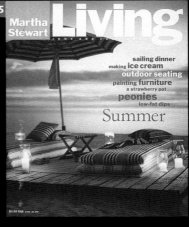

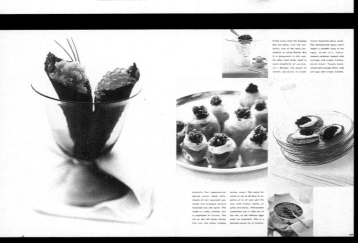

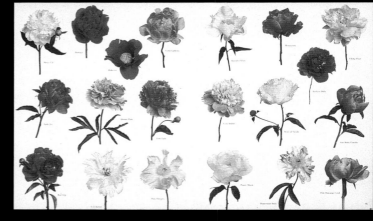

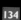
**134**

**Publication**  Martha Stewart Living
**Art Director**  Gael Towey
**Designer**  Eric Pike
**Photographer**  Carlton Davis
**Photo Editor**  Heidi Posner
**Date**  December 1994/January 1995
**Category**  Story

**135**

**Publication**  Martha Stewart Living
**Art Director**  Gael Towey
**Designers**  Gael Towey, Eric Pike, Anne Johnson,
Claudia Bruno, Agnethe Glatved, Constance Old
**Photographers**  Gentl & Hyers, Victor Schrager, Dana Gallagher,
Carlton Davis, William Abranowicz, Maria Robledo, Davies & Starr
**Photo Editor**  Heidi Posner
**Date**  June/July 1994
**Category**  Entire Issue

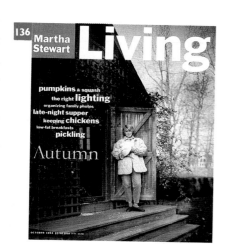

spices

PUMPKINS & SQUASH

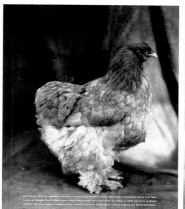

glossary

136

**Publication**  Martha Stewart Living
**Art Director**  Gael Towey
**Designers**  Gael Towey, Eric Pike, Anne Johnson,
Claudia Bruno, Agnethe Glatved, Constance Old
**Photographers**  Gentl & Hyers, William Abranowicz,
John Dugdale, Bruce Wolf, Christopher Baker, Victor Schrager,
Maria Robledo, Dana Gallagher, Stephen Lewis
**Photo Editor**  Heidi Posner
**Date**  October 1994
**Category**  Entire Issue

137

**Publication**  Martha Stewart Living
**Art Director**  Gael Towey
**Designer**  Anne Johnson
**Photographer**  Victoria Pearson
**Photo Editor**  Heidi Posner
**Date**  February/March 1994
**Category**  Story

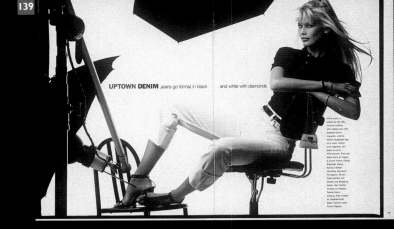

UPTOWN **DENIM** Jeans go formal, in black and white with diamonds

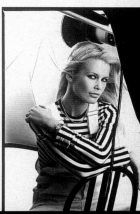

# ALBERT HADLEY
## takes on the future

The dean of American design—Sister Parish's partner for three decades, creator of decors for Kennedys, Astors, Rockefellers, Gettys— talks about design on the brink of the second millennium

INTERVIEW BY CHARLES BRICKER; PHOTOGRAPHY BY DAVID SEIDNER

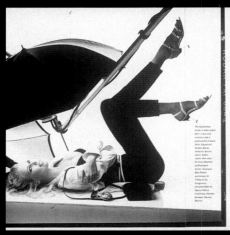

PRODUCED BY CLAUDIA LEBENTHAL; PHOTOGRAPHY BY WOLFGANG LUDES

Lamps on the high-voltage design circuit
## WATTS happening

---

## 138

**Publication** Elle Decor
**Art Director** Jo Hay
**Designer** Jo Hay
**Photographers** John Hall, Ken Shung
**Photo Editor** Jodi Lahaye
**Publisher** Hachette Filipacchi Magazines, Inc.
**Date** June/July 1994
**Category** Entire Issue

## 139

**Publication** Elle
**Creative Director** Regis Pagniez
**Art Director** Nora Sheehan
**Designers** Nora Sheehan, Regis Pagniez
**Photographer** Gilles Bensimon
**Publisher** Hachette Filipacchi Magazines, Inc.
**Date** July 1994
**Category** Story

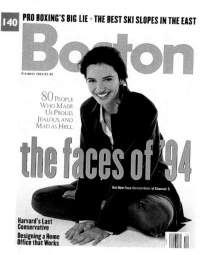

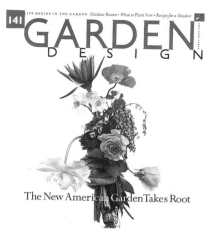

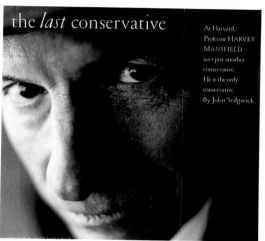

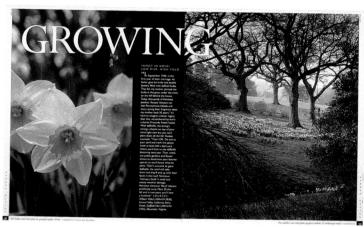

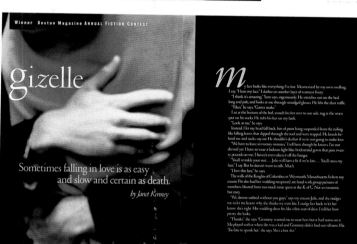

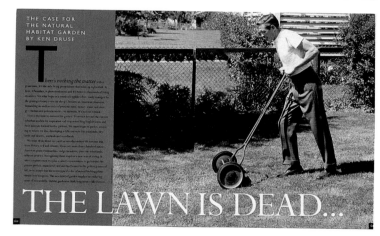

**140**

**Publication**  Boston
**Art Director**  Gregory Klee
**Designer**  Rina Migliaccio
**Illustrator**  Janet Woolley
**Photographers**  John Goodman, Stephen Wallis
**Publisher**  METROCORP
**Date**  December 1994
**Category**  Redesign

**141**

**Publication**  Garden Design
**Creative Director**  Michael Grossman
**Art Director**  Paul Roelofs
**Photographers**  Derek Fell, Huch Palmer, Petrified Films, Sylvia Plachy
**Photo Editor**  Susan Goldberger
**Publisher**  Meigher Communications
**Date**  April/May 1994
**Category**  Redesign

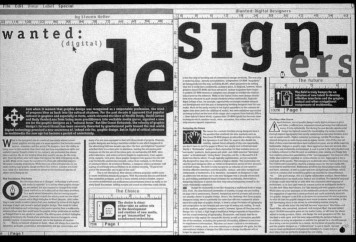

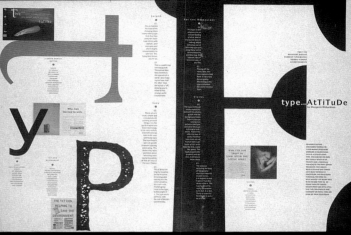

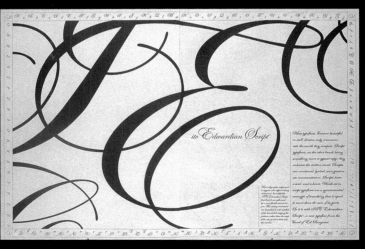

**Publication** Upper and Lower Case
**Art Directors** Woody Pirtle, John Klotnia
**Designers** Ivette Montes de Oca, Robert Spica
**Publisher** International Typeface Corporation

**Publication** Upper and Lower Case
**Art Directors** Woody Pirtle, John Klotnia
**Designers** Ivette Montes de Oca, Robert Spica
**Publisher** International Typeface Corporation

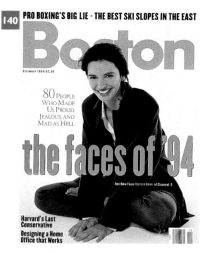

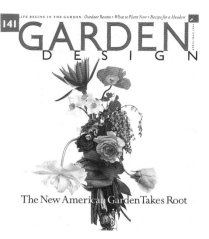

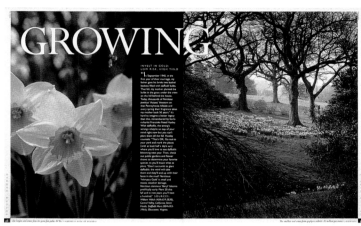

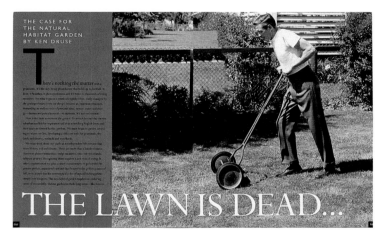

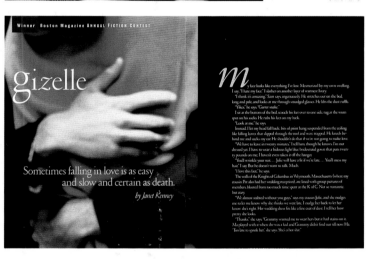

**140**

**Publication** Boston
**Art Director** Gregory Klee
**Designer** Rina Migliaccio
**Illustrator** Janet Woolley
**Photographers** John Goodman, Stephen Wallis
**Publisher** METROCORP
**Date** December 1994
**Category** Redesign

**141**

**Publication** Garden Design
**Creative Director** Michael Grossman
**Art Director** Paul Roelofs
**Photographers** Derek Fell, Huch Palmer, Petrified Films, Sylvia Plachy
**Photo Editor** Susan Goldberger
**Publisher** Meigher Communications
**Date** April/May 1994
**Category** Redesign

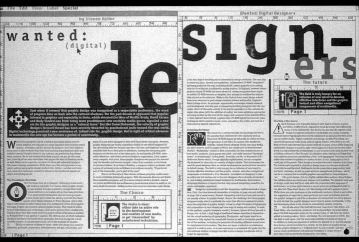

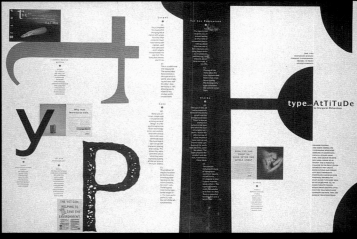

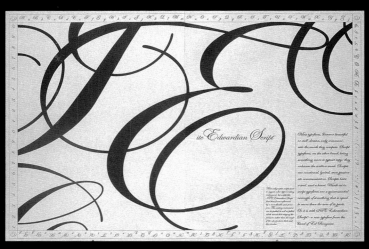

**Publication** Upper and Lower Case
**Art Directors** Woody Pirtle, John Klotnia
**Designers** Ivette Montes de Oca, Robert Spica
**Publisher** International Typeface Corporation
**Date** Winter 1994
**Category** Entire Issue

**Publication** Upper and Lower Case
**Art Directors** Woody Pirtle, John Klotnia
**Designers** Ivette Montes de Oca, Robert Spica
**Publisher** International Typeface Corporation
**Date** Summer 1994
**Category** Entire Issue

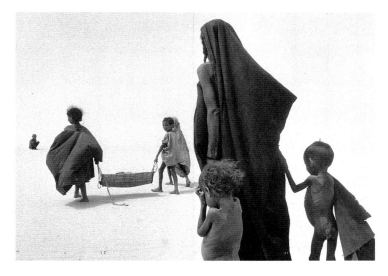

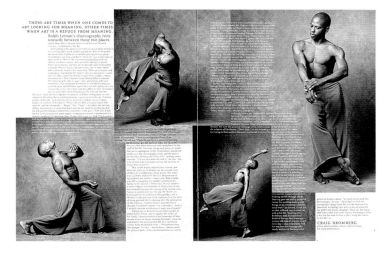

**144**

**Publication** UNIFEM 1993 Annual Report
**Art Director** Jurek Wajdowicz
**Designers** Lisa LaRochelle, Jurek Wajdowicz
**Photographer** Sebastiao Salgado
**Studio** Emerson, Wajdowicz Studios, Inc.
**Category** Entire Issue

**145**

**Publication** Dance Ink
**Art Director** J. Abbott Miller
**Photographer** Andrew Eccles
**Photo Editor** Kate Schlesinger
**Studio** Design/Writing/Research
**Date** Fall 1994
**Category** Entire Issue

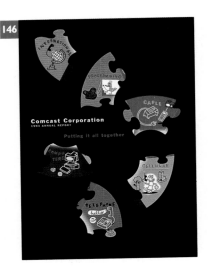

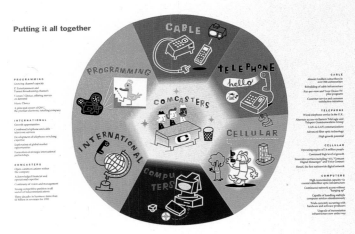

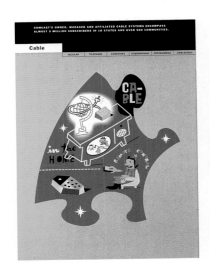

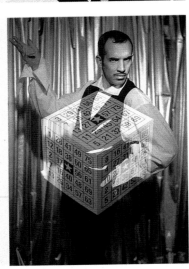

**Publication** Comcast Corporation 1993 Annual Report
**Creative Directors** Kent Hunter, Aubrey Balkind
**Designer** Kin Yuen
**Illustrator** J. Otto Siebold
**Photographer** Mark Jenkinson
**Studio** Frankfurt Balkind Partners
**Category** Entire Issue

**Publication** Beckett Paper Annual Report
**Design Director** John Pylypczak
**Art Director** Diti Katona
**Designer** John Pylypczak
**Photographer** Ron Baxter Smith
**Publisher** Concrete Design Communications Inc.
**Category** Entire Issue

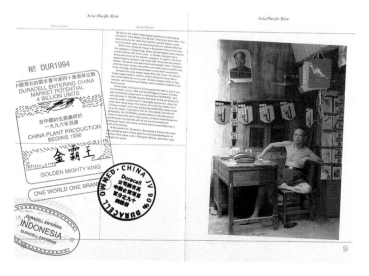

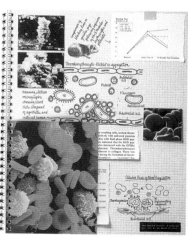

148

**Publication** Duracell Annual Report
**Art Director** David Kohler
**Designers** David Kohler, Margaret McGee
**Illustrators** American Banknote Company, David Kohler, Margaret McGee
**Photographer** Mike Goldwater
**Photo Editor** David Kohler
**Studio** Addison Corporate Annual Reports
**Date** September 1994
**Category** Entire Issue

149

**Publication** Ariad Pharmaceuticals 1993 Annual Report
**Art Directors** Woody Pirtle, John Klotnia
**Designers** John Klotnia, Ivette Montes de Oca
**Illustrator** Ivette Montes de Oca
**Photographer** John Paul Endress
**Studio** Pentagram Design NYC
**Date** July 1994
**Category** Entire Issue

YMCA
of Greater Toronto

Annual Report 1993/94
(and picture book)

ATMOS ENERGY CORPORATION 1993 ANNUAL REPORT

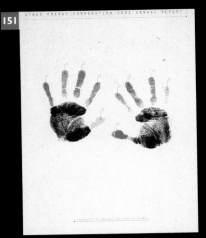

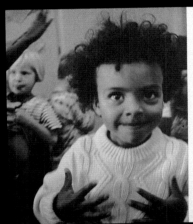

YMCA Child•Care celebrates 25 years of:

Growing bigger, getting better — we are now the largest provider of licensed child care in Canada with more than 125 locations. Quality care — there's a good reason why we try harder. Children are our future! Change, in every possible way — (we can imagine one sign outside the child care centres: 8.7 million diapers changed). Knowing that each child shows inside — individual attention and care.

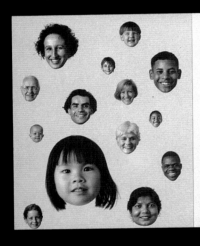

All ages, all stages. Who is a YMCA participant? Chances are, someone (in fact, many someones) you know. In Greater Toronto, 178,000 people — enough to fill the SkyDome three times over and have people hanging from the rafters and overflowing into the aisles, as well. They are new immigrants and fourth generation Canadians. All ages, all stages of ability. Some can afford to give generously to our YMCA, others are having a tough time and could not participate without financial assistance. They are ALL welcome.

150

**Publication** Concrete Design Communications Inc.
**Art Directors** John Pylypczak, Diti Katona
**Designers** John Pylypczak, Renata Chubb
**Illustrators** Roman Pylypczak, Diti Katona, John Pylypczak
**Category** Entire Issue

151

**Publication** Atmos Energy Corporation Annual Report
**Creative Directors** Ron Sullivan, Mark Perkins
**Design Director** Art Garcia
**Designers** Art Garcia, Randy Sheya, Shaun Marshall
**Illustrator** Art Garcia
**Photographers** Stan Wolenski, Jim Olvera
**Studio** Sullivan Perkins
**Category** Entire Issue

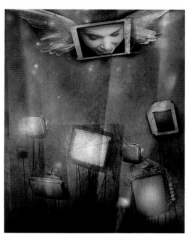

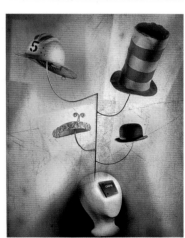

**152**

**Publication** Catalyst
**Art Director** Earl Gee
**Designers** Earl Gee, Fani Chung
**Illustrator** Earl Gee
**Photographers** Geoffrey Nelson, Lenny Lind
**Studio** Earl Gee Design
**Category** Entire Issue

**153**

**Publication** Chips and Technologies
**Creative Director** Bill Cahan
**Art Director** Bill Cahan
**Designers** Michael Verdine, Sharrie Brooks
**Photographer** Kevin Irby
**Photo Editors** Bill Cahan, Sharrie Brooks, Michael Verdine
**Studio** Cahan and Associates
**Category** Entire Issue

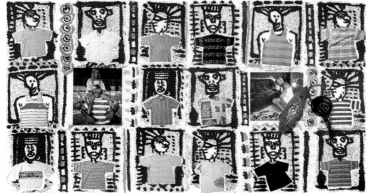

rock
and
roll

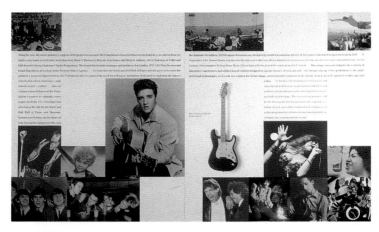

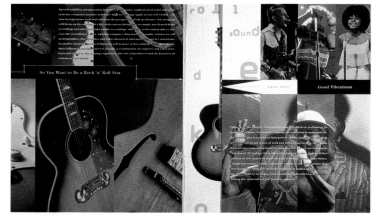

**Publication**  Gotcha Style
**Art Director**  Mike Salisbury
**Designers**  Mike Salisbury, Terry Lamb, Pat Linse
**Illustrators**  Patrick O'Neal, Terry Lamb, Elizabeth Salisbury
**Photo Editor**  Mike Punk
**Studio**  Mike Salisbury Communications Inc.
**Category**  Entire Issue

**Publication**  Rock and Roll Hall of Fame & Museum Brochure
**Design Director**  Mark Schwartz
**Art Directors**  Joyce Nesnadny, Mark Schwartz
**Designers**  Joyce Nesnadny, Michelle Moehler, Brian Lavy, Mark Schwartz
**Photographer**  Tony Festa
**Studio**  Nesnadny & Schwartz
**Category**  Entire Issue

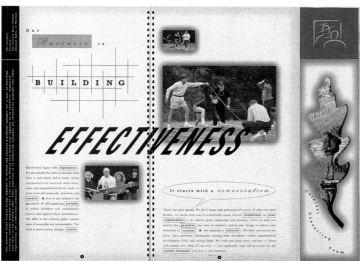

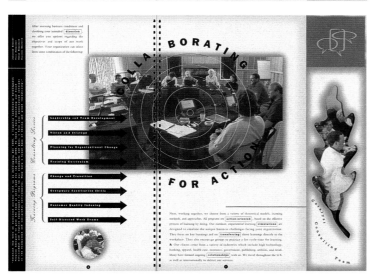

**152**

**Publication** Catalyst
**Art Director** Earl Gee
**Designers** Earl Gee, Fani Chung
**Illustrator** Earl Gee
**Photographers** Geoffrey Nelson, Lenny Lind
**Studio** Earl Gee Design
**Category** Entire Issue

**153**

**Publication** Chips and Technologies
**Creative Director** Bill Cahan
**Art Director** Bill Cahan
**Designers** Michael Verdine, Sharrie Brooks
**Photographer** Kevin Irby
**Photo Editors** Bill Cahan, Sharrie Brooks, Michael Verdine
**Studio** Cahan and Associates
**Category** Entire Issue

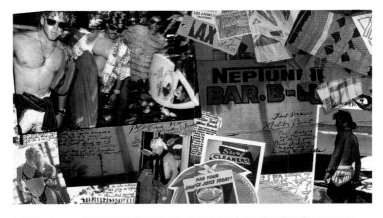

**Publication** Gotcha Style
**Art Director** Mike Salisbury
**Designers** Mike Salisbury, Terry Lamb, Pat Linse
**Illustrators** Patrick O'Neal, Terry Lamb, Elizabeth Salisbury
**Photo Editor** Mike Punk
**Studio** Mike Salisbury Communications Inc.
**Category** Entire Issue

**Publication** Rock and Roll Hall of Fame & Museum Brochure
**Design Director** Mark Schwartz
**Art Directors** Joyce Nesnadny, Mark Schwartz
**Designers** Joyce Nesnadny, Michelle Moehler, Brian Lavy, Mark Schwartz
**Photographer** Tony Festa
**Studio** Nesnadny & Schwartz
**Category** Entire Issue

**156**

**Publication** Mickelberry Corporation 1993 Annual Report
**Design Director** Peter Harrison
**Art Director** Susan Hochbaum
**Designer** Susan Hochbaum
**Illustrator** Philippe Lardy
**Photographer** John Paul Endress
**Studio** Pentagram Design NYC
**Date** April 1994
**Category** Entire Issue

**157**

**Publication** Houston Public Television 1993 Annual Report
**Art Director** Mark Geer
**Designer** Mark Geer
**Photography** Houston Public Television Archives
**Studio** Geer Design, Inc.
**Category** Entire Issue

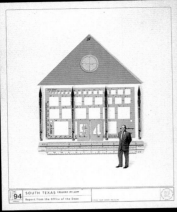

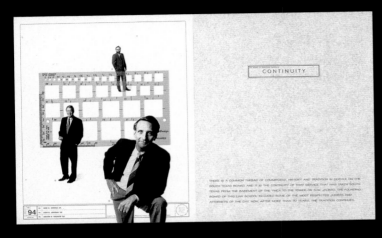

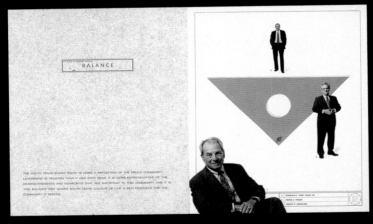

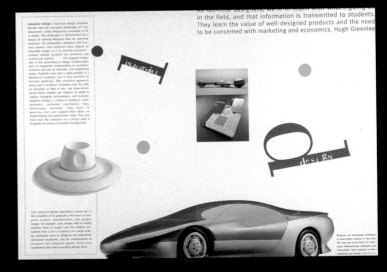

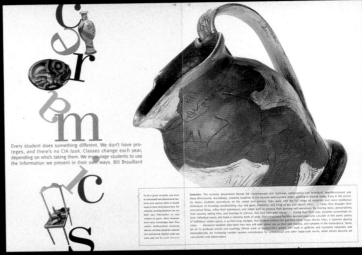

**Publication** South Texas College of Law 1994 Dean's Report
**Art Director** Mark Geer
**Designers** Mark Geer, Mandy Stewart
**Photographer** Chris Shinn
**Studio** Geer Design, Inc.
**Category** Entire Issue

**Publication** Cleveland Institute of Art Catalogue
**Design Director** Joyce Nesnadny
**Art Directors** Mark Schwartz, Joyce Nesnadny
**Designers** Joyce Nesnadny, Brian Lavy
**Photographers** Robert Muller, Mark Schwartz
**Studio** Nesnadny & Schwartz
**Category** Entire Issue

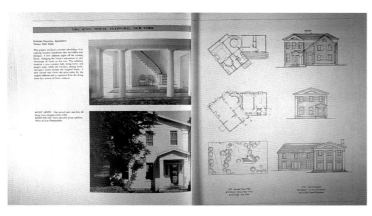

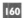

**160**

**Publication** The Classicist
**Art Director** Seth Joseph Weine
**Illustrator** Richard Cameron
**Photographer** Esto
**Client** Institute For The Study Of Classical Architecture
**Date** October 1994
**Category** Entire Issue

**161**

**Publication** Rough
**Art Director** Scott Ray
**Designers** Scott Ray, Bryan L. Peterson,
Dave Eliason, Nham T. Pham, Jan Wilson
**Illustrators** Aletha Rappel, Keith Graves
**Photographers** Roble Dupleix, Dick Patrick, P. Hollenback, J. Wong
**Studio** Peterson & Co.
**Date** November 1994
**Categories** Entire Issue
A  Spread

# True Wives' Tales

### By Jeannie Ralston

**WET SUIT**
Mom never heard of designer water. She just told you to drink plenty of the plain, unadulterated, fizzless, mineral-free stuff. And she was right. Black knit bikini by Prada. Shoes by Manolo Blahnik. These pages: Hair, Serge Normant; makeup, Laura Mercier; manicure, Sherii Bailey. Details, see Credits page.

**S**o what's up with old wives? How come they're held responsible for almost every cockamamy idea that was ever floated in the history of mankind? You never, ever hear the term *old husbands*, but we know that men have come up with some pretty wacky theories themselves. We don't want to get started on the blame-it-on-the-woman sexism inherent in the label "old wives' tales." This isn't a political manifesto, but it is a partial defense of so-called old wives.

Not that they don't have more than a few blemishes on their record. They were the ones, after all, who brought us such gems as tying a dirty sock around your neck to cure a sore throat and stepping in fresh cow dung to relieve athlete's foot. But they haven't been entirely loony. The heyday of old wives was those centuries before there was a doctor's office in every strip mall, before every quack with good teeth could have his or her own infomercial. This was back when women operated mostly on gut feeling and tradition, and a surprising number of their prescriptions have survived today. Many are as ignorable as John Travolta's attempts at a comeback, but in at least 21 cases it seems these mythical mothers were ahead of science.

### Eat your broccoli.

### Don't tweeze your eyebrows.

### Mother may have

### been annoying, but often

### she was right.

PHOTOGRAPHED BY MICHAEL THOMPSON

**WORRYWARTS**
She was wrong when she said your face was going to freeze into that frown, but her advice that you could worry yourself to death was right on.

# THE FOOD PUSHERS

**HOW'S THE PLUMBING?**

**CRADLE SONGS**

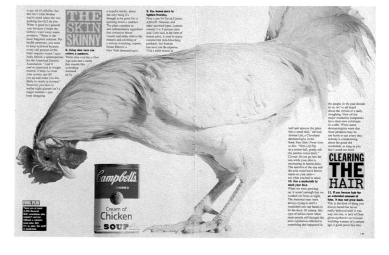

# THE SKIN SKINNY

# CLEARING THE HAIR

162

**Publication** Allure
**Design Director** Shawn Young
**Designer** Shawn Young
**Photographer** Michael Thompson
**Photo Editor** Judy White
**Publisher** Condé Nast Publications Inc.
**Date** May 1994
**Category** Story

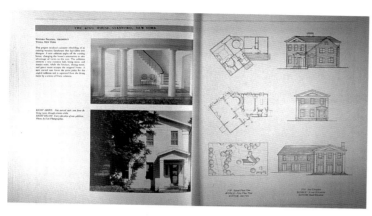

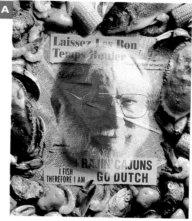

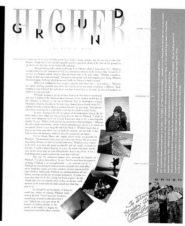

**160**

**Publication** The Classicist
**Art Director** Seth Joseph Weine
**Illustrator** Richard Cameron
**Photographer** Esto
**Client** Institute For The Study Of Classical Architecture
**Date** October 1994
**Category** Entire Issue

**161**

**Publication** Rough
**Art Director** Scott Ray
**Designers** Scott Ray, Bryan L. Peterson,
Dave Eliason, Nham T. Pham, Jan Wilson
**Illustrators** Aletha Rappel, Keith Graves
**Photographers** Roble Dupleix, Dick Patrick, P. Hollenback, J. Wong
**Studio** Peterson & Co.
**Date** November 1994
**Categories** Entire Issue
        A  Spread

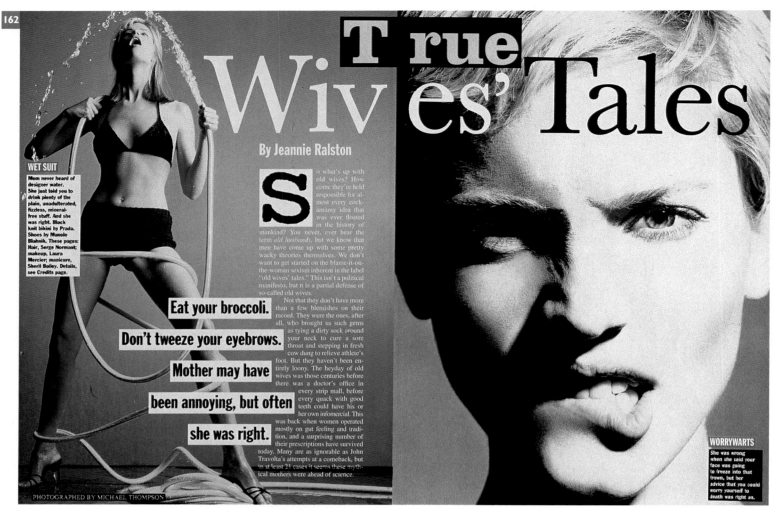

# True Wives' Tales

By Jeannie Ralston

**WET SUIT**
Mom never heard of designer water. She just told you to drink plenty of the plain, unadulterated, fizzless, mineral-free stuff. And she was right. Black knit bikini by Prada. Shoes by Manolo Blahnik. These pages: Hair, Serge Normant; makeup, Laura Mercier; manicure, Sheril Bailey. Details, see Credits page.

So what's up with old wives? How come they're held responsible for almost every cock-amamy idea that was ever floated in the history of mankind? You never, ever hear the term *old husbands*, but we know that men have come up with some pretty wacky theories themselves. We don't want to get started on the blame-it-on-the-woman sexism inherent in the label "old wives' tales." This isn't a political manifesto, but it is a partial defense of so-called old wives.

**Eat your broccoli.**

**Don't tweeze your eyebrows.**

**Mother may have**

**been annoying, but often**

**she was right.**

Not that they don't have more than a few blemishes on their record. They were the ones, after all, who brought us such gems as tying a dirty sock around your neck to cure a sore throat and stepping in fresh cow dung to relieve athlete's foot. But they haven't been entirely loony. The heyday of old wives was those centuries before there was a doctor's office in every strip mall, before every quack with good teeth could have his or her own infomercial. This was back when women operated mostly on gut feeling and tradition, and a surprising number of their prescriptions have survived today. Many are as ignorable as John Travolta's attempts at a comeback, but in at least 21 cases it seems these mythical mothers were ahead of science.

PHOTOGRAPHED BY MICHAEL THOMPSON

**WORRYWARTS**
She was wrong when she said your face was going to freeze into that frown, but her advice that you could worry yourself to death was right on.

# THE FOOD PUSHERS

**HOW'S THE PLUMBING?**

# THE SKIN SKINNY

# CLEARING THE HAIR

**Publication** Allure
**Design Director** Shawn Young
**Designer** Shawn Young
**Photographer** Michael Thompson
**Photo Editor** Judy White
**Publisher** Condé Nast Publications Inc.
**Date** May 1994
**Category** Story

163

# Crimes and Misdemeanors

Skin abuse is rampant. Sun exposure, dry heat, and pollution are accessories to the crime. The punishment: Wrinkles, lines, and scaly skin.

By Christian Wright

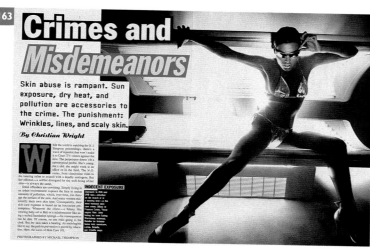

PHOTOGRAPHED BY MICHAEL THOMPSON

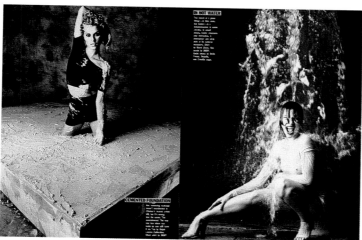

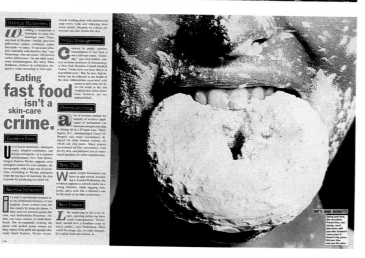

Eating fast food isn't a skin-care crime.

164

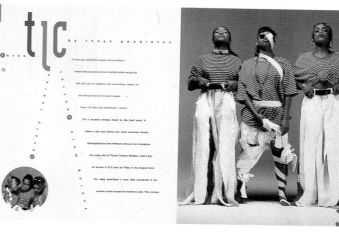

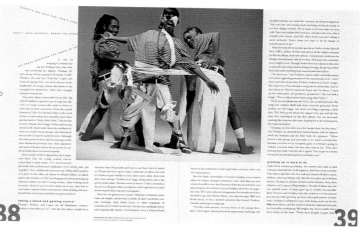

---

163

**Publication** Allure
**Design Director** Shawn Young
**Designer** Shawn Young
**Photographer** Michael Thompson
**Photo Editor** Judy White
**Publisher** Condé Nast Publications Inc.
**Date** December 1994
**Category** Story

164

**Publication** YSB
**Art Director** Lance Pettiford, Fo Wilson
**Designer** Lance Pettiford
**Photographer** Jeffrey Henson Scales
**Photo Editor** Stephen Chin
**Publisher** Paige Publications
**Studio** Studio W
**Date** July 1994
**Category** Story

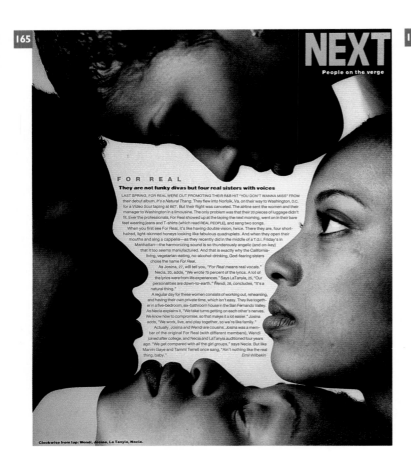

# NEXT
People on the verge

## FOR REAL
**They are not funky divas but four real sisters with voices**

LAST SPRING, FOR REAL WERE OUT PROMOTING THEIR R&B HIT "YOU DON'T WANNA MISS" FROM their debut album, *It's a Natural Thang*. They flew into Norfolk, Va. on their way to Washington, D.C. for a *Video Soul* taping at BET. But their flight was canceled. The airline sent the women and their manager to Washington in a limousine. The only problem was that their 20 pieces of luggage didn't fit. Ever the professionals, For Real showed up at the taping the next morning, went on in their bare feet wearing jeans and T-shirts (which read REAL PEOPLE), and sang two songs.

When you first see For Real, it's like having double vision, twice. There they are, four short-haired, light-skinned honeys looking like fabulous quadruplets. And when they open their mouths and sing a cappella—as they recently did in the middle of a T.G.I. Friday's in Manhattan—the harmonizing sound is so thunderously angelic (and on-key) that it too seems manufactured. And that is exactly why the California-living, vegetarian-eating, no-alcohol-drinking, God-fearing sisters chose the name For Real.

As Josina, 27, will tell you, "*For Real* means real vocals." Necia, 20, adds, "We wrote 75 percent of the lyrics. A lot of the lyrics were from life experiences." Says LaTanya, 25, "Our personalities are down-to-earth." Wendi, 28, concludes, "It's a natural thing."

A regular day for these women consists of working out, rehearsing, and having their own private time, which isn't easy. They live together in a five-bedroom, six-bathroom house in the San Fernando Valley. As Necia explains it, "We take turns getting on each other's nerves. We know how to compromise, so that makes it a lot easier." Josina adds, "We work, live, and play together, so we're like family."

Actually, Josina and Wendi are cousins. Josina was a member of the original For Real (with different members), Wendi joined after college, and Necia and LaTanya auditioned four years ago. "We get compared with all the girl groups," says Necia. But like Marvin Gaye and Tammi Terrell once sang, "Ain't nothing like the real thing, baby."
*Emil Wilbekin*

Clockwise from top: Wendi, Josina, La Tanyia, Necia.

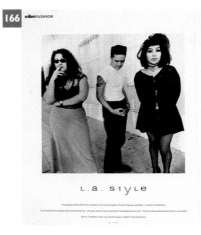

l.a. style

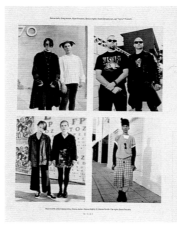

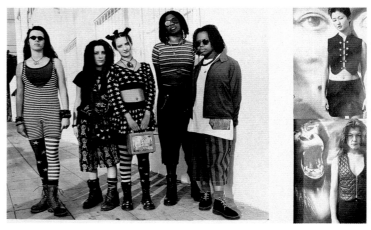

---

**165**

**Publication** Vibe
**Art Director** Diddo Ramm
**Designer** Ellen Fanning
**Photographer** Ben Ingham
**Photo Editor** George Pitts
**Publisher** Time Inc. Ventures
**Date** August 1994
**Category** Single Page

**166**

**Publication** Vibe
**Art Director** Diddo Ramm
**Designer** Ellen Fanning
**Photographer** Mary Ellen Mark
**Photo Editor** George Pitts
**Publisher** Time Inc. Ventures
**Date** August 1994
**Category** Story

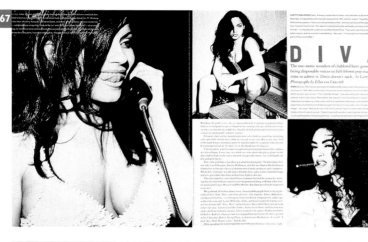

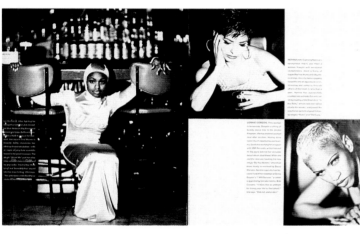

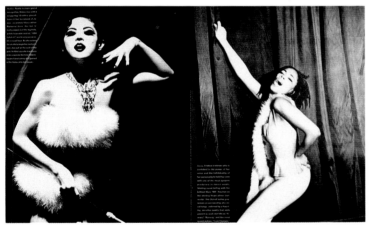

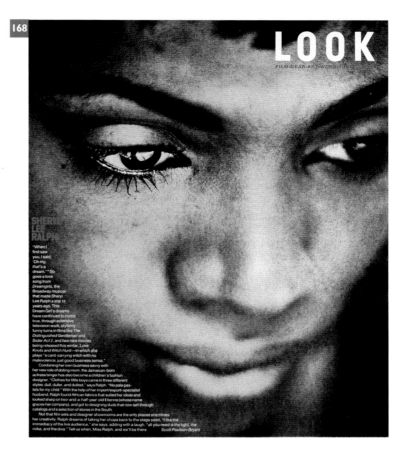

167

**Publication** Vibe
**Creative Director** Gary Koepke
**Art Director** Diddo Ramm
**Designer** Ellen Fanning
**Photographer** Ellen Von Unwerth
**Photo Editor** George Pitts
**Publisher** Time Inc. Ventures
**Date** March 1994
**Category** Story

168

**Publication** Vibe
**Art Director** Diddo Ramm
**Designer** Ellen Fanning
**Photographer** Phillip Dixon
**Photo Editor** George Pitts
**Publisher** Time Inc. Ventures
**Date** December 1994/January 1995
**Category** Single Page

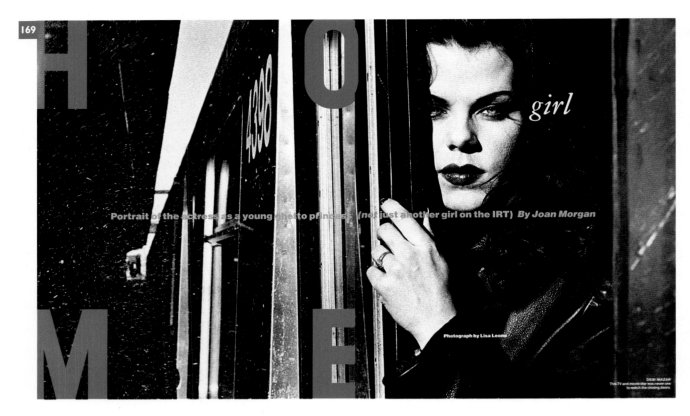

169

HOME girl

Portrait of the actress as a young ghetto princess (not just another girl on the IRT) *By Joan Morgan*

Photograph by Lisa Leone

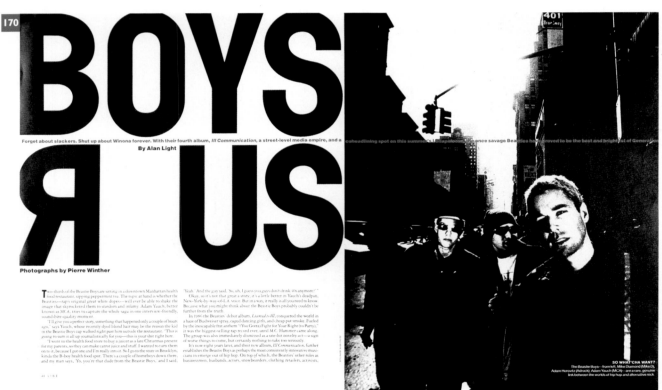

170

BOYS R US

Forget about slackers. Shut up about Winona forever. With their fourth album, *Ill Communication*, a street-level media empire, and a coheadlining spot on this summer's Lollapalooza, the once savage Beasties have proved to be the best and brightest of Generation
*By Alan Light*

Photographs by Pierre Winther

SO WHATCHA WANT?
The Beastie Boys—from left, Mike Diamond (Mike D), Adam Horovitz (Adrock), Adam Yauch (MCA)—are a rare, genuine link between the worlds of hip-hop and alternative rock.

---

169

**Publication** Vibe
**Creative Director** Gary Koepke
**Art Director** Diddo Ramm
**Designer** Ellen Fanning
**Photographer** Lisa Leone
**Photo Editor** George Pitts
**Publisher** Time Inc. Ventures
**Date** May 1994
**Category** Spread

170

**Publication** Vibe
**Creative Director** Gary Koepke
**Art Director** Diddo Ramm
**Designer** Ellen Fanning
**Photographer** Pierre Winther
**Photo Editor** George Pitts
**Publisher** Time Inc. Ventures
**Date** May 1994
**Category** Spread

# 171
## EXTRA LARGE

*While Seventh Avenue scrambles to keep up with street style, fashion designer Karl Kani is bringing his ghetto reality to the masses and building an empire. Scott Poulson-Bryant discovers how big jeans and big ideas are creating big business. Photographs by Everard Williams Jr.*

# 172

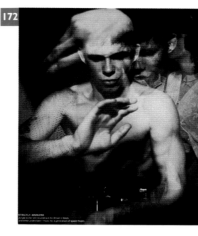

# GANG STA RA VE

*Fusing techno and hip hop, London's Jungle scene is stark, raving, and mad.*
by Simon Reynolds

He's a brother with a mission: "I have a nation to dress," Kani says. "That's my job, and I'm on it every day. I want to uplift black peop

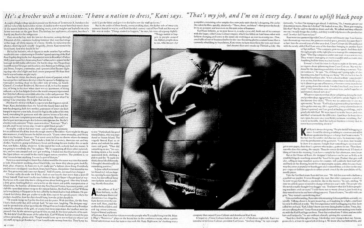

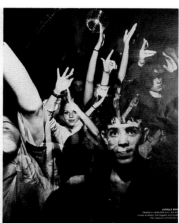

## TECHNO FINDS A FACE

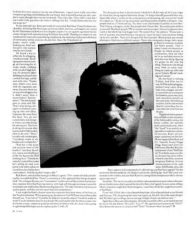

**171**

**Publication** Vibe
**Creative Director** Gary Koepke
**Art Director** Diddo Ramm
**Designer** Ellen Fanning
**Photographer** Edward Williams Jr.
**Photo Editor** George Pitts
**Publisher** Time Inc. Ventures
**Date** October 1994
**Category** Story

**172**

**Publication** Vibe
**Creative Director** Gary Koepke
**Art Director** Diddo Ramm
**Designer** Ellen Fanning
**Photographer** Davies & Davies
**Photo Editor** George Pitts
**Publisher** Time Inc. Ventures
**Date** March 1994
**Category** Story

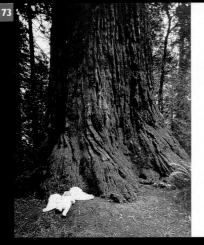

Logged or loved, the earth's
oldest, noblest trees may outlive
all our quarrels over them

# Redwoods Forever

*by PAUL BURKA · photographed by KAREN KUEHN*

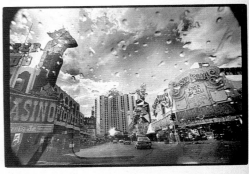

# Magic City

Las Vegas: world capital of illusion, where the
best sorcerers apprentice BY WILLIAM MURRAY

This is where redwoods attain dimensions that stun the senses...
higher than a 30-story building, heavier than the blue whale.

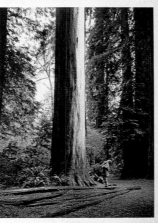

PHOTOGRAPHED BY Edward Gajdel

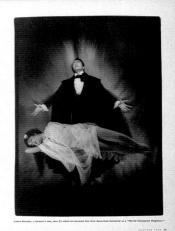

Regeneration is taking place on land denuded by logging, but it will
be centuries before the primeval splendor of the forest is restored.

### But How'd He Do That?

**173**

**Publication** Travel Holiday
**Art Director** Lou DiLorenzo
**Designer** Diane Bertolo
**Photographer** Karen Kuehn
**Photo Editor** Bill Black
**Date** April 1994
**Category** Story

**174**

**Publication** Travel Holiday
**Art Director** Lou DiLorenzo
**Designer** Lou DiLorenzo
**Photographer** Edward Gajdel
**Photo Editors** Bill Black, Stephanie Syrop
**Date** October 1994
**Category** Story

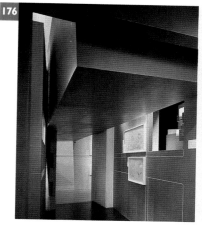
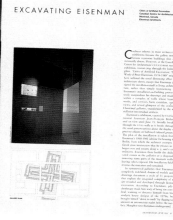

EXCAVATING EISENMAN

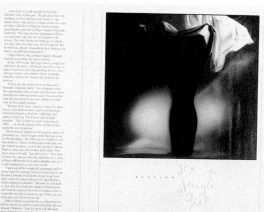

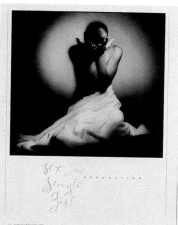

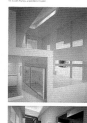

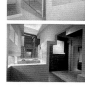

---

**175**

**Publication**  Clarity
**Creative Director**  Greg Breeding
**Designer**  Greg Breeding
**Illustrator**  Mark Allen
**Photographer**  Deborah Samuels
**Photo Editor**  Philip De Jong
**Publisher**  Journey Communications
**Date**  May/June 1994
**Category**  Story

**176**

**Publication**  Architecture Magazine/BPI
**Art Director**  Samuel G. Shelton
**Designers**  Neal T. Boulton, Robert J. Villaflor
**Photographers**  Michel Legendre, Jeff Goldberg
**Publisher**  KINETIK Communication Graphics, Inc.
**Date**  June 1994
**Category**  Story

1 The Pyramids, Giza

# New eyes on the Nile

Is there a sacred purpose behind the colossal monuments along the Nile? JOHN ANTHONY WEST thinks there is. With the help of vertiginous new photographs by MARILYN BRIDGES, he leads us on a magical mystery tour. Understand, he says, and the force is with you

MAPS by JOHN TOMANIO and GREGORY WAKABAYASHI

TRAVEL ADVISORY: The State Department reports that incidents of extremist violence are possible throughout Egypt, though there have been no specific threats against American citizens. Egypt's overall crime rate is low.

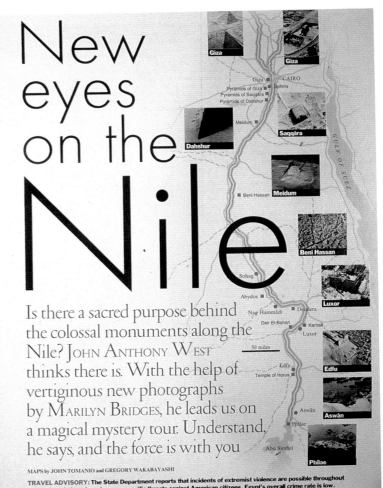

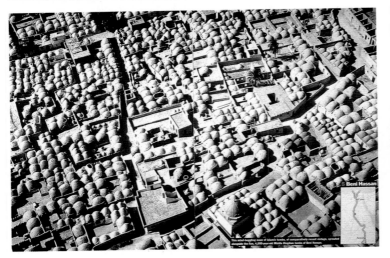

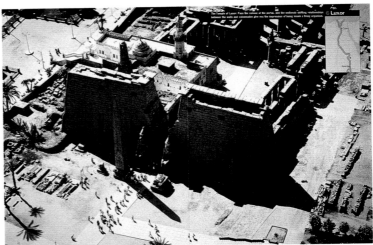

**177**

**Publication** Condé Nast Traveler
**Design Director** Diana LaGuardia
**Art Director** Christin Gangi
**Designer** Christin Gangi
**Photographer** Marilyn Bridges
**Photo Editor** Kathleen Klech
**Publisher** Condé Nast Publications Inc.
**Date** January 1994
**Category** Story

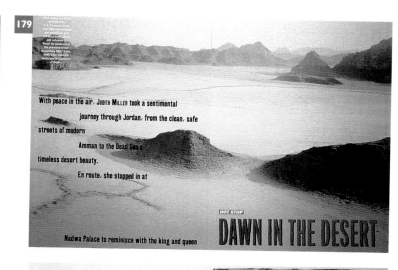

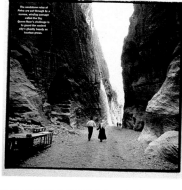

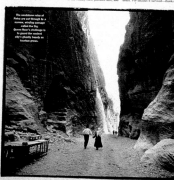

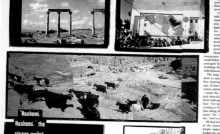

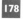

**178**

**Publication** Condé Nast Traveler
**Design Director** Diana LaGuardia
**Art Director** Christin Gangi
**Designer** Christin Gangi
**Photographer** Chip Simons
**Photo Editor** Kathleen Klech
**Publisher** Condé Nast Publications Inc.
**Date** November 1994
**Category** Story

**179**

**Publication** Condé Nast Traveler
**Design Director** Diana LaGuardia
**Art Director** Christin Gangi
**Designer** Christin Gangi
**Photographer** Annie Leibovitz
**Photo Editor** Kathleen Klech
**Publisher** Condé Nast Publications Inc.
**Date** October 1994
**Category** Story

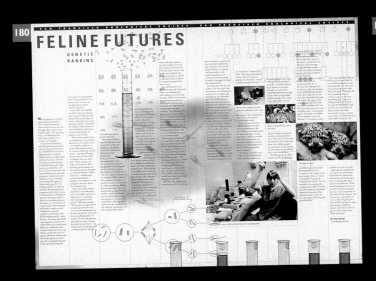

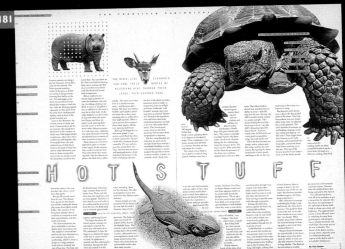

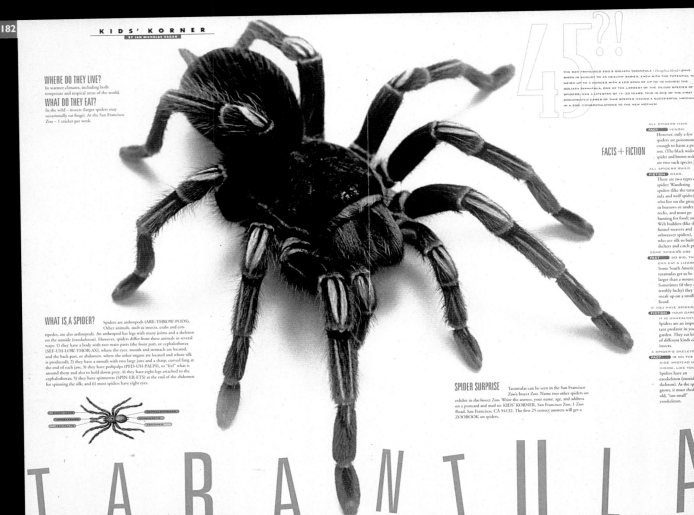

**180**

**Publication** Zoo Views
**Art Director** Melanie Doherty
**Designer** Joan Folkman
**Photographers** Steve Underwood, Phillip Pauliger, Rick Mann Shardt
**Studio** Melanie Doherty DSG.
**Date** May/June 1994
**Category** Spread

**181**

**Publication** Zoo Views
**Art Director** Melanie Doherty
**Designer** Joan Folkman
**Photographers** Steve Underwood, Phillip Pauliger, Rick Mann Shardt
**Studio** Melanie Doherty DSG.
**Date** July/August 1994
**Category** Spread

**182**

**Publication** Zoo Views
**Art Director** Melanie Doherty
**Designer** Joan Folkman
**Photographers** Steve Underwood, Phillip Pauliger, Rick Mann Shardt
**Studio** Melanie Doherty DSG.
**Date** November/December 1994
**Category** Spread

**183**

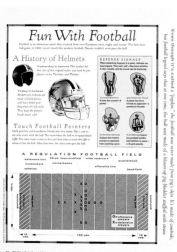

**184**

**183**

**Publication** Child
**Art Director** Richard Ferretti
**Designer** Janet Stein
**Illustrator** Peter Alsburg
**Photographer** Gary Denys
**Publisher** Gruner & Jahr
**Date** October 1994
**Category** Story

**184**

**Publication** Child
**Art Director** Richard Ferretti
**Designer** Richard Ferretti
**Photography** Dorling Kindersley
**Publisher** Gruner & Jahr
**Date** March 1994
**Category** Story

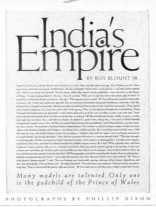

# India's Empire

BY ROY BLOUNT JR.

*Many models are talented. Only one is the godchild of the Prince of Wales.*

PHOTOGRAPHS BY PHILLIP DIXON

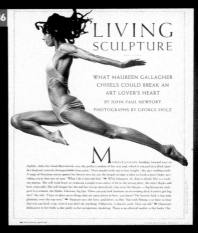
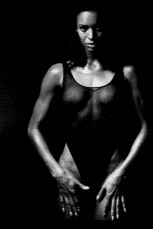

# LIVING SCULPTURE

WHAT MAUREEN GALLAGHER
CHISELS COULD BREAK AN
ART LOVER'S HEART

BY JOHN PAUL NEWPORT

PHOTOGRAPHS BY GEORGE HOLZ

INDIA'S EMPIRE
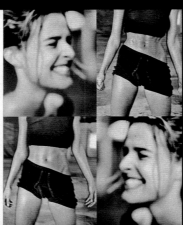

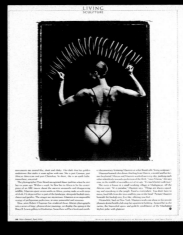
LIVING SCULPTURE
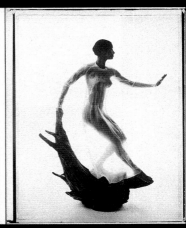

# Leaving THE Net

DOMINIK HASEK, THE BEST HOCKEY GOALIE IN THE WORLD, GOT
OUT OF CZECHOSLOVAKIA JUST FINE, BUT GETTING OUT OF
INDIANAPOLIS WAS ANOTHER STORY.    BY JAN NOVAK

F.

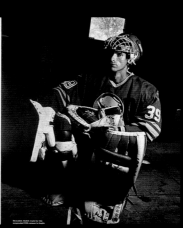

---

**185**

**Publication**  Men's Journal
**Art Director**  Mark Danzig
**Designer**  Mark Danzig
**Photographer**  Phillip Dixon
**Photo Editor**  Donna Bender
**Publisher**  Wenner Media
**Date**  May 1994
**Category**  Story

**186**

**Publication**  Men's Journal
**Art Director**  Mark Danzig
**Designer**  Mark Danzig
**Photographer**  George Holz
**Photo Editor**  Donna Bender
**Publisher**  Wenner Media
**Date**  April 1994
**Category**  Story

**187**

**Publication**  Men's Journal
**Art Director**  Mark Danzig
**Designer**  Mark Danzig
**Photographer**  Antonin Krotochvil
**Photo Editor**  Deborah Needleman
**Publisher**  Wenner Media
**Date**  December 1994
**Category**  Spread

COVER STORY

# Yellow FEVER

*Gold, the quintessential Asian gift,
has been reborn. Startling jewelry designs
and trendy, accessible boutiques are
capturing the imagination and cash of young
female employees, desperate to exude
the kind of chic that only money can buy*

WORDS BY VICTOR GEORGE PADDY
PHOTOGRAPHY BY JEAN-LOUIS WOLFF/LIGHT BRIGADE

ANDY CHUNG JUST COULDN'T make up her mind. Over and over again, the 28-year-old accounts clerk cradled the two gold bracelets in her hands, turned them over, gently fingered their 999 9-percent-pure-gold charms. A sea horse, an octopus and other cute water creatures dangled from the Seafood bracelet, a golden high-heeled shoe and a tiny, perfect perfume bottle set off the Fair Lady chain. Finally, her lunch hour nearly over, Chung turned to a stranger for advice. "Excuse me," she began, in the high, sweet voice of a child. "Which do you like?"

I pointed to Seafood, and that seemed to clarify things for the baby-faced woman with the caramel flares in her long, black hair. She thanked me,

Chain reaction: necklace and matching bracelet from Gold Master

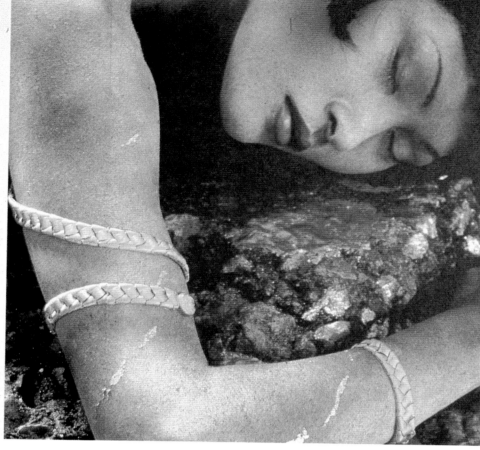

**Publication** Expression
**Art Director** Colleen McCudden
**Designer** Rina Poh
**Photographers** Jean-Louis Wolff, Light Brigade
**Photo Editor** Andrew Gun
**Publisher** M Design Company Ltd., Tokyo
**Date** December 1994/January 1995
**Category** Story

# all about suits

from collar to cuff, herringbone to houndstooth, we show you how to buy, how to wear and how to care for that most important element of your wardrobe, the business suit

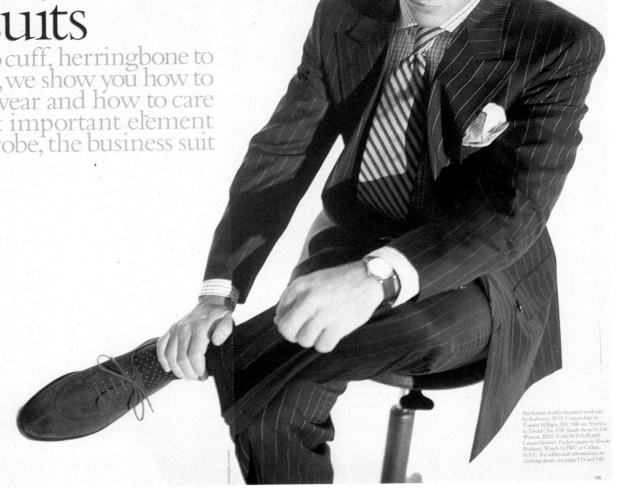

Believe it or not, to be considered well-dressed, you needn't go to the extremes of Charles Revson, the dandified founder of Revlon, who at one time had 200 custom-made suits in his wardrobe. It just isn't necessary to have so many (a five-day-a-week man will do fine with a half dozen seasonal suits) or to spend so much. In fact, thanks to ever-improving technology, a less-expensive suit today is of a better quality and will last longer than one from just a few years ago. But that doesn't mean you should scrimp.

We still recommend that you buy the most expensive suit you can afford this side of bankruptcy. Why? Pricier models generally have more hand-finishing—and as good as machines get, the hand is almost always the better tool. Plus, you'll soon forget the money you didn't save; the suit, though, will hang with you for years. Beyond that, heed this simple advice once offered to us by Gordon Cohen, a senior vice-president of Hart Schaffner & Marx: Pay attention to fit, durability, comfort (can you sit at your desk? get behind the wheel easily?) and the esoteric category of expression—you know, whether the suit says Wall Street or country gentleman or whatever, other image you want to convey.

Or to put it all another way, you've got to suit yourself. Which you'll be able to do in fine style after consulting these pages. —SCOTT OMELIANUK

Six-button double-breasted wool suit by Burberrys, $735. Cotton shirt by Tommy Hilfiger, $52. Silk tie, Nautica by David Chu, $38. Suede shoes by J.M. Weston, $500. Socks by Polo/Ralph Lauren Hosiery. Pocket square by Brooks Brothers. Watch by IWC at Cellini, N.Y.C. For additional information on clothing items, see pages 178 and 180.

## shapes

## pockets

## vents

## patterns

189

**Publication** GQ
**Art Director** Robert Priest
**Designer** Robert Priest
**Photographer** Francois Halard
**Photo Editor** Karen Frank
**Publisher** Condé Nast Publications Inc.
**Date** August 1994
**Category** Story

# HOW MANY SHOES DO YOU NEED?

If your jaw has just dropped to the tops of your scuffed wing tips,
these pages will show you how to look well-shod
instead of, well, shoddy

"FIRST," THE FASHION DOYEN NONPAREIL DIANA VREELAND ONCE SAID, "I'D PUT MONEY INTO SHOES. NO variety, just something I could wear with everything." She's right in her advice of course, but eventually a guy's got to want to branch out, even if he doesn't get Imelda Marcos–ian. After all, it would be absurd to barbecue one evening in the same balmorals you wore to that morning's business meeting, right?

Don't give us that look. A balmoral, and its relative, the blucher, are the two styles of business oxfords—oxfords being just about any shoes (save sneakers, boots and moccasins) that lace up. The former, named after the weekend retreat of Queen Victoria, has a closed throat (meaning the leather piece through which the laces pass is joined at the bottom in a V), as you'll see on the black wing tip when you turn the page. A blucher, named after a general who adopted the style, has an open throat, like the one on the shoe opposite. Of the two, the bal is slightly dressier. Got that?

Good, because now it's time to buy a pair—bringing us to the matter of fit and the fact that shoes usually don't...at least for most people who wear them. Why? Because so few understand that a shoe should fit at the ball of the foot, not the toe. The ball is where your foot bends. Likewise, the shoe bends at the widest part of the sole. If shoe and foot don't bend together, one on top of the other—ouch. That means that a shoe that fits properly at the ball can have more than a half-inch of leeway in the toe box. So stay away from the guy who presses on your toe to see if all's well. And try on a handful of pairs (both shoes, since one foot is usually larger than the other) to find the one that's most comfortable. You might also want to slip into a few pairs of shoes constructed on different lasts (the molds shoes are made around). Quality footwear, unlike Shoe-Town specials, can be constructed on either a high or a low last; a high last being better for someone with a high instep, a low last for a low instep. An additional fit tip: Get measured at about midday (your foot changes size throughout the day) and wear the same sort of sock you plan on wearing with what you're buying. In addition to a good fit, you'll want shoes that appear to be well-sewn (no gluing) with a leather lining and leather or rubber soles.

And that brings us to the point of this story: How many shoes should you own? There are as many answers to that question as holes in a wing tip. But if you can dress down one day at work, add a loafer to the black and the brown wing tip and the black cap toe you already have. If you're often in formalwear, you'll need a pump. And if it's hoops or hiking that occupies your off-hours, an activity-specific shoe is in order. As for the rest, well, you can't go wrong if you fill out the bottom of the closet with a selection from the following pages. —SCOTT OMELIANUK

**opposite page**
This cap-toed oxford with a punched medallion design—echoing the bows, buckles and crests that anointed men's footwear in previous eras—is as elegant as a shoe gets, whether for business or a night out. Shoes by Fratelli Rossetti.

164

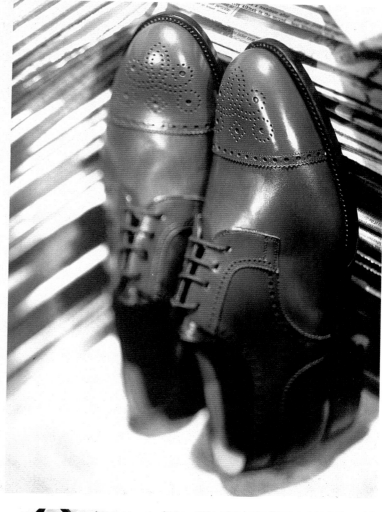

MARK WEISS

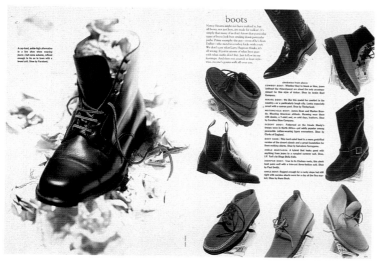

### boots

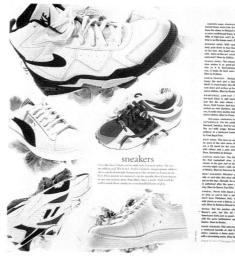

### sneakers

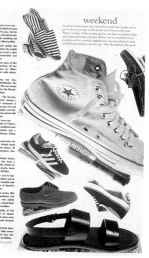

### weekend

---

190

**Publication** GQ
**Art Director** Robert Priest
**Designer** Laura Harrigan
**Photographer** Mark Weiss
**Photo Editor** Karen Frank
**Publisher** Condé Nast Publications Inc.
**Date** April 1994
**Category** Story

# So Fiennes

With the starring role in Quiz Show, Ralph Fiennes—rhymes with "shines"—has moved from Schindler's List to Hollywood's A-list

By Lucy Kaylin

Photographs by Gregory Heisler

# Reasonable Doubt

Of the ways Michael Jordan's daddy might have died late one summer night at the intersection of I-95 and US 74 in Robeson County, North Carolina, the least likely is that two boys, Daniel Green and Larry Demery, just walked up and shot him

By Scott Raab

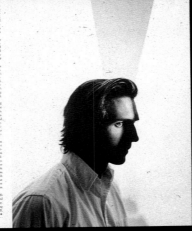

---

**191**

**Publication** GQ

**Art Director** Robert Priest

**Designer** Dina White

**Photographer** Gregory Heisler

**Photo Editor** Karen Frank

**Publisher** Condé Nast Publications Inc.

**Date** August 1994

**Category** Story

**192**

**Publication** GQ

**Art Director** Robert Priest

**Designer** Laura Harrigan

**Photographer** Mary Ellen Mark

**Photo Editor** Karen Frank

**Publisher** Condé Nast Publications Inc.

**Date** March 1994

**Category** Story

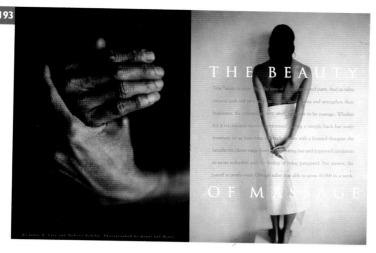

193

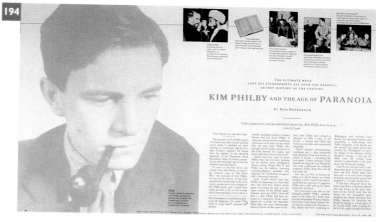

194

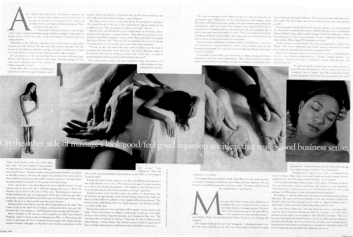

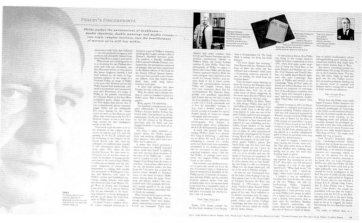

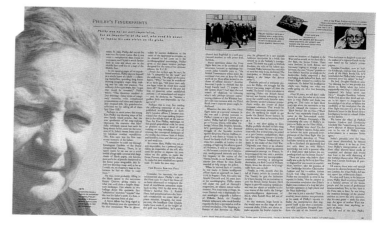

193

**Publication** Salon News
**Art Director** Jennifer Napier
**Designer** Jennifer Napier
**Photographer** Gentl & Hyers
**Publisher** Fairchild Publications
**Date** October 1994
**Category** Story

194

**Publication** The New York Times Magazine
**Art Director** Janet Froelich
**Designer** Petra Mercker
**Photographers** John Philby, Thomas Dobbie
**Photo Editor** Kathy Ryan
**Publisher** The New York Times
**Date** July 10, 1994
**Category** Story

# WAYNE LEVIN

Prepare to descend both below and beyond surfaces as you dive into the fantastic, undulating underwater realm of American photographer Wayne Levin. These images from his forthcoming book, *Through a Liquid Mirror*, capture a physical world rarely seen and entice emotions from the depths of our collective subconscious. Submerge yourself in this watery womb from which all life came, and reflect upon your feelings. You will not only discover another dimension of our planet, but of yourself as well.

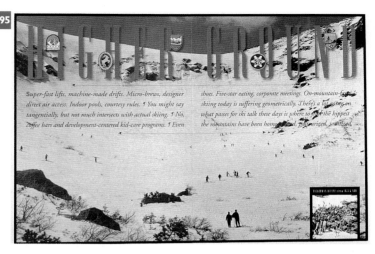

Super-fast lifts, machine-made drifts. Micro-brews, designer direct air access. Indoor pools, courtesy rules. ¶ You might say tangentially, but not much intersects with actual skiing. ¶ No, coffee bars and development-centered kid-care programs. ¶ Even shoes. Five-star eating, corporate meetings. On-mountain-for skiing today is suffering geometrically. There's a lot going on what passes for ski talk these days is where to find the hippest the mountains have been homogenized, pasteurized, sanitized.

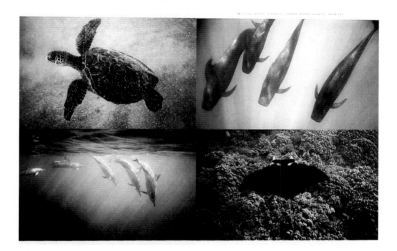

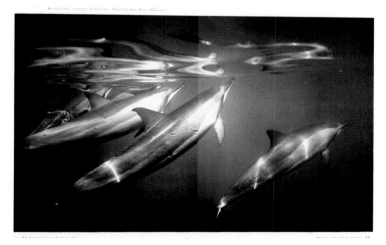

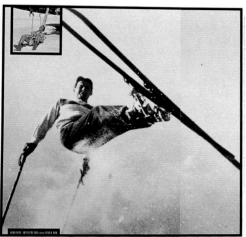

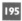

**194**

**Publication** Hemispheres
**Art Directors** Jaimey Easler, Greg Hausler
**Designer** Jaimey Easler
**Photographer** Wayne Levin
**Photo Editor** Aubrey Simpson
**Publisher** Pace Communications
**Date** March 1994
**Category** Story

**195**

**Publication** Hemispheres
**Art Directors** Jaimey Easler, Greg Hausler
**Designer** Jaimey Easler
**Photography** Aspen Historical Society, Tony Demin
**Photo Editor** Aubrey Simpson
**Publisher** Pace Communications
**Date** December 1994
**Category** Story

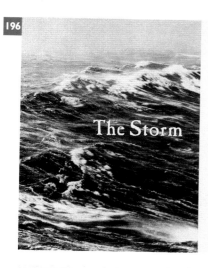

# The Storm

SIX YOUNG MEN SET OUT ON A DEAD-CALM SEA TO SEEK THEIR FORTUNES.
SUDDENLY THEY WERE HIT BY THE WORST GALE IN A CENTURY,
AND THERE WASN'T EVEN TIME TO SHOUT. By Sebastian Junger

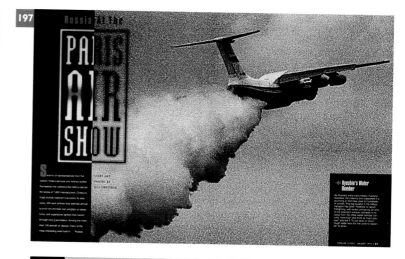

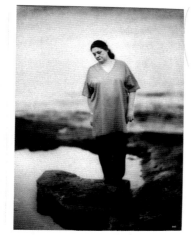

---

## 196

**Publication** Outside
**Art Director** Susan Casey
**Designer** Susan Casey
**Photographer** Raymond Meeks
**Photo Editor** Susan Smith
**Publisher** Mariah Media
**Date** October 1994
**Category** Story

## 197

**Publication** Popular Science
**Art Director** David Houser
**Designer** Thomas White
**Photographer** Bill Sweetman
**Publisher** Times Mirror Magazines
**Date** January 1994
**Category** Story

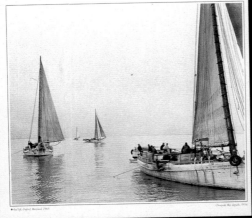

# O CHESAPEAKE

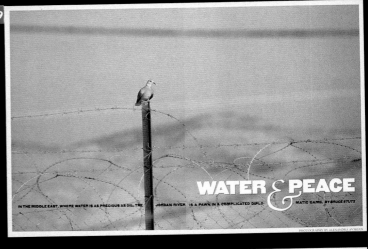

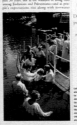
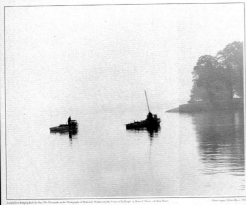
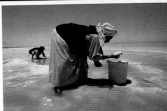
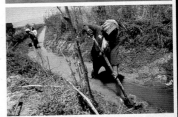

**198**

**Publication** Audubon
**Art Director** Suzanne Morin
**Photographer** Marion E. Warren
**Photo Editor** Peter Howe
**Publisher** National Audubon Society
**Date** September/October 1994
**Category** Story

**199**

**Publication** Audubon
**Art Director** Suzanne Morin
**Photographer** Alexandra Avakian
**Photo Editor** Peter Howe
**Publisher** National Audubon Society
**Date** September/October 1994
**Category** Story

108

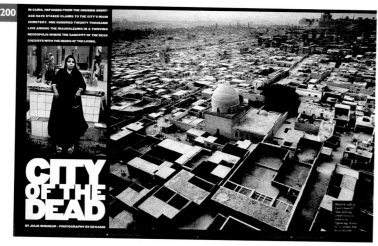

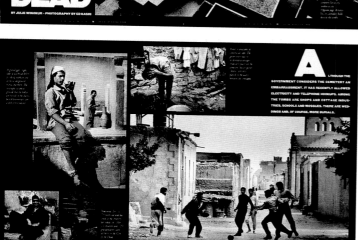

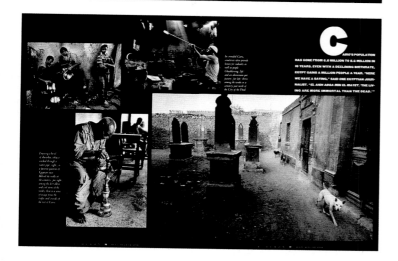

**200**

**Publication** Audubon
**Art Director** Suzanne Morin
**Designer** Suzanne Morin
**Photographer** Ed Kashi
**Photo Editor** Peter Howe
**Publisher** National Audubon Society
**Date** June/July 1994
**Category** Story

**201**

**Publication** Outside
**Art Director** Susan Casey
**Designers** Dean Abatemarco, Dave Allen, Dave Cox, Susan Casey
**Photographers** Darrell Jones, Jon Gipe, Macduff Everton, Marc Muench
**Photo Editors** Susan Smith, Emily Britton
**Publisher** Mariah Media
**Date** December 1994
**Category** Redesign

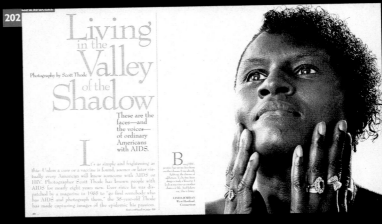

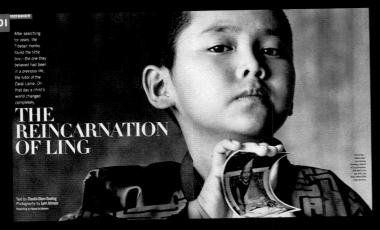

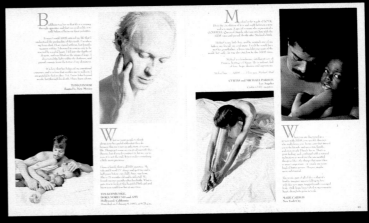

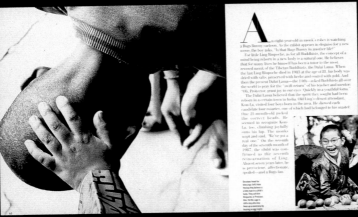

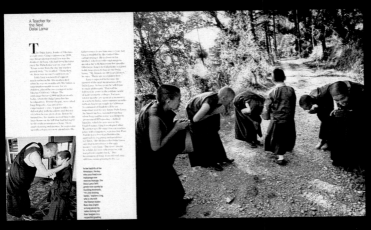

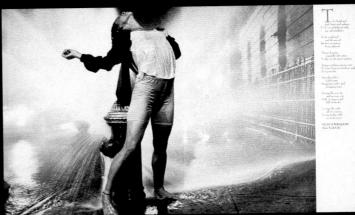

**201**

**Publication** Life
**Design Director** Tom Bentkowski
**Designer** Jean Andreuzzi
**Photographer** Lynn Johnson
**Photo Editor** Barbara Baker Burrows
**Publisher** Time Inc.
**Date** September 1994
**Category** Story

**202**

**Publication** Life
**Design Director** Tom Bentkowski
**Designer** Jean Andreuzzi
**Photographer** Scott Thode
**Photo Editor** David Friend
**Publisher** Time Inc.
**Date** February 1994
**Category** Story

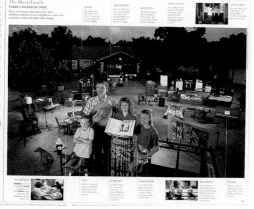
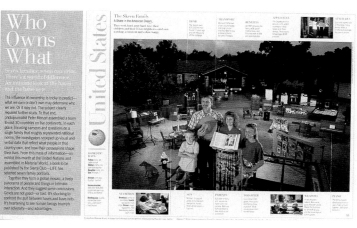

# A HOUSE FOR ALL AMERICA

FROM ONE OF AMERICA'S GREATEST ARCHITECTS: AN AFFORDABLE, ADAPTABLE HOME, WITH THE SPIRIT OF YESTERDAY MEETING THE NEEDS OF TOMORROW

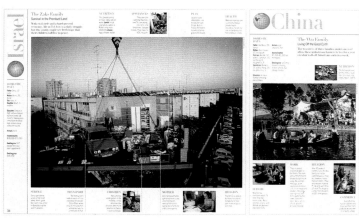

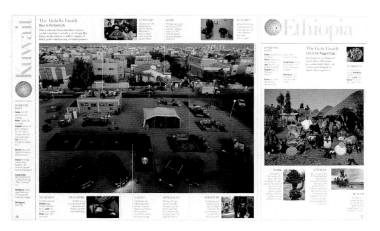

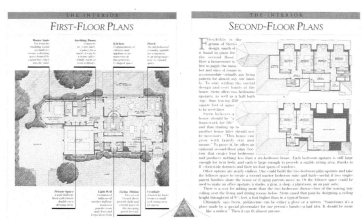

**203**

**Publication** Life
**Design Director** Tom Bentkowski
**Designer** Mimi Park
**Photographer** Peter Menzel
**Photo Editor** David Friend
**Publisher** Time Inc.
**Date** July 1994
**Category** Story

**204**

**Publication** Life
**Design Director** Tom Bentkowski
**Designer** Mimi Park
**Photo Editors** Heather White, Marie Schumann
**Publisher** Time Inc.
**Date** May 1994
**Category** Story

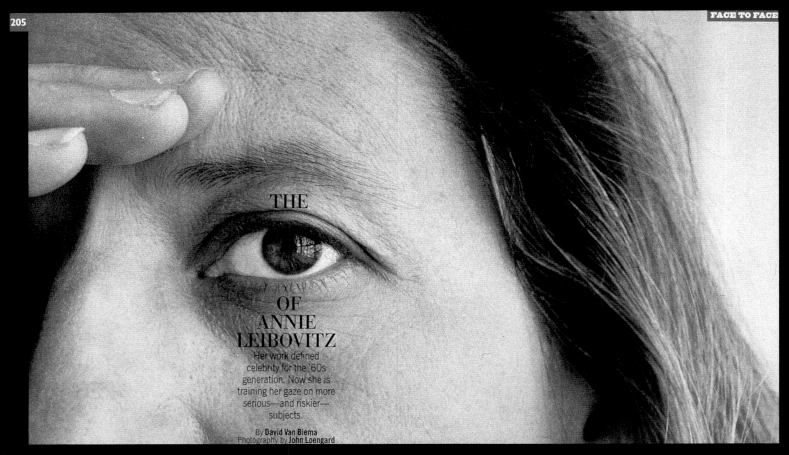

THE

OF
ANNIE
LEIBOVITZ

Her work defined
celebrity for the '60s
generation. Now she is
training her gaze on more
serious—and riskier—
subjects.

By David Van Biema
Photography by John Loengard

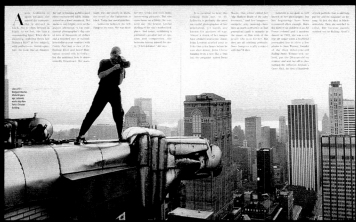

205

**Publication** Life
**Design Director** Tom Bentkowski
**Designer** Jean Andreuzzi
**Photographer** John Loengard
**Photo Editor** David Friend
**Publisher** Time Inc.
**Date** April 1994
**Categories** Spread
Story

# Yikes!

Photography by
**David Scharf**

Text by
**George Howe Colt**

IT HAS BEEN SAID that every creature on earth has a reason for being. Consider these electron-microscope photographs of live human parasites. To the ancient Greeks, who coined the word, *parasite* meant one who eats at another's table. Sounds downright neighborly until you consider that we're the hosts. We may be unwilling, even unwitting

*(continued on page 66)*

**STUBBORN SUCKER**
## LOUSE

When the poet Robert Burns addressed a passing louse as "Ye ugly, creepin', blastit wonner," he could have been describing any of 1,000 species, three of which feed on humans. The pinhead-size body louse *(left)* lives in clothing and moves to the wearer when hungry. The hair louse *(above)*, bane of schoolchildren, sets up camp on the scalp. The Schwarzeneggerian crab louse *(top)* clings to widely spaced hairs in the humid precincts it prefers. All three have claws that can hang on through the fiercest scratching and itching.

59

**MYOPIC SURGEON**
## MOSQUITO

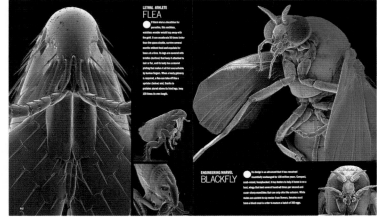

**LETHAL ATHLETE**
## FLEA

**ENGINEERING MARVEL**
## BLACKFLY

**Publication**  Life
**Design Director**  Tom Bentkowski
**Designer**  Mimi Park
**Photographer**  David Scharf
**Photo Editor**  Barbara Baker Burrows
**Publisher**  Time Inc.
**Date**  May 1994
**Categories**  Spread
　　　　　　　Story

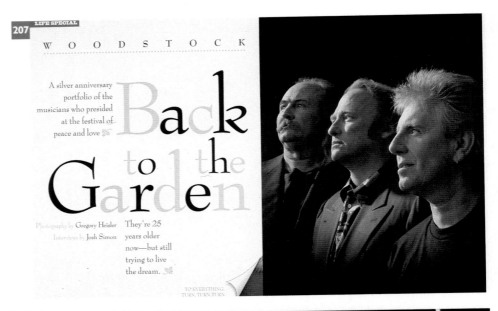

WOODSTOCK

A silver anniversary portfolio of the musicians who presided at the festival of peace and love

# Back to the Garden

Photography by Gregory Heisler
Interviews by Josh Simon

They're 25 years older now—but still trying to live the dream.

TO EVERYTHING, TURN, TURN, TURN

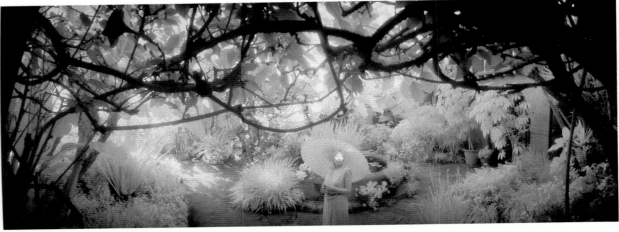

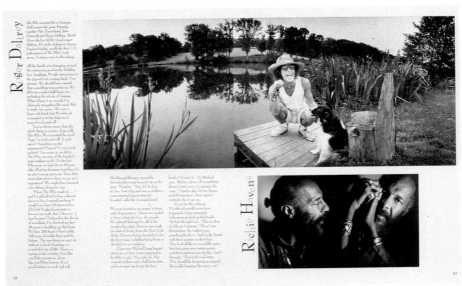

**207**

**Publication** Life
**Design Director** Tom Bentkowski
**Designer** Marti Golon
**Photographer** Gregory Heisler
**Photo Editor** David Friend
**Publisher** Time Inc.
**Date** August 1994
**Category** Story

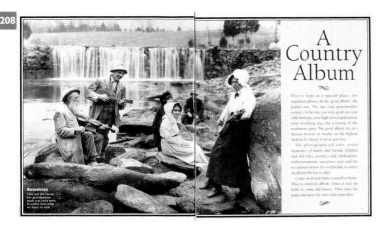

# A Country Album

They're kept in a special place, the important photos. In the "good album," the leather one. The one your grandmother owned. Or the one you were given on your 100th birthday, your high school graduation, your wedding day, the evening of the retirement party. The good album sits on a dresser drawer or maybe on the highest shelf in the library. It never gets lost.

The photographs tell tales, evoke memories of family and friends, children and old folks, journeys and celebrations, embarrassments, successes, joys and the occasional sorrow. It's worthwhile to reflect on all that life has to offer.

Come on in and make yourself at home. This is country's album. Open it and say hello to some old-timers. Then turn the pages and meet the ones who came after.

**Ancestors** They say the music our grandparents made was even more beautiful then when we listen to now.

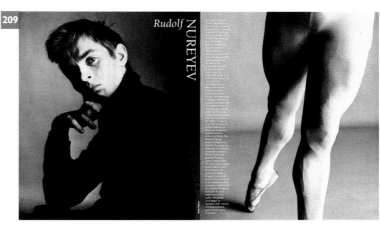

*Rudolf* NUREYEV

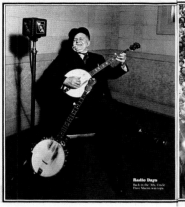

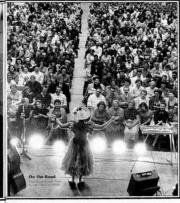

**Radio Days** Back in the '30s, Uncle Dave Macon was tops.

**On the Road**

*Pinky* LEE

*Spanky* McFARLAND

**Family Friends** At McSorley's in Manhattan in '43, that old folkie Woody Guthrie sure sounded country.

**Horsing Around** Gene Autry and Champion in an early publicity shot. Gene's wife, Ina Mae, played piano.

## 208

**Publication** Life
**Design Director** Tom Bentkowski
**Art Director** Marti Golon
**Photography** Bettman/INP, Les Leverett Collection, Yale Joel, Eric Schaal, Gene Bear Archives
**Photo Editor** Barbara Baker Burrows
**Publisher** Time Inc.
**Date** September 1994
**Category** Story

## 209

**Publication** Life
**Design Director** Tom Bentkowski
**Designer** Marti Golon
**Photographer** Irving Penn
**Photo Editor** Barbara Baker Burrows
**Publisher** Time Inc.
**Date** January 1994
**Category** Spread

## 210

**Publication** Life
**Design Director** Tom Bentkowski
**Designer** Marti Golon
**Photography** Archive Photos, Culver Pictures
**Photo Editor** Barbara Baker Burrows
**Publisher** Time Inc.
**Date** January 1994
**Category** Spread

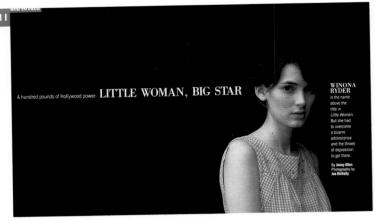

A hundred pounds of Hollywood power: **LITTLE WOMAN, BIG STAR**

**WINONA RYDER** is the name above the title in *Little Women*. But she had to overcome a bizarre adolescence and the throes of depression to get there.

By Jenny Allen
Photography by Joe McNally

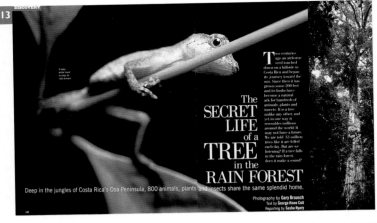

The **SECRET LIFE** of a **TREE** in the **RAIN FOREST**

Deep in the jungles of Costa Rica's Osa Peninsula, 800 animals, plants and insects share the same splendid home.

Photography by Gary Braasch
Text by George Howe Colt
Reporting by Sasha Nyary

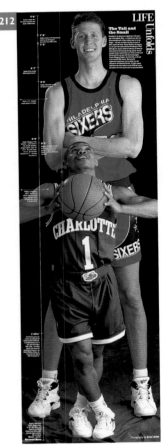

**The Tall and the Small**

LIFE Unfolds

Photography by Brian Lanker

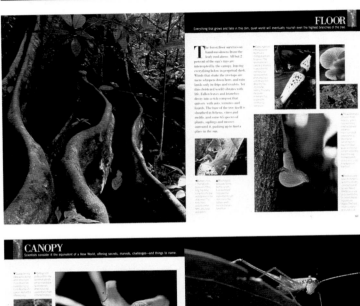

**211**

**Publication** Life
**Design Director** Tom Bentkowski
**Designer** Jean Andreuzzi
**Photographer** Joe McNally
**Photo Editor** Barbara Baker Burrows
**Publisher** Time Inc.
**Date** December 1994
**Category** Spread

**212**

**Publication** Life
**Design Director** Tom Bentkowski
**Designer** Mimi Park
**Photographer** Brian Lanker
**Photo Editor** Marie Schumann
**Publisher** Time Inc.
**Date** April 1994
**Category** Spread

**213**

**Publication** Life
**Design Director** Tom Bentkowski
**Designer** Mimi Park
**Photographer** Gary Braasch
**Photo Editor** Barbara Baker Burrows
**Publisher** Time Inc.
**Date** June 1994
**Category** Story

116

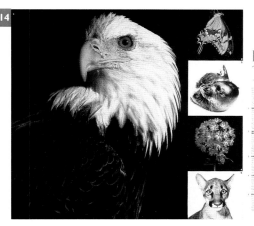

Can you imagine
a world without
panthers, plovers,
ferrets and
swamp pinks?

THE
ENDANGERED
100

LIFE
GOES
TO A
PARTY

1994: HOW AMERICANS CELEBRATE

BY CLAUDIA GLENN DOWLING
REPORTING BY HARRIET BARROVICK,
DAVID COHN CRAIG, MARNI CUTLER, SCOTT GUMMER,
STACI D. KRAMER, SASHA NYARY

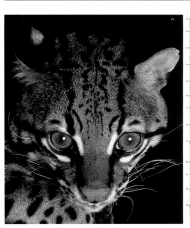
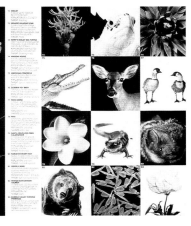

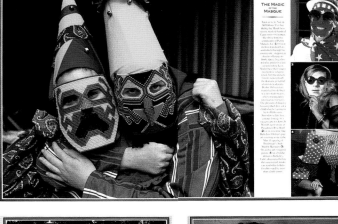

THE MAGIC
OF THE
MASQUE

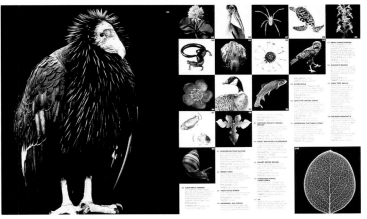
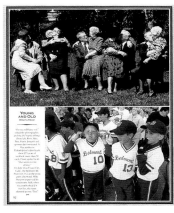
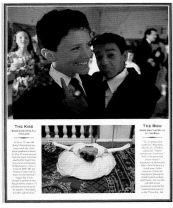

YOUNG
AND OLD

THE KISS

THE BOW

214

**Publication** Life
**Design Director** Tom Bentkowski
**Designer** Mimi Park
**Photographers** Susan Middleton, David Littshwager
**Photo Editor** David Friend
**Publisher** Time Inc.
**Date** September 1994
**Category** Story

215

**Publication** Life
**Design Director** Tom Bentkowski
**Designer** Marti Golon
**Photography** Dan Habib, Robert Yager, Rose Hartman,
Stephanie Rausser, John Chiasson, Sharon Wohlmuth,
William Mercer McLeod, William Snyder, Michael Melford
**Photo Editor** Barbara Baker Burrows
**Publisher** Time Inc.
**Date** November 1994
**Category** Story

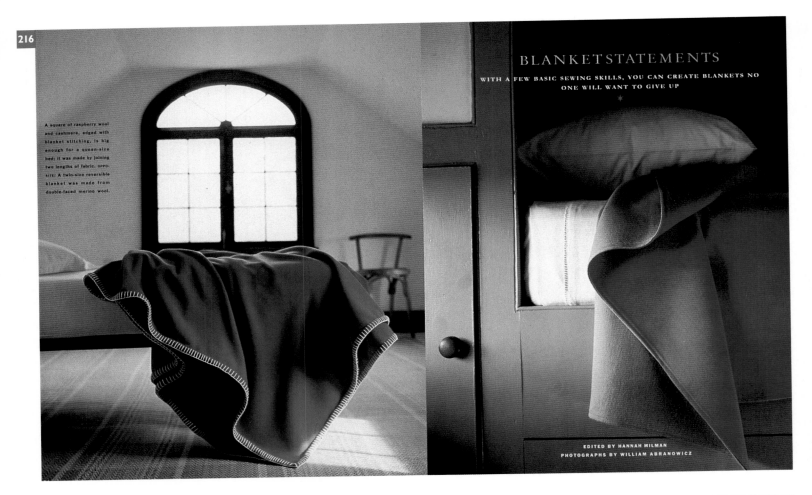

216

A square of raspberry wool and cashmere, edged with blanket stitching, is big enough for a queen-size bed; it was made by joining two lengths of fabric, crosswise; A twin-size reversible blanket was made from double-faced merino wool.

BLANKETSTATEMENTS
WITH A FEW BASIC SEWING SKILLS, YOU CAN CREATE BLANKETS NO ONE WILL WANT TO GIVE UP
*

EDITED BY HANNAH MILMAN
PHOTOGRAPHS BY WILLIAM ABRANOWICZ

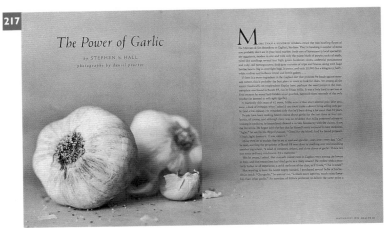

217

The Power of Garlic
BY STEPHEN S. HALL
photographs by daniel proctor

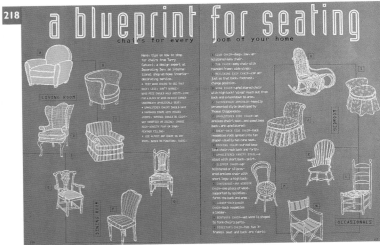

218

a blueprint for seating
chairs for every room of your home

216

**Publication**
Martha Stewart Living
**Art Director**  Gael Towey
**Designer**  Eric Pike
**Photographer**
William Abranowicz
**Photo Editor**  Heidi Posner
**Date**  February/March 1994
**Category**  Spread

217

**Publication**  Health
**Art Director**  Jane Palecek
**Designer**  Jane Palecek
**Photographer**  Daniel Proctor
**Publisher**  Time Publishing Ventures, Inc.
**Date**  July/August 1994
**Category**  Spread

218

**Publication**
Bride's & Your New Home
**Art Director**  Phyllis R. Cox
**Designer**  Robin Whitney
**Illustrator**  Pamela Kogen
**Publisher**  Condé Nast Publications Inc.
**Date**  December 1994
**Category**  Spread

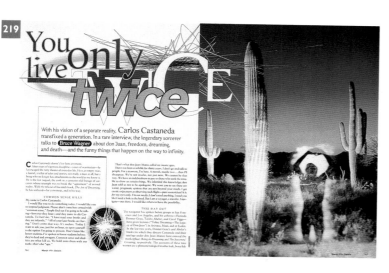

**219**

You only live twice

With his vision of a separate reality, Carlos Castaneda transfixed a generation. In a rare interview, the legendary sorcerer talks to Bruce Wagner about don Juan, freedom, dreaming, and death—and the funny things that happen on the way to infinity.

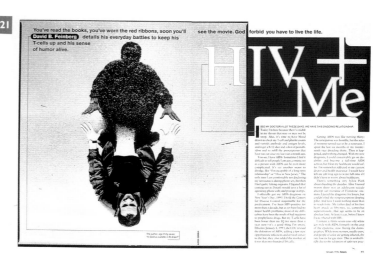

**221**

You've read the books, you've worn the red ribbons, soon you'll see the movie. God forbid you have to live the life. David B. Feinberg details his everyday battles to keep his T-cells up and his sense of humor alive.

HIV + Me

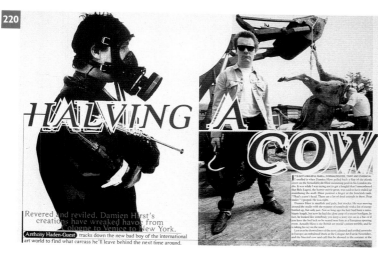

**220**

HALVING A COW

Revered and reviled, Damien Hirst's creations have wreaked havoc from Cologne to Venice to New York. Anthony Haden-Guest tracks down the new bad boy of the international art world to find what carcass he'll leave behind the next time around.

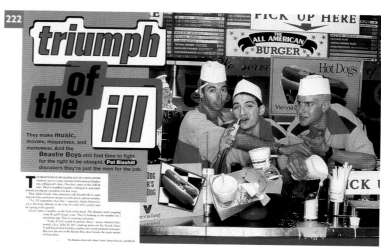

**222**

triumph of the ill

They make music, movies, magazines, and menswear. And the Beastie Boys still find time to fight for the right to be stoopid. Pat Blashill discovers they're just the men for the job.

---

**219**

**Publication** Details
**Art Director** Markus Kiersztan
**Designer** Petra Langhammer
**Photographer** Adam Weiss
**Photo Editor** Greg Pond
**Publisher** Condé Nast Publications Inc.
**Date** March 1994
**Category** Spread

**220**

**Publication** Details
**Art Director** Markus Kiersztan
**Designer** Lisa Steinmeyer
**Photographer** Nitin Vadukul
**Photo Editor** Greg Pond
**Publisher** Condé Nast Publications Inc.
**Date** April 1994
**Category** Spread

**221**

**Publication** Details
**Art Director** Markus Kiersztan
**Designer** Markus Kiersztan
**Photographer** Anton Corbijn
**Photo Editor** Greg Pond
**Publisher** Condé Nast Publications Inc.
**Date** January 1994
**Category** Spread

**222**

**Publication** Details
**Art Director** Markus Kiersztan
**Designer** David Warner
**Photographer** David LaChapelle
**Photo Editor** Greg Pond
**Publisher** Condé Nast Publications Inc.
**Date** June 1994
**Category** Spread

223

224

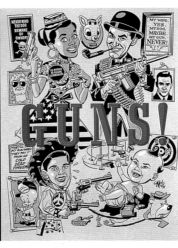

225

223

**Publication** Rough
**Art Director** Bryan L. Peterson
**Designer** Bryan L. Peterson
**Studio** Peterson & Co.
**Category** Spread

224

**Publication** American Way
**Art Director** Kyle D. Dreier
**Designer** Kyle D. Dreier
**Photographer** Frank Ockenfels 3
**Photo Editor** Marilyn Calley
**Publisher** American Airlines
Magazine Publications
**Date** March 15, 1994
**Category** Spread

225

**Publication** Spy
**Art Director** Alexander Knowlton
**Designers** Alexander Knowlton, Barbara Sullivan
**Illustrator** Mitch O'Connell
**Photographers** Michael Benabib, Richard Reyes,
H. Armstrong Roberts
**Photo Editor** Nicki Gostin
**Studio** Best Design, Incorporated
**Date** March 1994
**Category** Story

120

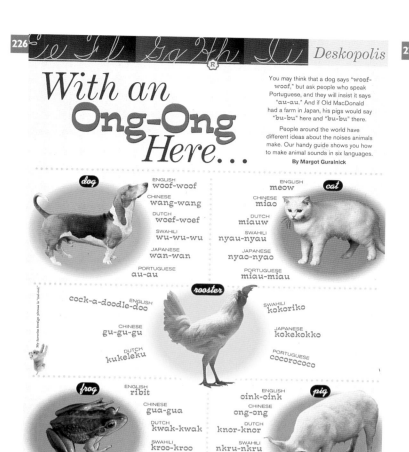

# With an Ong-Ong Here...

You may think that a dog says "woof-woof," but ask people who speak Portuguese, and they will insist it says "au-au." And if Old MacDonald had a farm in Japan, his pigs would say "bu-bu" here and "bu-bu" there.

People around the world have different ideas about the noises animals make. Our handy guide shows you how to make animal sounds in six languages.

By Margot Guralnick

**dog**
ENGLISH woof-woof
CHINESE wang-wang
DUTCH woef-woef
SWAHILI wu-wu-wu
JAPANESE wan-wan
PORTUGUESE au-au

**cat**
ENGLISH meow
CHINESE miao
DUTCH miauw
SWAHILI nyau-nyau
JAPANESE nyao-nyao
PORTUGUESE miau-miau

**rooster**
ENGLISH cock-a-doodle-doo
CHINESE gu-gu-gu
DUTCH kukeleku
SWAHILI kokoriko
JAPANESE kokekokko
PORTUGUESE cocorococo

**frog**
ENGLISH ribit
CHINESE gua-gua
DUTCH kwak-kwak
SWAHILI kroo-kroo
JAPANESE geko-geko
PORTUGUESE croác-croác-croác

**pig**
ENGLISH oink-oink
CHINESE ong-ong
DUTCH knor-knor
SWAHILI nkru-nkru
JAPANESE bu-bu
PORTUGUESE cron-cron

*Just like real life, this maze takes some wild twists and turns. Try it and see!*

Concept by Brad Herzog
Illustrations by Henrik Drescher

---

**226**

**Publication** Nickelodeon
**Design Director** Noel Claro
**Art Director** Alexa Mulvihill
**Designer** Daniel Carter
**Photo Editor** Ted Heller
**Publisher** MTV Networks
**Date** April/May 1994
**Category** Single Page

**227**

**Publication** Woodstock '94
**Design Director** Pegi Goodman
**Art Director** Jim Nicholas
**Designer** David R. Wolf
**Illustrator** Rob Winward
**Photographer** Rob Winward
**Publisher** Welsh Publishing Group Inc.
**Category** Spread

**228**

**Publication** Money Magazine For Kids
**Art Director** Don Morris
**Designers** Don Morris, James Reyman
**Illustrator** Henrik Drescher
**Publisher** Time Inc.
**Date** Fall 1994
**Category** Story

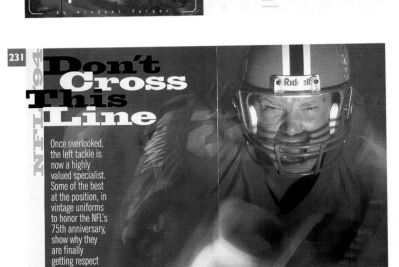

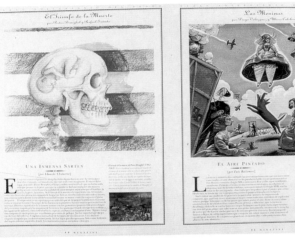

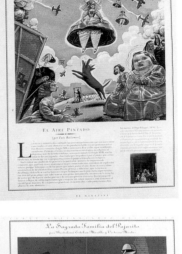

**229**

**Publication** El Mundo
**Design Director** Carmelo Caderot
**Art Director** Rodrigo Sanchez
**Designers** Rodrigo Sanchez, Miguel Buckenmeyer
**Illustrators** Ulises Culebro, Samuel Velasco,
Victoria Martos, Raul Arias, Rafael Sanudo
**Publisher** Unidad Editorial S.A.
**Category** Story

**230**

**Publication** Sports Illustrated
**Design Director** Steven Hoffman
**Designer** Craig Gartner
**Photo Editor** Heinz Kluetmeier
**Publisher** Time Inc.
**Date** December 23, 1994
**Category** Spread

**231**

**Publication** Sports Illustrated
**Design Director** Steven Hoffman
**Designer** Edward P. Truscio
**Photographer** Michael O'Neill
**Photo Editor** Heinz Kluetmeier
**Publisher** Time Inc.
**Date** September 5, 1994
**Category** Spread

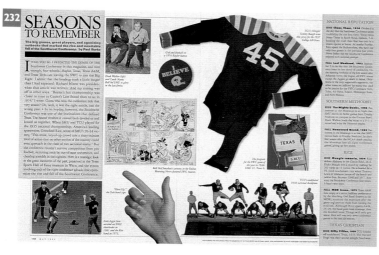

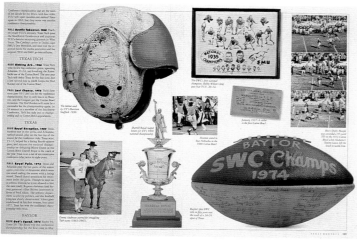

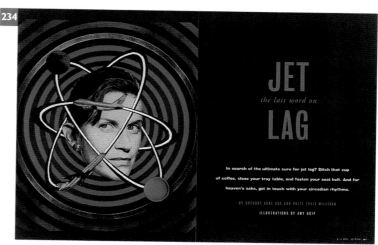

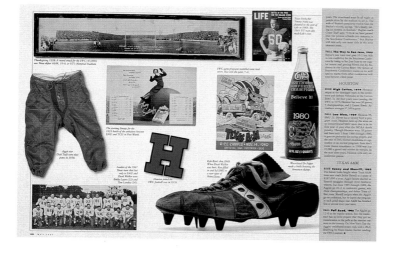

**232**

**Publication** Texas Monthly
**Art Director** D.J. Stout
**Designers** D.J. Stout, Nancy E. McMillen
**Photographer** Wyatt McSpadden
**Photo Editors** D.J. Stout, Nancy E. McMillen
**Publisher** Texas Monthly
**Date** May 1994
**Category** Story

**233**

**Publication** Surfing
**Art Director** Mike Salisbury
**Designer** Mike Salisbury
**Illustrator** Dan Georgopoulus
**Photographer** Jeff Hornbaker
**Photo Editor** Larry Moore
**Studio** Mike Salisbury Communications Inc.
**Category** Spread

**234**

**Publication** Selling
**Art Director** Teresa Fernandes
**Designer** Teresa Fernandes
**Illustrator** Amy Guip
**Publisher** Capital Cities/ABC Publishing, Inc.
**Date** June 1994
**Category** Spread

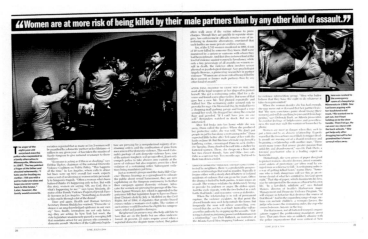

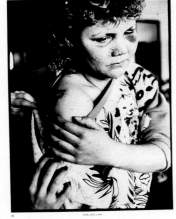

# A LOOK INTO HELL

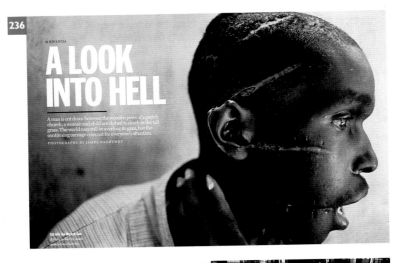

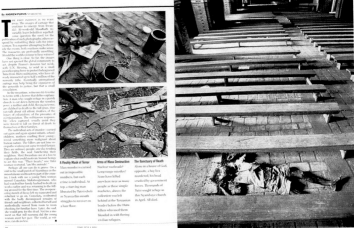

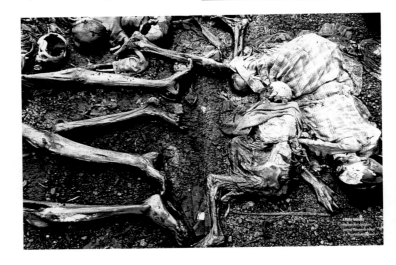

**Publication** Time
**Art Director** Arthur Hochstein
**Designer** Janet Waegel
**Photographer** Donna Ferrato
**Photo Editor** Michele Stephenson
**Publisher** Time Inc.
**Date** July 4, 1994
**Category** Story

**Publication** Time
**Art Director** Arthur Hochstein
**Designer** Jane Frey
**Photographer** James Nachtwey
**Photo Editor** Michele Stephenson
**Publisher** Time Inc.
**Date** July 4, 1994
**Category** Story

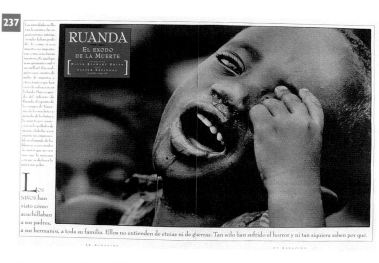

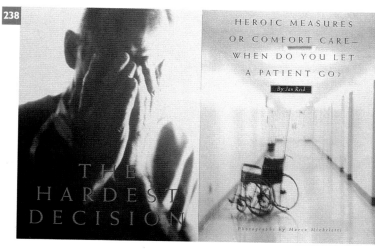

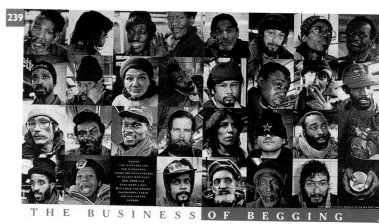

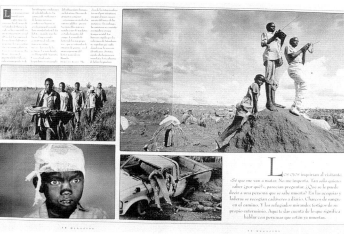

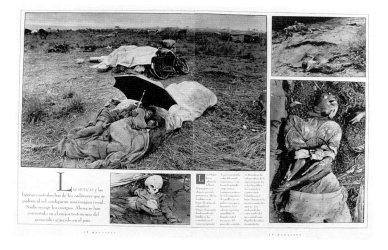

**237**

**Publication** El Mundo
**Design Director** Carmelo Caderot
**Art Director** Rodrigo Sanchez
**Designers** Rodrigo Sanchez, Miguel Buckenmeyer
**Photographer** David Stewart Smith
**Publisher** Unidad Editorial S.A.
**Category** Story

**238**

**Publication** Hippocrates
**Art Director** Jane Palecek
**Designer** Dorothy Marschall
**Photographer** Marco Micheletti
**Publisher** Time Publishing Ventures Inc.
**Date** May 1994
**Category** Spread

**239**

**Publication** The New York Times Magazine
**Art Director** Janet Froelich
**Designer** Petra Mercker
**Photographer** Donna Ferrato
**Photo Editor** Kathy Ryan
**Publisher** The New York Times
**Date** April 24, 1994
**Category** Spread

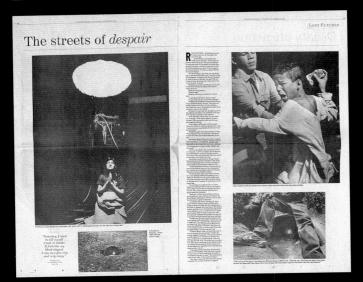

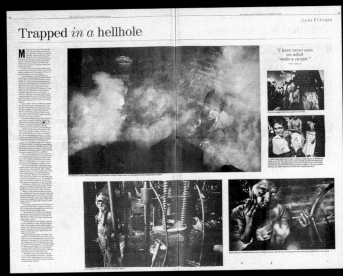

**240**

**Publication** The Boston Globe
**Art Director** Lucy Bartholomay
**Designer** Lucy Bartholomay
**Photographer** Stan Grossfeld
**Photo Editor** Lucy Bartholomay
**Publisher** The Boston Globe Publishing Co.
**Date** December 29, 1994
**Category** Story

**241**

**Publication** The Washington Times
**Art Director** Joseph W. Scopin
**Designer** Greg Groesch
**Illustrator** Alex Gonzalez
**Publisher** The Washington Times
**Date** June 6, 1994
**Category** Story

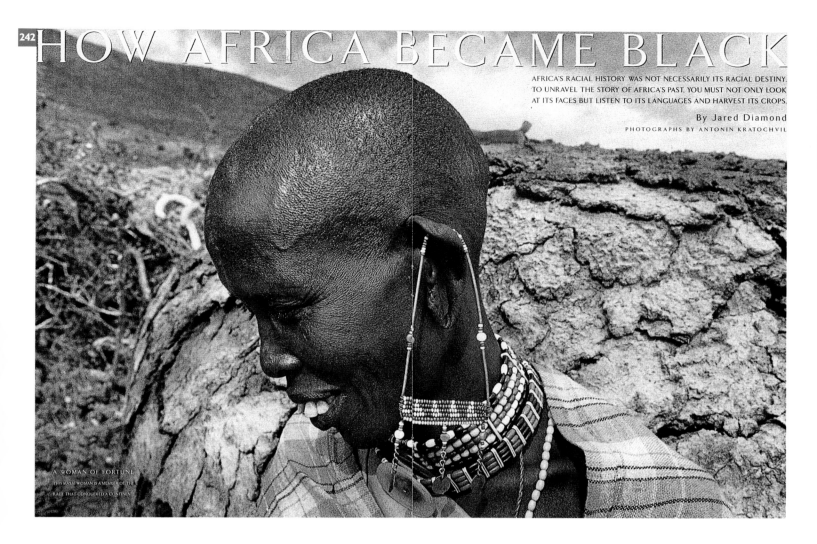

# HOW AFRICA BECAME BLACK

AFRICA'S RACIAL HISTORY WAS NOT NECESSARILY ITS RACIAL DESTINY.
TO UNRAVEL THE STORY OF AFRICA'S PAST, YOU MUST NOT ONLY LOOK
AT ITS FACES BUT LISTEN TO ITS LANGUAGES AND HARVEST ITS CROPS.

By Jared Diamond
PHOTOGRAPHS BY ANTONIN KRATOCHVIL

A WOMAN OF FORTUNE
THIS MASAI WOMAN IS A MEMBER OF THE
RACE THAT CONQUERED A CONTINENT.

243

**242**

**Publication** Discover
**Art Director** David Armario
**Designer** David Armario
**Photographer** Antonin Kratochvil
**Photo Editor** John Barker
**Publisher** Walt Disney Publishing
**Date** February 1994
**Category** Spread

**243**

**Publication** The New York Times
**Art Director** Jerelle Kraus
**Designer** Jerelle Kraus
**Illustrator** Hanoch Piven
**Publisher** The New York Times
**Date** May 14, 1994
**Category** Single Page

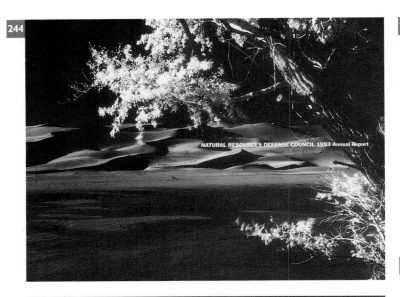

NATURAL RESOURCES DEFENSE COUNCIL 1993 Annual Report

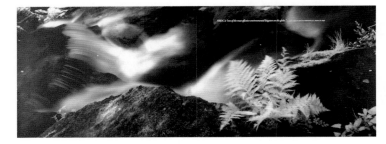

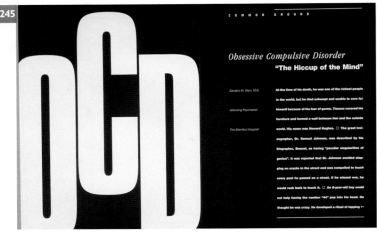

Obsessive Compulsive Disorder
"The Hiccup of the Mind"

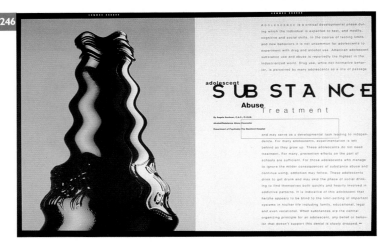

adolescent
SUBSTANCE
Abuse Treatment

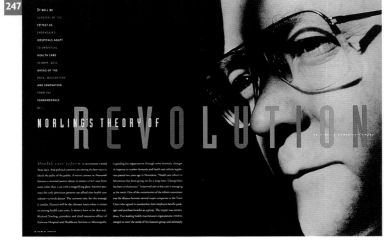

NORLING'S THEORY OF REVOLUTION

---

**244**

**Publication** Natural Resources
Defense Council 1993 Annual Report
**Art Director** Jurek Waidowicz
**Designers** Lisa LaRochelle,
Jurek Wajdowicz
**Photographer** Richard Elkins
**Studio** Emerson, Wajdowicz Studio, Inc.
**Category** Spread

**245**

**Publication**
Common Ground Newsletter
**Art Director** Scott Johnson
**Designer** Scott Johnson
**Studio** Scott Johnson Design
**Category** Spread

**246**

**Publication**
Common Ground Newsletter
**Art Director** Scott Johnson
**Designer** Scott Johnson
**Photographer** Stephen Pitkin
**Studio** Scott Johnson Design
**Category** Spread

**247**

**Publication**
Public Issues-MBIA Magazine
**Creative Director** David Barnett
**Photographer** Will Van Overbeck
**Studio** Barnett Group
**Date** Winter 1994
**Category** Spread

248

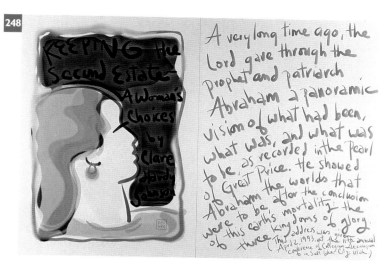

250

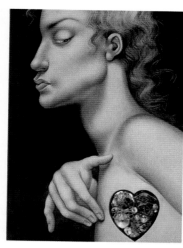

249

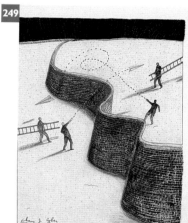

**POWERFUL PEACEMAKERS**

251

**MAKING WARHOL PAY**

By Vera Titunik

248

**Publication**
The Journal Of Collegium Aesculapium
**Art Director** Dung Hoang
**Designer** Dung Hoang
**Illustrator** Dung Hoang
**Studio** BYU Graphics
**Date** Spring 1994
**Category** Spread

249

**Publication** Quarterly
**Art Director** Mark Geer
**Designer** Mark Geer
**Illustrator** Alan E. Cober
**Studio** Geer Design, Inc.
**Category** Spread

250

**Publication** Stanford Medicine
**Art Director** David Armario
**Designer** David Armario
**Illustrator** Anita Kunz
**Client** Stanford Medicine
**Date** Summer 1994
**Category** Spread

251

**Publication** American Lawyer
**Art Director** Caroline Bowyer
**Designer** Caroline Bowyer
**Illustrator** David Pollard
**Photographer**
Timothy Greenfield-Sanders
**Photo Editor** Tracey Litt
**Publisher** American Lawyer Media LP
**Date** September 1994
**Category** Spread

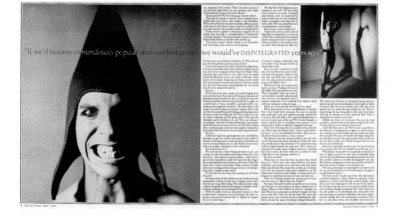

**251**

**Publication** Rolling Stone
**Art Director** Fred Woodward
**Designer** Fred Woodward
**Photographer** Herb Ritts
**Photo Editor** Jodi Peckman
**Publisher** Wenner Media
**Date** July 14-28, 1994
**Category** Spread

**252**

**Publication** Rolling Stone
**Art Director** Fred Woodward
**Designers** Fred Woodward, Geraldine Hessler
**Photographer** Matthew Rolston
**Photo Editor** Jodi Peckman
**Publisher** Wenner Media
**Date** April 7, 1994
**Category** Story

130

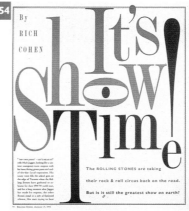

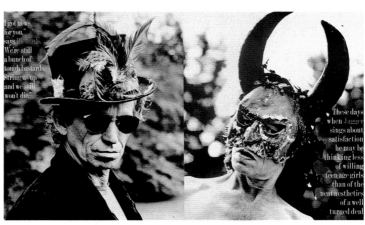

**253**

**Publication** Rolling Stone
**Art Director** Fred Woodward
**Designers** Fred Woodward, Gail Anderson
**Illustrator** Ralph Steadman
**Photo Editor** Jodi Peckman
**Publisher** Wenner Media
**Date** December 15, 1994
**Category** Story

**254**

**Publication** Rolling Stone
**Art Director** Fred Woodward
**Designers** Fred Woodward, Lee Bearson
**Photographer** Anton Corbijn
**Photo Editor** Jodi Peckman
**Publisher** Wenner Media
**Date** August 25, 1994
**Category** Story

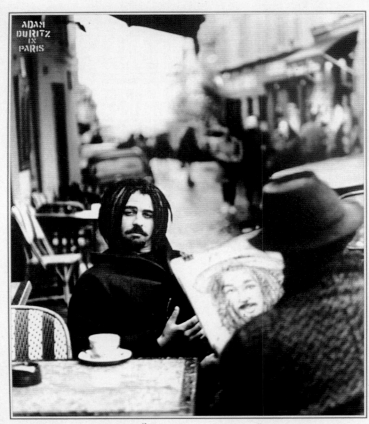

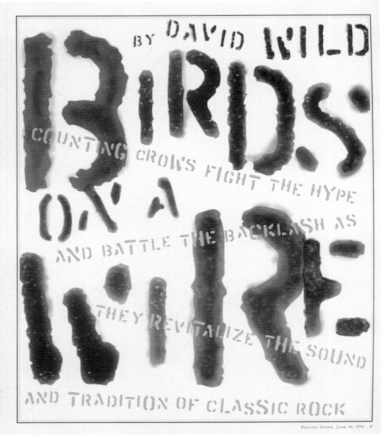

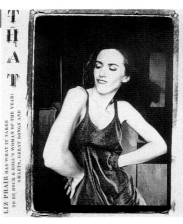

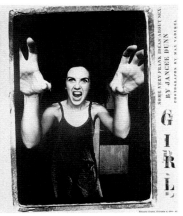

**255**

**Publication** Rolling Stone
**Art Director** Fred Woodward
**Designers** Fred Woodward, Gail Anderson
**Photographer** Mark Seliger
**Photo Editor** Jodi Peckman
**Publisher** Wenner Media
**Date** June 30, 1994
**Category** Spread

**256**

**Publication** Rolling Stone
**Art Director** Fred Woodward
**Designers** Fred Woodward, Gail Anderson
**Photographer** Anton Corbijn
**Photo Editor** Jodi Peckman
**Publisher** Wenner Media
**Date** September 8, 1994
**Category** Spread

**257**

**Publication** Rolling Stone
**Art Director** Fred Woodward
**Designers** Fred Woodward, Gail Anderson
**Photographer** Max Vadukul
**Photo Editor** Jodi Peckman
**Publisher** Wenner Media
**Date** October 6, 1994
**Category** Spread

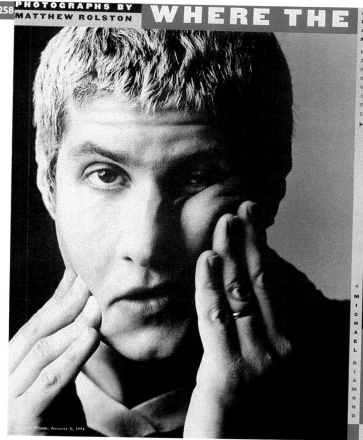

WHERE THE

ADAM HOROVITZ ▶

◀ MICHAEL DIAMOND

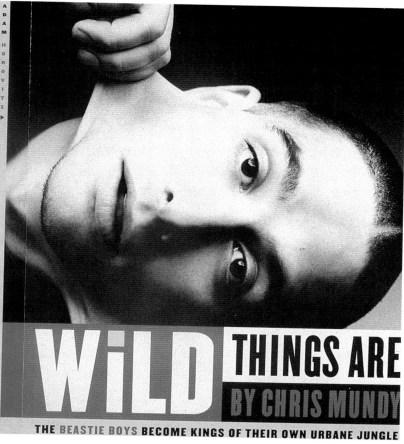

WiLD THINGS ARE

BY CHRIS MUNDY

THE BEASTIE BOYS BECOME KINGS OF THEIR OWN URBANE JUNGLE

"I THINK WE'RE CREATIVE," SAYS HOROVITZ. "BUT MASTER MINDS? NO."

258

**Publication** Rolling Stone
**Art Director** Fred Woodward
**Designers** Fred Woodward, Geraldine Hessler
**Photographer** Matthew Rolston
**Photo Editor** Jodi Peckman
**Publisher** Wenner Media
**Date** August 11, 1994
**Categories** Spread
　　　　　　　Story

133

**Publication** Ray Gun
**Art Director** David Carson
**Designer** David Carson
**Photographer** Peter Morello
**Studio** David Carson Design
**Date** August 1994
**Category** Spread

**Publication** Ray Gun
**Art Director** David Carson
**Designer** David Carson
**Photographer** Peter Morello
**Studio** David Carson Design
**Date** November 1994
**Category** Spread

**Publication** Ray Gun
**Art Director** David Carson
**Designer** David Carson
**Photographers** Steve Stickler,
Terry Richardson
**Studio** David Carson Design
**Date** August 1994

**Publication** Ray Gun
**Art Director** David Carson
**Designer** David Carson
**Photographer** Albert Watson
**Studio** David Carson Design
**Date** May 1994
**Category** Single Page

Get Your MOTOR Runnin. Head Out the Hi w a y

An independent bands typical tour vehicle is easily identifiable. Covered with bumper stickers, dust and finger-streaked 'wash me' signs on the outside, the van is almost always smelly and trash-strewn on the inside, where a veritable jigsaw puzzle of loaded equipment lies beneath a loft outfitted with a lumpy mattress. Some bands do things differently. Olympias Beat Happening used to criss-cross the US in a rental car, for example. While the rich and famous charter megabuses for comfort, most groups settle for creative solutions to beating the road blahs.

---

**263**

**Publication** Ray Gun
**Art Director** David Carson
**Designer** David Carson
**Photographer** Alan Messer
**Studio** David Carson Design
**Date** August 1994
**Category** Spread

**264**

**Publication** Ray Gun
**Art Director** David Carson
**Designer** David Carson
**Photographer** Doug Aitken
**Studio** David Carson Design
**Date** June/July 1994
**Category** Single Page

**265**

**Publication** Ray Gun
**Art Director** David Carson
**Designer** David Carson
**Studio** David Carson Design
**Date** June/July 1994
**Category** Spread

**266**

**Publication** Ray Gun
**Art Director** David Carson
**Designer** David Carson
**Photographer** David Carson
**Studio** David Carson Design
**Date** June/July 1994
**Category** Spread

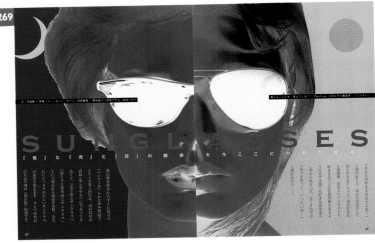

**267**

**Publication** Musician
**Creative Director**
Miriam Campiz
**Designer** Miriam Campiz
**Illustrator** Jennifer Jessee
**Photographer** David Jensen
**Photo Editor** Miriam Campiz
**Publisher** Billboard Publishing, Inc.
**Date** November 1994
**Category** Spread

**268**

**Publication** Private Clubs
**Art Director** Steve Connatser
**Designer** Steve Connatser
**Photographer** Gary McCoy
**Publisher** ACPI
**Date** July/August 1994
**Category** Spread

**269**

**Publication** Pacifica
**Design Director** Kunio Hayashi
**Designers** Kunio Hayashi,
Kevin Wilson
**Photographer** Vincent Huang
**Photo Editor** Kunio Hayashi
**Studio** Communication Design Corp.
**Client** Pacific Travelogue, Inc.
**Date** Summer 1994
**Category** Spread

**270**

**Publication** Guitar
**Designers** Stan Stanski,
Phil Varnall
**Photographer** Marty Temme
**Publisher** SMAY Vision
**Date** October 1994
**Category** Spread

136

# ILLUSTRATION

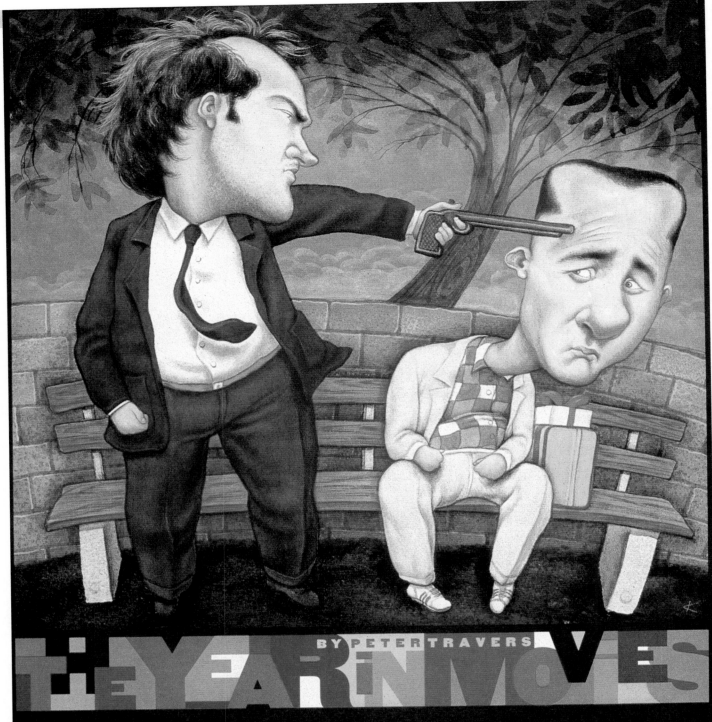

THE YEAR IN MOVIES

BY PETER TRAVERS

FUNNY THING HOW MOVIES CAN SCREW AROUND WITH YOUR HEAD. Characters from Quentin Tarantino's *Pulp Fiction* and Robert Zemeckis' *Forrest Gump* – the two polarizing hits of this dim-bulb year – have been mixing it up in my dreams. I keep seeing Tarantino threatening to get medieval on the ass of Tom Hanks' sweet simpleton if that sucker doesn't stop spouting holy-fool wisdom about how stupid is as stupid does. Is film violence getting to me? Hell, no! What's galling about *Gump* isn't the sentiment (the

LLUSTRATION BY ANITA KUNZ

ROLLING STONE, DECEMBER 29, 1994–JANUARY 12, 1995 · 193

271

**Publication** Rolling Stone
**Art Director** Fred Woodward
**Designer** Gail Anderson
**Illustrator** Anita Kunz
**Publisher** Wenner Media
**Date** December 29, 1994
**Category** Single Page

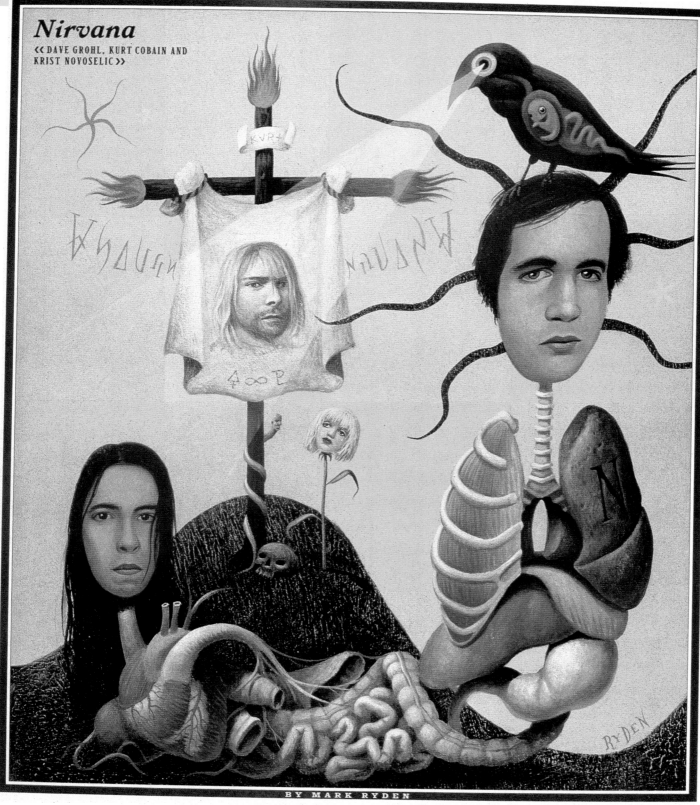

*Nirvana*
<< DAVE GROHL, KURT COBAIN AND
KRIST NOVOSELIC >>

BY MARK RYDEN

**272**

**Publication** Rolling Stone
**Art Director** Fred Woodward
**Designers** Fred Woodward, Gail Anderson,
Geraldine Hessler, Lee Bearson
**Illustrator** Mark Ryden
**Publisher** Wenner Media
**Date** November 17, 1994
**Category** Single Page

**273**

# HOW TO GIVE
# ORDERS
## LIKE A MAN

BY DEBORAH TANNEN

A UNIVERSITY PRESIDENT WAS EXPECTING A VISIT FROM a member of the board of trustees. When her secretary buzzed to tell her that the board member had arrived, she left her office and entered the reception area to greet him. Before ushering him into her office, she handed her secretary a sheet of paper and said: "I've just finished drafting this letter. Do you think you could type it right away? I'd like to get it out before lunch. And would you please do me a favor and hold all calls while I'm meeting with Mr. Smith?"

When they sat down behind the closed door of her office, Mr. Smith began by telling her that he thought she had spoken inappropriately to her secretary. "Don't forget," he said. "You're the president!"

Putting aside the question of the appropriateness of his admonishing the president on her way of speaking, it is revealing — and representative of many Americans' assumptions — that the indirect way in which the university president told her secretary what to do struck him as self-deprecating. He took it as evidence that she didn't think she had the right to make demands of her secretary. He probably thought he was giving her a needed pep talk, bolstering her self-confidence.

I challenge the assumption that talking in an indirect way necessarily reveals powerlessness, lack of self-confidence or anything else about the character of the speaker. Indirectness is a fundamental element in human communication. It is also one of the elements that varies most from one culture to another, and one that can cause confusion and misunderstanding when speakers have different habits with regard to using it. I also want to dispel the assumption that American women tend to be more indirect than American men. Women and men are both indirect, but in addition to differences associated with their backgrounds — regional, ethnic and class — they tend to be indirect in different situations and in different ways.

At work, we need to get others to do things, and we all have different ways of accomplishing this. Any individual's ways will vary depending on who is being addressed — a boss, a peer or a subordinate. At one extreme are bald commands. At the other are requests so indirect that they don't sound like requests at all, but are just a statement of need or a description of a situation. People with direct styles of asking others to do things perceive indirect requests — if they perceive them as requests at all — as manipulative. But this is often just a way of blaming others for our discomfort with their styles.

*Deborah Tannen is University Professor of Linguistics at Georgetown University. This article is adapted from "Talking From 9 to 5," due in October from William Morrow. Copyright © 1994 by Deborah Tannen.*

The indirect style is no more manipulative than making a telephone call, asking "Is Rachel there?" and expecting whoever answers the phone to put Rachel on. Only a child is likely to answer "Yes" and continue holding the phone — not out of orneriness but because of inexperience with the conventional meaning of the question. (A mischievous adult might do it to tease.) Those who feel that indirect orders are illogical or manipulative do not recognize the conventional nature of indirect requests.

Issuing orders indirectly can be the prerogative of those in power. Imagine, for example, a master who says "It's cold in here" and expects a servant to make a move to close a window, while a servant who says the same thing is not likely to see his employer rise to correct the situation and make him more comfortable. Indeed, a Frenchman raised in Brittany tells me that his family never gave bald commands to their servants but always communicated orders in indirect and highly polite ways. This pattern renders less surprising the finding of David Bellinger and Jean Berko Gleason that fathers' speech to their young children had a higher incidence than mothers' of both direct imperatives like "Turn the bolt with the wrench" and indirect orders like "The wheel is going to fall off."

The use of indirectness can hardly be understood without the cross-cultural perspective. Many Americans find it self-evident that directness is logical and aligned with power while indirectness is akin to dishonesty and reflects subservience. But for speakers raised in most of the world's cultures, varieties of indirectness are the norm in communication. This is the pattern found by a Japanese sociolinguist, Kunihiko Harada, in his analysis of a conversation he recorded between a Japanese boss and a subordinate.

The markers of superior status were clear. One speaker was a Japanese man in his late 40's who managed the local branch of a Japanese private school in the United States. His conversational partner was a Japanese-American woman in her early 20's who worked at the school. By virtue of his job, his age and his native fluency in the language being taught, the man was in the superior position. Yet when he addressed the woman, he frequently used polite language and almost always used indirectness. For example, he had tried and failed to find a photography store that would make a black-and-white print from a color negative for a brochure they were producing. He let her know that he wanted her to take over the task by stating the situation and allowed her to volunteer to do it: (This is a translation of the Japanese conversation.)

On this matter, that, that, on the leaflet? This photo, I'm thinking of changing it to black-and-white and making it clearer. . . . I went to a photo shop and asked them. They said they didn't do black-and-white. I asked if

> Directness is not necessarily logical or effective. Indirectness is not necessarily manipulative or insecure.

Illustrations by Gary Baseman

46

BASE MAN

**274**

**polo is my life by hun**

Fear and Loathing in Horse Country

illustrations by ralph steadman

Queer for Power, Slave to Speed... Adventures in the Pony Business

"Arms, my only ornament — my only rest, the fight."
—Cervantes, DON QUIXOTE

**I**

Whooping It Up With the Horse People: Trapped in a World of Beasts...The Genius of Genghis Khan and the Beauty of Sweet Belinda...On Fire With the Polo Fever...
Polo meant nothing to me when I was young. It was just another sport for the idle rich — golf on horseback — and on most days I had better things to do than hang around in a flimsy blue-striped tent on a soggy field far out on the River Road and drink gin with teen-age girls. But

*ROLLING STONE, DECEMBER 15, 1994 · 45*

**273**

**Publication** The New York Times Magazine
**Art Director** Janet Froelich
**Designer** Nancy Harris
**Illustrator** Gary Baseman
**Publisher** The New York Times
**Date** August 28, 1994
**Category** Spread

**274**

**Publication** Rolling Stone
**Art Director** Fred Woodward
**Designers** Fred Woodward, Gail Anderson, Lee Bearson
**Illustrator** Ralph Steadman
**Publisher** Wenner Media
**Date** December 15, 1994
**Category** Spread

BY JAY MARTEL

On "The Larry Sanders Show,"
Garry Shandling turns the talk-show
brouhaha into the funniest thing on TV

*"These reporters come on to do a story about the show, it's not exciting enough for them, so they make this shit up." – Arthur to Larry on "THE LARRY SANDERS SHOW"*

>>> Ideally, the first sentence of an article about Garry Shandling would set a provocative scene – such as Shandling calling

TRUE LIES

his co-workers "fucking idiots" – before settling down to the more mundane details about the life of a self-referential comedian and sometime talk-show host, the same Garry Shandling who played a self-possessed comedian on the TV show *It's Garry Shandling's Show* and who now plays a self-

absorbed TV talk-show host on the TV show *The Larry Sanders Show*, the same 44-year-old television auteur who has managed to turn selfness into a new TV form, the *narcissitcom*, without being self-indulgent and is now taking his act to the movies. But now it's too late, >>>

66 · ROLLING STONE, SEPTEMBER 8, 1994

ILLUSTRATION BY ROBERT RISKO

Illustration SILVER

275

**Publication** Rolling Stone
**Art Director** Fred Woodward
**Designers** Fred Woodward, Gail Anderson
**Illustrator** Robert Risko
**Publisher** Wenner Media
**Date** August 8, 1994
**Category** Spread

# THE SNIFF OF LEGEND

BY KAREN WRIGHT

ILLUSTRATIONS BY RALPH STEADMAN

HUMAN PHEROMONES? CHEMICAL SEX ATTRACTANTS? AND A SIXTH SENSE ORGAN IN THE NOSE? WHAT ARE WE, ANIMALS?

**276**

**Publication** Discover
**Art Director** David Armario
**Designers** James Lambertus, David Armario
**Illustrator** Ralph Steadman
**Publisher** Walt Disney Publishing
**Date** April 1994
**Category** Story

**277**

**Publication** Stanford Medicine
**Art Director** David Armario
**Designer** David Armario
**Illustrator** Anita Kunz
**Client** Stanford Medicine
**Date** Summer 1994
**Category** Spread

**278**

**Publication** Entertainment Weekly
**Design Director** Robert Newman
**Art Directors** Jill Armus, Elizabeth Betts
**Designer** Joe Kimberling
**Illustrator** Sue Coe
**Publisher** Time Inc.
**Date** December 30, 1994
**Category** Spread

*mended
hearts
grow
up*

AS MANY OF THE FIRST INFANTS

TO HAVE THEIR CONGENITALLY BROKEN HEARTS

MENDED ARE NOW REACHING WELL

INTO ADULTHOOD, MEDICINE IS LEARNING

HOW TO HANDLE ITS OWN SUCCESS.

THE GROWN-UP PATIENTS

NEED ADVICE ON

ADULT ISSUES, BUT

FROM WHICH

PHYSICIANS?

AS YOUNG ADULTS OUTGROW THEIR pediatricians, they're usually not sorry to leave behind the office full of crying infants and toddling youngsters, coloring books and *Highlights for Children.* ■ But when Kristen Williams was 24, she was crushed to learn that the doctor who had cared for her since she was born, had retired. ■ "I said, 'Oh no, now what do I do?' because I was used to seeing the same person all my life," she recalls. ■ When Williams was born with a complicated heart defect, her doctors said she had a 1 percent chance of surviving. They discovered that the one-day-old, "blue baby" had a condition known as transposition of the great arteries: Her aorta and pulmonary artery were attached to the wrong chambers of her heart. This defect causes

*by laurel joyce*

*illustration by anita kunz*

SUMMER 1994  STANFORD MEDICINE

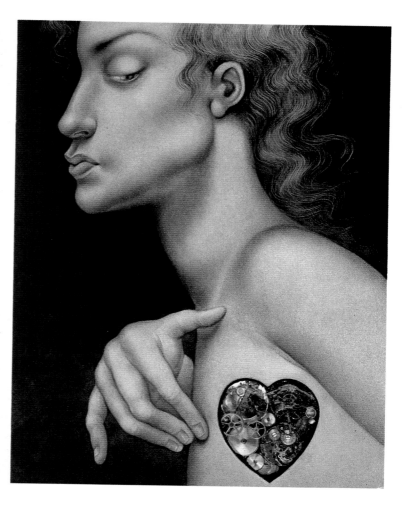

1994

THE BEST & WORST

# THE HALDEMAN DIARIES

**1** WHY WOULD THIS be the best CD-ROM of 1994 when other discs have slicker interfaces, neater effects, or more powerful interactivity? Because *The Haldeman Diaries: Inside the Nixon White House* (Sony Imagesoft, $69.95) gives you something you just can't get anywhere else: all 750,000 words of H.R. Haldeman's daily journal, kept while he was White House chief of staff during the Watergate era. The printed book has less than half that text and none of the 8 mm movies—the

disc has more than an hour's worth that Haldeman took of Nixon and others. This is great history and greater drama: a day-by-day account of the erosion of one man's and one nation's political faith.

**2** The Residents: Freak Show (*Voyager, $29.95*) A lot of pop stars came out with CD-ROMs in 1994 (see The Worst), but few discs matched the flat-out creativity of this creepy musical tour through an imaginary tent-show demimonde. Rock oddballs/eyeballs the Residents contribute characters, songs, and a general one-of-us philosophy, but it's designer Jim Ludtke who makes the lonely images stick to the back of your brain.

**3** Star Trek: The Next Generation Interactive Technical Manual (*Simon & Schuster Interactive, $69.95*) Even if

you're not a hard-breathing Trekkie, this disc is beguiling. Using a startling new software called QuickTime VR, *Manual* lets you dreamily whisk through the halls of the *Enterprise,* poking into drawers and closets and coming up with all sorts of nitty-gritty. There's a sneaky, underhanded thrill to the experience—like snooping through your friends' house while they're out buying groceries.

**4** Microsoft Complete NBA Basketball (*Microsoft, $29.95*) Maybe Bill Gates deserves to rule the known galaxy if he can keep coming up with CD-ROMs of this slam-dunk quality. Absolutely anything you would possibly want to know about professional basketball is here, in thumbnail, in depth, and (via an on-line component that lets you download the latest statistics) into the future.

B Y   T Y   B U R R

**multimedia**

ILLUSTRATION BY ZOE ZOE

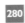

**279**

**Publication** Discover
**Art Director** David Armario
**Designer** David Armario
**Illustrator** Marshall Arisman
**Publisher** Walt Disney Publishing
**Date** March 1994
**Category** Story

**280**

**Publication** Garden Design
**Creative Director** Michael Grossman
**Art Director** Paul Roelofs
**Illustrator** Ross Macdonald
**Publisher** Meigher Communications
**Date** October/November 1994
**Category** Story

144

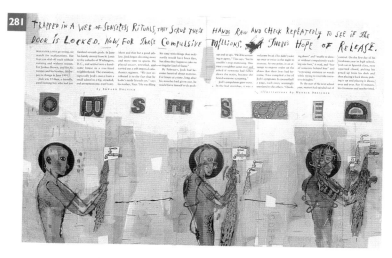

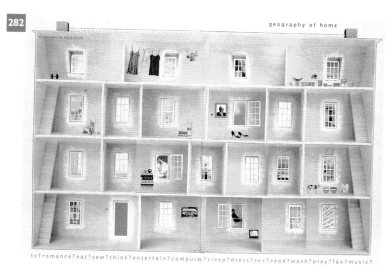

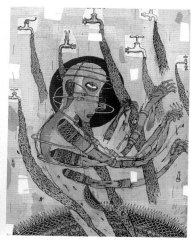

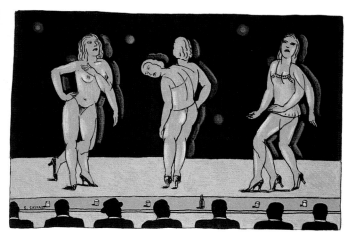

**281**

**Publication** Health
**Art Director** Jane Palecek
**Designer** Jane Palecek
**Illustrator** Henrik Drescher
**Publisher** Time Publishing Ventures, Inc.
**Date** September 9, 1994
**Category** Story

**282**

**Publication** Metropolis
**Art Directors** Carl Lehmann-Haupt,
Nancy Kruger Cohen
**Illustrator** Mara Kurtz
**Publisher** Havemeyer-Bellerophon Publications Inc.
**Date** May 1994
**Category** Spread

**283**

**Publication** Seccion Aurea
**Art Director** Hermenegildo Sabat
**Illustrator** Seymour Chwast
**Studio** The Pushpin Group, Inc.
**Date** October 1994
**Category** Spread

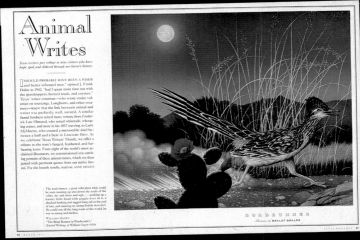

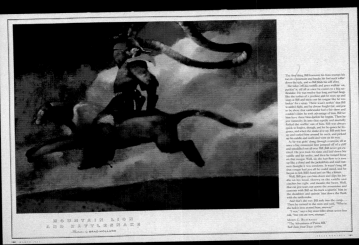

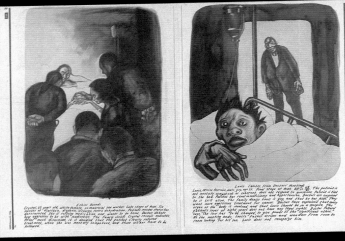

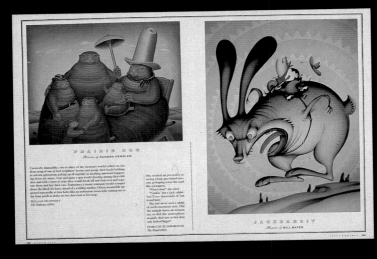

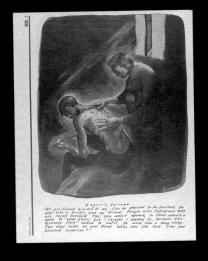

**284**

**Publication** Texas Monthly
**Art Director** D.J. Stout
**Designers** D.J. Stout, Nancy E. McMillen
**Illustrators** Braldt Bralds, James Marsh, John Collier, Brad Holland, Marshall Arisman
**Photo Editors** D.J. Stout, Nancy E. McMillen
**Publisher** Texas Monthly
**Date** March 1994
**Category** Story

**285**

**Publication** The Village Voice
**Design Director** Robert Newman
**Art Director** Florian Bachleda
**Illustrator** Sue Coe
**Publisher** Village Voice Publishing Corporation
**Date** February 22, 1994
**Category** Story

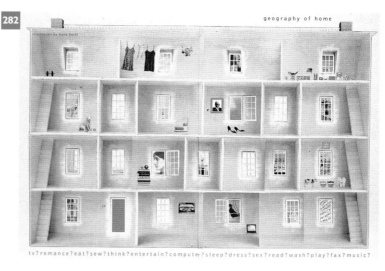

geography of home

tv?romance?eat?sew?think?entertain?computer?sleep?dress?sex?read?wash?play?fax?music?

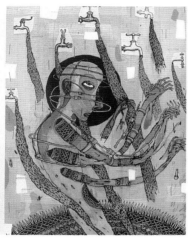

281

**Publication** Health
**Art Director** Jane Palecek
**Designer** Jane Palecek
**Illustrator** Henrik Drescher
**Publisher** Time Publishing Ventures, Inc.
**Date** September 9, 1994
**Category** Story

282

**Publication** Metropolis
**Art Directors** Carl Lehmann-Haupt,
Nancy Kruger Cohen
**Illustrator** Mara Kurtz
**Publisher** Havemeyer-Bellerophon Publications Inc.
**Date** May 1994
**Category** Spread

283

**Publication** Seccion Aurea
**Art Director** Hermenegildo Sabat
**Illustrator** Seymour Chwast
**Studio** The Pushpin Group, Inc.
**Date** October 1994
**Category** Spread

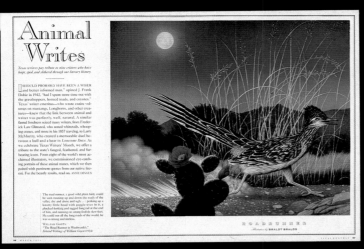

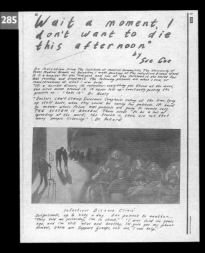

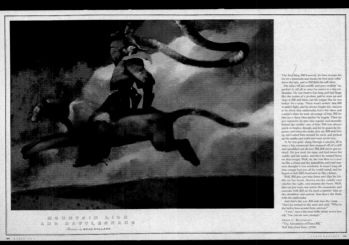

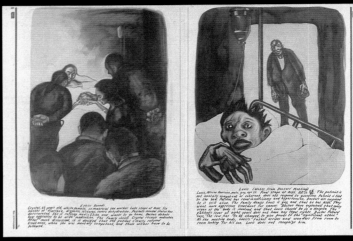

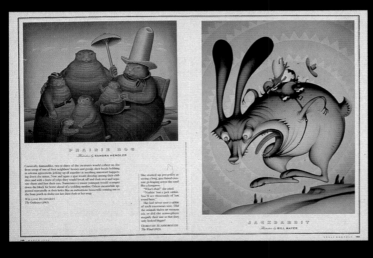

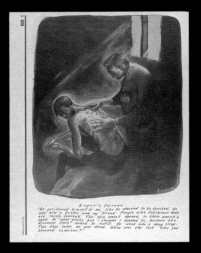

**284**

**Publication** Texas Monthly
**Art Director** D.J. Stout
**Designers** D.J. Stout, Nancy E. McMillen
**Illustrators** Braldt Bralds, James Marsh,
John Collier, Brad Holland, Marshall Arisman
**Photo Editors** D.J. Stout, Nancy E. McMillen
**Publisher** Texas Monthly
**Date** March 1994
**Category** Story

**285**

**Publication** The Village Voice
**Design Director** Robert Newman
**Art Director** Florian Bachleda
**Illustrator** Sue Coe
**Publisher** Village Voice Publishing Corporation
**Date** February 22, 1994
**Category** Story

Putting it all together

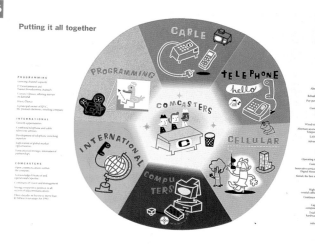

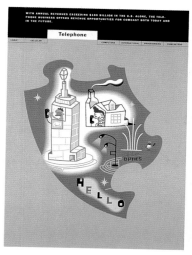

Illustration

MERIT

**Publication** Comcast Corporation 1993 Annual Report
**Creative Directors** Kent Hunter, Aubrey Balkind
**Designer** Kin Yuen
**Illustrator** J. Otto Siebold
**Photographer** Mark Jenkinson
**Studio** Frankfurt Balkind Partners
**Category** Story

**Publication** Local Initiatives Support Corporation
**Creative Directors** Kent Hunter, Aubrey Balkind
**Designer** Arturo Aranda
**Illustrator** Philippe Lardy
**Studio** Frankfurt Balkind Partners
**Category** Story

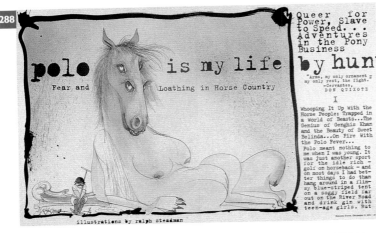

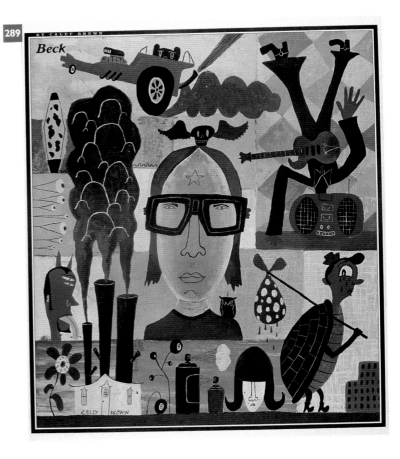

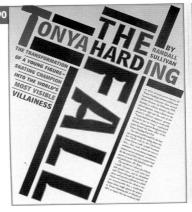

**288**

**Publication** Rolling Stone
**Art Director** Fred Woodward
**Designers** Fred Woodward, Gail Anderson
**Illustrator** Ralph Steadman
**Publisher** Wenner Media
**Date** December 15, 1994
**Category** Story

**289**

**Publication** Rolling Stone
**Art Director** Fred Woodward
**Designers** Fred Woodward, Gail Anderson, Geraldine Hessler, Lee Bearson
**Illustrator** Calef Brown
**Publisher** Wenner Media
**Date** November 11, 1994
**Category** Single Page

**290**

**Publication** Rolling Stone
**Art Director** Fred Woodward
**Designers** Fred Woodward, Gail Anderson
**Illustrator** John Collier
**Publisher** Wenner Media
**Date** July 14, 1994
**Category** Spread

148

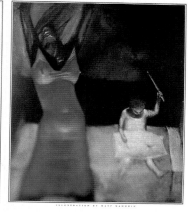

# KEEPING TIME BY JOHN SAYLES

A FICTION

THE OWNER ISN'T AROUND, so there is only an old man to help Mike with his kit. Each time Mike hands him another case from the van, he examines it, then nods and goes "Uh-huh" as if he's taking inventory. The old man is lanky, with maple-colored skin and eyes huge and soft behind thick lenses.

"Got to deal with the mess," he says when it's all inside and leaves Mike to set up alone.

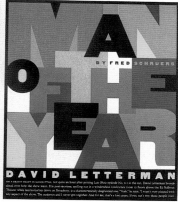

# MAN OF THE YEAR
## BY FRED SCHRUERS
### DAVID LETTERMAN

IN THE LAST DECADE of the Cold War, Ronald Reagan read a book. The book, *The Hunt for Red October*, was written by an unknown insurance agent, a Baltimore native named Tom Clancy who dreamed up the intricate plot while sitting in his office.

*Novelist* TOM CLANCY *keeps making new enemies*

BY RICH COHEN

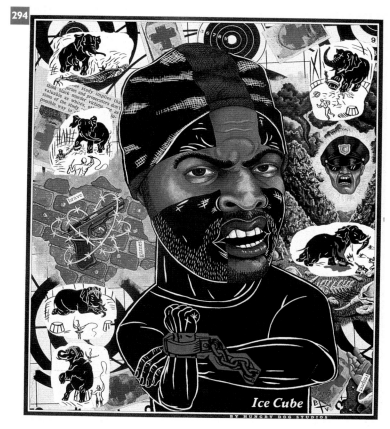

*Ice Cube*
BY HUNGRY DOG STUDIOS

**291**
**Publication** Rolling Stone
**Art Director** Fred Woodward
**Illustrator** Matt Mahurin
**Publisher** Wenner Media
**Date** December 9, 1994
**Category** Spread

**292**
**Publication** Rolling Stone
**Art Director** Fred Woodward
**Designer** Geraldine Hessler
**Illustrator** David Cowles
**Publisher** Wenner Media
**Date** December 29, 1994
**Category** Spread

**293**
**Publication** Rolling Stone
**Art Director** Fred Woodward
**Designers** Fred Woodward,
Gail Anderson
**Illustrator** Jonathon Rosen
**Publisher** Wenner Media
**Date** December 1, 1994
**Category** Spread

**294**
**Publication** Rolling Stone
**Art Director** Fred Woodward
**Designers** Fred Woodward,
Gail Anderson, Geraldine Hessler,
Lee Bearson
**Illustrator** HungryDogStudios
**Publisher** Wenner Media
**Date** November 17, 1994
**Category** Single Page

149

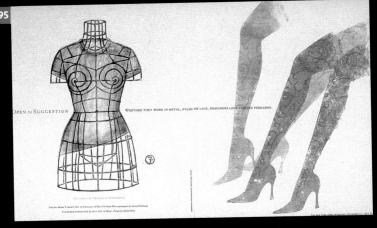

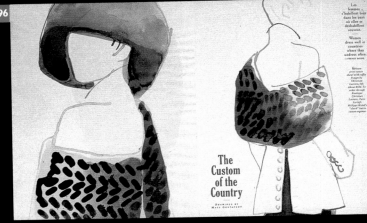

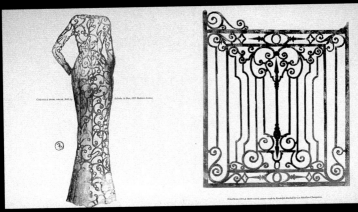

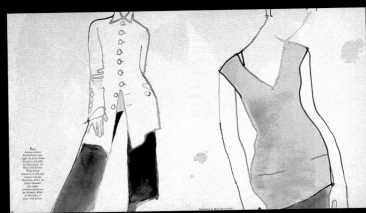

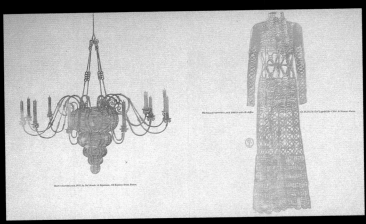

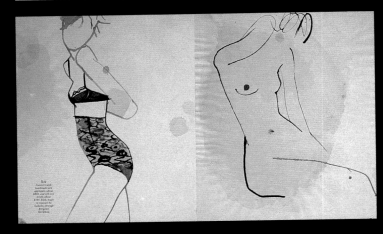

**295**
**Publication** The New York Times Magazine
**Art Director** Janet Froelich
**Designer** Lisa Naftolin
**Illustrator** Francois Berthoud
**Publisher** The New York Times
**Date** November 13, 1994
**Category** Story

**296**
**Publication** The New York Times Magazine
**Art Director** Janet Froelich
**Designer** Nancy Harris
**Illustrator** Mats Gustafson
**Publisher** The New York Times
**Date** March 20, 1994
**Category** Story

# The Downsizing Of Peter Perl

How I learned to live moderately and accept my Inner Slob

Illustrations by Blair Drawson

# Raging Al

*It's too easy to see Al D'Amato, ethics champion, as just an entertaining freak show. The question that needs answering is: Who put this guy at center stage?*

By Howard Kurtz

Illustrations by David Hughes

## FIVE INCHES

## GROOM

**297**
**Publication** Philadelphia Inquirer Magazine
**Design Director** Chrissy Dunleavy
**Art Director** Bert Fox
**Designer** Chrissy Dunleavy
**Illustrators** Milton Glaser,
Skip Liepke, Gary Kelley, Benoit,
Etienne Delessert, Janet Woolley
**Publisher** Philadelphia Inquirer
**Date** June 12, 1994
**Category** Story

**298**
**Publication** The Washington Post Magazine
**Art Director** Kelly Doe
**Designer** Kelly Doe
**Illustrator** Blair Drawson
**Publisher** The Washington Post Co.
**Date** December 4, 1994
**Category** Story

**299**
**Publication** The Washington Post Magazine
**Art Director** Kelly Doe
**Designer** Kelly Doe
**Illustrator** David Hughes
**Publisher** The Washington Post Co.
**Date** May 22, 1994
**Category** Story

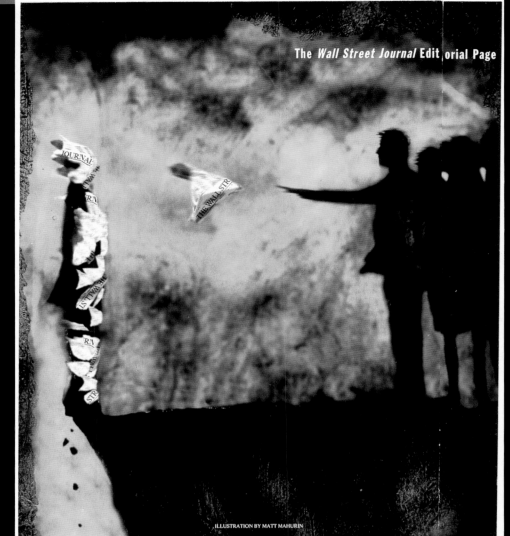

The *Wall Street Journal* Editorial Page

ILLUSTRATION BY MATT MAHURIN

ILLUSTRATED BY MATT MAHURIN
FOR NEW YORK

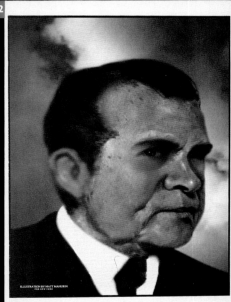

ILLUSTRATION BY MATT MAHURIN
FOR NEW YORK

**300**

**Publication** New York
**Design Director** Robert Best
**Art Director** Syndi Becker
**Designer** Syndi Becker
**Illustrator** Matt Mahurin
**Publisher** K-III Magazines
**Date** March 7, 1994
**Category** Spread

**301**

**Publication** New York
**Design Director** Robert Best
**Art Director** Syndi Becker
**Designer** Syndi Becker
**Illustrator** Matt Mahurin
**Publisher** K-III Magazines
**Date** June 20, 1994
**Category** Spread

**302**

**Publication** New York
**Design Director** Robert Best
**Art Director** Syndi Becker
**Illustrator** Matt Mahurin
**Publisher** K-III Magazines
**Date** May 9, 1994
**Category** Spread

## The Law Goes on a Treasure Hunt

In the Alice-in-Wonderland world of civil forfeiture, law-enforcement officials seize—and often keep—millions in cash, coffee, real estate. How does Sulphur, La., for instance, get away with seizing a Mercedes because of a minor drug violation?

BY DAVID HEILBRONER

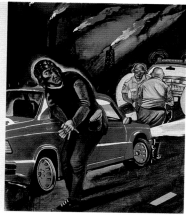

## Alzheimer's

BY ROBIN MARANTZ HENIG

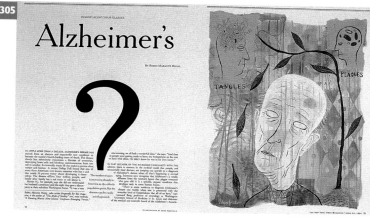

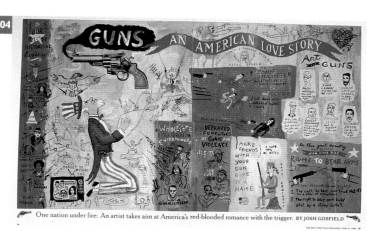

One nation under fire: An artist takes aim at America's red-blooded romance with the trigger. BY JOSH GOSFIELD

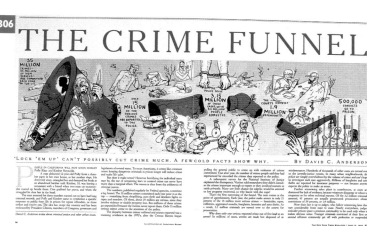

# THE CRIME FUNNEL

'LOCK 'EM UP' CAN'T POSSIBLY CUT CRIME MUCH. A FEW COLD FACTS SHOW WHY. — BY DAVID C. ANDERSON

**303**

**Publication**
The New York Times Magazine
**Art Director** Janet Froelich
**Designer** Nancy Harris
**Illustrator** Sue Coe
**Publisher** The New York Times
**Date** December 11, 1994
**Category** Spread

**304**

**Publication**
The New York Times Magazine
**Art Director** Janet Froelich
**Illustrator** Josh Gosfield
**Publisher** The New York Times
**Date** July 3, 1994
**Category** Spread

**305**

**Publication**
The New York Times Magazine
**Art Director** Janet Froelich
**Designer** Joel Cuyler
**Illustrator** Josh Gosfield
**Publisher** The New York Times
**Date** April 24, 1994
**Category** Spread

**306**

**Publication**
The New York Times Magazine
**Art Director** Janet Froelich
**Designer** Petra Mercker
**Illustrator** Jonathon Rosen
**Publisher** The New York Times
**Date** June 12, 1994
**Category** Spread

153

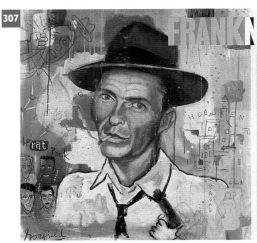

**307**

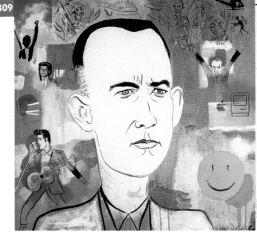

**309**

**308**

**310**

**307**

**Publication**
Entertainment Weekly
**Design Director**
Michael Grossman
**Art Director** Jill Armus
**Designer** Jill Armus
**Illustrator** Josh Gosfield
**Publisher** Time Inc.
**Date** February 18, 1994
**Category** Spread

**308**

**Publication**
Entertainment Weekly
**Design Director**
Robert Newman
**Art Director** Jill Armus
**Designers** Joe Kimberling,
Elizabeth Betts
**Illustrator** David Cowles
**Publisher** Time Inc.
**Date** 1994 Year End Special
**Category** Spread

**309**

**Publication** Time
**Art Director** Arthur Hochstein
**Designer** Thomas M. Miller
**Illustrator** Josh Gosfield
**Publisher** Time Inc.
**Date** August 1, 1994
**Category** Spread

**310**

**Publication** Time
**Art Director** Arthur Hochstein
**Designer** Janet Waegel
**Illustrator** C.F. Payne
**Publisher** Time Inc.
**Date** September 26, 1994
**Category** Spread

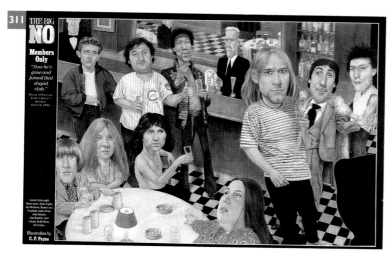

THE BARRAMUNDI PARADOX

**311**

**Publication** Esquire
**Art Director** Roger Black
**Designer** David O'Connor
**Illustrator** C.F. Payne
**Publisher** The Hearst Corporation-Magazines Division
**Date** July 1994
**Category** Spread

**312**

**Publication** Home Mechanix
**Art Director** Murray Greenfield
**Designer** Murray Greenfield
**Illustrator** David Pollard
**Publisher** Times Mirror Magazines
**Date** December 1994
**Category** Spread

**313**

**Publication** Men's Journal
**Art Director** Mark Danzig
**Designer** Susan Dazzo
**Illustrator** Brian Cronin
**Publisher** Wenner Media
**Date** April 1994
**Category** Spread

**314**

**Publication** Men's Journal
**Art Director** Mark Danzig
**Designer** Susan Dazzo
**Illustrator** Barry Blitt
**Publisher** Wenner Media
**Date** December 1994
**Category** Spread

Seduced by get-rich-quick promises, investors once again are flocking into the volatile world of commodities trading. Here's why most will get...

# BURNED ALIVE

BY SCOTT McMURRAY

ILLUSTRATION BY KINUKO CRAFT

---

RISK MANAGEMENT

The key to making good investments is generating the cash to fund them internally.

Without a clear set of risk-management goals, using derivatives can be dangerous.

From Pharaoh to Modern Finance

---

318

RANDOM WALK

A trendy young woman named Jane

Spent a fortune on clothes — but in vain;

She'd make the mistake of refusing to take

A cab when it started to rain.

FEBRUARY 1994 **worth** 128

Edward Gorey

---

# THE MARK OF THE BEAST

Some ran away, but Richard Seymour prefers to see Damien Hirst as an ad man with terrifying potential. Illustration by David Hughes

---

**315**
**Publication** Worth
**Art Director** Ina Saltz
**Designer** Ina Saltz
**Illustrator** Kinuko Craft
**Publisher** Capital Publishing
**Date** April 1994
**Category** Spread

**316**
**Publication** Blueprint
**Art Director** John Belknap
**Illustrator** David Hughes
**Publisher** Wordsearch Publishing
**Date** October 1994
**Category** Single Page

**317**
**Publication** Harvard Business Review
**Art Director** John O'Connor
**Designer** Kate Pestana
**Illustrator** Eric Dever
**Publisher** Harvard Business School
**Date** November/December 1994
**Category** Spread

**318**
**Publication** Worth
**Art Director** Ina Saltz
**Designer** Ina Saltz
**Illustrator** Edward Gorey
**Publisher** Capital Publishing
**Date** February 1994
**Category** Single Page

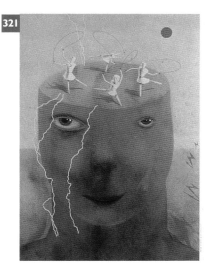

# WOOLY BULLY

### THE MINOANS' ROYAL BEAST

# ALL IN YOUR head

PRIONS, AND THE CASE OF THE MISSING DNA

The new teacher was sadistic and profoundly ignorant. But she kept order, and in the small Vermont town of Lost Nation, that excused a great number of shortcomings.

# DOWN THE COAT

One warm afternoon in early May, when the maple trees were just putting out and the hills above Lost Nation were light gold with the tiny new leaves, a battered old Ford rattletrap coughed and spluttered its way up the Fiddler's Elbow. It pulled into the schoolyard and came to a stop with a shudder beside Prof Chadbourn's Buick Roadmaster. Mr. Francis Dubois, Theresa Dubois's father and the chairman of the school directors, got out. With him was a big, beefy, red-faced woman of about

*fiction by*
HOWARD FRANK MOSHER

# DON'T FENCE ME IN

BARBED WIRE PRICKS THE CATTLEMAN'S HIDE

**319**
**Publication** TLC Monthly
**Art Director** John L. Sanford
**Designer** Rachel Faulise
**Illustrator** Will Wilson
**Publisher** Discovery Communications Inc.
**Category** Spread

**320**
**Publication** Yankee
**Art Directors** J. Porter, Doreen Means
**Illustrator** Phil Boatwright
**Publisher** Yankee Publishing Inc.
**Date** August 1994
**Category** Spread

**321**
**Publication** TLC Monthly
**Art Director** John L. Sanford
**Designer** Rachel Faulise
**Illustrator** Ian Pollock
**Publisher** Discovery Communications Inc.
**Date** May 1994
**Category** Spread

**322**
**Publication** TLC Monthly
**Art Director** John L. Sanford
**Designer** Rachel Faulise
**Illustrator** Bill Mayer
**Publisher** Discovery Communications Inc.
**Category** Spread

Illustration MERIT

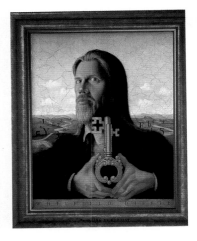

# PROPHET of PRIVACY

HE TOOK CRYPTOGRAPHY OUT OF THE HANDS OF THE SPOOKS
AND MADE PRIVACY POSSIBLE IN THE DIGITAL AGE.
BY INVENTING THE MOST REVOLUTIONARY CONCEPT IN
ENCRYPTION SINCE THE RENAISSANCE.
STEVEN LEVY DECODES WHITFIELD DIFFIE.

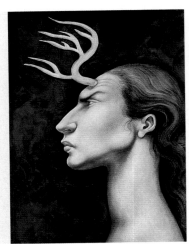

# MY SIS TER 'S TAIL

FICTION BY
CHRIS RISELEY

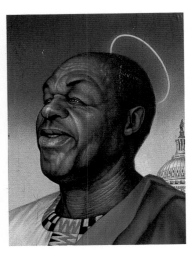

# BARRY'S SECOND COMING

BY MICHAEL K. FRISBY

# just as fierce

A
PERSONAL
ESSAY
BY
KATHERINE
DUNN

illustrations by anita kunz

---

**323**
**Publication** Wired
**Art Director** John Plunkett
**Designer** John Plunkett
**Illustrator** Rob Day
**Studio** Plunkett & Kuhr
**Date** November 1994
**Category** Spread

**324**
**Publication** Emerge
**Art Director** Wayne Fitzpatrick
**Designer** Wayne Fitzpatrick
**Illustrator** Joseph Salina
**Publisher** Black Entertainment
**Date** December 1994
**Category** Spread

**325**
**Publication** Buzz
**Design Director** Charles Hess
**Designer** Wanda Decca
**Illustrator** Kenton Nelson
**Publisher** Buzz, Inc.
**Date** November 1994
**Category** Spread

**326**
**Publication** Mother Jones
**Creative Director** Kerry Tremain
**Design Director** Marsha Sessa
**Designer** Marsha Sessa
**Illustrator** Anita Kunz
**Publisher**
Foundation for National Progress
**Date** November/December 1994
**Category** Spread

**319**

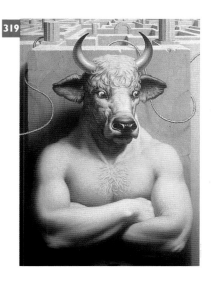

WOOLY
BULLY

THE MINOANS'
ROYAL BEAST

**321**

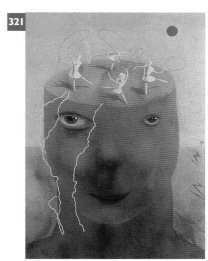

ALL IN
YOUR
head

PRIONS, AND THE

CASE OF THE

MISSING

DNA

**320**

The new teacher was sadistic and
profoundly ignorant. But she kept
order, and in the small Vermont
town of Lost Nation, that excused
a great number of shortcomings.

D O W N
T H E
C O A T

One warm afternoon in early May, when the maple
trees were just putting out and the hills above Lost Na-
tion were light gold with the tiny new leaves, a battered
old Ford rattletrap coughed and sputtered its way up the
Fiddler's Elbow. It pulled into the schoolyard and came
to a stop with a shudder beside Prof Chadbourn's Buick
Roadmaster. Mr. Francis Dubois, Theresa Dubois's fa-
ther and the chairman of the school directors, got out.
With him was a big, beefy, red-faced woman of about

fiction by
HOWARD FRANK MOSHER

**322**

DON'T
FENCE
ME IN

BARBED WIRE PRICKS
THE CATTLEMAN'S HIDE

---

**319**

**Publication** TLC Monthly
**Art Director** John L. Sanford
**Designer** Rachel Faulise
**Illustrator** Will Wilson
**Publisher** Discovery
Communications Inc.
**Category** Spread

**320**

**Publication** Yankee
**Art Directors** J. Porter,
Doreen Means
**Illustrator** Phil Boatwright
**Publisher** Yankee Publishing Inc.
**Date** August 1994
**Category** Spread

**321**

**Publication** TLC Monthly
**Art Director** John L. Sanford
**Designer** Rachel Faulise
**Illustrator** Ian Pollock
**Publisher** Discovery
Communications Inc.
**Date** May 1994
**Category** Spread

**322**

**Publication** TLC Monthly
**Art Director** John L. Sanford
**Designer** Rachel Faulise
**Illustrator** Bill Mayer
**Publisher** Discovery
Communications Inc.
**Category** Spread

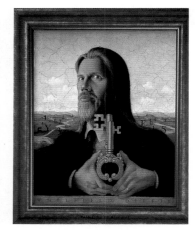

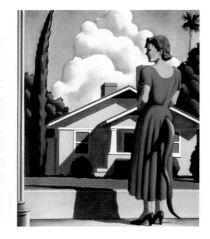

**323** PROPHET *of* PRIVACY

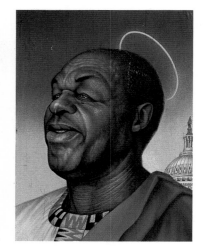

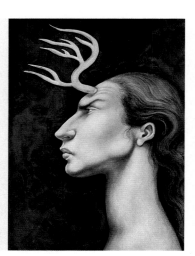

**324** BARRY'S SECOND COMING

**325** MY SIS TER 'S TAIL

**326** just as **fierce**

**323**
**Publication** Wired
**Art Director** John Plunkett
**Designer** John Plunkett
**Illustrator** Rob Day
**Studio** Plunkett & Kuhr
**Date** November 1994
**Category** Spread

**324**
**Publication** Emerge
**Art Director** Wayne Fitzpatrick
**Designer** Wayne Fitzpatrick
**Illustrator** Joseph Salina
**Publisher** Black Entertainment
**Date** December 1994
**Category** Spread

**325**
**Publication** Buzz
**Design Director** Charles Hess
**Designer** Wanda Decca
**Illustrator** Kenton Nelson
**Publisher** Buzz, Inc.
**Date** November 1994
**Category** Spread

**326**
**Publication** Mother Jones
**Creative Director** Kerry Tremain
**Design Director** Marsha Sessa
**Designer** Marsha Sessa
**Illustrator** Anita Kunz
**Publisher**
Foundation for National Progress
**Date** November/December 1994
**Category** Spread

victims of **violence**

The number of women and children caught in
the crossfire of domestic violence is growing in
Milwaukee, and the social programs created to
help are stretching to keep pace with the demand.

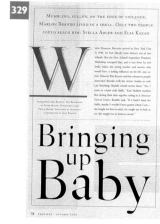

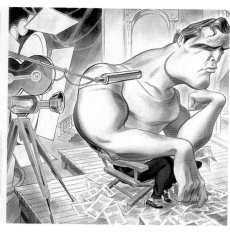

MUMBLING, SULLEN, ON THE EDGE OF VIOLENCE,
MARLON BRANDO LIVED IN A SHELL. ONLY TWO PEOPLE
COULD REACH HIM: STELLA ADLER AND ELIA KAZAN

Bringing
up
Baby

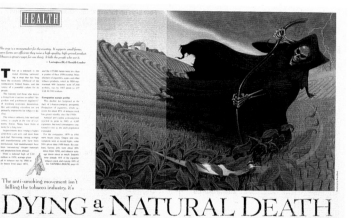

HEALTH

The anti-smoking movement isn't
killing the tobacco industry, it's

DYING a NATURAL DEATH

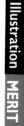

special
BREAST
CANCER
report

the
SEARCH
for
In honor of National Breast Cancer
Awareness Month, we offer cool-headed
insight into one very scary disease.
hope

One in nine. One in nine. One in nine.

---

**327**

**Publication** Milwaukee
**Art Director** Sharon K. Nelson
**Designer** Sharon K. Nelson
**Illustrator** Greg Spalenka
**Publisher** Quad Graphics
**Date** May 1994
**Category** Spread

**328**

**Publication**
American Medical News
**Art Director** Jef Capaldi
**Designer** Jef Capaldi
**Illustrator** David M. Beck
**Date** November 14, 1994
**Category** Spread

**329**

**Publication** Premiere
**Art Director** John Korpics
**Designer** John Korpics
**Illustrator** John Kascht
**Publisher** K-III Magazines
**Date** October 1994
**Category** Spread

**330**

**Publication** Shape
**Art Director** Kathy Nenneker
**Designer** Stephanie Birdsong
**Illustrator** Greg Spalenka
**Date** October 1994
**Category** Spread

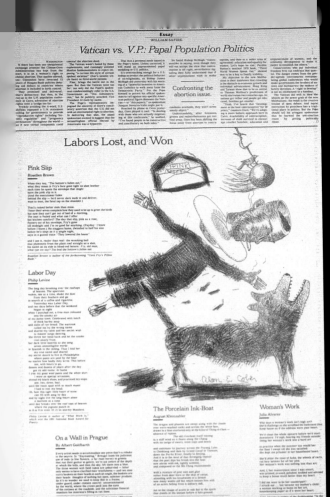

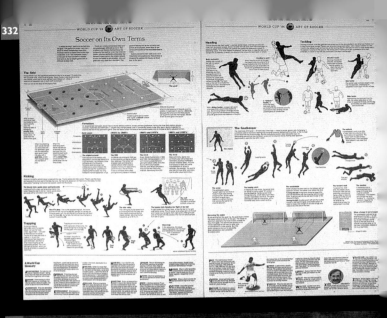

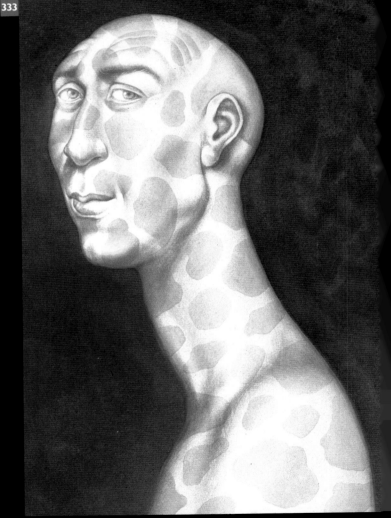

**331**
**Publication** The New York Times
**Art Director** Jerelle Kraus
**Designer** Jerelle Kraus
**Illustrator** Alan E. Cober
**Publisher** The New York Times
**Date** September 5, 1994
**Category** Single Page

**332**
**Publication** The New York Times
**Art Director** Fred Norgaard
**Designer** Fred Norgaard
**Illustrator** Megan Jaegerman
**Publisher** The New York Times
**Date** June 12, 1994
**Category** Story/Information Graphics

**333**
**Publication** Intolerance
**Creative Director** Sunil Bhandari
**Designer** Sunil Bhandari
**Illustrator** Anita Kunz
**Studio** Sunil Bhandari
**Date** Summer 1994
**Category** Spread

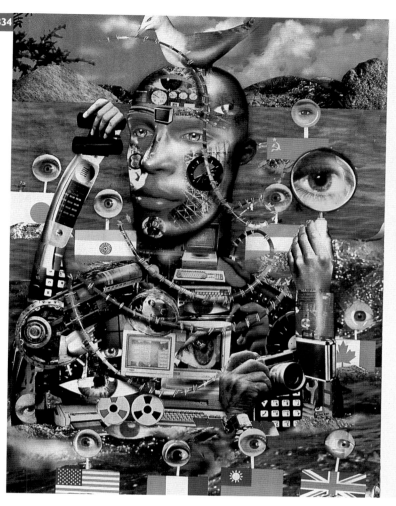

A spy coming in from the cold these days might well find an abundance of job opportunities within the international business community. As the globalization of commerce continues, companies around the world are finding corporate espionage a very real, every-day challenge.

Statistical data on the scope of the problem on an international level is hard to come by. However, Richard J. Heffernan, a 30-year veteran of the corporate cloak-and-dagger game who runs R.J. Heffernan Associates, a consulting firm based in Branford, Conn., has co-

ones targeting companies in other countries, as well."

Japan, with its well-developed electronics and automotive industries, is a favorite haunt for corporate spooks, says Akira Odani, president of Odani Research Co., in Larchmont, N.Y. "It is a daily problem for companies in Japan," he says. "The Japanese are always very curious about what their competitors are doing, so corporate intelligence is an accepted business activity there. But they have a real problem with illegal espionage."

To be sure, domestic cases of corporate espionage are a

## Selling Secrets

# Spies

### Corporate spies launch an international trade in proprietary information

authored two studies that have tracked corporate espionage incidents in the United States.

Two primary conclusions of the most recent study ("Technology Theft and Proprietary Information Assessment Survey," released last year) are that the incidence of theft of proprietary business information at U.S. companies has risen a dramatic 260% since 1985, and that foreign involvement in that theft is up nearly fourfold.

"The targeting of technology and proprietary information that takes place in the U.S. certainly parallels what is going on in other countries," says Heffernan, who advises the CIA and FBI on corporate espionage issues. "The same countries that are targeting U.S. companies are the

bigger problem for most companies, no matter where they are located, but the number of incidents involving foreign firms — and even foreign government intelligence organizations — is growing.

While some foreign firms have adopted win-at-any-cost strategies that often include state-sponsored corporate spying, U.S. companies have been loathe to do the same. Even though CIA Director R. James Woolsey has indicated a willingness to expand his agency's activities into corporate intelligence, U.S. law currently forbids it. And there seems to be little sentiment to change that approach.

At the same time, the concentration of wealth and R&D prowess in the United States, coupled with an open society

BY MICHAEL J. MCDERMOTT
ILLUSTRATION BY JANET WOOLLEY

June 1994 / PROFILES 51

Illustration MERIT

---

The finding that nerve cells "broadcast" messages to neighboring cells budges the dogma that information is always shared privately and cannot be divulged to other cells within hearing distance.
Memory's New Party Line

BY GABRIELLE STROBEL

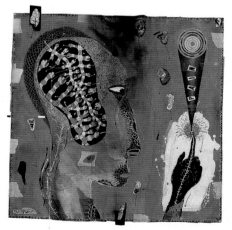

Mentoring
Moves
Mountains

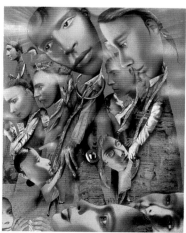

---

**Publication** Profiles
**Design Director** John Sizing
**Art Director** Joseph J. Polevy
**Illustrator** Janet Woolley
**Publisher** Marblehead Communications Inc.
**Date** June 1994
**Category** Spread

**Publication** Stanford Medicine
**Art Director** David Armario
**Designer** David Armario
**Illustrator** Henrik Drescher
**Publisher** Stanford Medicine
**Date** Spring 1994
**Category** Spread

**Publication** Stanford Medicine
**Art Director** David Armario
**Designer** David Armario
**Illustrator** Janet Woolley
**Publisher** Stanford Medicine
**Date** Spring 1994
**Category** Spread

161

**337**

**Publication** Nickelodeon
**Art Director** Alexa Mulvihill
**Illustrator** J. Otto Seibold
**Publisher** MTV Networks
**Date** December 1994
**Category** Single Page

**338**

**Publication** Money Magazine For Kids
**Art Director** Don Morris
**Designers** Don Morris, James Reyman
**Illustrator** Henrik Drescher
**Publisher** Time Inc.
**Date** Fall 1994
**Category** Story

# PHOTOGRAPHY

# The Fashion Circus

No clowning around. Glamour and whimsy are easy to swallow.

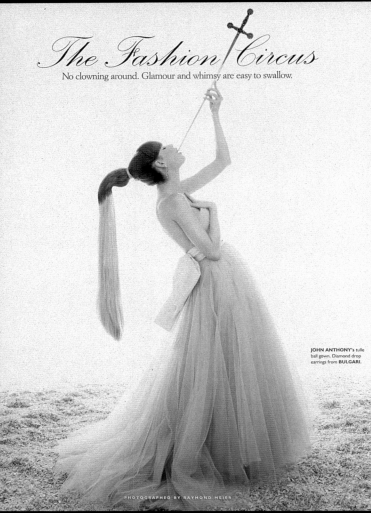

JOHN ANTHONY's tulle ball gown. Diamond drop earrings from BULGARI.

PHOTOGRAPHED BY RAYMOND MEIER

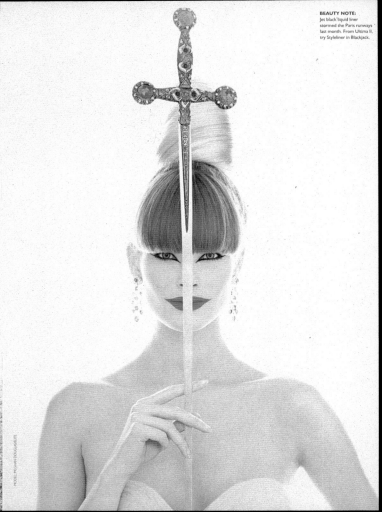

BEAUTY NOTE:
Jet black liquid liner stormed the Paris runways last month. From Ultima II, try Styleliner in Blackjack.

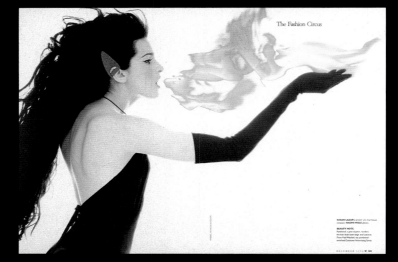

The Fashion Circus

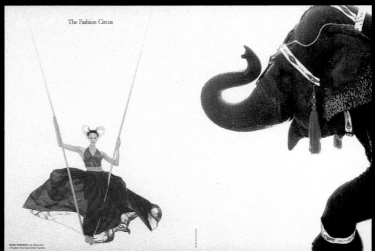

The Fashion Circus

---

**339**

**Publication** W
**Creative Director** Dennis Freedman
**Design Directors** Edward Leida, Jean Griffin
**Art Director** Kirby Rodriguez
**Designers** Edward Leida, Rosalba Sierra
**Photographer** Raymond Meier
**Publisher** Fairchild Publications
**Date** December 1994
**Category** Story/Fashion & Beauty

**340**

**Publication** Rolling Stone
**Art Director** Fred Woodward
**Designers** Fred Woodward, Lee Bearson
**Photographer** Mark Seliger
**Photo Editor** Jodi Peckman
**Publisher** Wenner Media
**Date** December 15, 1994
**Category** Spread/Still Life & Interiors

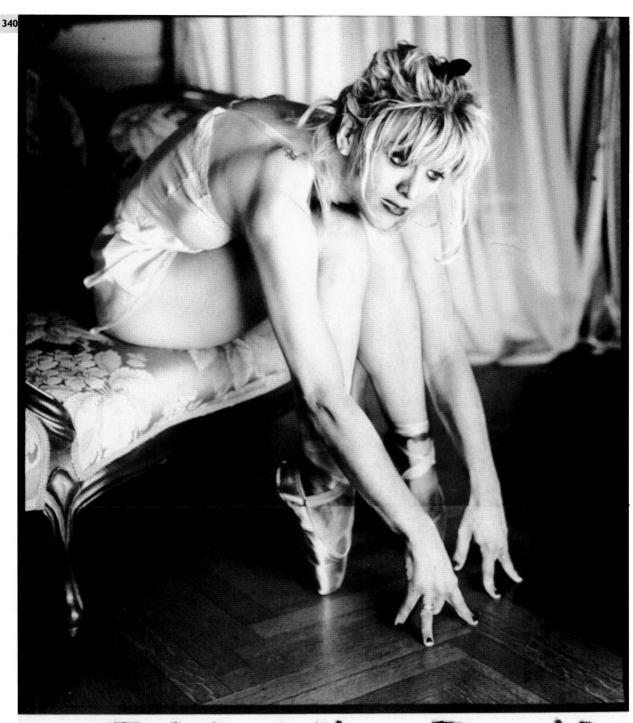

xxLifeAfterDeath

Courtney love

xxxPhotographxx
byMarkSeligerxxx
xxxxxxxxxxxxxxxxxxxX

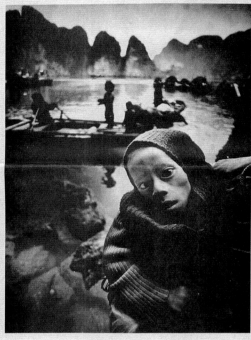

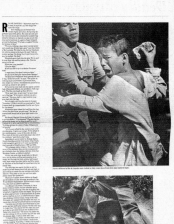

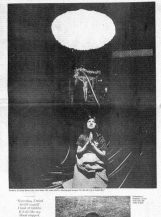

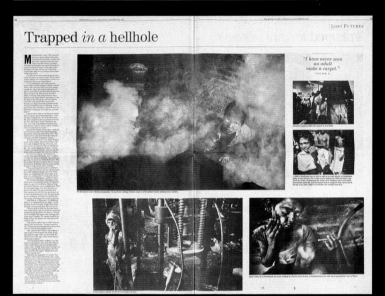

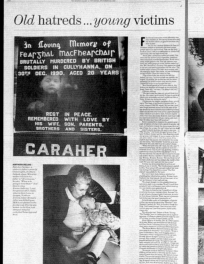

341

**Publication**  The Boston Globe
**Art Director**  Lucy Bartholomay
**Designer**  Lucy Bartholomay
**Photographer**  Stan Grossfeld
**Photo Editor**  Lucy Bartholomay
**Publisher**  The Boston Globe Publishing Co.
**Date**  December 29, 1994
**Category**  Story/Reportage & Travel

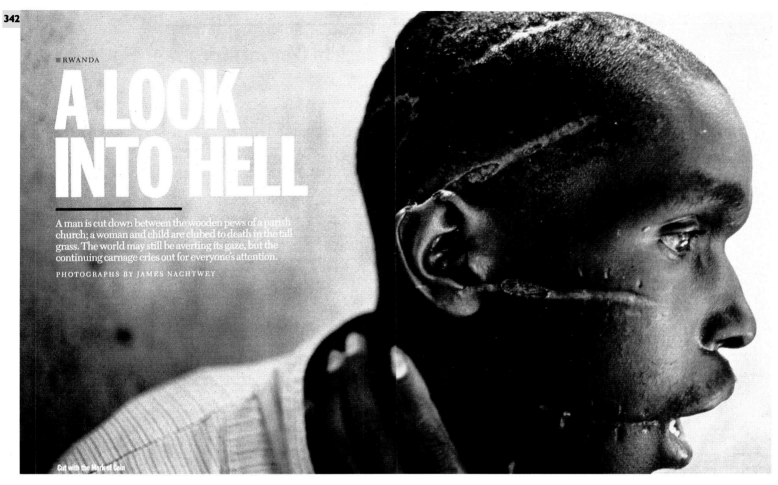

■RWANDA

# A LOOK INTO HELL

A man is cut down between the wooden pews of a parish church; a woman and child are clubed to death in the tall grass. The world may still be averting its gaze, but the continuing carnage cries out for everyone's attention.

PHOTOGRAPHS BY JAMES NACHTWEY

Cut with the Mark of Cain

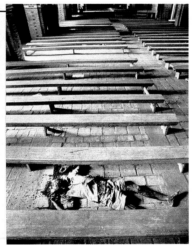

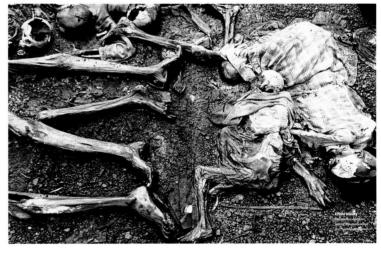

**A Fleshly Mask of Terror**

**Arms of Mass Destruction**

**The Sanctuary of Death**

**342**

**Publication** Time International
**Art Director** Arthur Hochstein
**Designer** Jane Frey
**Photographer** James Nachtwey
**Photo Editors** Michele Stephenson, Robert Stevens
**Publisher** Time Inc.
**Date** July 4, 1994
**Category** Story/Reportage & Travel

GREEN
AND TROLL

In the abandoned Los Angeles building she shares with boyfriend Troll, Green, 16, has been awake for nearly four days in the throes of acid and speed. She was 15 when she started using drugs at home in Houston. She calls her mom weekly, collect. "Each time I tell her I'll be home in a week, even though I know it's not true."

■ SOCIETY

# Running Scared

The perils of life on the streets only seem to grow, but so too do the numbers of children fleeing their homes

By JON D. HULL HOLLYWOOD

THE FIRST TIME CHRISTINE TRIED TO SELL HER BODY FOR MONEY, SHE WAS chased away by the prostitutes on Sunset Boulevard after just 20 minutes. "They told me to go home, said I was too young," says the short, thin, green-eyed girl with brown hair. Christine is not her real name; and she has no home, not anymore, certainly not on Sunset. Home was once a neatly kept two-story house in a middle-class section of Louisville, Kentucky, with Mom and Dad and a little sister. Home was also screams and broken glass and calls to 911. "My mom and dad fight a lot, and I just couldn't stand it anymore," Christine says. "So I made it my New Year's resolution: No more fighting." On Jan. 2 she slipped out the kitchen door at 5 a.m., with $144, two cans of Diet Coke, six cans of Star-Kist tuna fish, a jar of Skippy peanut butter, her diary, some clothes, a pocket knife and a photo of her

343

**Publication** Time
**Art Director** Arthur Hochstein
**Designer** Sharon Okamoto
**Photographer** Steve Liss
**Photo Editors** Michele Stephenson, MaryAnne Golon
**Publisher** Time Inc.
**Date** November 21, 1994
**Category** Story/Reportage & Travel

344

**Publication** The New York Times Magazine
**Art Director** Janet Froelich
**Designer** Petra Mercker
**Photographer** Donna Ferrato
**Photo Editor** Kathy Ryan
**Publisher** The New York Times
**Date** April 24, 1994
**Category** Story/Reportage & Travel

345

**Publication** Life
**Design Director** Tom Bentkowski
**Designers** Tom Bentkowski, Mimi Park
**Photographer** Larry Towell
**Photo Editor** David Friend
**Publisher** Time Inc.
**Date** October 1994
**Category** Spread/Reportage & Travel

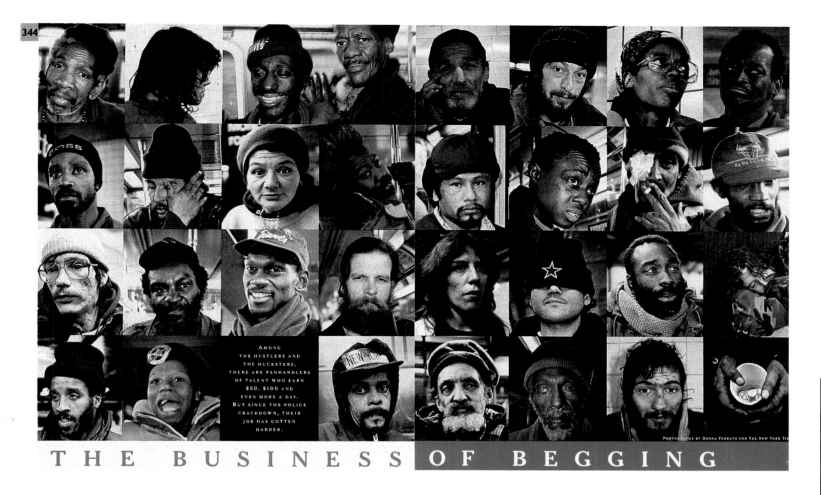

AMONG THE HUSTLERS AND THE HUCKSTERS, THERE ARE PANHANDLERS OF TALENT WHO EARN $50, $100 AND EVEN MORE A DAY. BUT SINCE THE POLICE CRACKDOWN, THEIR JOB HAS GOTTEN HARDER.

PHOTOGRAPHS BY DONNA FERRATO FOR THE NEW YORK TIMES

# THE BUSINESS OF BEGGING

The world of the Old Colony Mennonites is a well-preserved slice of 16th century life. Rejecting progress as ungodly, living in a closed society, the faithful dress, work, speak and worship like Germans of the Reformation era. To preserve their way of life, they fled from Europe to Canada in the last century, then moved on to Mexico in the 1920s. There they farmed in biblical simplicity until drought and cheap U.S. produce killed their livelihood. Looking for jobs, hundreds of destitute families have now returned to Canada, where many toil in the fields for third-world wages. **Larry Towell** has documented on film this latest stage in their

## ENDLESS
# EXODUS

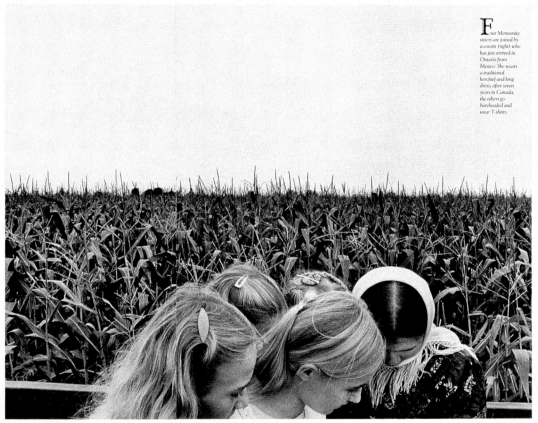

Four Mennonite sisters are joined by a cousin (right) who has just arrived in Ontario from Mexico. She wears a traditional kerchief and long dress; after seven years in Canada, the others go bareheaded and wear T-shirts.

90

Reporting by JOSH SIMON

BY MATT MAHURIN

*Henry Rollins*

# The Twilight of the Texas Rangers

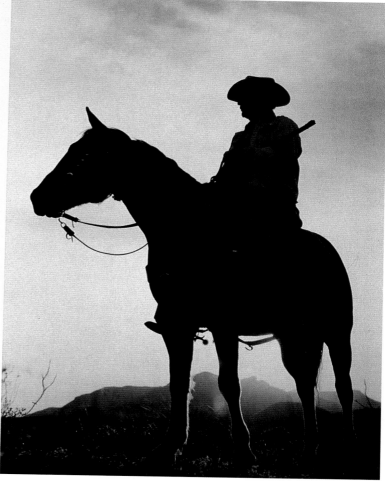

For 170 years, the legendary lawmen have faced down cattle rustlers, serial killers, and every threat imaginable. Now they must grapple with their most dangerous foe: the modern world.

BY ROBERT DRAPER

⟶ × × × ⟵

The end of a long ride: Retired Ranger Joaquin Jackson of Alpine.

PHOTOGRAPHS BY DAN WINTERS

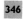

**Publication** Rolling Stone
**Art Director** Fred Woodward
**Designers** Fred Woodward, Gail Anderson, Geraldine Hessler, Lee Bearson
**Photographer** Matt Mahurin
**Photo Editors** Jodi Peckman, Denise Sfraga
**Publisher** Wenner Media
**Date** November 17, 1994
**Category** Single Page

**Publication** Texas Monthly
**Art Director** D.J. Stout
**Designers** D.J. Stout, Nancy E. McMillen
**Photographer** Dan Winters
**Photo Editors** D.J. Stout, Nancy E. McMillen
**Publisher** Texas Monthly
**Date** February 1994
**Category** Story/Reportage & Travel

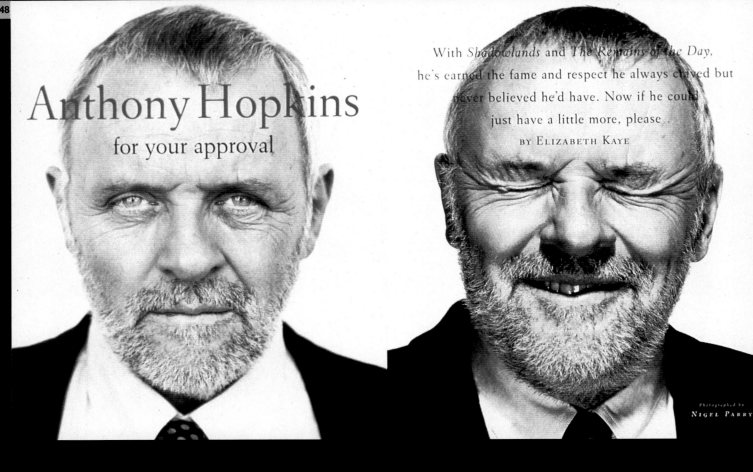

# Anthony Hopkins
## for your approval

With *Shadowlands* and *The Remains of the Day*, he's earned the fame and respect he always craved but never believed he'd have. Now if he could just have a little more, please

BY ELIZABETH KAYE

Photographed by
NIGEL PARRY

With his second movie, Pulp Fiction, *gaining widespread critical acclaim, Quentin Tarantino, an unabashed blaxploitation film freak, has dodged the bullet of a sophomore slump. Manohla Dargis finds out what Hollywood's hottest young filmmaker is shooting for.* Photograph by Jean Baptiste Mondino

# a bloody pulp

It's 11:30 p.m. and I'm on the phone talking to Quentin Tarantino, trying to shake sleep off me like water. "Do you want me to bring anything over?" I ask. "You know, something to drink?"

"Well," he says, "ah, actually, I'd like some cereal." I pause. "Okay, what do you want?"

"I'd really like some Cocoa Pebbles," says the director of 1992's ultraviolent sensation *Reservoir Dogs.* "But if they don't have that, then Fruity Pebbles. But if they don't have that, then I'd like Cocoa Puffs and some milk and some Coke."

I drive to Ralphs supermarket and buy a late-night snack that seems more suitable for a growing teenage boy than for the hottest young filmmaker in Hollywood. Tooling along the nearly empty streets of L.A. on my way to his apartment, I get the feeling that I've already entered a reality directed by somebody else. In three days, Tarantino will be on his way to the prestigious Cannes Film Festival with his second feature, *Pulp Fiction,* a bloody carnival featuring the unlikely combo of Bruce Willis, Samuel L. Jackson, Uma Thurman, and one of his favorite actors, John Travolta. Two weeks later he'll win the festival's top honor, the Palme d'Or. The only one who won't be surprised is the director himself.

I arrive at Tarantino's apartment around midnight, fully loaded. The 31-year-old director has recently discovered that Travolta used to live in this very apartment. It's a lovely bit of serendipity that feeds Tarantino's well-known obsession with movies and pop culture, which is evident in his clutter of artifacts great and kitschy. Quentin's Playhouse is crammed with stacks of laser discs, dog-eared books by film critic Pauline Kael, scattered CDs, a grisly rubber head from some F/X outfit, and a miscellany of movie and TV lunchboxes, board games, and dolls (Vinnie Barbarino, among others). Posters for vintage Hollywood, early Godard, and recent Tarantino line the walls, including one from his first film, *Reservoir Dogs,* and a gorgeous Japanese ad for *True Romance,* which

he wrote, inscribed by director Tony Scott ("The best script and best movie I ever worked on! Give me more!"). When he shows me his wall of videotapes and tosses cassettes into my arms, he seems like the Great Gatsby showing off his custom-made shirts to Daisy—at once delighted and clumsy with the fruits of success.

As he stomps about his apartment, Tarantino evokes the overgrown toddler in *Honey, I Blew Up the Kid,* a larger-than-life beguiler on the rampage. Still, he's a tease and strangely smooth, even though hanging out with him is like being a losing contestant on *Jeopardy!*—all your answers are invariably a beat too slow. Exhaustion, as it turns out, will be a familiar sensation when I finish with him, or maybe it's when he finishes with me. (His buddy and *Pulp Fiction* actor Eric Stoltz calls him Hurricane Quentin.)

We break for coffee and doughnuts (the cereal was for later), and as if to initiate me into his world, he invites me to watch *The Big Bird Cage* on his TV, which has dimensions to rival the obelisk in *2001: A Space Odyssey.* A women-in-chains quickie, *Bird Cage* was produced in 1972 when Tarantino was all of nine; it's the kind of movie teenage boys watch while working the muscles in their right hand. It features a number of exploitation-film regulars, but its real star is a gun-slinging, belly-baring spitfire by the name of Pam Grier, whom Tarantino, an ardent fan, dubs "the queen of women."

For all his enthusiasms, though, *fan* is a dirty word for Tarantino. "You've got to stop yourself from being a total fan boy and working with people just because you like them," he insists. Still, royalty is royalty, and during preproduction on *Pulp Fiction,* he called in his queen. "She read for the part that Rosanna Arquette played: Jody," he says. It turned out that Grier and the role weren't quite right for each other, which hasn't dampened his ardor one bit: "When we work together, it's got to be absolutely right, so it's not a gimmick, so it's nothing stupid. In my office at Jersey Films, I have all these Pam Grier posters

on my wall. She came in, and I made sure she was the last person that we saw that day so everyone else could leave and she and I could talk. She came in and thanked me for the plug in *Reservoir Dogs.* We talked and really hit it off, and then she looked around at *Coffy* and *Foxy Brown* and *Sheba Baby,* all these posters, and she goes, 'Now, tell me, seriously, did you put all this shit up because you knew I was coming in?' I said, 'No. Actually, I almost took all this down because I knew you were coming in, but I thought, Fuck it.' " He laughs. "She sent me a postcard. It's really sexy, her in a bikini lounging in a little wading pool...*God!*"

Tarantino first hit the zeitgeist in 1992 with *Reservoir Dogs,* an art house sensation that became as notorious for its grisly pyrotechnics as for its cinematic virtuosity. After years of making the rounds as an actor-in-waiting, he'd finally gotten a movie off the ground by teaming up with someone as hungry as himself. Lawrence Bender, a dancer turned aspiring mogul, was the first producer Tarantino met in Hollywood who'd actually made a movie. "After a couple of months hanging out," says Bender, "he said, 'Look, I've got this idea for *Reservoir Dogs.* I'm going to write it, and we're going to go off and make it.' He literally, literally, *literally* wrote *Reservoir Dogs* in three and a half weeks. I just flipped." Bender passed it along to his acting teacher, who gave the script to Harvey Keitel. "He read it," Bender says, "and called me up right away: 'Lawrence, this material is wonderful. I haven't read characters like this in years. I'll do anything to help you get this movie made.' That was the beginning of this whole thing."

Before it was even in the can, *Reservoir Dogs* had a buzz. The story of a heist gone wrong, the all-boy production featured a sexy cast (Keitel, Michael Madsen, Tim Roth), sizzling dialogue, a twisted structure, and enough punch lines to make all its carnage go down a bit smoother. Rarely has a debut film raised as many red flags

**ULTRAVIOLENT SENSATION**
"Either you dig it," says Tarantino, "or you walk out of the theater in disgust."

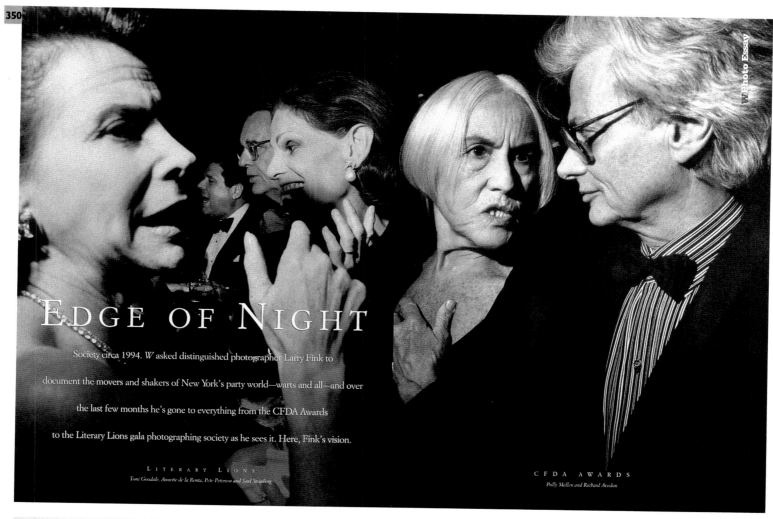

# EDGE OF NIGHT

Society circa 1994. *W* asked distinguished photographer Larry Fink to

document the movers and shakers of New York's party world—warts and all—and over

the last few months he's gone to everything from the CFDA Awards

to the Literary Lions gala photographing society as he sees it. Here, Fink's vision.

LITERARY LIONS
*Toni Goodale, Annette de la Renta, Pete Peterson and Saul Steinberg*

CFDA AWARDS
*Polly Mellen and Richard Avedon*

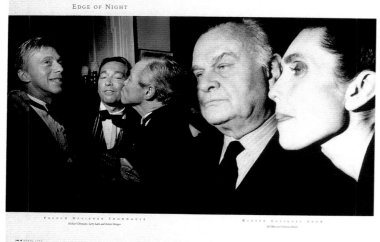

EDGE OF NIGHT

FRENCH DESIGNER SHOWHOUSE

WINTER ANTIQUES SHOW

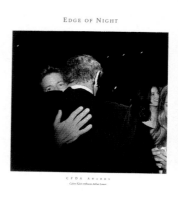

EDGE OF NIGHT

CFDA AWARDS

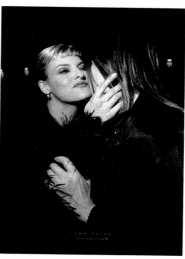

---

**Publication** Premiere
**Art Director** John Korpics
**Designer** John Korpics
**Photographer** Nigel Parry
**Photo Editor** Charlie Holland
**Publisher** K-III Magazines
**Date** February 1994
**Category** Spread/Reportage & Travel

**Publication** Vibe
**Art Director** Diddo Ramm
**Designer** Ellen Fanning
**Photographer** Jean Baptiste Mondino
**Photo Editor** George Pitts
**Publisher** Time Inc. Ventures
**Date** October 1994
**Category** Spread/Fashion & Beauty

**Publication** W
**Creative Director** Dennis Freedman
**Design Directors** Edward Leida, Jean Griffin
**Art Director** Kirby Rodriguez
**Designers** Edward Leida, Rosalba Sierra
**Photographer** Larry Fink
**Publisher** Fairchild Publications
**Date** April 1994
**Category** Story/Reportage & Travel

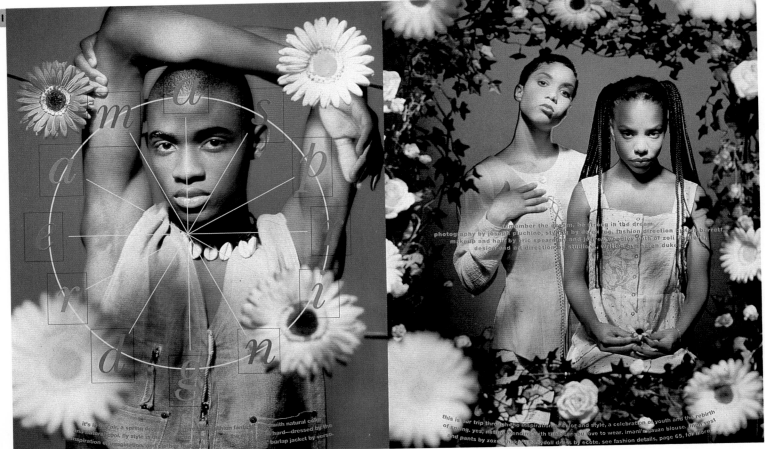

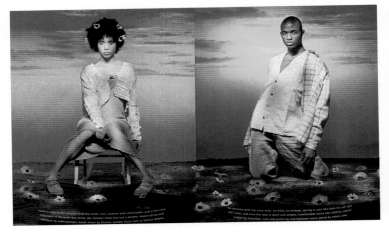

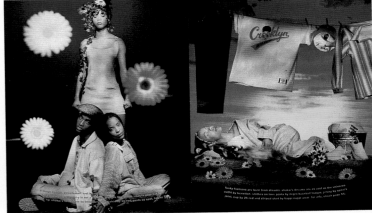

**Publication** YSB
**Art Directors** Fo Wilson, Lance Pettiford
**Designer** Fo Wilson
**Photographer** Joseph Pluchino
**Photo Editor** Stephen Chin
**Publisher** Paige Publications
**Studio** Studio W
**Date** March 1994
**Category** Story/Fashion & Beauty

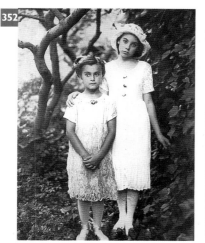

*the secret garden*

*The most romantic and graceful details*

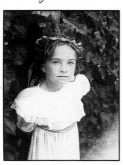

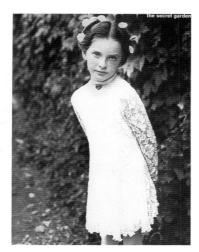

the secret garden

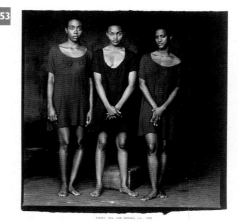

# VIRTUAL REALITY

In Melodie McDaniel's
staged photographs,
fiction is
stranger than truth

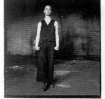

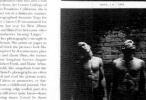
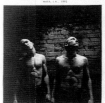

**352**

**Publication** Earnshaw's
**Creative Director** Nancy Campbell
**Photographer** Alexandra Stonehill
**Publisher** Earnshaw Publications
**Date** August 1994
**Category** Story/Fashion & Beauty

**353**

**Publication** Elle
**Creative Director** Regis Pagniez
**Art Director** Nora Sheehan
**Designer** Nora Sheehan
**Photographer** Melodie McDaniel
**Photo Editor** Alison Morley
**Publisher** Hachette Filipacchi Magazines, Inc.
**Date** March 1994
**Category** Story/Still Life & Interiors

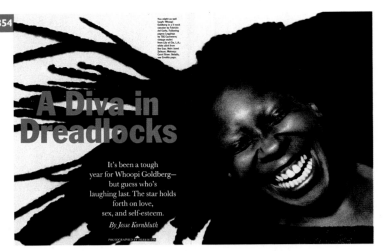

# A Diva in Dreadlocks

It's been a tough
year for Whoopi Goldberg—
but guess who's
laughing last. The star holds
forth on love,
sex, and self-esteem.

*By Jesse Kornbluth*

PHOTOGRAPHED BY HERB RITTS

## The only problem with a mouth that's so frequently in gear is that it's hard to stop.

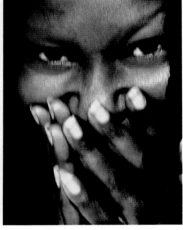

AVENUE STYLE

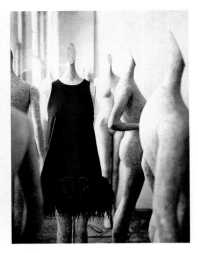

# EVENING
## enchantments

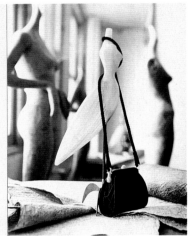

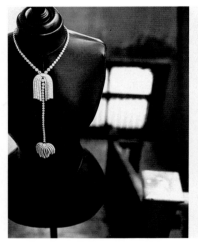

---

**354**

**Publication** Allure
**Design Director** Shawn Young
**Designer** Shawn Young
**Photographer** Herb Ritts
**Photo Editor** Judy White
**Publisher** Condé Nast Publications Inc.
**Date** September 1994
**Category** Story/Fashion & Beauty

**355**

**Publication** Avenue
**Art Director** Lori Ende
**Designer** Lori Ende
**Photographer** Christopher Micaud
**Publisher** Avenue Magazine Inc.
**Date** October 1994
**Category** Story/Still Life & Interiors

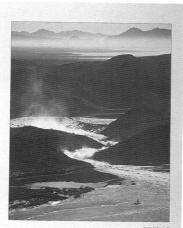

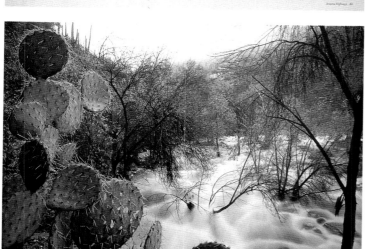

# O CHESAPEAKE

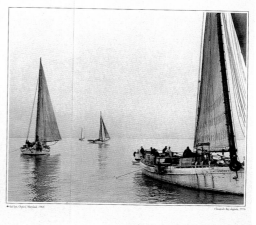

PHOTOGRAPHY BY MARION E. WARREN

O CHESAPEAKE

O CHESAPEAKE

## 356

**Publication** Arizona Highways
**Art Director** Christine Mitchell
**Designer** Christine Mitchell
**Photo Editor** Peter Ensenberger
**Publisher** Arizona Highways
**Date** March 1994
**Category** Photography/Story/Reportage & Travel

## 357

**Publication** Audubon
**Art Director** Suzanne Morin
**Photographer** Marion E. Warren
**Photo Editor** Peter Howe, Laleli Lopez
**Publisher** National Audubon Society
**Date** September/October 1994
**Category** Story/Reportage & Travel

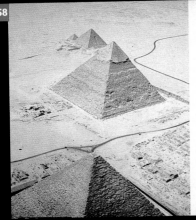

New
eyes
on the
Nile

Is there a sacred purpose behind
the colossal monuments along the
Nile? JOHN ANTHONY WEST
thinks there is. With the help of
vertiginous new photographs
by MARILYN BRIDGES, he leads us on
a magical mystery tour. Understand,
he says, and the force is with you

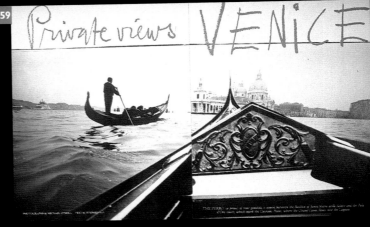

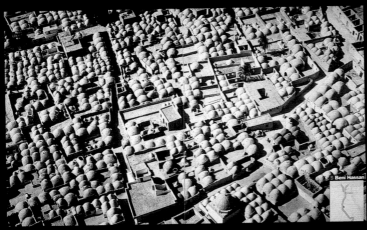

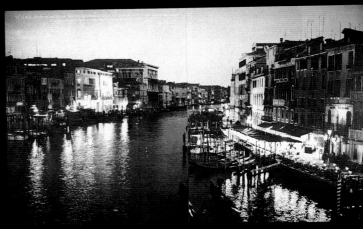

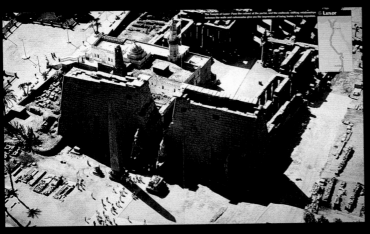

**358**

**Publication** Condé Nast Traveler
**Design Director** Diana LaGuardia
**Art Director** Christin Gangi
**Designer** Christin Gangi
**Photographer** Marilyn Bridges
**Photo Editor** Kathleen Klech
**Publisher** Condé Nast Publications Inc.
**Category** Story/Reportage & Travel

**359**

**Publication** Condé Nast Traveler
**Design Director** Diana LaGuardia
**Art Director** Christin Gangi
**Designer** Stephen Orr
**Photographer** Michael O'Neill
**Photo Editor** Kathleen Klech
**Publisher** Condé Nast Publications Inc.
**Date** December 1994
**Category** Story/Reportage & Travel

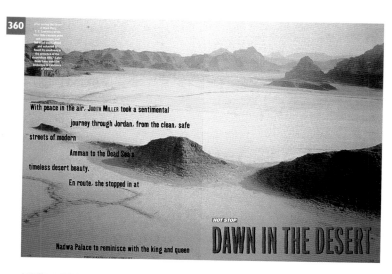

With peace in the air, JUDITH MILLER took a sentimental

journey through Jordan, from the clean, safe

streets of modern

Amman to the Dead Sea's

timeless desert beauty.

En route, she stopped in at

**HOT STOP**

**DAWN IN THE DESERT**

Nadwa Palace to reminisce with the king and queen

**GREAT BEACHES OF THE WORLD**
**Pure Mediterranean**

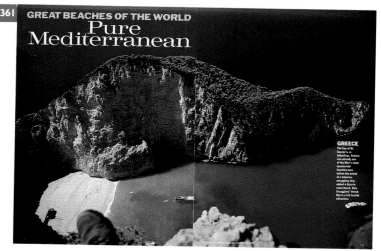

GREECE
The bay of St. George's, in Zakynthos, Greece, was already one of the Med's most spectacular beaches even before the wreck of a tobacco-smuggling ship added a bizarre extra touch. Now Smugglers' Wreck Bay is a hot tourist attraction.

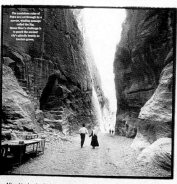

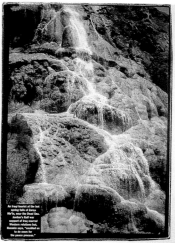

After his death, the king believes, only democracy will sustain Jordan

MEDITERRANEAN BEACHES

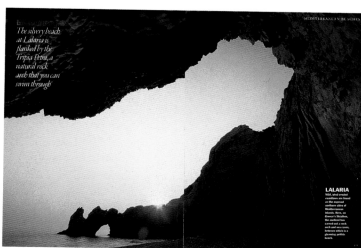

The silvery beach at Lalaria is flanked by the Tripia Petra, a natural rock arch that you can swim through

LALARIA
Wild, wind-eroded conditions are found on the exposed northern sides of Mediterranean islands. Here, on Greece's Skiathos, the seabed has carved out a rock arch and sea caves, between which is a gleaming pebble beach.

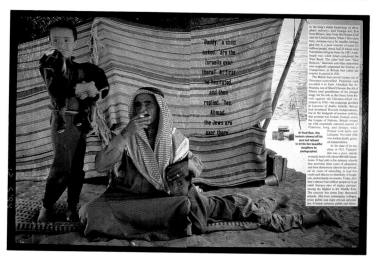

Daddy, a child asked, are the Israelis over there? At first he hesitated, and then replied, Yes, Ahmad, the Jews are over there

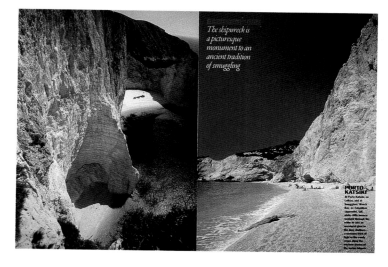

The shipwreck is a picturesque monument to an ancient tradition of smuggling

PORTO KATSIKI

**360**

**Publication** Condé Nast Traveler
**Design Director** Diana LaGuardia
**Art Director** Christin Gangi
**Designer** Christin Gangi
**Photographer** Annie Leibovitz
**Photo Editor** Kathleen Klech
**Publisher** Condé Nast Publications Inc.
**Date** October 1994
**Category** Story/Reportage & Travel

**361**

**Publication** Condé Nast Traveler
**Design Director** Diana LaGuardia
**Art Director** Christin Gangi
**Designer** Christin Gangi
**Photographer** Hakan Ludwigsson
**Photo Editor** Kathleen Klech
**Publisher** Condé Nast Publications Inc.
**Date** May 1994
**Category** Story/Reportage & Travel

Photography MERIT

**179**

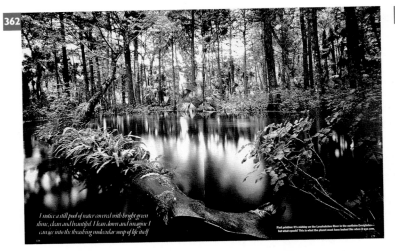

I notice a still pool of water covered with bright green slime, clean and beautiful. I lean down and imagine I can see into the thrashing molecular soup of life itself

AFRICA'S RACIAL HISTORY WAS NOT NECESSARILY ITS RACIAL DESTINY.
TO UNRAVEL THE STORY OF AFRICA'S PAST, YOU MUST NOT ONLY LOOK
AT ITS FACES, BUT LISTEN TO ITS LANGUAGES AND HARVEST ITS CROPS.

By Jared Diamond
PHOTOGRAPHS BY ANTONIN KRATOCHVIL

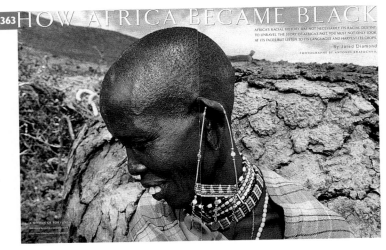

Out here, South Florida seems freshly emerged from the ocean, still dripping and draining back into the Gulf, as if the Ice Age had ended only yesterday

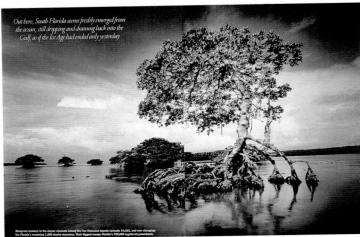

## Sex and the Brain

IN THE SUMMER OF 1991, NEUROBIOLOGIST SIMON LEVAY PUBLISHED
A SMALL STUDY ON A MINUTE PART OF THE HUMAN BRAIN. LITTLE
DID HE REALIZE IT WOULD CATAPULT HIM FROM HIS SCIENTIFIC
IVORY TOWER INTO THE HEATED FRAY OF HOMOSEXUAL POLITICS.

By David Nimmons
Photographs by Dan Winters

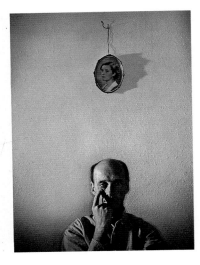

It's as if you are at sea and are standing upon a shimmering grassy plain that floats like the Sargasso between the firmament above and the firmament below

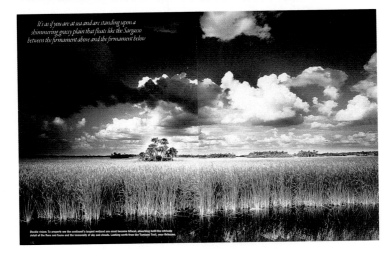

**362**

**Publication** Condé Nast Traveler
**Design Director** Diana LaGuardia
**Art Director** Christin Gangi
**Designer** Christin Gangi
**Photographer** Clyde Butcher
**Photo Editor** Kathleen Klech
**Publisher** Condé Nast Publications Inc.
**Date** September 1994
**Category** Story/Reportage & Travel

**363**

**Publication** Discover
**Art Director** David Armario
**Designer** David Armario
**Photographer** Antonin Kratochvil
**Photo Editor** John Barker
**Publisher** Walt Disney Magazine Publishing
**Date** February 1994
**Category** Spread/Reportage & Travel

**364**

**Publication** Discover
**Art Director** David Armario
**Designer** David Armario
**Photographer** Dan Winters
**Photo Editor** John Barker
**Publisher** Walt Disney Magazine Publishing
**Date** March 1994
**Category** Spread/Reportage & Travel

# DINING WITH THE SNAKES

Watching a python eat a rat is not a spectacle for the squeamish. But it is a lesson in some prodigious feats of physiology.

BY JARED DIAMOND

Photographs by David Liittschwager and Susan Middleton

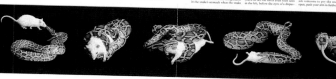

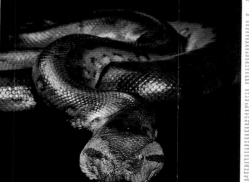

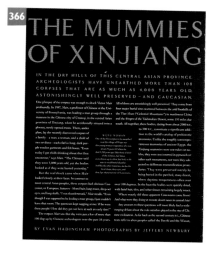

# THE MUMMIES OF XINJIANG

IN THE DRY HILLS OF THIS CENTRAL ASIAN PROVINCE, ARCHAEOLOGISTS HAVE UNEARTHED MORE THAN 100 CORPSES THAT ARE AS MUCH AS 4,000 YEARS OLD, ASTONISHINGLY WELL PRESERVED – AND CAUCASIAN.

BY EVAN HADINGHAM   PHOTOGRAPHS BY JEFFERY NEWBURY

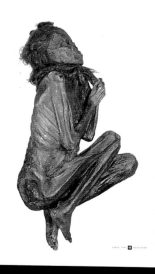

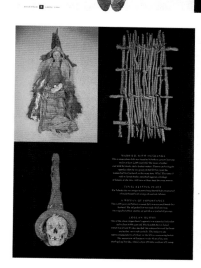

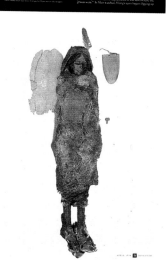

**365**

**Publication** Discover
**Art Director** David Armario
**Designer** David Armario
**Photographers** Susan Middleton, David Liittschwager
**Photo Editor** John Barker
**Publisher** Walt Disney Magazine Publishing
**Date** April 1994
**Category** Story/Reportage & Travel

**366**

**Publication** Discover
**Art Director** David Armario
**Designers** James Lambertus, David Armario
**Photographer** Jeffery Newbury
**Photo Editors** John Barker, Dawn Morishigre
**Publisher** Walt Disney Magazine Publishing
**Date** April 1994
**Category** Story/Reportage & Travel

Photography **MERIT**

# HORNE AGAIN

THE SAUCY GRANDE DAME OF SONG RETURNS— AND ON HER OWN TERMS

BY LISA SCHWARZBAUM

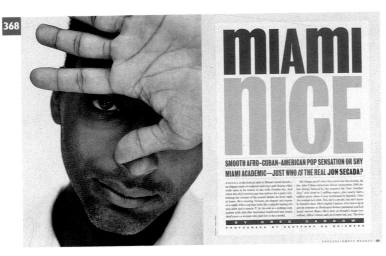

# MIAMI NICE

SMOOTH AFRO-CUBAN-AMERICAN POP SENSATION OR SHY MIAMI ACADEMIC—JUST WHO *IS* THE REAL JON SECADA?

BY GREG SANDOW
PHOTOGRAPH BY GEOFFROY DE BOISMENU

# Oscar '93

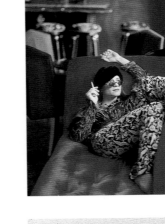
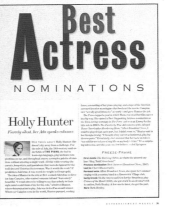

# Best Actress
NOMINATIONS

## Holly Hunter
*Fiercely silent, her Ada speaks volumes*

FREEZE-FRAME

# Behind the Scenes

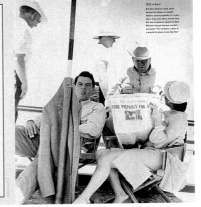

---

**367**

**Publication** Entertainment Weekly
**Design Director** Robert Newman
**Designer** Elizabeth Betts
**Photographer** Cleo Sullivan
**Photo Editors** Julie Mihaly, Doris Brautigan
**Publisher** Time Inc.
**Date** May 13, 1994
**Category** Spread/Still Life & Interiors

**368**

**Publication** Entertainment Weekly
**Design Director** Robert Newman
**Art Director** Jill Armus
**Designer** Michael Picon
**Photographer** Geoffroy de Boismenu
**Photo Editors** Michele Romero, Mary Dunn
**Publisher** Time Inc.
**Date** June 17, 1994
**Category** Story/Still Life & Interiors

**369**

**Publication** Entertainment Weekly
**Design Director** Michael Grossman
**Art Director** Don Morris
**Designers** Don Morris, James Reyman
**Photographer** Geoff Spear
**Photo Editor** Mary Dunn
**Publisher** Time Inc.
**Date** Special Issue
**Category** Story/Still Life & Interiors

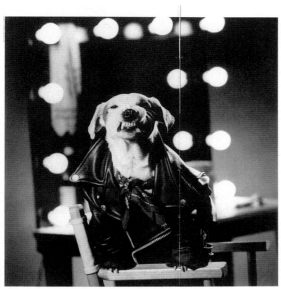

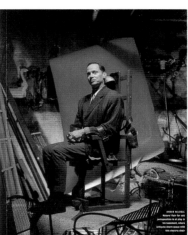

**370**

**Publication** Entertainment Weekly
**Design Director** Robert Newman
**Designer** Jill Armus
**Illustrator** Blake Little
**Photo Editors** Debbe Edelstein, Michael Kochman
**Publisher** Time Inc.
**Date** May 20, 1994
**Category** Spread/Still Life & Interiors

**371**

**Publication** Entertainment Weekly
**Design Director** Robert Newman
**Art Director** Elizabeth Betts
**Photographer** Paul Fusco
**Photo Editors** Michele Romero, Mark Jacobson
**Publisher** Time Inc.
**Date** Special Issue
**Category** Spread/Reportage & Travel

**372**

**Publication** Entertainment Weekly
**Design Director** Robert Newman
**Designer** Elizabeth Betts
**Photographer** Andrew Brusso
**Photo Editors** Ramiro Fernandez, Mary Dunn
**Publisher** Time Inc.
**Date** April 29, 1994
**Category** Spread/Still Life & Interiors

# So Fiennes

With the starring role in Quiz Show,
Ralph Fiennes—rhymes with
"shines"—has moved from Schindler's List
to Hollywood's A-list

By Lucy Kaylin

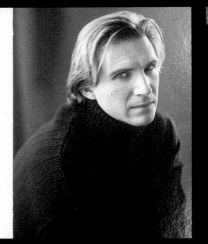

# Blown Away

If this is
the last
thing you
ever see,
then you
will, in
your final
moments,
understand
that the
handgun
exists for
one very
simple
purpose

Stories by Tom Junod, Scott Raab and Peter Richmond
Photographs by Dan Winters

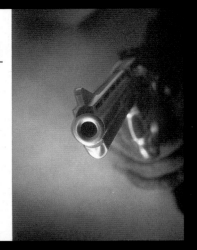

## The Black Talon

Winchester built the best bullet in history.
It's not Winchester's fault that Jason White and
Marilyn Leath were murdered with it

By Peter Richmond

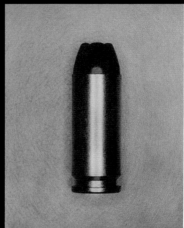

## The Guilty Party

Kevin did nothing wrong. He defended himself.
He knows this. But Kevin can't stop hearing that
boy scream, just before he died

By Scott Raab

---

**373**

**Publication** GQ
**Art Director** Robert Priest
**Designer** Dina White
**Photographer** Gregory Heisler
**Photo Editor** Karen Frank
**Publisher** Condé Nast Publications Inc.
**Date** August 1994
**Category** Story/Reportage & Travel

**374**

**Publication** GQ
**Art Director** Robert Priest
**Designer** Laura Harrigan
**Photographer** Dan Winters
**Photo Editor** Karen Frank
**Publisher** Condé Nast Publications Inc.
**Date** July 1994
**Category** Story/Still Life & Interiors

# SKIN CRIMES
## THE RISKS WE TAKE, THE PRICE WE PAY.

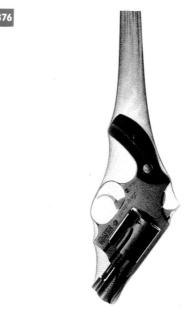

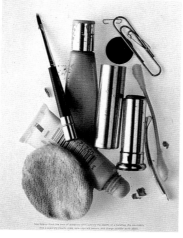

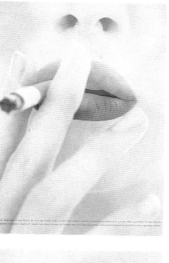

**Publication** Harper's Bazaar
**Creative Director** Fabien Baron
**Art Director** Joel Berg
**Designer** Johan Svensson
**Photographer** Raymond Meier
**Publisher** The Hearst Corporation-Magazines Division
**Date** May 1994
**Category** Story/Still Life & Interiors

**Publication** Harper's Bazaar
**Creative Director** Fabien Baron
**Art Director** Joel Berg
**Designer** Johan Svensson
**Photographer** Raymond Meier
**Publisher** The Hearst Corporation-Magazines Division
**Date** February 1994
**Category** Single Page

**Publication** Harper's Bazaar
**Creative Director** Fabien Baron
**Art Director** Joel Berg
**Designer** Johan Svensson
**Photographer** Raymond Meier
**Publisher** The Hearst Corporation-Magazines Division
**Date** March 1994
**Category** Single Page

Photography **MERIT**

185

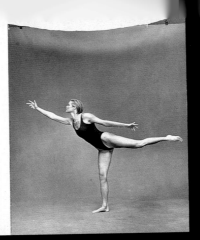

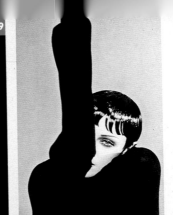

## states of grace

Their flesh has the old divine suppleness and strength,
They know how to swim, row, ride, wrestle, shoot, run, strike, retreat, advance, resist, defend themselves,
They are ultimate in their own right—they are calm, clear, well possess'd of themselves.
—Walt Whitman, Leaves of Grass

By Peter de Jonge
Photographed by Wayne Maser

### Madonna makes dance!
Primally sexual, stripped down and muscular, Martha Graham's aesthetic is here made eternally new by Madonna, who recalls her first meeting with the legend. Photographed by Peter Lindbergh

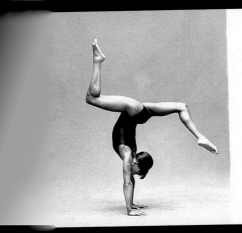

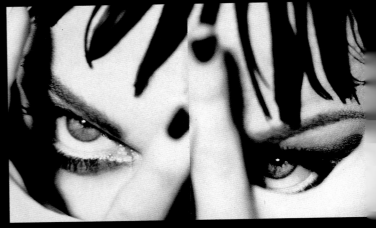

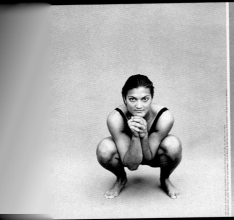

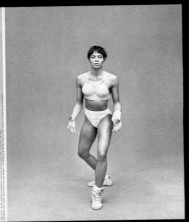

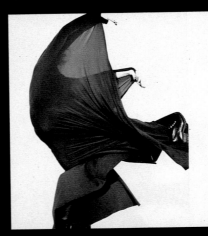

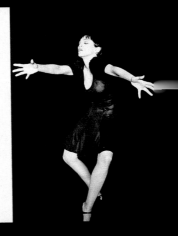

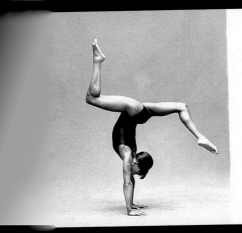

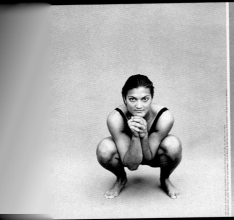

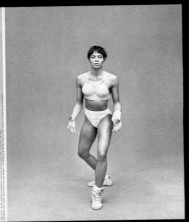

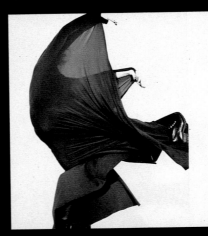

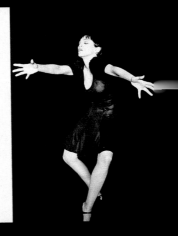

**378**

**Publication** Harper's Bazaar
**Creative Director** Fabien Baron
**Art Director** Joel Berg
**Designer** Johan Svensson
**Photographer** Wayne Maser
**Publisher** The Hearst Corporation-Magazines Division
**Date** May 1994

**379**

**Publication** Harper's Bazaar
**Creative Director** Fabien Baron
**Art Director** Joel Berg
**Designer** Johan Svensson
**Photographer** Peter Lindbergh
**Publisher** The Hearst Corporation-Magazines Division
**Date** May 1994

Window Shopping

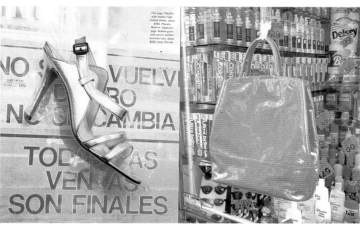

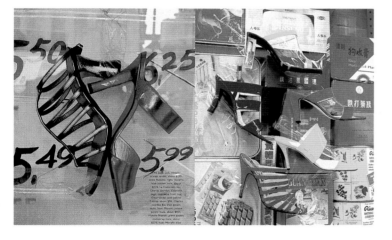

Hanging Out

For one crazy, glitzy, gritty day, artist
Jack Pierson photographed Naomi Campbell
as they roamed downtown Manhattan.
By Jim Lewis

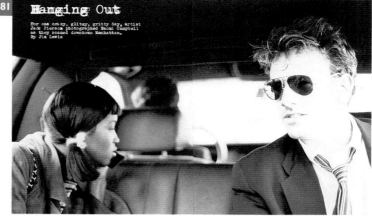

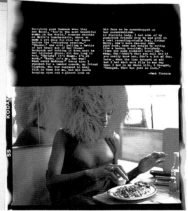

**380**

**Publication** Harper's Bazaar
**Creative Director** Fabien Baron
**Art Director** Johan Svensson
**Photographer** Raymond Meier
**Publisher** The Hearst Corporation-Magazines Division
**Date** December 1994
**Category** Story/Still Life & Interiors

**381**

**Publication** Harper's Bazaar
**Creative Director** Fabien Baron
**Art Director** Joel Berg
**Designer** Johan Svensson
**Photographer** Jack Pierson
**Publisher** The Hearst Corporation-Magazines Division
**Date** June 1994
**Category** Story/Fashion & Beauty

# White hot

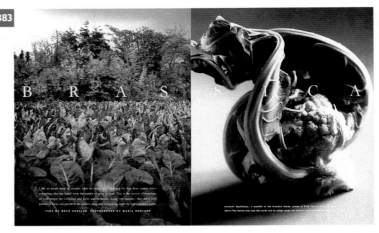

**382**

**Publication** House Beautiful
**Art Director** Andrzej Janerka
**Designers** Andrzej Janerka, Jennifer Carling
**Photographer** Mary Ellen Bartley
**Publisher** The Hearst Corporation-Magazines Division
**Date** February 1994
**Category** Story/Still Life & Interiors

**383**

**Publication** Martha Stewart Living
**Art Director** Gael Towey
**Designer** Claudia Bruno
**Photographer** Maria Robledo
**Photo Editor** Heidi Posner
**Date** November 1994
**Category** Story/Still Life & Interiors

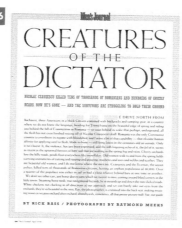
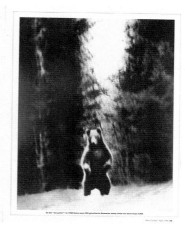

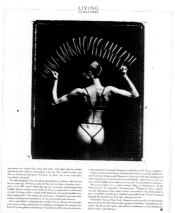
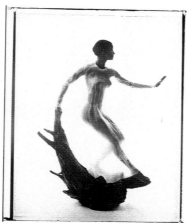
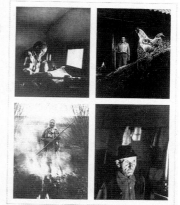

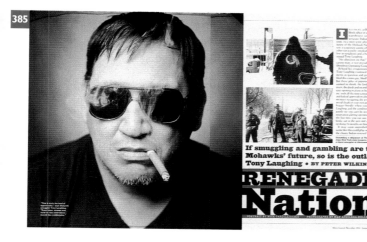
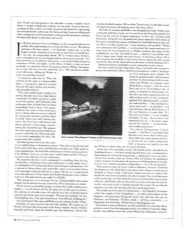

**384**

**Publication** Men's Journal
**Art Director** Mark Danzig
**Designer** Mark Danzig
**Photographer** George Holz
**Photo Editor** Donna Bender
**Publisher** Wenner Media
**Date** April 1994
**Category** Story/Fashion & Beauty

**385**

**Publication** Men's Journal
**Art Director** Mark Danzig
**Designer** Mark Danzig
**Photographer** Nick Cardillicchio
**Photo Editor** Deborah Needleman
**Publisher** Wenner Media
**Date** December 1994/January 1995
**Category** Spread/Reportage & Travel

**386**

**Publication** Men's Journal
**Art Director** Mark Danzig
**Designer** Mark Danzig
**Photographer** Raymond Meeks
**Photo Editor** Allyson M. Torrisi
**Publisher** Wenner Media
**Date** April 1994
**Category** Story/Reportage & Travel

The world of the Old Colony Mennonites is a well-preserved slice of 16th century life. Rejecting progress as ungodly, living in a closed society, the faithful dress, work, speak and worship like Germans of the Reformation era. To preserve their way of life, they fled from Europe to Canada in the last century, then moved on to Mexico in the 1920s. There they farmed in biblical simplicity until drought and cheap U.S. produce killed their livelihood. Looking for jobs, hundreds of destitute families have now returned to Canada, where many toil in the fields for third-world wages. Larry Towell has documented on film this latest stage in their

# ENDLESS EXODUS

# Living in the Valley of the Shadow

Photography by Scott Thode

These are the faces—and the voices—of ordinary Americans with AIDS.

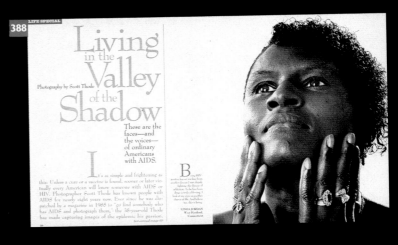

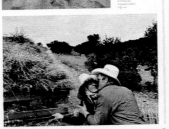
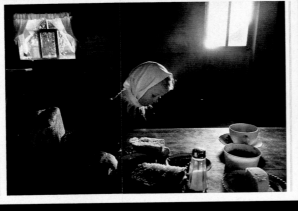

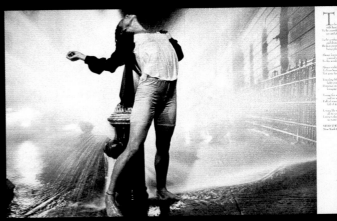

---

## 387

**Publication** Life
**Design Director** Tom Bentkowski
**Designers** Tom Bentkowski, Mimi Park
**Photographer** Larry Towell
**Photo Editor** David Friend
**Publisher** Time Inc.
**Date** October 1994
**Category** Story/Reportage & Travel

## 388

**Publication** Life
**Design Director** Tom Bentkowski
**Designer** Jean Andreuzzi
**Photographer** Scott Thode
**Photo Editor** David Friend
**Publisher** Time Inc.
**Date** February 1994
**Category** Story/Reportage & Travel

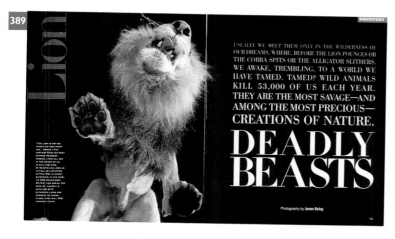

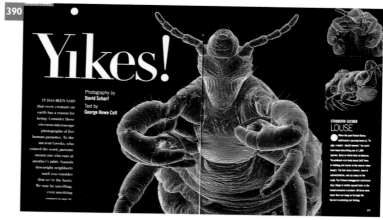

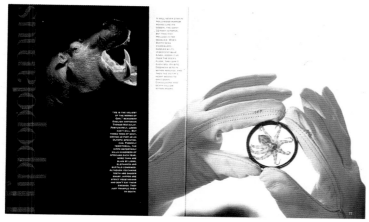

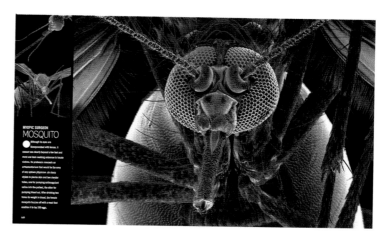

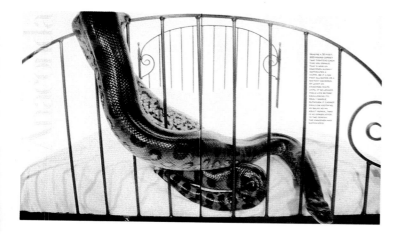

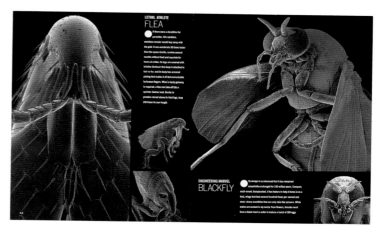

Photography MERIT

**Publication** Life
**Design Director** Tom Bentkowski
**Designer** Mimi Park
**Photographer** James Balog
**Photo Editor** David Friend
**Publisher** Time Inc.
**Date** March 1994
**Category** Story/Reportage & Travel

**Publication** Life
**Design Director** Tom Bentkowski
**Designer** Mimi Park
**Photographer** David Scharf
**Photo Editor** Barbara Baker Burrows
**Publisher** Time Inc.
**Date** May 1994
**Category** Story/Reportage & Travel

**391** WOODSTOCK

A silver anniversary portfolio of the musicians who presided at the festival of peace and love

# Back to the Garden

They're 25 years older now—but still trying to live the dream.

Photography by Gregory Heisler
Interviews by Josh Simon

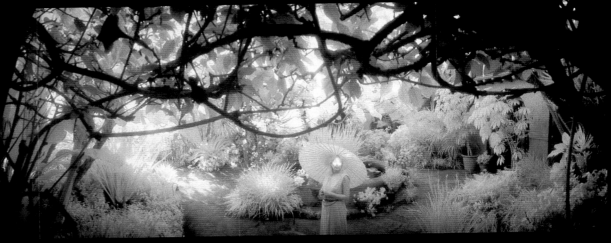

**391**

**Publication** Life
**Design Director** Tom Bentkowski
**Designer** Marti Golon
**Photographer** Gregory Heisler
**Photo Editor** David Friend
**Publisher** Time Inc.
**Date** August 1994
**Category** Story/Reportage & Travel

**392**

**Publication** Life
**Design Director** Tom Bentkowski
**Designer** Marti Golon
**Photographer** Andy Levin
**Photo Editor** David Friend
**Publisher** Time Inc.
**Date** November 1994
**Category** Spread/Reportage & Travel

192

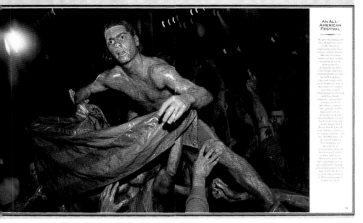

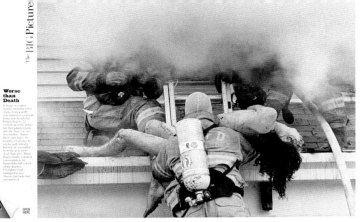

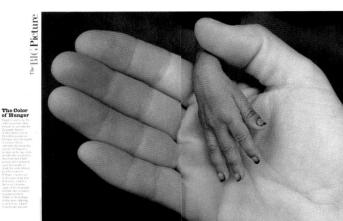

**393**

**Publication** Life
**Design Director** Tom Bentkowski
**Designer** Mimi Park
**Photographer** Matt Mahurin
**Photo Editor** David Friend
**Publisher** Time Inc.
**Date** February 1994
**Category** Spread/Photo Illustration

**394**

**Publication** Life
**Design Director** Tom Bentkowski
**Designer** Jean Andreuzzi
**Photographer** Glenn Hartong
**Photo Editor** Barbara Baker Burrows
**Publisher** Time Inc.
**Date** November 1994
**Category** Spread/Reportage & Travel

**395**

**Publication** Life
**Design Director** Tom Bentkowski
**Designer** Marti Golon
**Photographer** Odd R. Anderson
**Photo Editors** Barbara Baker Burrows, Lee Dudley
**Publisher** Time Inc.
**Date** November 1994

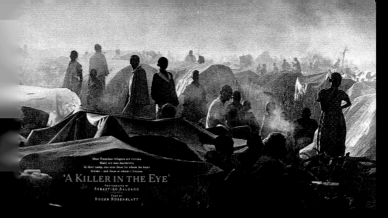

'A KILLER IN THE EYE'

PHOTOGRAPHS BY
SEBASTIÃO SALGADO

TEXT BY
ROGER ROSENBLATT

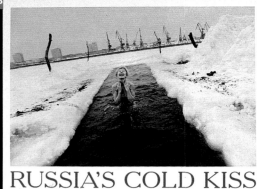

# RUSSIA'S COLD KISS

Out of the degradation of daily life comes a yearning for transcendence and spirituality. PHOTOGRAPHS BY ELLEN BINDER

## TAKING HAITI

Photographers and television crews have launched their own invasion. Aiming and shooting, they frame our perceptions and become more than witnesses.

Photographs by ALEX WEBB
Text by DAVID C. UNGER

**396**
**Publication** The New York Times Magazine
**Art Director** Janet Froelich
**Designer** Petra Mercker
**Photographer** Sebastiao Salgado
**Photo Editor** Kathy Ryan
**Publisher** The New York Times
**Date** May 5, 1994
**Category** Spread/Reportage & Travel

**397**
**Publication** The New York Times Magazine
**Art Director** Janet Froelich
**Designer** Nancy Harris
**Photographer** Alex Webb
**Photo Editor** Kathy Ryan
**Publisher** The New York Times
**Date** October 23, 1994
**Category** Spread/Reportage & Travel

**398**
**Publication** The New York Times Magazine
**Art Director** Janet Froelich
**Designer** Nancy Harris
**Photographer** Ellen Binder
**Photo Editor** Kathy Ryan
**Publisher** The New York Times
**Date** May 1, 1994
**Category** Spread/Reportage & Travel

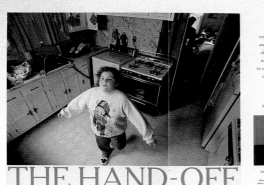

Within five years, AIDS will have created some 100,000 orphans, and Christy Mirach will be one of them. But Evelyn Mirach is not leaving her daughter's fate to chance: The two go on a search to find another mother, good enough for Christy.

BY TED CONOVER
PHOTOGRAPHS BY SCOTT THODE

# THE HAND-OFF

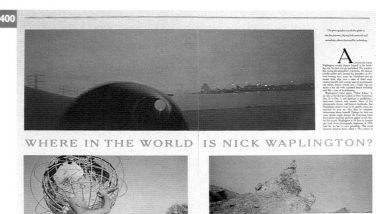

## WHERE IN THE WORLD | IS NICK WAPLINGTON?

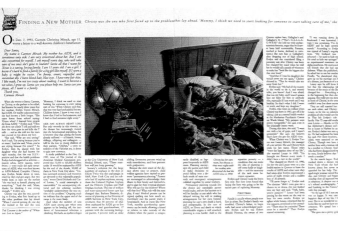

FINDING A NEW MOTHER

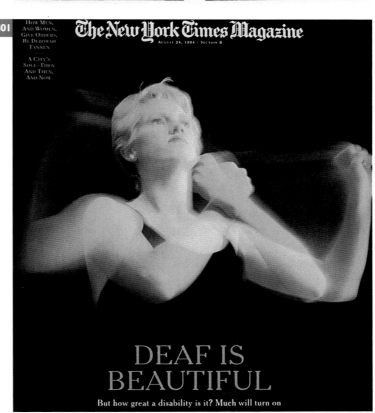

HOW MEN,
AND WOMEN,
GIVE ORDERS,
BY DEBORAH
TANNEN

A CITY'S
SOUL—THEN
AND THEN,
AND NOW

# The New York Times Magazine
AUGUST 28, 1994 / SECTION 6

# DEAF IS BEAUTIFUL

But how great a disability is it? Much will turn on

Photography MERIT

---

**Publication** The New York Times Magazine
**Art Director** Janet Froelich
**Designer** Petra Mercker
**Photographer** Scott Thode
**Photo Editor** Kathy Ryan
**Publisher** The New York Times
**Date** May 8, 1994
**Category** Story/Reportage & Travel

**Publication** The New York Times Magazine
**Art Director** Janet Froelich
**Designer** Joel Cuyler
**Photographer** Nick Waplington
**Photo Editor** Kathy Ryan
**Publisher** The New York Times
**Date** May 5, 1994
**Category** Spread/Reportage & Travel

**Publication** The New York Times Magazine
**Art Director** Janet Froelich
**Photographer** Christian Witkin
**Photo Editor** Kathy Ryan
**Publisher** The New York Times
**Date** August 28, 1994
**Category** Single Page

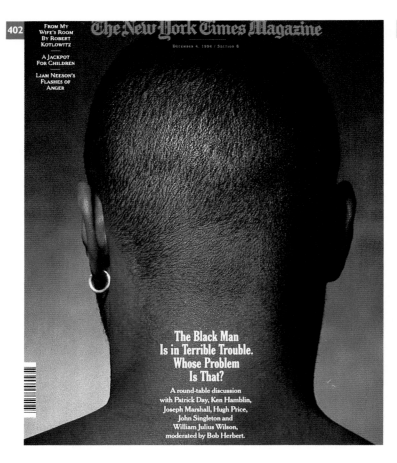

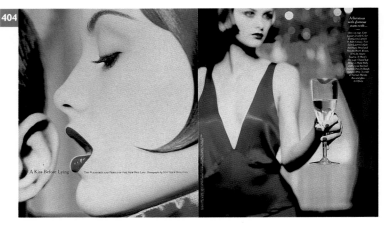

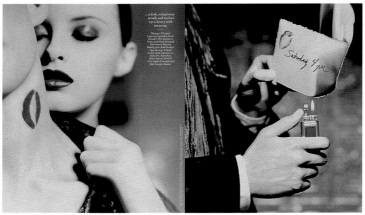

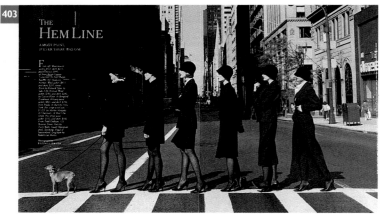

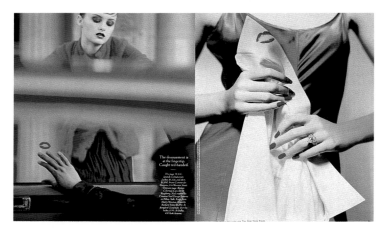

**402**

**Publication** The New York Times Magazine
**Art Director** Janet Froelich
**Designers** Janet Froelich, Lisa Naftolin
**Photographer** Albert Watson
**Photo Editor** Kathy Ryan
**Publisher** The New York Times
**Date** December 4, 1994
**Category** Cover

**403**

**Publication** The New York Times Magazine
**Art Director** Janet Froelich
**Designer** Catherine Gilmore-Barnes
**Photographer** Rodney Smith
**Publisher** The New York Times
**Date** October 30, 1994
**Category** Spread/Fashion & Beauty

**404**

**Publication** The New York Times Magazine
**Art Director** Janet Froelich
**Designer** Lisa Naftolin
**Illustrator** Lisa Naftolin
**Photographer** Mathew Rolston
**Photo Editor** Kathy Ryan
**Publisher** The New York Times
**Date** August 11, 1994
**Category** Story/Fashion & Beauty

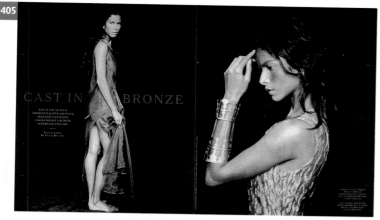

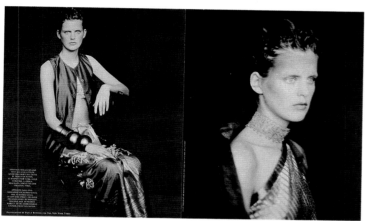

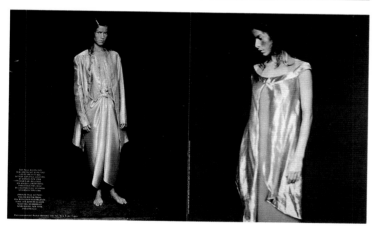

**405**

**Publication** The New York Times Magazine
**Art Director** Janet Froelich
**Photographer** Paolo Roversi
**Publisher** The New York Times
**Date** May 8, 1994
**Category** Story/Fashion & Beauty

**406**

**Publication** The New York Times Magazine
**Art Director** Janet Froelich
**Designer** Lisa Naftolin
**Photographer** Sarah Moon
**Photo Editor** Sarah Moon
**Publisher** The New York Times
**Date** October 9, 1994
**Category** Story/Fashion & Beauty

# The Storm

SIX YOUNG MEN SET OUT ON A DEAD-CALM SEA TO SEEK THEIR FORTUNES.
SUDDENLY THEY WERE HIT BY THE WORST GALE IN A CENTURY,
AND THERE WASN'T EVEN TIME TO SHOUT. By Sebastian Junger

Photographs by Raymond Meeks

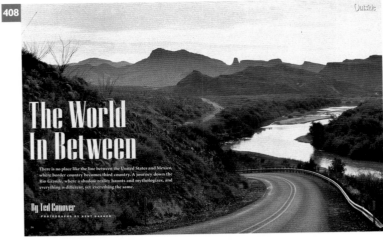

# The World In Between

There is no place like the line between the United States and Mexico,
where border country becomes third country. A journey down the
Rio Grande, where a shadow reality haunts and mythologizes, and
everything is different, yet everything is the same.

## By Ted Conover

PHOTOGRAPHS BY KENT BARKER

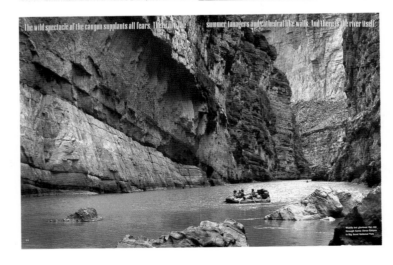

The wild spectacle of the canyon supplants all fears. There are the summer tanagers and cathedral-like walls. And there is the river itself.

---

**407**

**Publication** Outside
**Art Director** Susan Casey
**Designer** Susan Casey
**Photographer** Raymond Meeks
**Photo Editor** Susan Smith
**Publisher** Mariah Media
**Date** October 1994
**Category** Story/Reportage & Travel

**408**

**Publication** Outside
**Art Director** Susan Casey
**Designer** Susan Casey
**Photographer** Kent Barker
**Photo Editor** Susan Smith
**Publisher** Mariah Media
**Date** December 1994
**Category** Story/Reportage & Travel

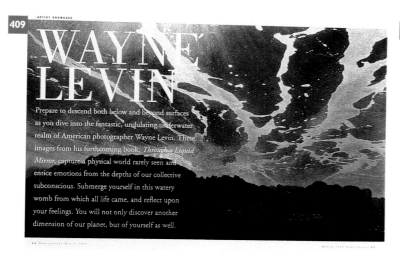

# WAYNE LEVIN

Prepare to descend both below and beyond surfaces as you dive into the fantastic, undulating underwater realm of American photographer Wayne Levin. These images from his forthcoming book, *Through a Liquid Mirror*, capture a physical world rarely seen and entice emotions from the depths of our collective subconscious. Submerge yourself in this watery womb from which all life came, and reflect upon your feelings. You will not only discover another dimension of our planet, but of yourself as well.

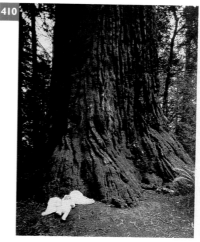

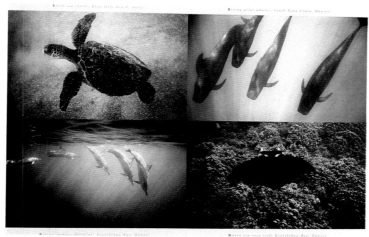

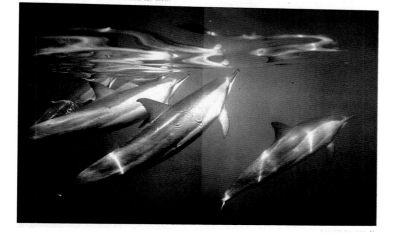

Logged or loved, the earth's oldest, noblest trees may outlive all our quarrels over them

## Redwoods Forever

by PAUL BURKA · photographed by KAREN KUEHN

## In Harmony

IN CAPTURING AN ENCOUNTER AND CREATING AN IMAGE, photographers can literally stop time, transforming a fleeting moment of ordinary life into something permanent and extraordinary. A truly peaceful place can affect us in a similar way, overshadowing our petty cares and linking us to something large and unforgettable. Accordingly, we asked 11 fine photographers for pictures of their most peaceful moments. On these pages, their selections and comments are as various as the places they photographed. From the Supreme Court Building to a Buddhist sanctuary overlooking Da Nang, from a deserted French garden to a Chinese grandfather's protective hand, these pictures share a sense of connection, a harmony created between the photographer and the image—and now, between the image and you.

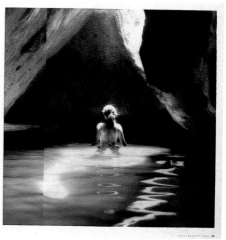

Photography MERIT

---

**Publication** Hemispheres
**Art Directors** Jaimey Easler, Greg Hausler
**Designer** Jaimey Easler
**Photographer** Wayne Levin
**Photo Editor** Aubrey Simpson
**Publisher** Pace Communications
**Date** March 1994
**Category** Story/Reportage & Travel

**Publication** Travel Holiday
**Art Director** Lou Dilorenzo
**Designer** Diane Bertolo
**Photographer** Karen Kuehn
**Photo Editor** Bill Black
**Date** April 1994
**Category** Spread/Reportage & Travel

**Publication** Travel Holiday
**Art Director** Lou Dilorenzo
**Designer** Diane Bertolo
**Photographer** Sally Gall
**Photo Editors** Bill Black, Stephanie Syrop
**Date** July/August 1994
**Category** Spread/Reportage & Travel

# "WE GET ALL HYPED UP, WE DO A DRIVE-BY" A REPORT FROM THE FRONT LINES OF THE SAN ANTONIO GANG WARS.

BY AUDREY DUFF

PHOTOGRAPHS BY DAN WINTERS

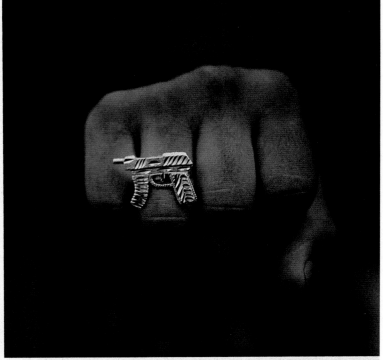

IT'S ONE-FIFTEEN IN THE MORNING ON A Sunday in May. At the Alazan Apache Courts, one of San Antonio's toughest housing projects, seven teenage boys wearing designer jeans and polo shirts huddle behind the fence and garbage dumpster that separate the rear courtyard from the street. The boys crack jokes and suck down forty-ounce bottles of malt liquor.

The cover is decent here. They can see the street through the fence, and they have memorized every car in the neighborhood and its owner. Anyone cruising by looking to shoot somebody would have difficulty aiming into the shadows of the Courts. The boys, ranging in age from sixteen to eighteen, are members of three different gangs that get along—usually. They

**LAST YEAR, THERE WERE 3.5 DRIVE-BY SHOOTINGS A DAY IN SAN ANTONIO. SAYS A POLICEMAN: "PEOPLE ARE AFRAID TO GO OUTSIDE."**

lean against the dumpster or sit with their backs against a concrete wall. Just blocks away live their "enemies," members of rival gangs from neighboring housing projects: the Cassiano Homes, the San Juan Homes, the Villa Veramendi, and the Victoria Courts, all warring fiefdoms clustered on San Antonio's West Side.

"You always got to watch your back," says one of the boys, a sixteen-year-old who joined his first gang when he was eleven. He chats amiably about what he and his friends do for fun. "We get really drunk," he says. "We get all hyped up, and we do a drive-by or something like that."

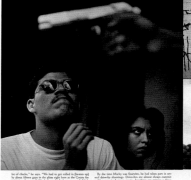

**412**

**Publication** Texas Monthly
**Art Director** D.J. Stout
**Designers** D.J. Stout, Nancy E. McMillen
**Photographer** Dan Winters
**Photo Editors** D.J. Stout, Nancy E. McMillen
**Publisher** Texas Monthly
**Date** October 1994
**Category** Story/Reportage & Travel

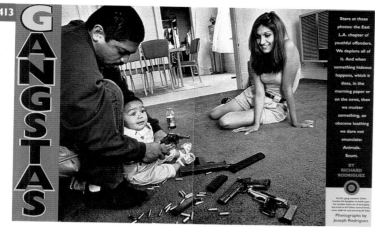

**413** GANGSTAS

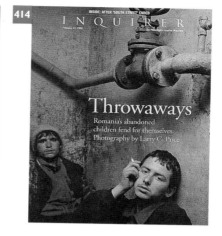

**414** INQUIRER

Throwaways
Romania's abandoned
children fend for themselves.
Photography by Larry C. Price

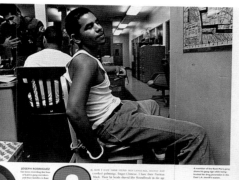

DESPERATE FOR FOOD AND
SHELTER, ROMANIA'S
"THROWAWAY" CHILDREN
LIVE BY THEIR OWN RULES.

WHAT IT
TAKES
TO
SURVIVE

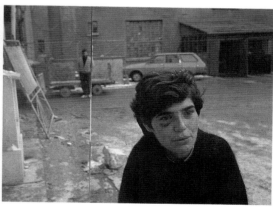

Photography MERIT

**413**

**Publication** Mother Jones
**Creative Director** Kerry Tremain
**Design Director** Marsha Sessa
**Designer** Marsha Sessa
**Photographer** Joseph Rodriguez
**Publisher** Foundation For National Progress
**Date** January/February 1994
**Category** Story/Reportage & Travel

**414**

**Publication** Philadelphia Inquirer Magazine
**Design Director** Chrissy Dunleavy
**Art Director** Bert Fox
**Designer** Bert Fox
**Photographer** Larry C. Price
**Photo Editor** Bert Fox
**Publisher** Philadelphia Inquirer
**Date** February 13, 1994
**Category** Story/Reportage & Travel

201

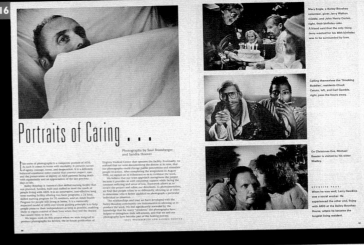

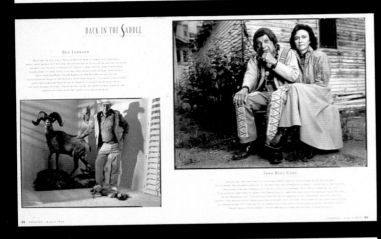

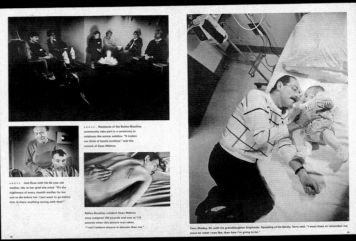

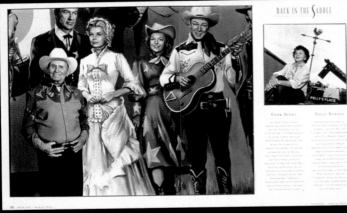

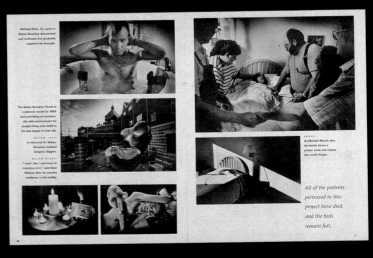

**415**

**Publication** Premiere
**Art Director** John Korpics
**Designer** John Korpics
**Photographer** Mary Ellen Mark
**Photo Editor** Charlie Holland
**Publisher** K-III Magazines
**Date** March 1994
**Category** Story/Reportage & Travel

**416**

**Publication** Outtakes
**Photographers** Sandra Hoover, Saul Bromberger
**Photo Editor** Peter Howe
**Company** Peter Howe Inc.
**Category** Story/Reportage & Travel

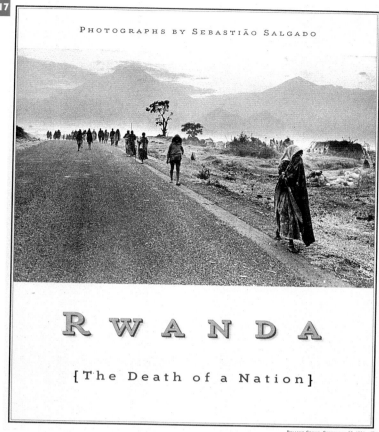

PHOTOGRAPHS BY SEBASTIÃO SALGADO

# R W A N D A

{The Death of a Nation}

Rolling Stone, September 22, 1994 · 67

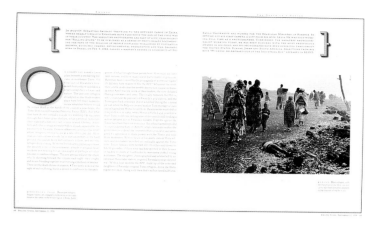

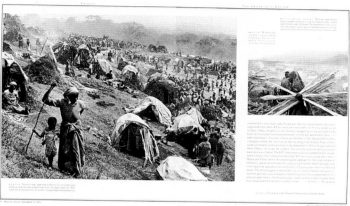

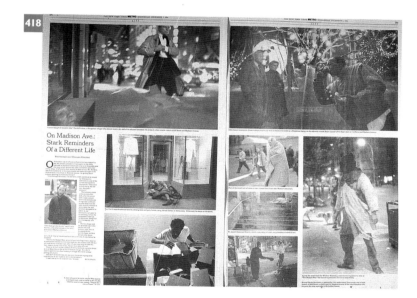

On Madison Ave.: Stark Reminders Of a Different Life

**Publication** Rolling Stone
**Art Director** Fred Woodward
**Designer** Fred Woodward
**Photographer** Sebastiao Salgado
**Photo Editor** Jodi Peckman
**Publisher** Wenner Media
**Date** September 22, 1994
**Category** Story/Reportage & Travel

**Publication** The New York Times
**Art Director** Margaret O'Connor
**Photographer** Edward Keating
**Photo Editor** Mark Bussell
**Publisher** The New York Times
**Date** December 7, 1994

203

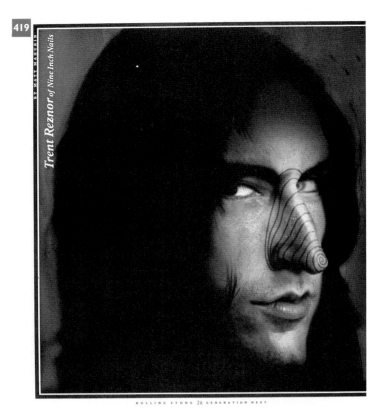

419 *Trent Reznor* of *Nine Inch Nails*

BY MATT MAHURIN

ROLLING STONE 28 GENERATION NEXT

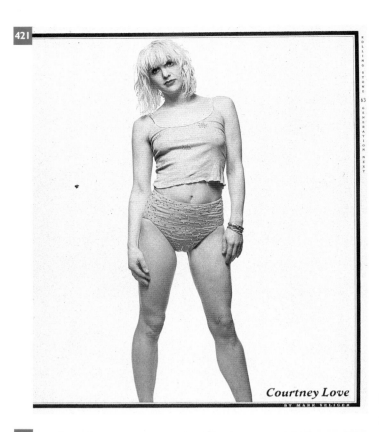

421 *Courtney Love*

BY MARK SELIGER

ROLLING STONE 63 GENERATION NEXT

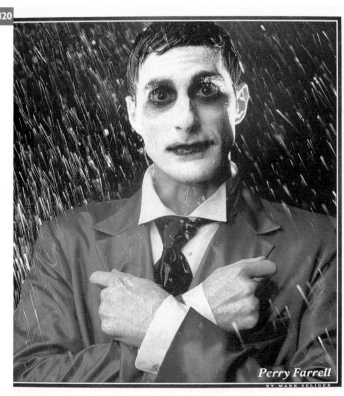

420 *Perry Farrell*

BY MARK SELIGER

ROLLING STONE 27 GENERATION NEXT

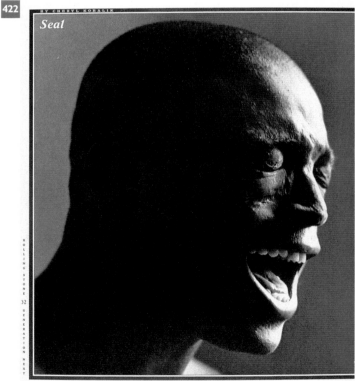

422 *Seal*

BY CHERYL KORALIK

ROLLING STONE 32 GENERATION NEXT

**419**

**Publication** Rolling Stone
**Art Director** Fred Woodward
**Designers** Fred Woodward, Gail Anderson, Geraldine Hessler, Lee Bearson
**Photographer** Matt Mahurin
**Photo Editors** Jodi Peckman, Denise Sfraga
**Publisher** Wenner Media
**Date** November 17, 1994
**Category** Single Page

**420**

**Publication** Rolling Stone
**Art Director** Fred Woodward
**Designers** Fred Woodward, Gail Anderson, Geraldine Hessler, Lee Bearson
**Photographer** Mark Seliger
**Photo Editors** Jodi Peckman, Denise Sfraga
**Publisher** Wenner Media
**Date** November 17, 1994
**Category** Single Page

**421**

**Publication** Rolling Stone
**Art Director** Fred Woodward
**Designers** Fred Woodward, Gail Anderson, Geraldine Hessler, Lee Bearson
**Photographer** Mark Seliger
**Photo Editor** Jodi Peckman
**Publisher** Wenner Media
**Date** December 15, 1994
**Category** Single Page

204

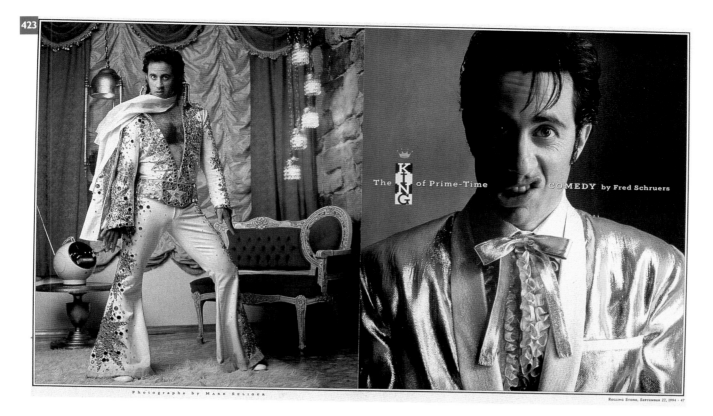

Photographs by MARK SELIGER

The KING of Prime-Time COMEDY by Fred Schruers

ROLLING STONE, SEPTEMBER 22, 1994 · 47

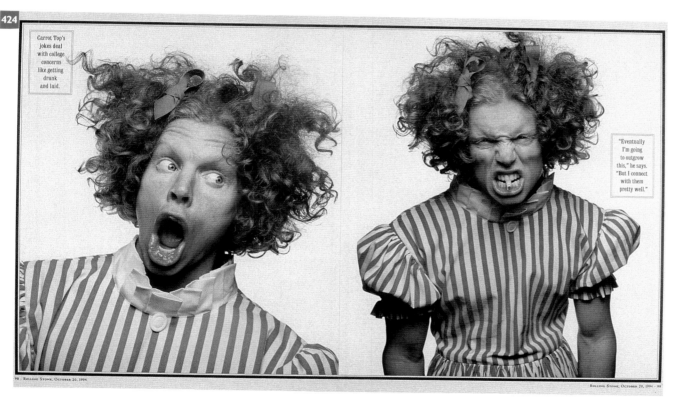

Carrot Top's jokes deal with college concerns like getting drunk and laid.

"Eventually I'm going to outgrow this," he says. "But I connect with them pretty well."

98 · ROLLING STONE, OCTOBER 20, 1994

ROLLING STONE, OCTOBER 20, 1994 · 99

**422**

**Publication** Rolling Stone
**Art Director** Fred Woodward
**Designers** Fred Woodward, Gail Anderson, Geraldine Hessler, Lee Bearson
**Photographer** Cheryl Koralik
**Photo Editors** Jodi Peckman, Denise Sfraga
**Publisher** Wenner Media
**Date** November 11, 1994
**Category** Single Page

**423**

**Publication** Rolling Stone
**Art Director** Fred Woodward
**Designers** Fred Woodward, Gail Anderson
**Photographer** Mark Seliger
**Photo Editor** Jodi Peckman
**Publisher** Wenner Media
**Date** September 22, 1994
**Categories** Story/Still Life & Interiors
Single Pages

**424**

**Publication** Rolling Stone
**Art Director** Fred Woodward
**Photographer** Mark Seliger
**Photo Editor** Jodi Peckman
**Publisher** Wenner Media
**Date** October 20, 1994
**Category** Story/Still Life & Interiors

Photography MERIT

205

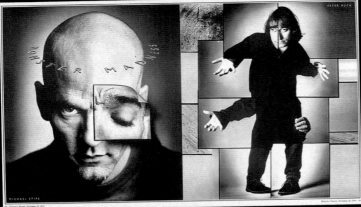

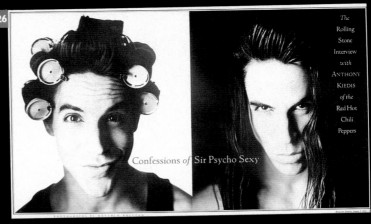

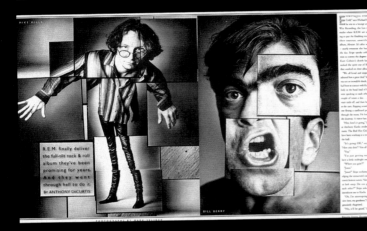

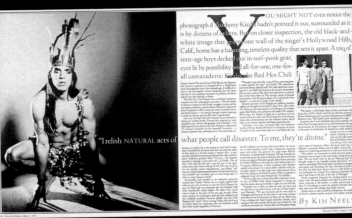

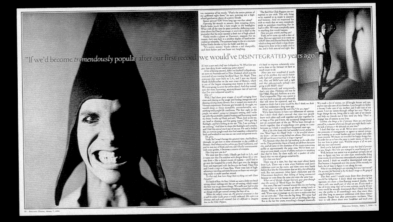

425

**Publication** Rolling Stone
**Art Director** Fred Woodward
**Designer** Fred Woodward
**Photographer** Mark Seliger
**Photo Editor** Jodi Peckman
**Publisher** Wenner Media
**Date** October 20, 1994
**Category** Story/Still Life & Interiors

426

**Publication** Rolling Stone
**Art Director** Fred Woodward
**Designers** Fred Woodward, Geraldine Hessler
**Photographer** Matthew Rolston
**Photo Editor** Jodi Peckman
**Publisher** Wenner Media
**Date** April 7, 1994
**Category** Story/Still Life & Interiors

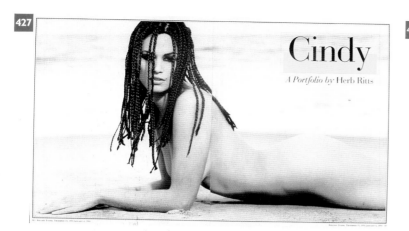

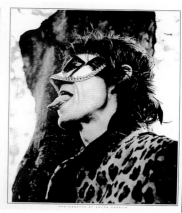

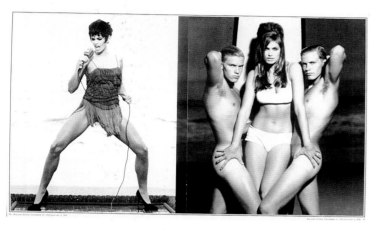

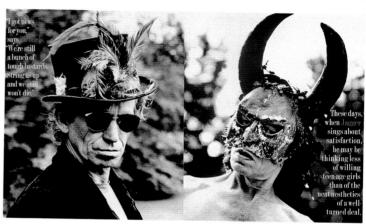

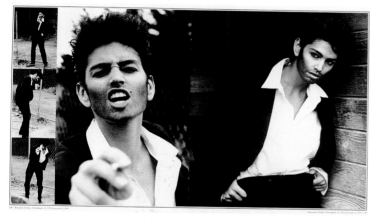

**427**

**Publication** Rolling Stone
**Art Director** Fred Woodward
**Designer** Fred Woodward
**Photographer** Herb Ritts
**Photo Editor** Jodi Peckman
**Publisher** Wenner Media
**Date** December 23 1994
**Category** Story/Still Life & Interiors

**428**

**Publication** Rolling Stone
**Art Director** Fred Woodward
**Designers** Fred Woodward, Lee Bearson
**Photographer** Anton Corbijn
**Photo Editor** Jodi Peckman
**Publisher** Wenner Media
**Date** August 25, 1994
**Category** Story/Still Life & Interiors

Photography MERIT

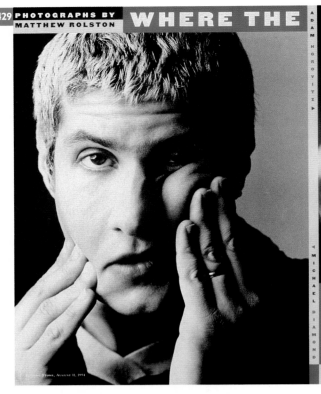
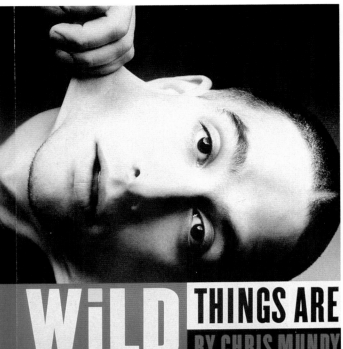

# WHERE THE WILD THINGS ARE

BY CHRIS MUNDY

THE BEASTIE BOYS BECOME KINGS OF THEIR OWN URBANE JUNGLE

YAUCH, DIAMOND, HOROVITZ (CLOCKWISE FROM TOP) IN 1986

"I THINK WE'RE CREATIVE," SAYS HOROVITZ. "BUT MASTER MINDS? NO."

---

**429**

**Publication**  Rolling Stone
**Art Director**  Fred Woodward
**Designers**  Fred Woodward, Geraldine Hessler
**Photographer**  Matthew Rolston
**Photo Editor**  Jodi Peckman
**Publisher**  Wenner Media
**Date**  August 11, 1994
**Category**  Story/Still Life & Interiors

**430**

**Publication**  Rolling Stone
**Art Director**  Fred Woodward
**Designers**  Fred Woodward, Geraldine Hessler
**Photographer**  Albert Watson
**Photo Editor**  Jodi Peckman
**Publisher**  Wenner Media
**Date**  November 3, 1994
**Category**  Story/Still Life & Interiors

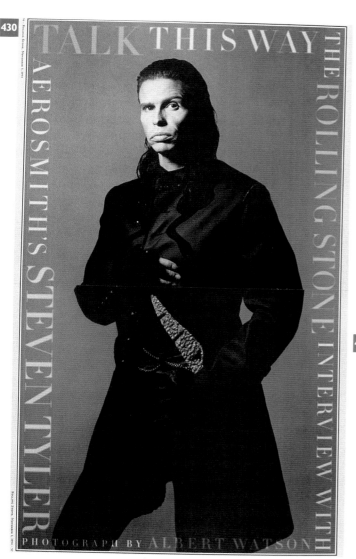

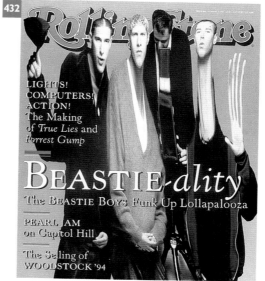

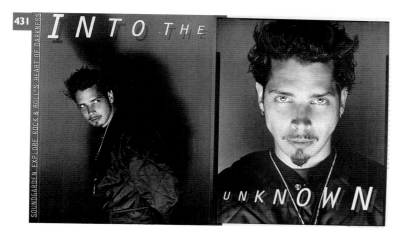

**Publication** Rolling Stone
**Art Director** Fred Woodward
**Designers** Fred Woodward, Geraldine Hessler
**Photographer** Mark Seliger
**Photo Editor** Jodi Peckman
**Publisher** Wenner Media
**Date** June 16, 1994
**Category** Story/Still Life & Interiors

**Publication** Rolling Stone
**Art Director** Fred Woodward
**Designer** Fred Woodward
**Photographer** Matthew Rolston
**Photo Editor** Jodi Peckman
**Publisher** Wenner Media
**Date** August 11, 1994
**Category** Single Page

**Publication** Rolling Stone
**Art Director** Fred Woodward
**Designer** Debra Bishop
**Photographer** Raymond Meier
**Photo Editor** Jodi Peckman
**Publisher** Wenner Media
**Date** June 30, 1994
**Category** Spread/Still Life & Interiors

209

# MARTIN
## LAWRENCE

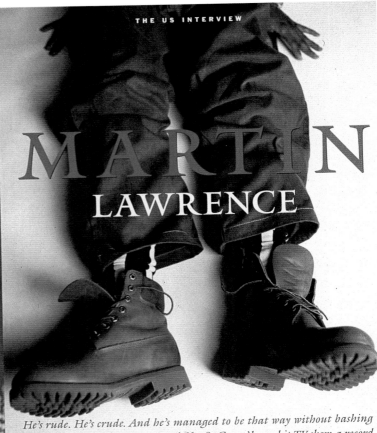

*He's rude. He's crude. And he's managed to be that way without bashing anybody. The star of 'Martin' and 'You So Crazy' has a hit TV show, a record and a movie deal with Fox, and Martin Lawrence is only going to get larger.*

BY TRIP GABRIEL • PHOTOGRAPHS BY PEGGY SIROTA

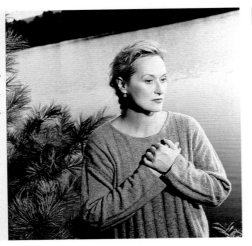

MERYL STREEP

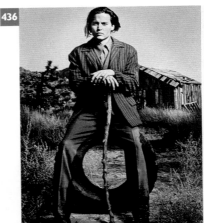

# JOhnny
### Depp

---

**Publication** US
**Art Director** Richard Baker
**Designer** Richard Baker
**Photographer** Mark Seliger
**Photo Editors** Jennifer Crandall, Rachel Knepfer
**Publisher** US Magazine Co.,L.P.
**Date** February 1994
**Category** Spread/Still Life & Interiors

**Publication** US
**Art Director** Richard Baker
**Designer** Richard Baker
**Photographer** Mary Ellen Mark
**Photo Editor** Jennifer Crandall
**Publisher** US Magazine Co.,L.P.
**Date** October 1994
**Category** Spread/Still Life & Interiors

**Publication** US
**Art Director** Richard Baker
**Designers** Richard Baker, Lisa Wagner
**Photographer** Peggy Sirota
**Photo Editors** Jennifer Crandall, Rachel Knepfer
**Publisher** US Magazine Co., L.P.
**Date** April 1994
**Category** Spread/Still Life & Interiors

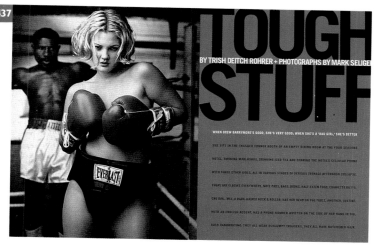

# TOUGH STUFF

BY TRISH DEITCH ROHRER + PHOTOGRAPHS BY MARK SELIGER

WHEN DREW BARRYMORE'S GOOD, SHE'S VERY GOOD; WHEN SHE'S A 'BAD GIRL,' SHE'S BETTER

SHE SITS IN THE SMALLEST CORNER BOOTH OF AN EMPTY DINING ROOM AT THE FOUR SEASONS

HOTEL, SMOKING MARLBOROS, DRINKING ICED TEA AND SHARING THE HOTEL'S CELLULAR PHONE

WITH THREE OTHER GIRLS, ALL IN VARIOUS STAGES OF SERIOUS TEENAGE AFTERNOON COLLAPSE.

THERE ARE PLACKS EVERYWHERE, NOTE PADS, BAGS, BOOKS, HALF-EATEN FOOD, CIGARETTE BUTTS.

ONE GIRL, MEL, A DARK-HAIRED ROCK & ROLLER, HAS HER HEAD ON THE TABLE; ANOTHER, JUSTINE,

WITH AN ENGLISH ACCENT, HAS A PHONE NUMBER WRITTEN ON THE SIDE OF HER HAND IN THE

BOLD HANDWRITING. THEY ALL WEAR SCHLUMPY TROUSERS, THEY ALL HAVE BUTCHERED HAIR.

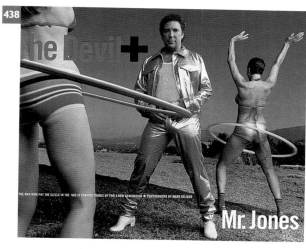

By Gerri Hirshey

the Devil +

THE MAN WHO PUT THE SIZZLE IN THE '60S IS SHAKING THINGS UP FOR A NEW GENERATION + PHOTOGRAPHS BY MARK SELIGER

## Mr. Jones

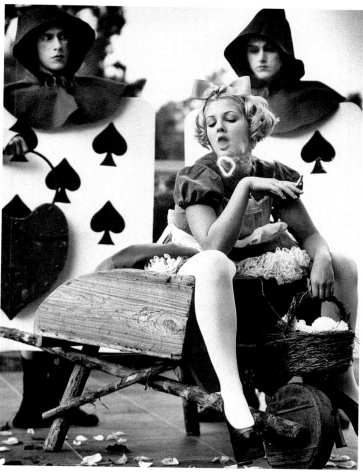

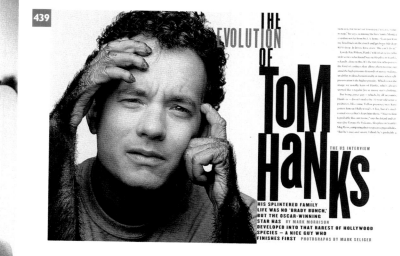

# THE EVOLUTION OF TOM HANKS

THE US INTERVIEW

HIS SPLINTERED FAMILY LIFE WAS NO 'BRADY BUNCH,' BUT THE OSCAR-WINNING STAR HAS BY MARK MORRISON DEVELOPED INTO THAT RAREST OF HOLLYWOOD SPECIES — A NICE GUY WHO FINISHES FIRST PHOTOGRAPHS BY MARK SELIGER

---

**437**

**Publication** US
**Art Director** Richard Baker
**Designer** Richard Baker
**Photographers** Mark Seliger
**Photo Editor** Jennifer Crandall, Rachel Knepfer
**Publisher** US Magazine Co., L.P.
**Date** May 1994
**Category** Story/Still Life & Interiors

**438**

**Publication** US
**Art Director** Richard Baker
**Designers** Richard Baker, Lisa Wagner
**Photographer** Mark Seliger
**Photo Editor** Jennifer Crandall
**Publisher** US Magazine Co., L.P.
**Date** December 1994
**Category** Story/Still Life & Interiors

**439**

**Publication** US
**Art Director** Richard Baker
**Designer** Richard Baker
**Photographer** Mark Seliger
**Photo Editor** Jennifer Crandall
**Publisher** US Magazine Co., L.P.
**Date** August 1994
**Category** Spread/Still Life & Interiors

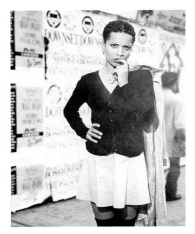

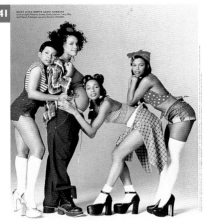

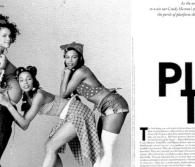

L . a . style

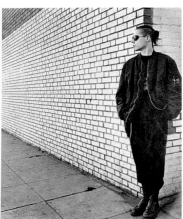

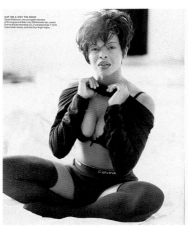

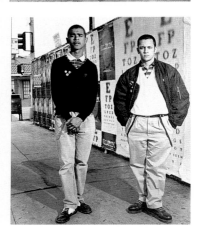

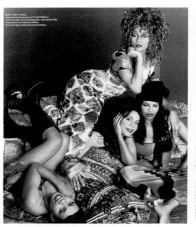

# PILLOW TALK

"LUTHER WAS
JUST SO NASTY,"
DAWN SAYS,
HE TOLD US,
'I DON'T WANT TO
SEE YOUR FACES.'
IT WAS SICK.
WE WERE SO
STRESSED OUT
FROM HIM THAT
BY THE TIME
WE LEFT, ALL
ANYONE WANTED
WAS TO GET
HOME."

---

**440**

**Publication**  Vibe
**Art Director**  Diddo Ramm
**Designer**  Ellen Fanning
**Photographer**  Mary Ellen Mark
**Photo Editor**  George Pitts
**Publisher**  Time Inc. Ventures
**Date**  August 1994
**Category**  Story/Fashion & Beauty

**441**

**Publication**  Vibe
**Creative Director**  Gary Koepke
**Art Director**  Diddo Ramm
**Designer**  Ellen Fanning
**Photo Editor**  George Pitts
**Publisher**  Time Inc. Ventures
**Date**  April 1994
**Category**  Story/Fashion & Beauty

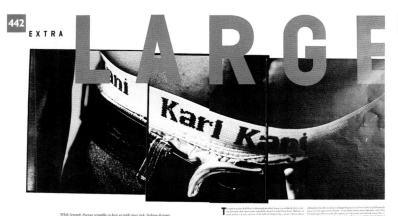

## EXTRA LARGE

While Seventh Avenue scrambles to keep up with street style, fashion designer Karl Kani is bringing his ghetto reality to the masses and building an empire. Scott Poulson-Bryant discovers how hip jeans and big ideas are creating his business. Photographs by Everard Williams Jr.

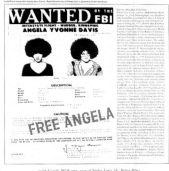

…with Cynda Williams, star of Spike Lee's *Mo' Better Blues*, Carl Franklin's *One False Move*, and the upcoming PBS series, *Tales of the City*.

Photographs by Albert Watson

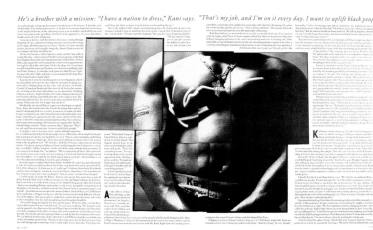

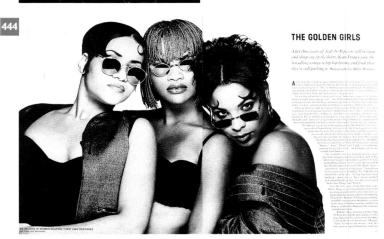

### THE GOLDEN GIRLS

After three years of Salt-N-Pepa are still in vogue and shaking up the charts. Karen France puts the bestselling women in hip-hop history and finds that they're still pushing it. Photographs by Albert Watson

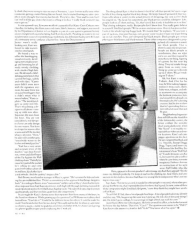

**442**

**Publication** Vibe
**Art Director** Diddo Ramm
**Designer** Ellen Fanning
**Photographer** Edward Williams Jr.
**Photo Editor** George Pitts
**Publisher** Time Inc. Ventures
**Date** October 1994
**Category** Story/Fashion & Beauty

**443**

**Publication** Vibe
**Creative Director** Gary Koepke
**Art Director** Diddo Ramm
**Designer** Ellen Fanning
**Photographer** Albert Watson
**Photo Editor** George Pitts
**Publisher** Time Inc. Ventures
**Date** March 1994
**Category** Spread/Fashion & Beauty

**444**

**Publication** Vibe
**Creative Director** Gary Koepke
**Art Director** Diddo Ramm
**Designer** Ellen Fanning
**Photographer** Albert Watson
**Photo Editor** George Pitts
**Publisher** Time Inc. Ventures
**Date** February 1994
**Category** Spread/Still Life & Interiors

Photography MERIT

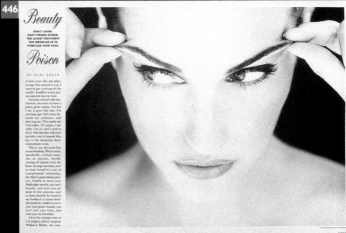

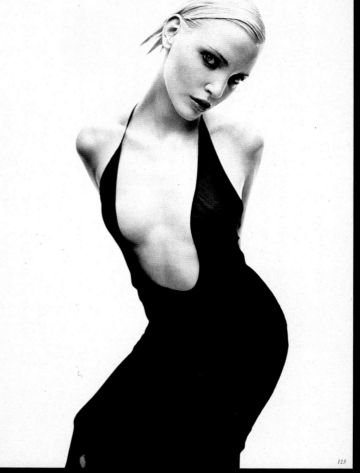

**445**

**Publication** W
**Creative Director** Dennis Freedman
**Design Directors** Edward Leida, Jean Griffin
**Art Director** Kirby Rodriguez
**Designers** Edward Leida, Rosalba Sierra
**Photographer** Raymond Meier

**446**

**Publication** Health
**Art Director** Jane Palecek
**Designer** Jane Palecek
**Photographer** David Peterson
**Publisher** Time Publishing Ventures Inc.
**Date** January/February 1994

**447**

**Publication** Glamour (France)
**Art Director** Thomas Lenthal
**Photographer** Geoffroy de Boismenu
**Category** Spread/Fashion & Beauty

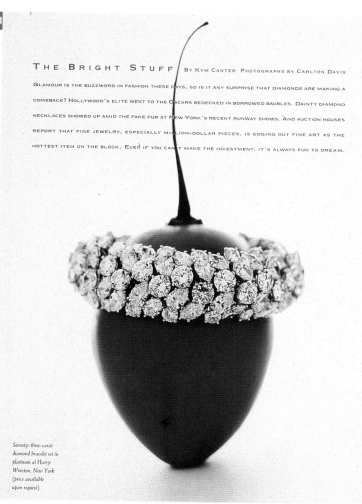

THE BRIGHT STUFF BY KYM CANTER PHOTOGRAPHS BY CARLTON DAVIS

GLAMOUR IS THE BUZZWORD IN FASHION THESE DAYS, SO IS IT ANY SURPRISE THAT DIAMONDS ARE MAKING A

COMEBACK? HOLLYWOOD'S ELITE WENT TO THE OSCARS BEDECKED IN BORROWED BAUBLES. DAINTY DIAMOND

NECKLACES SHOWED UP AMID THE FAKE FUR AT NEW YORK'S RECENT RUNWAY SHOWS. AND AUCTION HOUSES

REPORT THAT FINE JEWELRY, ESPECIALLY MILLION-DOLLAR PIECES, IS EDGING OUT FINE ART AS THE

HOTTEST ITEM ON THE BLOCK. EVEN IF YOU CAN'T MAKE THE INVESTMENT, IT'S ALWAYS FUN TO DREAM.

*Seventy-three-carat diamond bracelet set in platinum at Harry Winston, New York (price available upon request).*

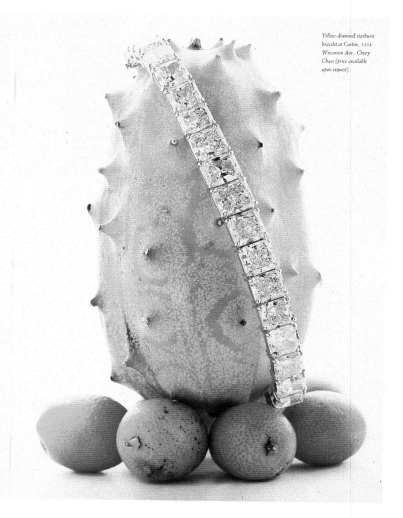

*Yellow-diamond starburst bracelet at Cartier, 5454 Wisconsin Ave., Chevy Chase (price available upon request).*

## Style & Glamour

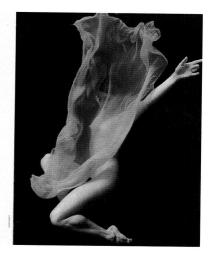

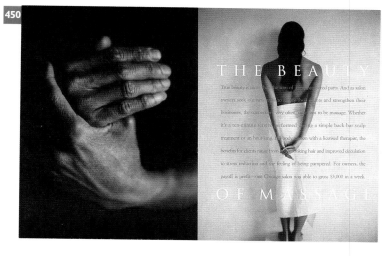

THE BEAUTY

OF MASSAGE

---

 **448**

**Publication** The Washington Post Magazine
**Art Director** Kelly Doe
**Designer** Sandra Schneider
**Photographer** Carlton Davis
**Photo Editor** Karen Tanaka
**Publisher** The Washington Post Co.
**Date** June 5, 1994
**Category** Story/Fashion & Beauty

 **449**

**Publication** American Photo
**Art Director** Patricia Marroquin
**Designer** Nancy Mazzei
**Photographer** Howard Schatz
**Photo Editor** Patricia Marroquin
**Publisher** Hachette Filipacchi Magazines, Inc.
**Date** November/December 1994
**Category** Spread/Fashion & Beauty

 **450**

**Publication** Salon News
**Design Directors** Jean Griffin, Edward Leida
**Art Director** Jennifer Napier
**Designer** Jennifer Napier
**Photographers** Gentl & Hyers
**Publisher** Fairchild Publications
**Date** October 1994
**Category** Spread/Fashion & Beauty

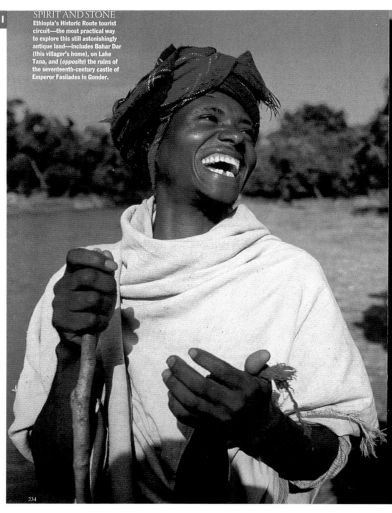

SPIRIT AND STONE
Ethiopia's Historic Route tourist circuit—the most practical way to explore this still astonishingly antique land—includes Bahar Dar (this villager's home), on Lake Tana, and (opposite) the ruins of the seventeenth-century castle of Emperor Fasilades in Gonder.

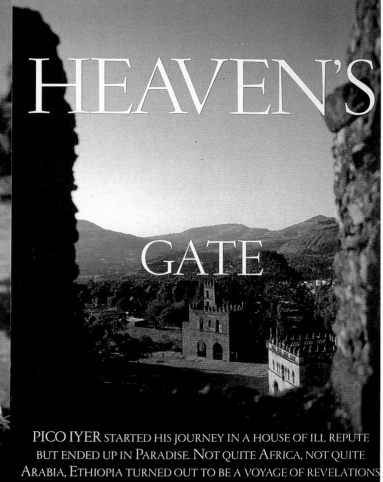

# HEAVEN'S
# GATE

PICO IYER STARTED HIS JOURNEY IN A HOUSE OF ILL REPUTE
BUT ENDED UP IN PARADISE. NOT QUITE AFRICA, NOT QUITE
ARABIA, ETHIOPIA TURNED OUT TO BE A VOYAGE OF REVELATIONS

PHOTOGRAPHS by ROB HOWARD

ONE PICTURE

---

**451**

**Publication** Condé Nast Traveler
**Design Director** Diana LaGuardia
**Art Director** Christin Gangi
**Designer** Stephen Orr
**Photographer** Rob Howard
**Photo Editor** Kathleen Klech
**Publisher** Condé Nast Publications Inc.
**Date** November 1994
**Category** Spread/Reportage & Travel

**452**

**Publication** Audubon
**Art Director** Suzanne Morin
**Photographer** Pierre Perrin
**Photo Editor** Laleli Lopez
**Publisher** National Audubon Society
**Date** March/April 1994
**Category** Spread/Reportage & Travel

**453**

**Publication** San Francisco Focus
**Art Director** David Armario
**Designer** David Armario
**Photographer** Dan Winters
**Publisher** KQED, Inc.
**Date** March 1994
**Category** Spread/Reportage & Travel

# HINDU LOVE GODS

IN INDIA'S BOLLYWOOD, THE MODEL ISN'T SATYAJIT RAY, IT'S JOHN RAMBO *and* BY ANDREW POWELL

*ANKITA PURI*

PHOTOGRAPHED BY MARY ELLEN MARK

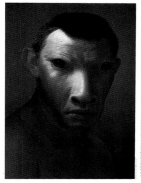

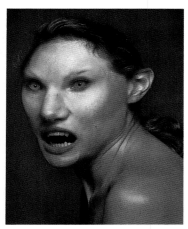

DANIEL LEE

# GANGSTA PHO BIA

Flushed with anticrime fever, and inspired by the high-profile arrests of several of rap's main contenders, the U.S. Congress believes it has narrowed in on the causes of urban violence. Darius James travels to Chocolate City, where gangsta rap is taking the fall.

Taking the rap: MCA Records' Ernie Singleton with Yo Yo on the Hill.

"Gangster rap is largely an indictment of bourgeois black cultural and political institutions... [it] has embarrassed black bourgeois culture and exposed its polite sexism and its disregard for gay men and lesbians."
—Professor Michael Eric Dyson, Brown University

**Opening my eyes the morning of February 11, in a Washington,** D.C., hotel room, I discovered one night of freezing precipitation had accomplished what all my years of reading pamphlets on urban guerrilla warfare, armchair theorizing, and protest demonstrations had not: shut down all federal and local government.

Under poor weather conditions the night before, I'd flown to Washington to attend the first in a series of congressional hearings on "music lyrics and interstate commerce," which concerned, specifically, the content, production, and distribution of a genre within hip hop's African-American, oral-and-rhythm-based musical form labeled, in the latest media-stoked hysteria, "gangsta rap."

In the *Superfly* phase of the '70s, I'd been ejected from my high school civics class for a markedly un-American act I will not describe here in great detail (Hint: It involved a lit match and a piece of striped, star-stained cloth — just testing to see if anyone in this country genuinely believed in the "Bill of Rights"); as a result, I had no idea how the mechanics of government actually worked and I didn't know what to expect from the hearing which, despite the snowfall, was still on.

This first hearing wasn't going to be the last of it. The congressional subcommittee I was attending would follow with two more sessions. And later that month, Senator Carol Moseley-Braun would conduct her own inquiry into gangsta rap and its effects on the minds of children for the Senate's Juvenile Justice Subcommittee, with a guest list overlapping that of the congressional hearings. Moseley-Braun would try to line up Luther Campbell, but he would be MIA. Dionne Warwick would appear to make a plea for the end of sexism, and Dr. Robert T.M. Phillips would testify that action against gangsta rap was about the "protection of our children from pathology." Harry Allen, "Media Assassin," would submit a written statement calling for a broader investigation into "all forms of commercial or commercialized 'speech' which demean and/or are violent, as such pertains to youth; for example, some forms of print and other media advertising; numerous television talk shows; or certainly many 'shock jock/hate' radio programs."

Indeed, as ridiculous as it might seem on the surface, what really bugged me about the premise for all these hearings was the fact that Rush Limbaugh and his ilk were not being brought before the subcommittees to answer for *their* "manufactured message" of demogoguery, deception, misogyny, and homophobia, as the subcommitee press release had called gangsta rap to do. Their testimony might explain the existence of internalized racism among our nation's precious and impressionable youth which, in turn, vents itself

## 454
**Publication** Premiere
**Art Director** John Korpics
**Designer** John Korpics
**Photographer** Mary Ellen Mark
**Photo Editor** Charlie Holland
**Publisher** K-III Magazines
**Date** June 1994
**Category** Spread/Reportage & Travel

## 455
**Publication** Spin
**Art Directors** Bruce Ramsay, Paula Kelly
**Designer** Paula Kelly
**Photographer** Charles Kennedy
**Photo Editor** Shana Sobel
**Publisher** Camouflage Association
**Category** Single Page

## 456
**Publication** American Photo
**Art Director** Patricia Marroquin
**Designer** Kurt Hansen
**Photographer** Daniel Lee
**Photo Editor** Carol Squires
**Publisher** Hachette Filipacchi Magazines, Inc.
**Date** May/June 1994
**Category** Spread/Photo Illustration

Photography MERIT

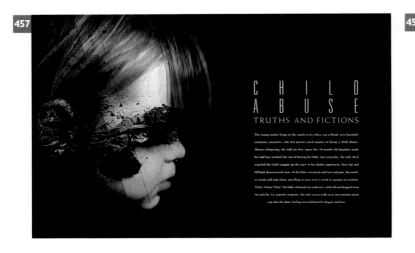

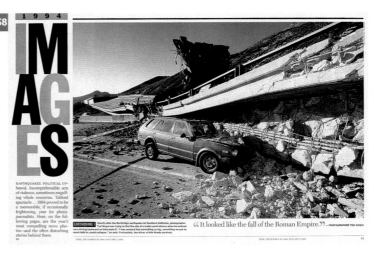

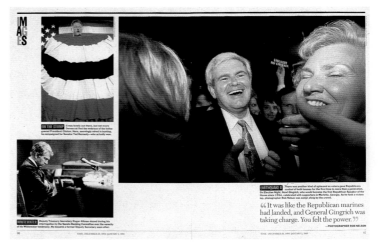

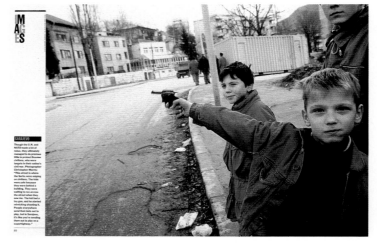

**457**

**Publication** Penthouse
**Art Director** Dwayne Flinchum
**Designer** Dwayne Flinchum
**Photographer** Eric Dinyer
**Studio** Eric Dinyer Imaging
**Category** Spread/Photo Illustration

**458**

**Publication** Time
**Art Director** Arthur Hochstein
**Designer** Janet Waegel
**Photographers** Ted Soqui, Rob Nelson, Diana Walker, Christopher Morris
**Photo Editors** Jay Colton, Michele Stephenson
**Publisher** Time Inc.
**Date** December 26, 1994
**Category** Story/Reportage & Travel

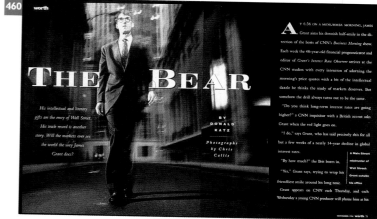

**459**

**Publication**
Newsweek International
**Art Director** David Bayer
**Designer** David Bayer
**Photographer** Richard Toshman
**Photo Editor** David Bayer
**Publisher** Newsweek
**Date** June 13, 1994
**Category** Spread/Photo Illustration

**460**

**Publication** Worth
**Art Director** Ina Saltz
**Designer** Lynette Cortez
**Photographer** Chris Callis
**Photo Editor** Anne Stovell
**Publisher** Capital Publishing
**Date** November 1994
**Category** Spread/Reportage & Travel

**461**

**Publication** GQ
**Art Director** Robert Priest
**Designer** Daniel Stark
**Photographer** Max Aguillera-Hellweg
**Photo Editor** Karen Frank
**Publisher** Condé Nast Publications Inc.
**Date** January 1994
**Category** Spread/Reportage & Travel

462

# Childhood Lost

The landscape of life is utterly changed for children today: Their lives are full, but the front yards and sidewalks and tree houses are empty. BY MELISSA FAY GREENE

During my childhood, in the famous tract-housing, station-wagon, black-and-white-TV fifties, children dashed in after school, inhaled their snacks, and were shooed back outdoors by their mothers. And that was the last the children were seen till dinnertime, when the aproned mothers stood on front porches and back steps and sang out their children's names. In the deliciously idle, random hours between about 3:30 and 6:00 p.m., packs of elementary-school-age children owned the neighborhood. I personally spent a lot of time standing, like a sailor in a crow's nest, in the top branches of a tree I regarded as my own, down the street from my house in Dayton, Ohio. With my beloved dog—unleashed—I walked through the woods, along footpaths worn smooth by generations of children, as if the children themselves were the most recent Indian tribe in the vicinity.

Because this was Ohio, we engaged every fall in Buckeye Wars, our walks home from school delayed by the necessity of squatting, opening our hinged metal lunch boxes, and scooping hundreds of the smooth fat nuts inside. In our fort in a vacant lot, we stockpiled the buckeyes and guarded them until such time as the boy from an adjacent street, whom we regarded as something of a hood, arrived with his gang pulling metal wagons brimming with their own fresh buckeyes, and we thrillingly pelted each other. We flew back into our houses to use the bathroom and gulp tepid water from plastic, toothpastey bathroom cups, then tore back outside. The only time I remember being driven somewhere by my mother after school was to the dentist.

I think about all this from time to time as I watch my own children—ages 13, ten, six, and two—and wonder when their fun is going to start. Recalling my dreamy, all-afternoon walks with my romping dog, in and out of the woods, through other neighborhoods, I think about my children and wonder: Are they not old enough yet? Do they need a dog? (But we have a dog.) Was I older when I explored? And then I wonder if I have subconsciously demobilized them, knowing with what

"Fireflies" by Keith Carter

December/January 1995, PARENTING / 99

---

463

When Rwanda's youngest citizens look to the future, all they can see is the horror of the recent past. What will become of them?

BY BILL BERKELEY
PHOTOGRAPHS BY
ANTONIN KRATOCHVIL

## The Children of Rwanda

In a voice that barely rises above a whisper, 13-year-old Reveriani Rurangwa recounts the day last April when Red Cross workers pulled him from a pile of corpses that included his mother, his father, his brothers and sisters, as well as several hundred friends and neighbors.

"We were all inside the Catholic church."

*Zairian relief workers take every opportunity to cradle and caress young refugees in their care. Here, they bathe two small orphans.*

126 / PARENTING December/January 1995

December/January 1995 PARENTING / 127

---

462

**Publication** Parenting
**Design Director** Jonathan Tuttle
**Art Director** Alan Avery
**Designer** Jonathan Tuttle
**Photographer** Keith Carter
**Photo Editor** Tripp Mikich
**Publisher** Time Inc. Ventures
**Date** December 1994/January 1995
**Category** Spread/Photo Illustration

463

**Publication** Parenting
**Design Director** Jonathan Tuttle
**Art Director** Alan Avery
**Designer** Jonathan Tuttle
**Photographer** Antonin Kratochvil
**Photo Editor** Tripp Mikich
**Publisher** Time Inc. Ventures
**Date** December 1994/January 1995
**Category** Spread/Reportage & Travel

464

**Publication** Parenting
**Design Director** Jonathan Tuttle
**Art Director** Sharon Ludtke
**Designer** Sharon Ludtke
**Photographer** Neal Brown
**Photo Editor** Tripp Mikich
**Publisher** Time Inc. Ventures
**Date** May 1994
**Category** Spread/Still Life & Interiors

220

# HOW SAFE IS THE FOOD WE EAT?

*According to the headlines, if pesticides don't get you, bacteria or gene splicing will. A guide to the real risks and ways to avoid them. BY GAIL ZYLA*

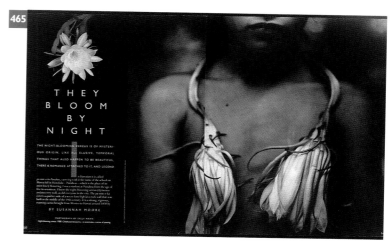

## THEY BLOOM BY NIGHT

THE NIGHT-BLOOMING CEREUS IS OF MYSTERIOUS ORIGIN, LIKE ALL ELUSIVE, TEMPORAL THINGS THAT ALSO HAPPEN TO BE BEAUTIFUL. THERE IS ROMANCE ATTACHED TO IT, AND LEGEND

BY SUSANNAH MOORE

PHOTOGRAPHY BY SALLY MANN

**AFTER THE FLOOD** BY MATT MAHURIN

## music
# mighty seal

Life is pain and leads to the grave. Unless you happen to be Seal.
*WILLIAM SHAW MEETS THE POP METAPHYSICIAN AND SOUL SURVIVOR*

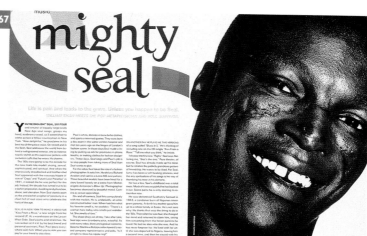

**465**

**Publication** Garden Design
**Creative Director** Michael Grossman
**Art Director** Paul Roelofs
**Photographer** Sally Mann
**Photo Editor** Susan Goldberger
**Publisher** Meigher Communications
**Category** Spread/Still Life & Interiors

**466**

**Publication** Buzz
**Design Director** Charles Hess
**Photographer** Matt Mahurin
**Photo Editor** Charles Hess
**Publisher** Buzz, Inc.
**Date** May 1994
**Category** Spread/Photo Illustration

**467**

**Publication** Details
**Art Director** Markus Kiersztan
**Designer** David Warner
**Photographer** Richard Burbridge
**Photo Editor** Greg Pond
**Publisher** Condé Nast Publications Inc.
**Date** October 1994
**Category** Spread/Still Life & Interiors

Photography MERIT

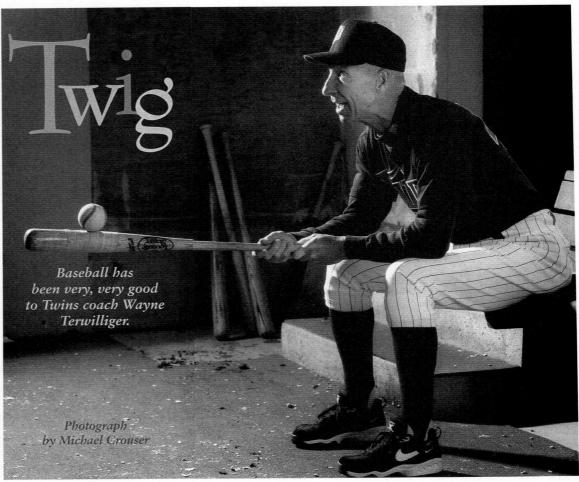

## PORTRAIT

# Twig

JUST THREE YEARS AGO, he was rated the best first base coach in the American League. Yet Minnesota Twins coach Wayne Terwilliger is truly from another era—the golden age of baseball. He played for Calvin Griffith's Washington Senators, the Brooklyn Dodgers, the New York Giants, and the Kansas City Athletics—teams that have not existed for a generation. His first major league hit came against Boston—not the Red Sox, but the Braves, who later moved to Milwaukee and eventually to Atlanta. He was a teammate of Willie Mays' during the Say Hey Kid's heyday, and he coached for Ted Williams.

But "Twig," as he's known to friends, doesn't live in the past.

"How can I?" he asked. "Somebody was asking me about some of the great hitters the '53 and '54 Washington Senators had. I started talking about Pete Runnels and Jackie Jensen, and I realized those guys are all dead.

"I'd rather talk about fighting my way into the locker room after we won the 1991 World Series, backing into the training room, and finding Dan Gladden there by himself. We're watching a replay of the final out, and Gladden, a damned tough guy, gently brushes his hand against mine and says, 'Damn, this is great.'

"Or 1987. Two months after we won the World Series—and that was the first pennant winner I'd ever been with—there was a banquet in my hometown in Michigan. I brought that Wheaties box with the team's picture on it. I tried to read the back of the box, and I couldn't read it without blubbering in front of 250 people."

Now 69 years old, Terwilliger knows his major league career won't last forever. Six feet tall and a trim 170 pounds, he remains in great shape, but his contract expires at the end of the season, and he knows that this could be his last year with the Twins.

Still, as he slips on a glove that third baseman Scott Leius gave him, he says, "You know, after 45 years of being in and out of the major leagues, I still get goose bumps when I put on one of these." —PAUL LEVY

*Baseball has been very, very good to Twins coach Wayne Terwilliger.*

*Photograph by Michael Crouser*

16 • Minnesota Monthly • August 1994

August 1994 • Minnesota Monthly • 17

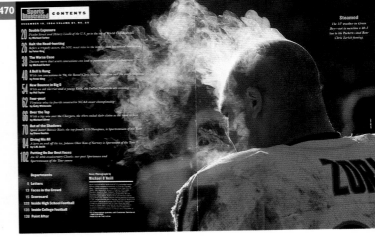

**Publication** Minnesota Monthly
**Art Director** Mark Shafer
**Designer** Brian Dohahue
**Photographer** Michael Crouser
**Photo Editor** Mark Shafer
**Publisher** Minnesota Monthly Publications
**Date** August 1994
**Category** Spread/Reportage & Travel

**Publication** Sports Illustrated
**Design Director** Steven Hoffman
**Designer** Craig Gartner
**Photographer** Simon Bruty
**Photo Editor** Heinz Kluetmeier
**Publisher** Time Inc.
**Date** December 27,1993-January 3,1994
**Category** Spread/Reportage & Travel

**Publication** Sports Illustrated
**Design Director** Steven Hoffman
**Art Director** F. Darrin Perry
**Photographer** Michael O'Neill
**Photo Editor** Heinz Kluetmeier
**Publisher** Time Inc.
**Date** December 19, 1994
**Category** Spread/Reportage & Travel

# STUDENT COMPETITION

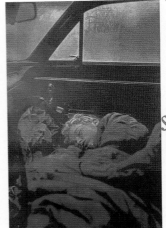

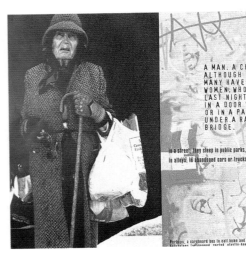

**471**   **B. W. Honeycutt Award Winner**
**Designer** Soo Jung Lee
**Title** biG:the magazine of NY city
**School** School of Visual Arts, New York City
**Category** Publication Design

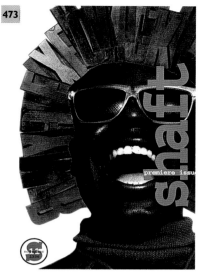

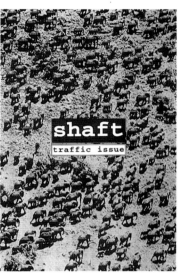

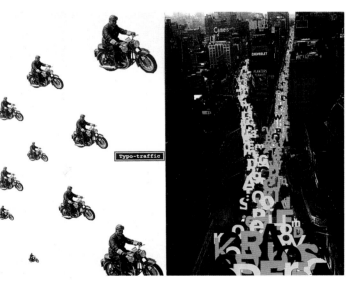

**Student Competition EXCELLENCE**

**472**

**Designer** Michael A. Petersen
**Title** Towers Art & Literature Annual
**School** Northern Illinois University, De Kalb, Illinois
**Category** Redesign

**473**

**Designer** So Takahashi
**Title** Shaft
**School** School of Visual Arts, New York City
**Category** Publication Design

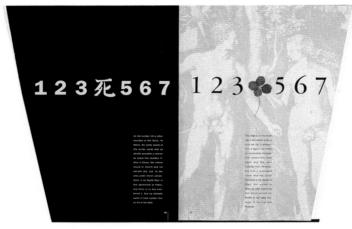

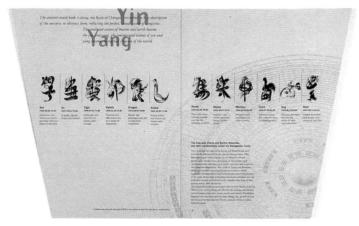

**474**

**Designer** David Byun
**Title** A-Z
**School** School of Visual Arts, New York City
**Category** Publication Design

**475**

**Designers** Byeong-hye Lee, Heejung Kim, Nam-Yun Jean
**Title** + − = 0
**School** Pratt Institute, Brooklyn, New York
**Category** Design/Spreads

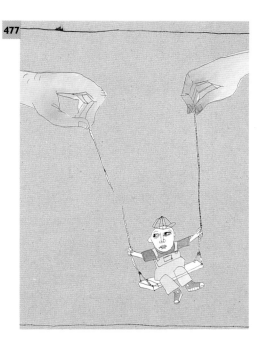

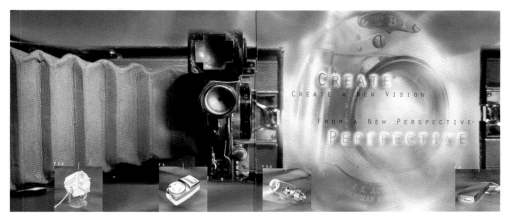

THE BACHELOR OF FINE ARTS
DEGREE IN PHOTOGRAPHY

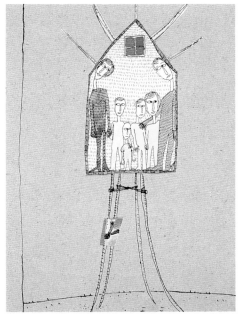

**476**

**Designers** Jody Haneke, Michael Long
**Photographers** Jody Haneke, Michael Long
**Title** Ringling BFA in Photography Catalogue
**School** Ringling School of Art & Design, Sarasota, Florida
**Categories** Photography
Publication Design

**477**

**Illustrator** Sophie Casson
**Title** Fathers & Child Rearing
Step Families and Their Problems
**School** Université du Québec à Montréal
Montréal, Canada
**Category** Illustration

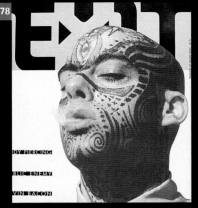

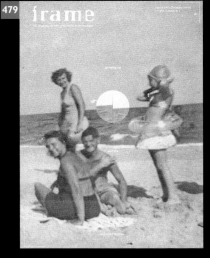

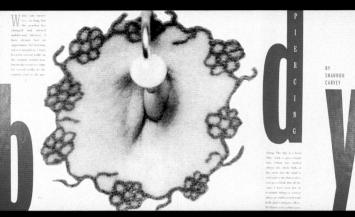

**478**

**Designer** Yoomi Chong
**Title** Exit
**School** School of Visual Arts, New York City
**Categories** Publication Design
　　　　　　　Design/Spreads

**479**

**Designer** Thomas Noller
**Title** Frame
**School** Pratt Institute, Brooklyn, New York
**Category** Publication Design

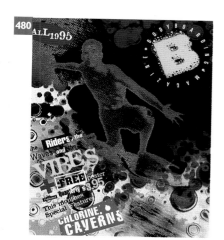

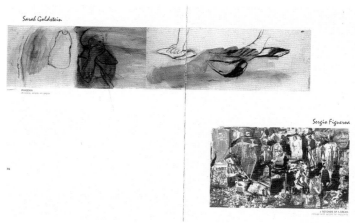

**480**

**Designer** Kevin Reid
**Title** Bodyboarding
**School** University of North Texas, Denton, Texas
**Category** Redesign

**481**

**Designer** Joanna Berzowska
**Title** Volute
**School** Concordia University, Montréal, Québec
**Category** Redesign

Student Competition MERIT

229

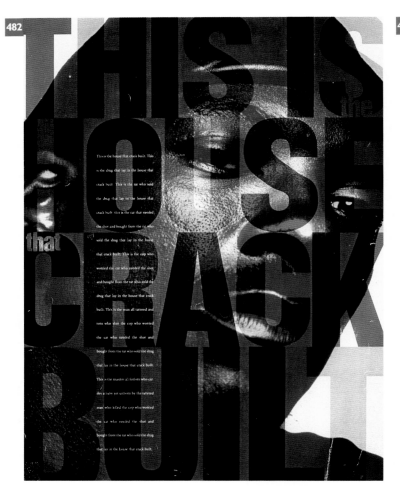

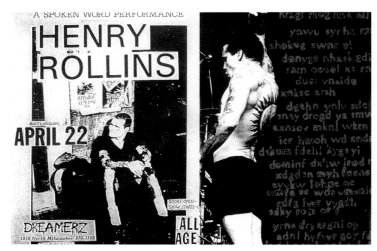

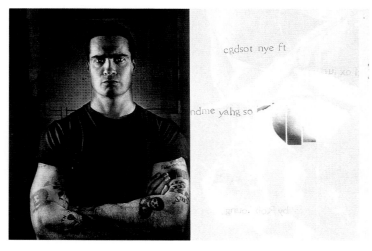

**482**

**Designer** David Harley
**Title** Crack House Poem
**School** Parsons School of Design
New York City
**Category** Design Single

**483**

**Designer** David Byun
**Title** Music
**School** School of Visual Arts
New York City
**Category** Design/Spread

**484**

**Designer** April Papenfuss
**Photographer** April Papenfuss
**Title** Music
**School** School of Visual Arts, New York City
**Categories** Design/Stories
Photography

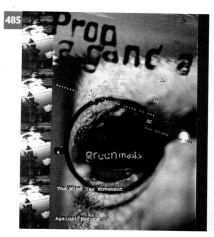

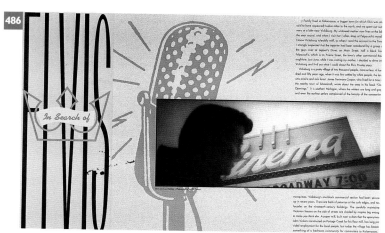

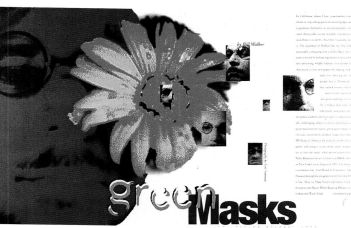

**Designer** Jay Simmons
**School** University of North Texas, Denton, Texas
**Title** Propaganda
**Category** Redesign

**Designer** Anna Tan
**Title** Elvis
**School** Rochester Institute of Technology, Rochester, New York
**Category** Design/Spreads

**Student Competition MERIT**

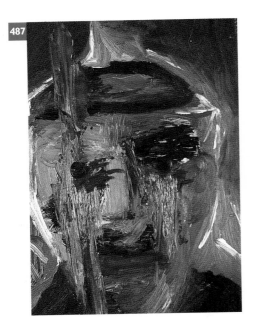

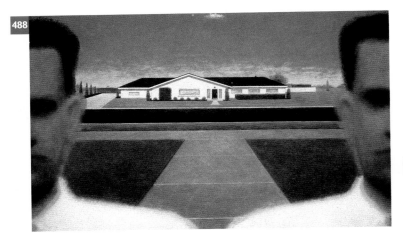

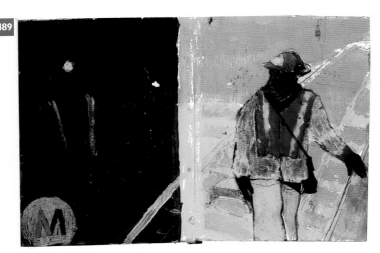

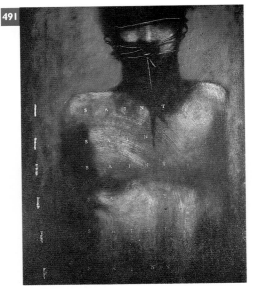

**487**
**Illustrator** James N. Scola
**Title** War & Peace
**School** School of Visual Arts
New York City
**Category** Illustration

**488**
**Illustrator** Lane Twitchell
**Title** Song
**School** School of Visual Arts
New York City
**Category** Illustration

**489**
**Illustrator** Riccardo Vecchio
**Title** Union Square
Subway Workers
**School** School of Visual Arts
New York City
**Category** Illustration

**490**
**Photographer** Neil Robbins
**School** Rochester Institute
of Technology,
Rochester, New York
**Title** Phobias
**Category** Photography

**491**
**Illustrator** Cedric DeSouza
**Title** Consequence of Honesty
**School** Atlanta College of Art
Atlanta, Georgia
**Category** Illustration

# INDEX

■ **CREATIVE DIRECTORS**

**Balkind**, Aubrey — 80, 147
**Barnett**, David — 128, 129
**Baron**, Fabien — 16, 17, 40, 41, 68, 69, 70, 71, 72, 73, 185, 186, 187
**Bhandari**, Sunil — 160
**Breeding**, Greg — 95
**Cahan**, Bill — 83
**Campbell**, Nancy — 175
**Campiz**, Miriam — 136
**Fey**, Jeff — 52
**Freedman**, Dennis — 164, 173, 214
**Grossman**, Michael — 32, 77, 144, 221
**Hunter**, Kent — 80, 147
**Koepke**, Gary — 49, 91, 92, 93, 212, 213
**Pagniez**, Regis — 76, 175
**Perkins**, Mark — 82
**Sullivan**, Ron — 82
**Tremain**, Kerry — 158, 201

■ **DESIGN DIRECTORS**

**Bentkowski**, Tom — 28, 29, 30, 110, 111, 112, 113, 114, 115, 116, 117, 169, 190, 191, 192, 193
**Best**, Robert — 44, 152
**Caderot**, Carmelo — 13, 122, 125
**Claro**, Noel — 121
**Dunleavy**, Chrissy — 151, 201
**Garcia**, Art — 82
**Goodman**, Pegi — 121
**Griffin**, Jean — 164, 173, 214, 215
**Grossman**, Michael — 48, 62, 154, 182
**Harrison**, Peter — 85
**Hayashi**, Kunio — 136
**Hess**, Charles — 158, 221
**Hoffman**, Steven — 122, 222
**Isley**, Alexander — 50
**Jean-Louis**, Galie — 19, 20, 21, 54
**Kalman**, Tibor — 18, 58, 59
**Kruger Cohen**, Nancy — 26
**LaGuardia**, Diana — 96, 97, 178, 179, 180, 216
**Leeds**, Greg — 55
**Lehmann-Haupt**, Carl — 26
**Leida**, Edward — 164, 173, 214, 215
**Mitchell**, Patrick — 60, 61
**Nesnadny**, Joyce — 86
**Newman**, Robert — 37, 48, 63, 143, 146, 154, 182, 183
**Pylypczak**, John — 80
**Schwartz**, Mark — 84
**Scopin**, Joseph W. — 55
**Sessa**, Marsha — 158, 201
**Sizing**, John — 161
**Tuttle**, Jonathan — 220
**Yoffe**, Ira — 57
**Young**, Shawn — 88, 89, 176

■ **ART DIRECTORS**

**Armario**, David — 31, 127, 129, 142, 143, 144, 161, 180, 181, 216
**Armus**, Jill — 37, 62, 143, 154, 182, 183
**Avery**, Alan — 220
**Bachleda**, Florian — 146
**Baker**, Richard — 66, 210, 211
**Bartholomay**, Lucy — 126, 166

**Bayer**, David — 219
**Becker**, Syndi — 152
**Belknap**, John — 53, 156
**Berg**, Joel — 16, 17, 40, 68, 71, 72, 73, 185, 186, 187
**Betts**, Elizabeth — 143, 183
**Black**, Roger — 155
**Bowyer**, Caroline — 129
**Brewer**, Linda — 56
**Cahan**, Bill — 83
**Capaldi**, Jef — 159
**Carson**, David — 24, 25, 35, 49, 134, 135
**Casey**, Susan — 107, 109, 198
**Coates**, Stephen — 15, 36
**Compton**, Paul — 55
**Connatser**, Steve — 136
**Cox**, Phyllis R. — 118
**Danzig**, Mark — 100, 155, 189
**DiLorenzo**, Lou — 94, 199
**Doe**, Kelly — 151, 215
**Doherty**, Melanie — 54, 98
**Dreier**, Kyle D. — 120
**Easler**, Jaimey — 106, 199
**Ende**, Lori — 176
**Eustace**, Paul — 70
**Fernandes**, Teresa — 123
**Ferretti**, Richard — 99
**Fitzpatrick**, Wayne — 158
**Flinchum**, Dwayne — 218
**Fox**, Bert — 151, 201
**Froelich**, Janet — 51, 105, 125, 140, 150, 153, 168, 194, 195, 196, 197
**Gangi**, Christin — 96, 97, 178, 179, 180, 216
**Garlan**, Judy — 50
**Gee**, Earl — 83
**Geer**, Mark — 85, 86, 129
**Golon**, Marti — 115
**Greenfield**, Murray — 155
**Hausler**, Greg — 106, 199
**Hay**, Jo — 76
**Heller**, Steven — 57
**Hoang**, Dung — 35, 129
**Hochbaum**, Susan — 85
**Hochstein**, Arthur — 42, 43, 124, 154, 167, 168, 218
**Houser**, David — 107
**Janerka**, Andrzej — 188
**Johnson**, Scott — 128
**Kalish**, Nicki — 56, 57
**Kascht**, John — 55
**Katona**, Diti — 80, 82
**Kelly**, Paula — 217
**Kiersztan**, Markus — 39, 119, 221
**Klee**, Gregory — 77
**Klein**, Nikolai — 55
**Klotnia**, John — 78, 81
**Kner**, Andrew P. — 53
**Knowlton**, Alexander — 120
**Kohler**, David — 81
**Korpics**, John — 64, 65, 159, 172, 202, 217
**Kraus**, Jerelle — 127, 160
**Kruger Cohen**, Nancy — 45, 145
**Lappen**, Arlene — 62
**Lehmann-Haupt**, Carl — 45, 145
**Lenthal**, Thomas — 214
**Ludtke**, Sharon — 220
**Marroquin**, Patricia — 215, 217
**McCudden**, Colleen — 101
**Means**, Doreen — 157
**Miller**, J. Abbott — 79
**Mitchell**, Christine — 177
**Morin**, Suzanne — 108, 109, 177, 216
**Morris**, Don — 62, 121, 162, 182

**Mulvihill**, Alex — 121, 162
**Napier**, Jennifer — 105, 215
**Nelson**, Sharon K. — 159
**Nenneker**, Kathy — 159
**Nesnadny**, Joyce — 32, 84, 86
**Nicholas**, Jim — 121
**Norgaard**, Fred — 160
**O'Connor**, John — 156
**O'Connor**, Margaret — 203
**O'Neal**, Patrick — 59
**Palecek**, Jane — 118, 125, 145, 214
**Perry**, F. Darrin — 222
**Peterson**, Bryan L. — 120
**Pettiford**, Lance — 89, 174
**Phelps**, Lynn — 53
**Pirtle**, Woody — 78, 81
**Plunkett**, John — 27, 49, 66, 67, 158
**Polevy**, Joseph J. — 161
**Porter**, J. — 157
**Porter**, Mark — 58
**Priest**, Robert — 34, 102, 103, 104, 184, 219
**Pylypczak**, John — 82
**Ramm**, Diddo — 49, 90, 91, 92, 93, 172, 212, 213
**Ramsay**, Bruce — 217
**Ray**, Scott — 52, 87
**Raye**, Robynne — 52
**Rodriguez**, Kirby — 164, 173, 214
**Roelofs**, Paul — 32, 77, 144, 221
**Ryan**, Greg — 56
**Sabat**, Hermenegildo — 145
**Salisbury**, Mike — 53, 59, 84, 123
**Saltz**, Ina — 156, 219
**Sanchez**, Rodrigo — 13, 122, 125
**Sanford**, John L. — 157
**Schwartz**, Mark — 32, 84, 86
**Scopin**, Joseph W. — 126
**Shafer**, Mark — 222
**Sheehan**, Nora — 76, 175
**Shelton**, Samuel G. — 95
**Sokolow**, Rena — 54
**Stout**, D.J. — 123, 146, 171, 200
**Stowell**, Scott — 18, 58, 59
**Strassburger**, Michael — 52
**Svensson**, Johan — 41, 69, 70, 71, 72, 187
**Towey**, Gael — 14, 74, 75, 118, 188
**Waidowicz**, Jurek — 79, 128
**Weine**, Seth Joseph — 87
**Wilson**, Fo — 89, 174
**Woodward**, Fred — 10, 11, 12, 22, 23, 38, 46, 47, 130, 131, 132, 133, 138, 139, 140, 141, 148, 149, 165, 170, 203, 204, 205, 206, 207, 208, 209

■ **DESIGNERS**

**Abatemarco**, Dean — 109
**Allen**, Dave — 109
**Anderson**, Gail — 10, 11, 12, 131, 132, 138, 139, 141, 148, 149, 170, 204, 205
**Andreuzzi**, Jean — 110, 112, 116, 190, 193
**Aranda**, Arturo — 147
**Armario**, David — 31, 127, 129, 142, 144, 161, 180, 181, 216
**Armus**, Jill — 62, 63, 154, 183
**Austopchuk**, Christopher — 57
**Bachleda**, Florian — 37
**Baker**, Richard — 66, 210, 211
**Bartholomay**, Lucy — 126, 166
**Bayer**, David — 219
**Bearson**, Lee — 10, 11, 131, 139, 141, 148, 149, 164, 170, 204, 205, 207
**Becker**, Syndi — 152
**Bentkowski**, Tom — 28, 29, 169, 190
**Bertolo**, Diane — 94, 199

Design INDEX

## ■ PHOTO EDITORS

**Albert**, Alice 18, 58, 59
**Albertone**, Alfredo 18, 58, 59

**Babcock**, Alice 48, 63
**Baker Burrows**, Barbara 30, 110, 113, 115, 116, 117, 191, 193
**Barker**, John 31, 127, 180, 181
**Bartholomay**, Lucy 126, 166
**Bayer**, David 219
**Bender**, Donna 100, 183, 189
**Bernstein**, Lynn 62
**Black**, Bill 94, 199
**Brautigan**, Doris 48, 63, 182
**Britton**, Emily 109
**Brooks**, Sharrie 83
**Bussell**, Mark 203

**Cahan**, Bill 83
**Calley**, Marilyn 120
**Campiz**, Miriam 136
**Chin**, Stephen 89, 174
**Colton**, Jay 218
**Crandall**, Jennifer 66, 210, 211

**De Jong**, Philip 95
**Dougherty**, Chris 64, 65
**Dudley**, Lee 30, 193
**Dunn**, Marry 37, 48, 62, 63, 182, 183

**Edelstein**, Debbe 183
**Ensenberger**, Peter 177

**Fernandez**, Ramiro 183
**Fitzgerald**, F. Stop 53
**Fox**, Bert 201
**Frank**, Karen 34, 102, 103, 104, 184, 219
**Friend**, David 28, 110, 111, 112, 114, 117, 168, 190, 191, 192, 193

**Goldberger**, Susan 32, 77, 221
**Golon**, MaryAnne 168
**Gosfield**, Josh 153
**Gostin**, Nicki 120
**Gun**, Andrew 101

**Hayashi**, Kunio 136
**Heller**, Ted 121
**Hess**, Charles 221
**Holland**, Charlie 64, 65, 172, 202, 217
**Howe**, Peter 108, 109, 177, 202

**Jacobson**, Mark 37, 62, 183
**Jean-Louis**, Galie 19, 20, 21, 54

**Klech**, Kathleen 96, 97, 178, 179, 180, 216
**Kluetmeier**, Heinz 122, 222
**Knepfer**, Rachel 66, 210, 211
**Kochman**, Michael 183
**Kohler**, David 81

**Lahaye**, Jodi 76
**Litt**, Tracey 129
**Lopez**, Laleli 177, 216
**Lorentzen**, Miriam 57

**Marroquin**, Patricia 215
**McDonagh**, Fiona 10, 11

**McMillen**, Nancy E. 123, 146, 171, 200
**Mihaly**, Julie 182
**Mikich**, Tripp 220
**Moon**, Sarah 197
**Moore**, Larry 123
**Morishigre**, Dawn 31, 181
**Morley**, Alison 175

**Needleman**, Deborah 100, 189

**Peckman**, Jodi 10, 11, 12, 22, 23, 38, 46, 47, 130, 131, 132, 133, 165, 170, 203, 204, 205, 206, 207, 208, 209
**Perry**, Rick 56
**Pitts**, George 49, 90, 91, 92, 93, 172, 212, 213
**Pond**, Greg 39, 119, 221
**Porges**, Vivette 29
**Posner**, Heidi 14, 74, 75, 118, 188
**Punk**, Mike 84

**Rein**, Ilana 18
**Romero**, Michele 62, 182, 183
**Ryan**, Kathy 51, 105, 125, 168, 194, 195, 196

**Schapf**, Jordan 44
**Schlesinger**, Kate 79
**Schumann**, Marie 111, 116
**Sfraga**, Denise 10, 11, 170, 204, 205
**Shafer**, Mark 222
**Simpson**, Aubrey 106, 199
**Smith**, Susan 107, 109, 198
**Sobel**, Shana 217
**Squires**, Carol 217
**Stephenson**, Michele 124, 167, 168, 218
**Stevens**, Robert 167
**Stout**, D.J. 123, 146, 171, 200
**Stovell**, Anne 219
**Syrop**, Stephanie 94, 199

**Tanaka**, Karen 215
**Torrisi**, Allyson M. 189

**Verdine**, Michael 83
**Vermazen**, Susan 44

**White**, Heather 37, 62, 111
**White**, Judy 88, 89, 176

## ■ PHOTOGRAPHERS

**Abranowicz**, William 74, 75, 118
**Afanador**, Ruven 62
**Aguillera-Hellweg**, Max 219
**Aitken**, Doug 135
**Andersen**, Odd R. 30, 193
**Annalisa** 20
**Arsenault**, Daniel 60
**Astor**, Josef 62
**Avakian**, Alexandra 108
**Avedon**, Richard 17, 73

**Baker**, Christopher 75
**Balog**, James 191
**Barker**, Kent 198
**Bartley**, Mary Ellen 188
**Bell**, Colin 24
**Benabib**, Michael 120
**Bensimon**, Gilles 76
**Berman**, Zeke 33
**Binder**, Ellen 194
**Borris**, Dan 11

**Braasch**, Gary 116
**Bridges**, Marilyn 96, 178
**Light Brigade** 101
**Broden**, Fredrik 60
**Bromberger**, Saul 202
**Brown**, Neal 220
**Brusso**, Andrew 183
**Bruty**, Simon 222
**Burbridge**, Richard 70, 221
**Butcher**, Clyde 180

**Callis**, Chris 219
**Cardillicchio**, Nick 189
**Carson**, David 135
**Carter**, Keith 220
**Chalkin**, Dennis 42
**Chiasson**, John 117
**Corbijn**, Anton 47, 62, 119, 131, 132, 207
**Crouser**, Michael 222

**Davies & Starr** 74
**Davies & Davies** 93
**Davis**, Carlton 14, 74, 215
**de Boismenu**, Geoffroy 182, 214
**Demarchelier**, Patrick 17, 71, 72
**Demin**, Tony 106
**Denys**, Gary 99
**Dinyer**, Eric 218
**Dixon**, Phillip 91, 100
**Dobbie**, Thomas 105
**Dolan**, John 14
**Dorling Kindersley** 99
**Douglas Brothers**, The 61
**Dugdale**, John 75
**Dupleix**, Roble 87

**Eccles**, Andrew 79
**Elkins**, Richard 128
**Enderle**, O'Hana 14
**Endress**, John Paul 85, 86
**Esto** 87, 95
**Everton**, Macduff 109

**Fell**, Derek 77
**Ferebee**, Stewart 14
**Ferrato**, Donna 124, 125, 169
**Festa**, Tony 84
**Fink**, Larry 173
**Flynn**, Bryce 57
**Fournier**, Frank 42
**Fusco**, Paul 183

**Gajdel**, Edward 94
**Gall**, Sally 199
**Gallagher**, Dana 74, 75
**Gentl & Hyers** 74, 75, 105, 215
**Gipe**, Jon 109
**Goldberg**, Jeff 95
**Goldwater**, Mike 81
**Goodman**, John 77
**Greenfield-Sanders**, Timothy 129
**Grossfeld**, Stan 126, 166
**Guip**, Amy 21, 54

**Habib**, Dan 117
**Halard**, Francois 102
**Hall**, John 76
**Hanauer**, Mark 11

**Haneke**, Jody — 227
**Hartman**, Rose — 117
**Hartong**, Glenn — 193
**Heisler**, Gregory — 104, 114, 184, 192
**Hollenback**, P. — 87
**Holz**, George — 100, 189
**Hoover**, Sandra — 202
**Hornbaker**, Jeff — 123
**Houston Public Television Archives** — 85
**Howard**, Rob — 216
**Huang**, Vincent — 136

**Icaza**, Iraida — 54
**Ingham**, Ben — 90
**Irby**, Kevin — 83

**Jeanson**, Thibault — 14
**Jenkinson**, Mark — 80
**Jensen**, David — 136
**Joel**, Yale — 115
**Johnson**, Lynn — 110
**Jones**, Darrell — 109

**Kashi**, Ed — 109
**Keating**, Edward — 203
**Kennedy**, Charles — 217
**Kerslake**, Kevin — 49
**Koralik**, Cheryl — 11, 205
**Kratochvil**, Antonin — 64, 100, 127, 180, 220
**Kuehn**, Karen — 94, 199

**Lacagnina**, Abrams — 61
**LaChapelle**, David — 119
**Lanker**, Brian — 116
**Lee**, Daniel — 217
**Legendre**, Michel — 95
**Leibovitz**, Annie — 97, 179
**Leone**, Lisa — 92
**Levin**, Andy — 192
**Levin**, Wayne — 106, 199
**Levine**, Cynthia — 25
**Lewis**, Stephen — 75
**Lieberath**, Frederik — 73
**Lind**, Lenny — 83
**Lindbergh**, Peter — 40, 68, 70, 72, 73, 186
**Liss**, Steve — 168
**Littshwager**, David — 117, 181
**Loengard**, John — 112
**Long**, Michael — 227
**Luchford**, Glenn — 71
**Ludwigsson**, Hakan — 179

**Macpherson**, Andrew — 64
**Mahurin**, Matt — 11, 46, 170, 193, 204, 221
**Mann & Man**, — 53
**Mann**, Sally — 221
**Mark**, Mary Ellen — 90, 104, 202, 210, 212, 217
**Maser**, Wayne — 70, 71, 186
**McArthur**, Pete — 61
**McCoy**, Gary — 136
**McDaniel**, Melodie — 175
**McDean**, Craig — 41
**McGlynn**, David — 67
**McLeod**, William Mercer — 49, 117
**McNally**, Joe — 116
**McSpadden**, Wyatt — 123
**Meeks**, Raymond — 107, 189, 198

**Meier**, Raymond — 16, 17, 72, 73, 164, 185, 187, 209, 214
**Melford**, Michael — 117
**Menzel**, Peter — 111
**Messer**, Alen — 135
**Meuser**, Philip — 45
**Micaud**, Christopher — 176
**Micheletti**, Marco — 125
**Middleton**, Susan — 117, 181
**Mondino**, Jean Baptiste — 172
**Moon**, Sarah — 197
**Morello**, Peter — 134
**Morris**, Christopher — 218
**Morrison**, Alistair — 63
**Morrison**, Terry — 56
**Muench**, Marc — 109
**Muller**, Robert — 86
**Muzi**, Marcos — 58

**Nachtwey**, James — 124, 167
**Nelson**, Rob — 218
**Nelson**, Geoffrey — 83
**Newbury**, Jeffery — 31, 48, 181

**O'Neill**, Michael — 44, 51, 122, 178, 222
**Ockenfels 3**, Frank — 11, 46, 48, 120
**Olvera**, Jim — 82

**Palmer**, Huch — 77
**Parry**, Nigel — 172
**Patrick**, Dick — 87
**Pauliger**, Phillip — 54, 98
**Pearson**, Victoria — 14, 75
**Penn**, Irving — 115
**Perrin**, Pierre — 216
**Peterson**, David — 214
**Peterson**, Mark — 51, 65
**Phelps**, Bill — 53
**Philby**, John — 105
**Picayo**, José — 11
**Pierson**, Jack — 187
**Pitkin**, Stephen — 128
**Plachy**, Silvia — 77
**Pluchino**, Joseph — 174
**Porto**, James — 66, 67
**Price**, Larry C. — 201
**Proctor**, Daniel — 118

**Rau**, Andre — 13
**Rausser**, Stephanie — 117
**Reinhard**, Hans — 42
**Reyes**, Richard — 120
**Rheims**, Bettina — 39
**Richardson**, Terry — 134
**Ritts**, Herb — 130, 176, 207
**Robbins**, Neil — 232
**Roberts**, H. Armstrong — 120
**Robledo**, Maria — 14, 74, 75, 188
**Rodriguez**, Joseph — 201
**Rolston**, Mathew — 47, 130, 133, 196, 206, 208, 209
**Roversi**, Pao — 197

**Salgado**, Sebastiao — 12, 79, 194, 203
**Salisbury**, Mark — 59
**Samuels**, Deborah — 61, 95
**Scales**, Jeffrey Henson — 89
**Schaal**, Eric — 115
**Schafer**, Scott — 19
**Scharf**, David — 113, 191

**Schatz**, Howard — 215
**Schrager**, Victor — 14, 74, 75
**Schwartz**, Mark — 86
**Seliger**, Mark — 11, 22, 23, 38, 46, 47, 66, 132, 165, 204, 205, 206, 209, 210, 211
**Selkirk**, Neil — 49, 67
**Shardt**, Rick Mann — 54, 98
**Shinn**, Chris — 86
**Shung**, Ken — 76
**Silano**, Bill — 72
**Simons**, Chip — 97
**Sirota**, Peggy — 210
**Smith**, David Stewart — 125
**Smith**, Rodney — 196
**Smith**, Ron Baxter — 80
**Snyder**, William — 117
**Soqui**, Ted — 218
**Spear**, Geoff — 182
**Stickler**, Steve — 134
**Stonehill**, Alexandra — 175
**Sullivan**, Cleo — 182
**Sweetman**, Bill — 107

**Temme**, Marty — 136
**Testino**, Mario — 68
**Thain**, Alastair — 62
**Thode**, Scott — 110, 190, 195
**Thompson**, Michael — 88, 89
**Thurnher**, Jeffrey — 63
**Toscani**, Oliviero — 53, 58
**Toshman**, Richard — 219
**Towell**, Larry — 28, 169, 190

**Underwood**, Steve — 54, 98

**Vadukul**, Max — 132
**Vadukul**, Nitin — 119
**Van Overbeck**, Will — 128
**Von Unwerth**, Ellen — 37, 91

**Waine**, Michael — 59
**Walker**, Diana — 218
**Wallis**, Stephen — 77
**Waplington**, Nick — 195
**Warren**, Marion E. — 108, 177
**Watson**, Albert — 11, 48, 51, 134, 196, 208, 213
**Webb**, Alex — 194
**Weber**, Bruce — 53
**Weber**, Uli — 49
**Wegman**, William — 44
**Weiss**, Adam — 119
**Weiss**, Mark — 103
**White**, Steven — 11
**Williams Jr.**, Edward — 93, 213
**Williamson**, Andrew — 45
**Winters**, Dan — 34, 62, 171, 180, 184, 200, 216
**Winther**, Pierre — 92
**Winward**, Rob — 121
**Witkin**, Christian — 195
**Wohlmuth**, Sharon — 117
**Wolenski**, Stan — 82
**Wolf**, Bruce — 75
**Wolff**, Jean-Louis — 101
**Wong**, J. — 87

**Yager**, Robert — 117

**Zahedi**, Firooz — 44
**Zemanek**, Bill — 67

## ■ ILLUSTRATORS

**Allen**, Mark — 95
**Alsburg**, Peter — 99
**American Banknote Company** — 81
**Arias**, Raul — 122
**Arisman**, Marshall — 144, 146
**Asmussen**, Don — 55

**Bartalos**, Michael — 62
**Baseman**, Gary — 35, 140
**Beck**, David M. — 159
**Benoit** — 151
**Beregausky** — 35
**Berthoud**, Francois — 150
**Blitt**, Barry — 60, 155
**Boatwright**, Phil — 157
**Bralds**, Braldt — 146
**Brower**, Steven — 53
**Brown**, Calef — 37, 148

**Cameron**, Richard — 87
**Casson**, Sophie — 227
**Chwast**, Seymour — 50, 145
**Cober**, Alan E. — 129, 160
**Coe**, Sue — 143, 146, 153
**Collier**, John — 146, 148
**Cowles**, David — 149, 154
**Craft**, Kinuko — 156
**Cronin**, Brian — 60, 155
**Culebro**, Ulises — 122

**Day**, Rob — 158
**Delessert**, Etienne — 151
**DeSouza**, Cedric — 232
**Dever**, Eric — 156
**Drawson**, Blair — 151
**Drescher**, Henrik — 62, 121, 145, 161, 162

**Ellis**, Kevin E. — 19

**Finch**, Sharon Roy — 55
**Fredrickson**, Mark — 42

**Garcia**, Art — 82
**Gee**, Earl — 83
**Georgopoulus**, Dan — 123
**Glaser**, Milton — 151
**Gonzalez**, Alex — 126
**Gorey**, Edward — 156
**Gosfield**, Josh — 56, 62, 153, 154
**Graves**, Keith — 52, 87
**Grosueld**, Regina — 53
**Guip**, Amy — 61, 62, 123
**Gustafson**, Mats — 150

**Hoang**, Dung — 129
**Holland**, Brad — 61, 146
**Hughes**, David — 151, 156
**HungryDogStudios** — 149

**Irby**, Kevin — 61

**Jaben**, Seth — 61
**Jaegerman**, Megan — 160
**Jessee**, Jennifer — 136

**Kascht**, John — 159
**Katona**, Diti — 82
**Kelley**, Gary — 151
**Kogen**, Pamela — 118
**Kohler**, David — 81

**Krause**, Kai — 66
**Kroninger**, Stephen — 37
**Kunz**, Anita — 129, 138, 143, 158, 160
**Kurtz**, Mara — 145

**Lamb**, Terry — 84
**Lardy**, Philippe — 85, 147
**Liepke**, Skip — 151
**Little**, Blake — 183
**Lynn**, Eric — 35

**Macdonald**, Ross — 144
**Mahurin**, Matt — 149, 152
**Marsh**, James — 146
**Martos**, Victoria — 122
**Mayer**, Bill — 157
**McGee**, Margaret — 81
**Merriam-Webster, Inc.,** — 33
**Montes de Oca**, Ivette — 81

**Naftolin**, Lisa — 196
**Nelson**, Kenton — 158
**Nicky** — 35

**O'Connell**, Mitch — 120
**O'Neal**, Patrick — 84
**Oko & Mano, Inc.** — 57

**Payne**, C.F. — 42, 43, 154, 155
**Piven**, Hanoch — 127
**Plunkett**, John — 27
**Pollard**, David — 129, 155
**Pollock**, Ian — 157
**Pylypczak**, John — 82
**Pylypczak**, Roman — 82

**Rappel**, Aletha — 87
**Risko**, Robert — 141
**Rosen**, Jonathon — 149, 153
**Ryden**, Mark — 139

**Salina**, Joseph — 158
**Salisbury**, Elizabeth — 84
**Sanudo**, Rafael — 122
**Schumacher**, Ward — 54
**Scola**, James N. — 232
**Searle**, Ronald — 56
**Seibold**, J. Otto — 80, 147, 162
**Sis**, Peter — 56
**Spalenka**, Greg — 159
**Steadman**, Ralph — 131, 140, 142, 148
**Steinberg**, James — 57
**Suter**, David — 55

**Twitchell**, Lane — 232

**Vecchio**, Riccardo — 232
**Velasco**, Samuel — 122

**Wilson**, Will — 157
**Winward**, Rob — 121
**Woolley**, Janet — 77, 151, 161

## ■ PUBLICATIONS

Allure — 88, 89, 176
American Lawyer — 129
American Medical News — 159
American Photo — 215, 217
American Way — 120
Anchorage Daily News/Impulse — 19, 20, 21, 54

Architecture Magazine/BPI — 95
Ariad Pharmaceuticals 1993 Annual Report — 81
Arizona Highways — 177
Atlantic Monthly — 50
Atmos Energy Corporation Annual Report — 82
Audubon — 108, 109, 177, 216
Avenue — 176

Beckett Paper — 80
Blown Away — 59
Blueprint — 53, 156
Boston — 77
Boston Globe, The — 54, 126, 166
Bride's & Your New Home — 118
Buzz — 158, 221

California Active — 53
Capitol Offense, The — 52
Catalyst — 83
Child — 99
Chips and Technologies — 83
Clarity — 95
Classicist, The — 87
Cleveland Institute of Art Catalogue — 86
Colors — 18, 58, 59
Comcast Corporation 1993 Annual Report — 80, 147
Common Ground Newsletter — 128
Concrete Design Communications Inc. — 82
Condé Nast Traveler — 96, 97, 178, 179, 180, 216

Dance Ink — 79
Details — 39, 119, 221
Discover — 31, 127, 142, 144, 180, 181
Duracell Annual Report — 81

Earnshaw's — 175
El Mundo — 13, 122, 125
Elle — 76, 175
Elle Decor — 76
Emerge — 158
Entertainment Weekly — 37, 48, 62, 63, 143, 154, 182, 183
Esquire — 155
Expression — 101
EYE — 15, 36

Garbage — 60, 61
Garden Design — 32, 77, 144, 221
Glamour (France) — 214
Gotcha Style — 84
GQ — 34, 102, 103, 104, 184, 219
Guitar — 136

Harper's Bazaar — 16, 17, 40, 41, 68, 69, 70, 71, 72, 73, 185, 186, 187
Harvard Business Review — 156
Health — 118, 145, 214
Hemispheres — 106, 199
Hippocrates — 125
Home Mechanix — 155
House Beautiful — 188
Houston Public Television 1993 Annual Report — 85

Intolerance — 160

Journal Of Collegium Aesculapium, The — 35, 129

LIFE — 28, 29, 30, 110, 111, 112, 113, 114, 115, 116, 117, 169, 190, 191, 192, 193
Local Initiatives Support Corporation — 147

Martha Stewart Living — 14, 74, 75, 118, 188
Men's Journal — 100, 155, 189

Metropolis 26, 45, 145
Mickelberry Corporation 1993 Annual Report 85
Milwaukee 159
Minnesota Monthly 222
Money Magazine For Kids 121, 162
Mother Jones 158, 201
Musician 136

Natural Resources Defense Council 128
New York 44, 152
New York Times, The 56, 57, 127, 160, 203
New York Times Magazine, The 51, 105, 125, 140, 150, 153, 169, 194, 195, 196, 197
Newsweek International 219
Nickelodeon Magazine 121, 162

Outside 107, 109, 198
Outtakes 202

Pacifica 136
Parade 57
Parenting 220
Penthouse 218
Philadelphia Inquirer Magazine 151, 201
Popular Science 107
Premiere 64, 65, 159, 172, 202, 217
Print 53
Private Clubs 136
Progressive Corporation, The 33
Profiles 161
Public Issues—MBIA Magazine 128

Quarterly 129

Ray Gun 24, 25, 35, 49, 134, 135
Rock & Roll Hall of Fame, Museum Brochure 84
Rolling Stone 10, 11, 12, 22, 23, 38, 46, 47, 130, 131, 132, 133, 138, 139, 140, 141, 148, 149, 165, 170, 171, 203, 204, 205, 206, 207, 208, 209
Rough 52, 87, 120

Salon News 105, 215
San Francisco Focus 216
Seccion Aurea 145
Selling 123
Shape 159
Shots 53
South Texas College of Law Dean's Report 86
Spin 217
Sports Illustrated 122, 222
Spy 120
Stanford Medicine Magazine 129, 143, 161
Surfing 123

Texas Monthly 123, 146, 171, 200
3 Sixty 50
Time 42, 43, 124, 154, 167, 168, 218
TLC Monthly 157
Travel Holiday 94, 199

UNIFEM 1993 Annual Report 79
Upper and Lower Case 78
US 66, 210, 211

Vibe 49, 90, 91, 92, 93, 172, 173, 212, 213
Village Voice, The 146

W 164, 173, 214
Wall Street Journal Reports, The 55
Washington Post Magazine, The 151, 215
Washington Times, The 55, 126
Wired 27, 49, 66, 67, 158

Woodstock '94 121
Worth 156, 219

Yankee 157
YSB 89, 174

Zoo Views 54, 98

## ■ PUBLISHERS

ACPI 136
American Airlines Magazine Publications 120
American Lawyer Media LP 129
Anchorage Daily News 19, 20, 21, 54
Arizona Highways 177
Avenue Magazine Inc. 176

Billboard Publishing, Inc. 136
Black Entertainment 158
Boston Globe Publishing Co., The 54, 126, 166
Buzz, Inc. 158, 221
BYU Graphics 35

Camouflage Association 217
Capital Cities/ABC Publishing, Inc. 123
Capital Publishing 156, 219
Colors Magazine SRL 18, 58, 59
Concrete Design Communications Inc. 80, 82
Condé Nast Publications Inc. 34, 39, 88, 89, 96, 97, 102, 103, 104, 118, 119, 176, 178, 179, 180, 184, 216, 219, 221

Discovery Communications Inc. 157
Dovetale Publishers 60, 61

Earnshaw Publications 175

Fairchild Publications 105, 164, 173, 214, 215
Foundation for National Progress 158, 201

Gruner & Jahr 99

Hachette Filipacchi Magazines, Inc 76, 175, 215, 217
Harvard Business School 156
Havemeyer Bellerophon Publications, Inc. 26, 45, 145
Hearst Corporation-Magazines Division, The 16, 17, 40, 41, 68, 69, 70, 71, 72, 73, 155, 185, 186, 187, 188

International Typeface Corporation 78

Journey Communications 95

K-III Magazines 64, 65, 152, 159, 172, 202, 217
KINETIK Communication Graphics, Inc. 95
KQED, Inc. 216

M Design Company Ltd. 101
Marblehead Communications Inc. 161
Mariah Media 107, 109, 198
Meigher Communications 32, 77, 144, 221
METROCORP 77
Minnesota Monthly Publications 222
Modern Dog 52
MTV Networks 121, 162

National Audubon Society 108, 109, 177, 216
Newsweek 219
New York Times, The 51, 56, 57, 105, 125, 140, 150, 153, 160, 169, 194, 195, 196, 197, 203

Pace Communications 106, 199
Paige Publication 89, 174
Parade Publications Inc. 57
Philadelphia Inquirer 151, 201

Quad Graphics 159

SMAY Vision 136
Stanford Medicine 129, 143, 161
Star Tribune 53

Texas Monthly 123, 146, 171, 200
Time Inc. 14, 28, 29, 30, 37, 42, 43, 48, 62, 63, 110, 111, 112, 113, 114, 115, 116, 117, 121, 122, 124, 142, 143, 154, 162, 167, 168, 169, 182, 183, 190, 191, 192, 193, 218, 222
Time Inc. Ventures 49, 90, 91, 92, 93, 172, 173, 212, 213, 220
Time Publishing Ventures Inc. 118, 125, 145, 214
Times Mirror Magazines 107, 155

Unidad Editorial S.A. 13, 122, 125
US Magazine Co.,L.P. 66, 210, 211

Village Voice Publishing Corporation 146

Wall Street Journal, The 55
Walt Disney Publishing 31, 127, 142, 144, 180, 181
Washington Post Co., The 151, 215
Washington Times, The 55, 126
Welsh Publishing Group Inc. 121
Wenner Media 10, 11, 12, 22, 23, 38, 46, 47, 100, 130, 131, 132, 133, 138, 139, 140, 141, 148, 149, 155, 165, 170, 171, 189, 203, 204, 205, 206, 207, 208, 209
Wordsearch Publishing 53, 156

Yankee Publishing Inc. 157

## ■ STUDIOS, FIRMS & CLIENTS

Addison Corporate Annual Reports 81
Alexander Isley Design 49

Barnett Group 128, 129
Best Design, Incorporated 120
BYU Graphics 129

Cahan and Associates 83
Communication Design Corp. 136

David Carson Design 24, 25, 35, 49, 134, 135
Design/Writing/Research 79

Earl Gee Design 83
EMap Business Communications 15, 36
Emerson, Wajdowicz Studio, Inc. 79, 128
Eric Dinyer Imaging 218

Frankfurt Balkind Partners 80, 147

Geer Design, Inc. 85, 86, 129

Institute for the Study of Classical Architecture 87

Melanie Doherty DSG. 54, 98
Mike Salisbury Communications 53, 59, 84, 123

Nesnadny & Schwartz 33, 84, 86

Pentagram Design NYC 81, 85
Peter Howe Inc. 202
Peterson & Co. 52, 87, 120
Plunkett & Kuhr 27, 49, 66, 67, 158
Pushpin Group, Inc., The 50, 145

Scott Johnson Design 128
Steven Brower Design 53
Studio W 89, 174
Sullivan Perkins 82
Sunil Bhandari 160

Voyager Company, The 50

| DATE DUE | |
|---|---|
|  |  |
|  |  |
|  |  |
|  |  |
|  |  |
|  |  |
|  |  |
|  |  |
|  |  |
|  |  |
|  |  |
|  |  |
|  |  |
|  |  |
|  |  |
|  |  |
|  |  |
|  |  |